Victorian Landscape Watercolors

Victorian Landscape Watercolors

Scott Wilcox

Christopher Newall

Hudson Hills Press · New York
in association with the Yale Center for British Art

First Edition

© 1992 by the Yale Center for British Art

All rights reserved under International and
Pan-American Copyright Conventions.
Published in the United States by Hudson Hills Press, Inc.,
Suite 1308, 230 Fifth Avenue, New York, NY 10001-7704.

Distributed in the United States, its territories and
possessions, Canada, Mexico, and Central and South America
by National Book Network, Inc.
Distributed in the United Kingdom and Eire
by Shaunagh Heneage Distribution.
Distributed in Japan by Yohan
(Western Publications Distribution Agency).

Editor and Publisher: Paul Anbinder

Copy Editor: Fronia W. Simpson

Proofreader: Lydia Edwards

Indexer: Peter Rooney

Designer: Howard I. Gralla

Composition: Trufont Typographers

Manufactured in Japan by Toppan Printing Company

Library of Congress Cataloguing-in-Publication Data

Wilcox, Scott. 1952–
Victorian landscape watercolors
Scott Wilcox, Christopher Newall.—1st ed.
p. cm.
Catalogue of an exhibition held at
the Yale Center for British Art, Sept. 9–Nov. 1, 1992,
the Cleveland Museum of Art. Nov. 18, 1992—Jan. 3, 1993, and
the Birmingham Museum and Art Gallery, Feb. 11—Apr. 12, 1993.
Includes bibliographical references (p.) and index.
1. Watercolor painting, British—Exhibitions.
2. Watercolor painting, Victorian—Great Britain—Exhibitions.
3. Landscape painting, British—Exhibitions.
4. Landscape painting—19th century—Great Britain—Exhibitions.
I. Newall, Christopher.
II. Yale Center for British Art.
III. Cleveland Museum of Art.
IV. Birmingham Museum and Art Gallery.
V. Title.
ND2243.G7W55 1992
758′.142′0942074—dc20 92-10149
 CIP

Dates of the exhibition:

Yale Center for British Art
September 9–November 1, 1992

Cleveland Museum of Art
November 18, 1992—January 3, 1993

Birmingham Museum and Art Gallery
February 11—April 12, 1993

Support for the exhibition in New Haven and Cleveland has come
from the National Endowment for the Arts, a Federal agency.

ISBN: 1-55595-071-X (alk. paper)

Contents

Lenders to the Exhibition

Aberdeen Art Gallery and Museums

Visitors of the Ashmolean Museum, Oxford

Birmingham Museum and Art Gallery

Chris Beetles Limited

Trustees of the British Museum, London

Mr. and Mrs. Michael Bryan

Chart Analysis Limited

Cleveland Museum of Art

Mr. and Mrs. Richard Dorment

Randall S. Firestone

Syndics of the Fitzwilliam Museum, Cambridge

Glasgow Art Gallery and Museum

Guildhall Art Gallery, Corporation of London

Harris Museum and Art Gallery, Preston

Hunterian Art Gallery, University of Glasgow

Laing Art Gallery, Newcastle upon Tyne,
Tyne and Wear Museums

Maidstone Museums and Art Gallery

National Galleries of Scotland, Edinburgh

Phillips and Deans

Private collections

Janine Rensch, Switzerland

Robertson Collection, Orkney

Trustees of the Tate Gallery, London

Robert Tuggle

Board of Trustees of the Victoria and
Albert Museum, London

Walker Art Gallery, Liverpool, National Museums
and Galleries on Merseyside

Whitworth Art Gallery, University of
Manchester

Yale Center for British Art, New Haven

Foreword

It was a French critic, Edmond About, who wrote in 1855 that "watercolor is, for the English, a national art." In previous exhibitions at the Center we have traced those developments which, by the middle of the nineteenth century, placed painting in watercolor in Britain on an equal footing with painting in oils. With this selection of *Victorian Landscape Watercolors*, Scott Wilcox and Christopher Newall not only demonstrate the truth in About's words, they proceed to illustrate the richness and diversity of what followed in landscape watercolors produced by British artists in the second half of the nineteenth century.

In 1985 Scott Wilcox wrote the catalogue of *British Watercolors: Drawings of the 18th and 19th Centuries from the Yale Center for British Art* to accompany the exhibition which toured throughout the United States under the auspices of the American Federation of Arts. To a certain extent, *Victorian Landscape Watercolors* provides a sequel to that extremely successful visual account of the history of watercolor painting. It too is a traveling exhibition, and we acknowledge with gratitude the interest of our partners in Cleveland and Birmingham, whose participation has enabled us to plan on an international scale. Once again, it is a pleasure to collaborate with Hudson Hills Press as the publishers of a catalogue which will not only accompany the exhibition to all three venues but will survive it as a handsomely produced permanent addition to the literature of Victorian art.

In other respects the differences between this exhibition and its predecessor are significant. *British Watercolors* was based exclusively upon the Center's own holdings, whereas *Victorian Landscape Watercolors* is heavily dependent upon loans from both private and public collections. In place of a broad chronological survey, this exhibition provides a detailed study in one period, Victorian, of one subject, landscape, as it was treated in one medium, watercolor. In the course of doing so, it charts important theoretical as well as practical developments. Aware of Christopher Newall's demonstrated interest in both, and his knowledge of Victorian paintings in British collections, Scott Wilcox invited him to join in selecting the show and writing the catalogue. Each has contributed from his own scholarly perspective, and we are indebted to them for insights which are as varied as the landscapes through which they guide us.

Finally, the Center is proud to acknowledge the assistance of the National Endowment for the Arts, which is a Federal agency, toward the cost of mounting the exhibition in New Haven and Cleveland. We also wish to thank British Airways for their sponsorship as international carriers of the exhibition, and Crabtree & Evelyn for designing and producing publicity materials for the showing in New Haven.

Duncan Robinson, DIRECTOR
YALE CENTER FOR BRITISH ART

Authors' Acknowledgments

First and foremost we should like to record our personal thanks to the many private collectors and public institutions that enabled us to assemble such a splendid and representative group of landscape watercolors of the Victorian period. The exhibition and this publication stand as records of their helpfulness, generosity, and enthusiasm for the project.

Among the many individuals who assisted us with our research, helped to secure and facilitate loans, and provided much-valued advice, we extend particular thanks to the following: Chris Beetles, Judith Bronkhurst, John Crabbe, Liz Dent, Judy Egerton, Albert Gallichan, Robin Hamlyn, Martin Hopkinson, Ralph Hyde, Francina Irwin, the Reverend Ross Kennedy, Alex Kidson, Vivien Knight, Susan Lambert, Lionel Lambourne, Margaret MacDonald, Sandra Martin, John Millard, David and Monica Moore, Edward Morris, Jane Munro, Peter Nahum, Sheila O'Connell, Janice Reading, Sarah Richardson, Pamela Robertson, Peter Rose, David Scrase, Joseph Sharples, Janet Skidmore, Peyton Skipwith, Catharina Slautterback, Greg Smith, Michael Spender, Lindsay Stainton, Allen Staley, Hugh Stevenson, Veronica Tonge, Julian Treuherz, Henry Wemyss, Catherine Whistler, Stephen Whittle, Andrew Wilton, and Andrew Wyld.

Without the continuing support of Duncan Robinson and much hard work by the rest of the staff of the Yale Center for British Art, this exhibition would have been impossible. We offer special thanks to Barbara Allen, Suzanne Beebe, Richard Caspole, Constance Clement, Theresa Fairbanks, Christopher Foster, Julia Friedheim,

Timothy Goodhue, Robert Hubany, Marilyn Hunt, David Mills, Patrick Noon, Martha Pigott, and Gail Schuster. Of the many people at the Cleveland Museum of Art and the Birmingham Museum and Art Gallery who helped with the exhibition, Bruce Robertson and Michael Miller must be singled out at Cleveland, and Jane Farington, Richard Lockett, Evelyn Silber, and Stephen Wildman at Birmingham.

It has been a great pleasure working with the publisher Paul Anbinder, the designer Howard Gralla, and the editor Fronia W. Simpson. Their efforts have resulted in a more graceful and handsome book than we could ever have anticipated.

Finally, we owe a special debt of gratitude to Carolyn Wilcox and Jenny Newall for their support, encouragement, and astute criticism. To them and to Emma, Alfred, and George, this book is lovingly dedicated.

SW
CN

11

Introduction

IN A notice of a recently published drawing manual by the elderly watercolorist Francis Nicholson, William Henry Pyne wrote in 1823 of the art of which Nicholson had been a distinguished practitioner: "With reference to Water Colour Painting, we have to speak of a new art, originating with the English, and perfected within the age whence it began."[1] In a series of articles on watercolor, Pyne, a landscape painter as well as a writer on the arts, celebrated "that English school, as it now stands recorded, the admiration of all nations."[2] The nationalistic note sounded by Pyne was echoed in discussions of watercolor throughout the nineteenth century.

It was not that watercolor was new or an English invention; however, the practice of watercolor art had undergone a radical transformation within the lifetimes of Nicholson and Pyne, and their fellow countrymen could justifiably lay claim to that achievement. Central to the promotion of watercolor as an autonomous art form was the establishment in 1804 of the Society of Painters in Water-Colours, of which Nicholson was a founding member.

From their beginning, the Society's annual exhibitions showed a pronounced bias toward landscape subjects. This reflected in part the roots of watercolor painting in topographical draftsmanship, but it was also frequently asserted that the watercolor medium was particularly well suited to capturing those effects of light and atmosphere that were at the heart of landscape painting.

Watercolor painting of the second half of the century was very different from that known to Nicholson and Pyne, yet the same associations of landscape with the Society and with watercolor continued to be made. The *Art Journal* in 1852 commented that "the Society of Water-Colour Painters has always been an association of landscape painters."[3] In 1876 the *Spectator* found the key to the success enjoyed by watercolor art specifically in its relation to landscape: "In Water-Colour painting, we have an art that, as such, is hardly a century old, and which, as a genuine product of the time, has a sensitive, if not a very vigorous vitality. For this several reasons might be assigned; the most obvious, perhaps[,] is the ascendancy of Landscape as a subject of modern art."[4] The foremost reason given for the rise of landscape painting was the growing abstraction of religious thought, with the subsequent transference of spiritual feeling from traditional religious subjects to natural beauty. Whatever explanations could be advanced for the nineteenth-century taste for landscape, it was clear to the *Spectator*'s critic, as it was to many writers on art in the period, that there was a special affinity between landscape painting and the watercolor medium: "The very transparency and softness of the material are in keeping with the phase of feeling [for the spiritual in nature] we have attempted to indicate, while its superior handiness enables the artist to follow Nature into her haunts, and catch her more fleeting expressions with greater readiness than his fellow-craftsman in oils."

The generation of artists responsible for the extraordinary parallel rise of watercolor and landscape painting passed from the scene in the 1840s and 1850s. Both watercolor and landscape art were frequently seen after mid-

century as beginning a long and unchecked decline, and this view has continued to characterize most thinking on the subject. For example, in a 1977 essay titled "Victorian Landscape Painting: A Change in Outlook," W. F. Axton seemed to dismiss his own subject with the statement: "The deaths of Turner and Constable early in the reign of Victoria marked the end of the brief but great era of English landscape painting."[5] Later in the essay he claimed that the ideals and methods of the Pre-Raphaelites dominated painting from nature in Great Britain for the rest of the century and thus felt justified in limiting his discussion to the Pre-Raphaelites and ignoring later developments. Axton was undoubtedly influenced by the only extended scholarly treatment of landscape painting in the period, Allen Staley's *The Pre-Raphaelite Landscape*, which appeared in 1973. It might have been hoped that Staley's ground-breaking work would lead to the exploration of other aspects of Victorian landscape, but in the almost twenty years since its publication – a period that has seen burgeoning interest in other areas of Victorian art – little consideration has been given to the subject.

While the second half of the nineteenth century lacked a commanding genius of the stature of Turner, and while there is a retrospective flavor to much of the later landscape painting in watercolors, the perception of decline must be understood as originating first in the artistic polemics of that period and later in the wholesale rejection of Victorian art by early-twentieth-century modernism. What happened to the landscape watercolor in the Victorian period was not the slow death of a great tradition but a process of questioning and experimentation in style and content. It was a time of lively debate over what landscape and what watercolor should be.

Indeed, Victorian landscape painting in watercolors is so rich and diverse and the artists engaged in the genre so numerous that any survey such as the present one must necessarily be highly selective. Many worthy artists have had to be excluded, not without regret on our part; and certain areas of landscape painting are not as fully represented as one or the other of us might wish. While acknowledging that our decisions as to what watercolors should be included and which artists considered result from personal assessments of what is beautiful, interesting, and significant, we have sought to offset this subjectivity by using contemporary reviews and articles and by focusing on the watercolor societies to gauge what the major trends were and which watercolorists were perceived as important.

The concentration on the London-based societies does make a certain London bias inevitable in our account. Although we have included artists who worked and exhibited outside London, such a bias cannot be entirely avoided. Despite the flourishing art activity in centers such as Liverpool and the afterlife of such earlier artistic centers as Norwich and Bristol, London remained the focal point. British landscape painting was essentially an urban art form, produced by city-based artists for a metropolitan audience.

Our account begins with a consideration of the continuing influence of the great generation who earlier in the century had established the landscape watercolor as a major British contribution to the arts. The second chapter examines the role of the landscape watercolor in John Ruskin's aesthetic thought as well as his own dominant role in shaping that art. Relying heavily on the popular criticism of the period, the third chapter looks at the place of landscape within the watercolor societies and its development as it appeared in the societies' annual exhibitions. The final chapter deals with the tug of new and old, foreign and native in the later Victorian period.

While the chapters set out the major themes, issues, and figures in British landscape painting in watercolors from 1840 to the end of the century, these do not constitute the whole story. Many of the interesting byways and sidelights that give such a distinctive flavor to the landscape art of the period are explored in the entries for individual works. It is our intention that these entries form a sort of narrative of their own, amplifying and enriching that of the main text. The entries have been arranged chronologically. In most cases the watercolors bear dates inscribed by the artists or are datable on the basis of exhibitions in which they appeared or other documentary evidence. In a few instances, when there is no clear indication of the date of a work, we have slipped it into the chronology at a point that seems appropriate.

NOTE Throughout the Victorian period, the art of painting in watercolors was centered in the two established watercolor societies. The changes in their official titles along with the informal names by which they were known can lead to confusion. The older body, founded in 1804, was the Society of Painters in Water-Colours, which became the Royal Society of Painters in Water-Colours in 1881. After 1832, it was commonly referred to as the Old Water-Colour Society to distinguish it from the New Society of Painters in Water Colours, which came into existence in that year. The New Society changed its title to the Institute of Painters in Water Colours in 1863. It became the Royal Institute of Painters in Water Colours in 1883.

References to *The Works of John Ruskin*, ed. E. T. Cook and Alexander Wedderburn, 39 vols. (London: George Allen, 1903–12), are given in the text by volume and page number.

1. Ephraim Hardcastle [W. H. Pyne], "On Painting in Water Colours, No. II," *Somerset House Gazette, and Literary Museum* 1 (October 25, 1823): 47.
2. Ephraim Hardcastle [W. H. Pyne], "The Rise and Progress of Water Colour Painting in England, No. I," *Somerset House Gazette, and Literary Museum* 1 (November 8, 1823): 66.
3. *Art Journal*, November 1, 1852, p. 331.
4. *Spectator*, April 29, 1876, pp. 559–60.
5. W. F. Axton, "Victorian Landscape Painting: A Change in Outlook," *Nature and the Victorian Imagination*, ed. U. C. Knoepflmacher and G. B. Tennyson (Berkeley and Los Angeles: University of California Press, 1977), p. 284.

Victorian Landscape Watercolors

Chapter One

"They Leave Other Lights behind Them"

IN ITS review of the annual exhibition of the Society of Painters in Water-Colours in 1842, the *Art-Union* commented:

The Society as a whole, has, we have no doubt, carried the art of Painting in Water Colours as far as it can be carried. Some great and original mind may, possibly, strike out a new path, and lead the way to improvements of which we can now have no conception; but until this has been done, the annual exhibitions will exhibit only the same pictures we have seen – differing only in subjects from those which the respective artists have already produced.[1]

Watercolor seemed to have reached a state which, for better or worse, admitted of no foreseeable advance. Yet new paths were being blazed both inside and outside the Society. The watercolorists William Henry Hunt and John Frederick Lewis pioneered a popular new look in watercolor painting, and John Ruskin, spreading his fledgling critical wings, celebrated the medium's practitioners of the present and recent past, while advancing new notions of what watercolor and landscape art should be.

Over the next two decades, landscape painting in watercolor changed dramatically. The leading landscapists of the Society in the early 1840s – David Cox, Peter DeWint, and its president, Anthony Vandyke Copley Fielding – were members of the generation that had come to maturity in the first decade of the century. These exponents of an older style of landscape watercolor left the scene in the same years that the new conception of watercolor, to which Hunt, Lewis, and Ruskin contributed, gained ground with artists, critics, and the general public. Together these two developments constituted a decisive break in the history of watercolor painting; however, the new ideas did not fully supplant the old, nor did the deaths of the great watercolorists of the first half of the century mark the end of their influence. The legacy of Cox, DeWint, and a few of their contemporaries, most especially Joseph Mallord William Turner, was substantial. Their position as classic masters of the medium guaranteed that their successors of whatever stylistic stripe would be judged by the standards they had set; moreover, their works provided an important alternative to those newer models of landscape and technique that came to the fore. This chapter will track and assess the legacy of that older generation through the second half of the century.

William Henry Hunt was actually a part of that generation, but his particular evolution as a watercolor painter fed directly into the midcentury changes in watercolor art. A Society member, he had in the 1830s abandoned landscape for genre and still life. The shift in subjects was accompanied by a change of style. The simple washes of color and prominent pen-and-ink outlines rooted in eighteenth-century practice were replaced by a technique of stippling and a liberal use of bodycolor (opaque watercolor, also called gouache). Lost to the ranks of the landscapists, Hunt, nonetheless, provided a forceful stylistic example for landscape painters with his popular fruit pieces and bird's nests (fig. 1). Actually, within the context of the new detailed naturalism, Hunt's still lifes were seen as landscapes in microcosm.

In the Society exhibitions of the 1840s, John Frederick Lewis was conspicuous by his absence. Through the previous decade his detailed and vibrant watercolors of Spanish and Italian subjects had won considerable acclaim. He left England for Italy and the Middle East in 1837, finally settling in Cairo. When his contributions to the exhibitions back in London ceased after 1841, the critics and his fellow Society members were bereft of one of that group's leading lights. On his return to London and the Society in the early 1850s, his new watercolors of Eastern scenes created a sensation.

Like Hunt, Lewis was not a landscape painter; the sun-drenched landscapes of these works served only as a backdrop for exotic genre subjects such as *The Frank Encampment* (fig. 2). Once again like Hunt, his color, touch, and use of bodycolor were compelling and readily translatable lessons for the landscape specialists. Both Hunt and Lewis pointed the way to a new watercolor style – one that would in the popular mind be associated with the movement known as Pre-Raphaelitism.

The early 1840s also saw the emergence of a critical voice that would be inextricably linked to the development of the landscape watercolor. The first volume of John Ruskin's *Modern Painters* appeared in 1843. In this, his first book, the Oxford undergraduate (as he was identified on its title page) argued for the achievements of the school of landscape that was based in the Society, but whose greatest genius – J. M. W. Turner – was outside it. At the heart of the book was Ruskin's explication and justification of Turner's landscape art. The presumption of some of Ruskin's pronouncements was more than offset by the eloquence, fervency, and acuteness of much else in the volume and by the commanding vision of landscape art that he espoused. Ruskin would be a spokesman and advocate but even more an inspiration for the significant changes that were about to occur in landscape watercolors.

Ruskin could make extravagant claims for the modern landscape school in the early 1840s; by the mid-1850s both the situation and the writer's perceptions of it had changed. In his *Academy Notes* for 1857, Ruskin, after commending the steady advance of Pre-Raphaelite principles in the exhibitions of the Royal Academy, turned to the Society of Painters in Water-Colours. He compared the Society to the firm of Fortnum and Mason, supplying the demand of the British public for "a kind of Potted Art, of an agreeable flavour, suppliable and taxable as a patented commodity, but in no wise to be thought of or criticised as *Living Art*." From this general condemnation of the Society's watercolors, Ruskin excluded only the works of the elderly David Cox, declaring, "There is not any other landscape which comes near these works of David Cox in simplicity or seriousness" (14.122–23).

The Society of Painters in Water-Colours exhibition the following year received favorable treatment in Ruskin's *Academy Notes*, but the 1859 exhibitions of the Old Society (as it was known by then) and its younger rival, the New Society of Painters in Water Colours, occasioned an even more scathing attack:

In spite of all the apparent exertion, and reflex of Pre-Raphaelite minuteness from the schools above them, the Water-Colour Societies are in steady descent. They were founded first on a true and simple school of broad light and shade – grey touched with golden colour on the lights. This with clear and delicate washes for its transparent tones, was the method of all the earlier men; and the sincere love of Nature which existed in the hearts of the first water-colour masters – Girtin, Cozens, Robson, Copley Fielding, Cox, Prout, and De Wint – formed a true and progressive school, till Hunt, the greatest of all, perfected his art. Hunt and Cox alone are left of all that group, and their works in the Old Water-Colour are the only ones which are now seriously worth looking at. (14.246–47)

Within a month of these words' appearing in print, David Cox had died, leaving William Henry Hunt as the sole survivor of the watercolor masters enumerated by Ruskin. And Hunt, in devoting himself to still-life subjects painted in a meticulously detailed bodycolor technique, had set himself apart from those landscape watercolorists with whom Ruskin had grouped him.

The 1850s saw the passing of the old guard of landscape painting in watercolors: Peter DeWint's death in 1849 was followed by J. M. W. Turner's in 1851, Copley Fielding's in 1855, and David Cox's in 1859. Ruskin was not alone in seeing the decade as the passing of an era and in charting the decline of the watercolor school. According to the *Spectator* in 1858:

England, with great traditions in her water-colour school, and with an amount of potential skill in that school beyond comparison with any country, has at this moment scarcely a water-colour painter who is thoroughly an artist. To go on in its present path can only bring the school lower and lower. . . . Who is to succeed – we do not say to such an unique and creative genius as Turner – but to Lewis, who has already seceded from this branch of art, to David Cox, or to William Hunt?[2]

As with Ruskin's Fortnum and Mason analogy, critics frequently made the imputation that the current low state of watercolor was directly attributable to the artists' succumbing to the temptations of easy repetition and commercialism. Nostalgia for the grand old men could be used as a truncheon with which to beat the artists of the present. But a genuine sense of loss pervaded the criticism even of those writers prepared to give the younger generation its due. The *Art Journal* in 1855 wrote:

The stars of the old school of water colours are setting one by one, but they leave other lights behind them. The last few years have borne away some of the oldest and best of the water colour painters, and although there is no lack of brilliancy and effort in the works of those that remain, we cannot say that we do not miss those productions to which the eye has been for so many years accustomed.[3]

Who were the rising figures in the watercolor societies, poised to take the places of the passing generation? The established landscapists were Edward Duncan, William

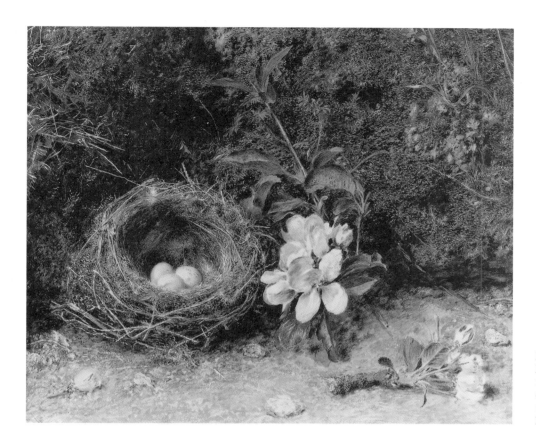

Fig. 1. William Henry Hunt, *A Bird's Nest with Sprays of Apple Blossoms*, ca. 1845–50. Watercolor and body-color over pencil, 255 × 307 mm (10 × 12⅛ in.). Yale Center for British Art, Paul Mellon Collection.

Fig. 2. John Frederick Lewis, *A Frank Encampment in the Desert of Mt. Sinai*, 1856. Watercolor and bodycolor over pencil, 648 × 1343 mm (25½ × 52⅞ in.). Yale Center for British Art, Paul Mellon Collection.

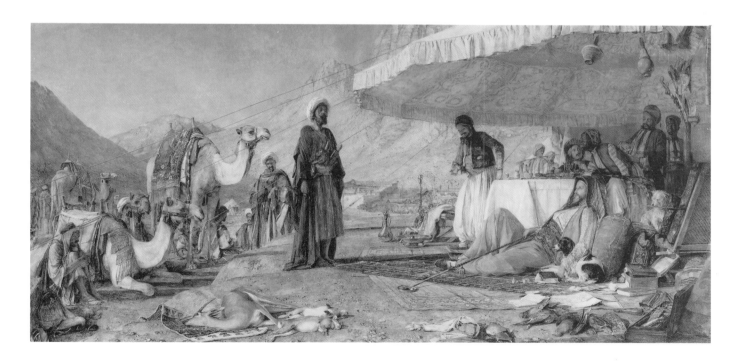

Callow, George Arthur Fripp, and Thomas Miles Richardson, Jr., in the Old Society, and Aaron Penley in the New. Most of these artists remained wedded to formulas of picturesque landscape already established at the beginning of the century.

Their individual styles were compounded of the manners of Turner, John Varley, and Samuel Prout, with a little – in Callow's case, more than a little – of the dash of

Richard Parkes Bonington. The breadth and mellow coloring of Varley's and Prout's early works, however, had been exchanged for increased picturesque detail and color schemes in a higher key.

Of the younger artists, Charles Vacher and Thomas Charles Leeson Rowbotham – becoming members of the New Society in 1850 and 1851 respectively – continued this conventionally picturesque landscape art. Also in the

New Society, William Bennett and David Hall McKewan showed signs of perpetuating the style of David Cox, while Edmund George Warren began to capitalize on the more palatable aspects of Pre-Raphaelite color and detail. Charles Davidson, another promising newcomer in the early 1850s, seems to have been seeking a salable mix of Pre-Raphaelite and more traditional elements.

None of these artists, with the possible exception of Fripp, achieved more than a momentary place in the front rank of watercolor landscapists. It was against this background of updated picturesque forms and techniques together with a few tentative forays into new practice that the "old school" came into focus.

From the mid-1840s, the three artists most frequently cited as embodying the old school of landscape watercolor were Cox, DeWint, and Copley Fielding. As their works disappeared from the walls of the annual exhibitions, they were appropriated to serve a variety of symbolic ends. Throughout the rest of the century, questions about the state of landscape painting and the art of watercolor were often framed in terms of the relationship with the achievements of these three.

The three were not in any sense interchangeable. Copley Fielding, the most old-fashioned, was at the same time the closest to the fashionable midcentury picturesque landscape. Compositions such as *The Close of Day* (cat. no. 20), typical of the great exhibition pieces of the last years of his life, self-consciously evoked the pictorial structures of the eighteenth century. His slick, soft finish recalled the grand exhibition manner of the early years of the Society of Painters in Water-Colours, while conforming to the current taste for finish.

Although many of the younger exponents of the conventional picturesque, such as Thomas Miles Richardson, Jr., were indebted to Copley Fielding's example, it was never possible to speak of a Copley Fielding school, as one could, at various times in the second half of the century, speak of a Cox school. The one artist who could be seen as quite specifically inheriting both a style and a subject matter from Copley Fielding was Henry George Hine. His softly atmospheric watercolors of the Sussex Downs (cat. nos. 66 and 70) developed one of the picture types that Copley Fielding, in his lifetime, had made very much his own.

Cox's watercolors presented a marked contrast to Copley Fielding's when the two men were rival patriarchs of the Old Society in the late 1840s and early 1850s. As its president and a particularly prolific exhibitor, Copley Fielding enjoyed a high profile, but when the contrast was drawn between the style of Cox, perceived as bold and manly, and that of Copley Fielding, which tended to the bland and overly refined, it was Cox who appeared to have the greater claim to greatness. In reviewing the 1848 exhibition, the *Spectator* noted:

David Cox, who catches the roughness and freshness of nature, is rougher in his execution, and leaves scraps of white paper floating across his skies in a manner as unprincipled as ever; while Copley Fielding tends unceasingly towards the opposite extreme, finishing off with a smoothness and blended softness that emulate the style of the best tea-trays.[4]

The following year the *Spectator* returned to the theme, criticizing the "ultra-graceful tendency" which made Copley Fielding reduce his landscape interpretations to the level of the fashionably pretty illustrations for Christmas annuals. The reviewer noted that a dawning "sense of this effeminate exaggeration" led the artist to attempt some works in a crude, sketchy manner, but these were just as unconvincing. The contrast was again drawn with David Cox: "In David Cox this rough manner is but the more pronounced form of an original blemish, considerably redeemed by great vigour."[5]

With the issue drawn as one between manliness and effeminacy, Cox's art was bound to have the advantage, particularly in regard to an art form (watercolor) that had long struggled to assert its professionalism against associations with the pastime of lady amateurs. Furthermore, Cox's blunt and forthright style made for a more telling contrast with the rising tide of Pre-Raphaelitism. Cox and the Pre-Raphaelites were readily accepted as representing opposite ends of the stylistic spectrum. It was, however, asserted that these seemingly antithetical approaches to nature – "the most blurred daub of Cox, and the most microscopic Praeraphaelitism" – were equally capable of expressing natural truth.[6] Compared to either, Copley Fielding's landscape art could seem shallow and artificial.

DeWint and Cox were closer in style and were frequently joined in critical commentary. In 1845 the *Spectator* dubbed them "the two pillars of the good and true English School of water-colour painting, as applied to landscape; and we do not perceive any one to supply their places hereafter." Both were regarded as "inimitable in representing the out-door freshness and daylight brightness of our moist climate,"[7] and both were accused of selecting subjects that were not picturesque or even of painting watercolors that had no subject at all.[8]

Each had gained a reputation as a bold and fluent manipulator of the medium. DeWint's technique was based on warm and fluid sweeps of color, evident in *Brougham Castle* and *Cornfield, Windsor* (cat. nos. 3 and 4). Cox's manner had a more nervous quality, his forms built up through a succession of "very spirited touches" of the brush.[9]

In his major exhibition pieces, Cox expanded this basic approach with sponging, rubbing and scraping out, and with further layering of brushstokes, yet the freedom of his "spirited touches" remained. A comparison of his *Vale of Clwyd* of 1848 (cat. no. 14) with DeWint's *On the Dart* of 1849 (cat. no. 15) indicates the greater roughness that Cox permitted himself even in the grandest of his later finished works. In his later works, DeWint, like Copley Fielding, was essentially continuing a long-established personal style; Cox was forging a new one. This development on Cox's part was at times ignored, at times deplored, in a few instances recognized for what it was. The

Art Journal in 1852 observed that "his manner is still transitional, there is yet much to be looked for from him."[10]

Ultimately it was Cox's greater roughness and ruggedness, along with his greater longevity, which led to his becoming the great exemplar of the early watercolor style in all its boldness and simplicity. In the 1850s he was dubbed "the general commanding-in-chief" and "the father of this section of the profession."[11] The reviews of that decade tended to concentrate on the power of his landscape images and the peculiar means by which he achieved it. In 1852 the *Spectator* noted: "In his works there are power and insight enough to swamp all the others put together." The theme was expanded in a review a few years later: "Once more that grand old man David Cox shows his juniors how easily he can beat all their most deliberate undertakings, by dabbing – one would have said at haphazard – a brush with dusky blues and greys over a bit of packing-paper."[12] The *Athenaeum* sought a military simile, of Cromwell's troops routing the Royalists, to convey the same idea: "That veteran David breaks through all these prettinesses as the Ironsides broke through the silks and feathers forty abreast. His thunderous blues, almost opaque; his rainy browns and ragged grey skies, though groped for and sponged and scrubbed, have a tremendous power about them, which no smart colouring can attain."[13]

Not every reviewer responded so positively to Cox's freedom of handling. As early as 1845, the critic for the *Art-Union* complained that "he is carrying his free style to the extremity of looseness," and warned two years later: "There is a freedom which gives value to certain effects, but which, beyond an absolute limit, produces nothing but confusion."[14]

By the mid-1850s, when Cox suffered a stroke that accentuated the tendencies to roughness already inherent in his late style, the critics could be less kind. Against the expressions of praise for the vigorous grand old man of the watercolor tradition, we must set the following from the *Athenaeum*: "It is painful to descend to the black, watery spongings of Mr. D. Cox, who has really painted too well to hope in old age to surpass himself. This is mere inarticulate babbling, and can obtain no listeners. A good name should not be thus traded on."[15]

Whether it was seen as a kind of rough magic or as "inarticulate babbling," the sketchlike, unformed look of Cox's late work was its keynote. And it was the association of Cox's work with simple, direct sketching that made it such a potent symbol for those later artists and critics who stood out against prevailing standards of high finish and overelaboration.

Cox himself was careful to maintain the distinction between his sketches, such as *View near Bettws-y-Coed* (cat. no. 12), and the watercolors he finished for exhibition, such as his *Vale of Clwyd*, *Penmaen Bach*, and *Keep the Left Road* (cat. nos. 14, 18, and 21). While the exhibition pieces do show a freshness and freedom characteristic of the sketch, they also have a scale and a solid, considered structure that are totally unsketchlike. Although the

brushwork is loose and roughhewn in appearance, the surface of these watercolors is often heavily worked with scraping and rubbing out, a layering of washes, and a "mosaic" (to use Cox's own word) of brushstrokes.

Cox's letters show the degree of care and the extent of trouble he took in creating these works. The process was anything but the haphazard slopping of paint on paper suggested by the critics. At times Cox expressed the fear that the roughness of his works would bring down critical censure; in a more combative mood, he acknowledged but dismissed the charge of roughness, stating that his purposes were not properly understood.[16] Behind Cox's difficulties lay the struggle to bring the sketch aesthetic and the exhibition aesthetic into a creative synthesis.

Cox's popular image was not that of an artist grappling with such issues. He was seen as a type of natural genius, whose art sprang from a direct connection with nature and bypassed both the normal tenets of artistic technique and the deeper intellectual processes. In the first volume of *Modern Painters*, Ruskin wrote appreciatively but condescendingly of Cox's art, at one point referring to the artist as "simple-minded as a child" (3.253n). In his *Academy Notes* in the 1850s, he was generous in his praise, his objections to the broadness of Cox's handling shrinking before the acknowledged power and dignity of the artist's conceptions.

As Cox's reputation grew in the years after his death, Ruskin came to be less favorably disposed to his works, putting a negative twist on his perception of Cox as a natural artist. In his *Lectures on Landscape*, delivered at Oxford in 1871, he paired Cox with John Constable as possessing "a form of blunt and untrained faculty." These artists represented "the qualities adverse to all accurate science or skill in landscape art" (22.58).

In lectures given at Oxford in 1884, Ruskin grouped Cox with DeWint, Copley Fielding, and George Fennel Robson as never having "had much thought or invention to disturb them." As Ruskin memorably put it, "They were, themselves, a kind of contemplative cattle and flock of the field, who merely liked being out of doors, and brought as much painted fresh air as they could, back into the house with them" (33.381).

The myth of the natural painter could be dismissive. But it could for Cox, as for Constable, be seen as a great strength. In Cox's case it could rescue his later work from charges of mannerism, since it guaranteed the naturalness of the method of representation. By the same token, however, it exposed any would-be followers to just such charges of mannerism, for their style could be seen as based not directly on nature but on Cox's art.

Despite the assertions that his art was inimitable and not to be recommended as a model for others, well before Cox's death a few young artists were working in his style. David Cox, Jr., William Bennett, and David Hall McKewan all seem to have been pupils of Cox, although of the three only the son had any extended, documented contact with the older artist. Bennett and McKewan both

joined the New Society of Painters in Water Colours in 1848, the same year in which the younger Cox, after several years with the New Society, switched allegiance and became an associate of the Society of which his father was a member.

Within a few years of joining the New Society, Bennett leapfrogged the other landscapists within its ranks to assume a position of preeminence. His style, recognized as vigorous and decisive in Cox's manner, propelled him past the tamer landscape visions of Penley, Rowbotham, and the promising young Charles Davidson, who had become an associate in the same year as Bennett.

In 1850 Bennett was identified as "perhaps the most distinguished among the landscape painters."[17] According to the *Athenaeum*, he maintained his supremacy the following year, although McKewan was now challenging him on the very same ground. In 1854 the same periodical referred to "the 'blobs' and broad touches of the Cox and Bennet[t] school"[18] in contrast to the newest sensation within the New Society, the Pre-Raphaelite–inspired landscapes of E. G. Warren. Bennett was acknowledged as the principal exponent of Cox-like freshness and freedom of touch in the New Society; he was even called its "David Cox."[19] However, the *Spectator* awarded the distinction of "chief representative of what Mr. Ruskin calls the 'blottesque' school" to McKewan.[20]

David Cox, Jr., never fully emerged from his father's shadow. His style was closely modeled on that of the elder Cox, and his choice of subjects, such as the brooding Welsh mountain landscape in this exhibition (cat. no. 39), frequently followed his father's. During the period in which both father and son were exhibiting with the Old Water-Colour Society and in the years immediately following his father's death, the son's less forceful interpretations of the father's art appeared a salutary corrective to the older man's excesses. If the elder Cox's vision of landscape was to survive at all, it seemed that it would have to be in some more moderate version, such as those offered by his son or by Bennett or McKewan.

At a point when the minute touch and brilliant color of a William Henry Hunt, a John Frederick Lewis, or an Edmund George Warren were celebrated as the greatest prodigies of watercolor art, and most landscape painting in the medium aspired to the slick picturesqueness characterized by Penley, Richardson, and Rowbotham, it is hardly surprising that even those artists who looked to Cox as a model should have stopped short of fully embracing what were seen as his eccentricities.

The force of the competing models was too pervasive. That Bennett's *Pass of Glencoe* (cat. no. 19) and McKewan's *Landscape with Stream and Haymakers near Bettws-y-Coed* (cat. no. 16) could be perceived as belonging to the school of "blob and blot" or "splash and splotch"[21] is indicative of a prevailing attitude toward finish. Yet it was the failure to grasp the implications of Cox's late manner, as Thomas Collier and others would do in the 1870s, that left the earlier Cox followers without any strong identity.

After initial promise they drifted to the margins of the landscape art of the period.

There were other artists who felt the influence of Cox in his later years. During the period when he resided in Harborne near Birmingham and summered in the Welsh village of Bettws-y-Coed, he attracted an admiring circle of landscape painters, both amateur and professional. Henry Maplestone was a Birmingham watercolorist whose work, exhibited at the New Society of Painters in Water Colours from 1841, showed a decidedly Cox-like character. So did the work of James William Whittaker, who actually took up residence in North Wales, at Llanrwst near Bettws-y-Coed. He was a member of the Old Water-Colour Society from 1864 until 1876, when he slipped from some rocks above the River Llugwy and drowned. As beginning landscape artists, both George Price Boyce and Alfred William Hunt personally knew and were influenced by Cox. In each case Cox's influence was rather quickly supplanted by a more Ruskinian and Pre-Raphaelite orientation, a sign of the times.

Bennett, McKewan, Whittaker, and the younger Cox never constituted a real school or movement or cohesive stylistic group. Expectations that they would succeed the elder Cox as leaders in an old style of landscape painting in watercolors remained unfulfilled. It was George Arthur Fripp, whose style was unrelated to that of Cox, who assumed that role and most successfully adapted the older values to newer tastes. As a critic wrote in 1869, "Mr. George Fripp has more than any other understood how to reconcile the largeness and simplicity of the older artists with the greater particularity of modern practice."[22]

Fripp was the friend of a fellow Bristol native, William James Müller. He also knew David Cox, Sr., and was responsible for bringing the two artists together in the late 1830s when Cox was searching for someone to give him lessons in oil painting. But Fripp's style reflected nothing of either Müller's dashing, sketchy manner or Cox's roughness. When Fripp first came to prominence in the exhibitions of the Society of Painters in Water-Colours in the 1840s, he was compared with DeWint, but his approach to watercolor really remained closer to that of his teachers in Bristol, Samuel Jackson and James Baker Pyne.

Fripp's work was characterized as having breadth, sober simplicity, and a solidity of style in contrast to "copying-machine," photographic literalism or high-flown poetical expression.[23] His steadfast refusal to employ bodycolor for anything more than highlights earned him considerable critical capital in the 1860s from the beleaguered defenders of the principle of "pure," that is, transparent, watercolor painting.

Although it was only one of many factors, the use of opaque color was widely seen as the great distinguishing feature separating the generation of Cox and DeWint from more recent practice. J. Beavington Atkinson, in reviewing the historical exhibition of watercolors at the London International Exhibition of 1862, after a long passage de-

voted to Cox, concluded: "With him [Cox] well nigh died out the so-called pure, unsophisticated English water-colour method, now, as we have already said, adulterated, and yet, as we think, enriched by liberal, or rather by judicious, mixture of opaque."[24]

Certainly the use of bodycolor increased dramatically in the 1850s. The *Athenaeum* announced in 1863 that "the long-affected abhorrence of body-colour in painting with water is dissipated before its sagacious use by Mr. W. Hunt and others."[25] Earlier in the same year the *Art Journal* had also commented on the growing use of bodycolor. It allowed that "unsophisticated drawings, after the older method practised for the most part by De Wint, Barrett, and Copley Fielding, possess a certain purity and quality of tone foreign to the modern and more mongrel admixture of opaque." But it approached the claims of each camp in a balanced way: "The advantages and the disadvantages pertaining to each of the two schools are so evenly balanced that a wise man, without dogmatically pledging himself to either, will successively adopt colours transparent or opaque, just as may best suit the exigencies of the drawing in hand."[26]

Samuel Redgrave, in his 1877 catalogue of the water-colors in the South Kensington Museum, was more dogmatic. For him watercolor had at the end of the first third of the century "arrived at the full perfection of which it seemed capable." In this perfect state of "true" watercolor painting, the general practice had been to use pigments transparently, "so that the full brilliancy and richness of the work should result from the white ground showing through them." Redgrave asserted:

Turner was ever a warm assertor of this principle, and never departed from it; Cox ever maintained it; but gradually other painters, in order to obtain greater brilliancy, to force their works as painters term it, or more especially to save labour, began to use opaque white on the salient points of their pictures. This led on to the much greater prevalence of its use.

Redgrave ended with the plea: "It is . . . earnestly to be hoped that the art as practised by Turner, Girtin, Cox and De Wint at his best period, may still find some loving and true followers, and that those who are now using white with taste will treat it with reserve as a dangerous ally or treacherous friend."[27]

If the later critical fortunes of the old school of water-color were bound up with the controversy over body-color versus transparent watercolor, the example of artists from that school, particularly Cox, DeWint, and Müller, also played a role in another great critical debate over the nature of watercolor painting, namely that of sketch versus finished work. Arguments about finish were hardly specific to British watercolor of the 1860s and 1870s; they were played out in other periods and other national schools. Yet the extraordinarily high degree of finish that had become fashionable in a medium long associated with the function of sketching gave the issue particular significance.

In 1862 the Society of Painters in Water-Colours inaugurated annual winter exhibitions for its members' sketches and studies, with the New Society following suit four years later. The debate was given a new focal point. As artists and critics tried to determine just what constituted a sketch and to sort out its relative importance in relation to the finished watercolor, they sought their examples of the true watercolor sketch in the work of Cox, DeWint, and Müller. There was no real unity of opinion as to what could be considered a sketch or study. Both Müller's *Leigh Woods* (cat. no. 7) and Ruskin's *In the Pass of Killiecrankie* (cat. no. 30) could be encompassed by the category. The artists of the watercolor societies were frequently reluctant to submit actual working drawings to the scrutiny of the public. It was a common complaint that the exhibitions ostensibly devoted to sketches and studies rarely contained many of either.

Although it was not shared by all artists and critics, a sort of ideal of the watercolor sketch did, however, emerge. In contrast to the exhibition watercolor, it was more intimate – a more direct expression of the artist's creativity. It spoke of genius and spontaneity against the mechanical. It made a more telling use of the medium's inherent properties – its fluidity and its capacity for rapid, meaningful gesture. And it looked like the work of Cox or DeWint or Müller. The *Spectator* contained a lengthy discourse on sketching, concluding that the successful sketch must convincingly demonstrate that the chosen means have been fully utilized. "No amount of elaboration in the studio could convey a stronger impression of fresh breezy air than one of old David Cox's memoranda, blotted down in half-an-hour in a hay-field with a big wet brush."[28] The sketch was an antidote to formulaic studio productions. The promotion of the sketch was a call for the artist to return to nature. DeWint was quoted: "Whenever I find myself getting particularly well satisfied with work done in my studio, I know there is something wrong; it is high time to go to Nature and be knocked down."[29]

Seen against the stringent requirements of Ruskinian truth to nature, however, the sketch – as opposed to the careful study from nature – was nothing more than an excuse for sloppiness. It masked insensitivity with superficial bravura:

All true finish, as Ruskin has long since explained, is but "added fact," and it is impossible to add facts to a sketch whose very existence is due to a falsifying of them for artistic purpose. . . . Cox's rough sketches of fresh blue skies, with white clouds, and a few trees tossing about in the wind, may win admiration from some people for their freshness and picturesqueness, but directly the attempt is made to elaborate them into finished pictures, the falsehood of detail becomes painfully apparent.[30]

The debate over sketch versus finish actually redefined Cox and DeWint, focusing attention squarely on their sketches. DeWint's *Brougham Castle* and *Cornfield, Windsor* (cat. nos. 3 and 4) became the true expressions of his ge-

nius, not *On the Dart* (cat. no. 15). Similarly, works such as Cox's *View near Bettws-y-Coed* (cat. no. 12) became more highly valued than his *Vale of Clwyd* (cat. no. 14).

While McKewan and Bennett had taken their cue from Cox's more elaborate studio works – deemed to have quite enough of the looseness and roughness of the sketch in themselves – it was to the sketches proper that the Cox followers of the 1870s looked for inspiration. Of this later brotherhood – as one of its members, James Orrock, termed it – Thomas Collier was the most distinguished. Orrock said of Collier, "He and Müller were the most impressive sketchers from Nature that I know."[31] Sketching from nature was, indeed, central to Collier's achievement, but his source and inspiration – apart from nature itself – was not so much Müller as Cox.

After attending the Manchester School of Art, Collier moved to Bettws-y-Coed, living there between 1864 and 1869. This may have been a conscious homage to Cox; certainly Collier's watercolors of the period, such as *Welsh Mountain Landscape* of 1869 (cat. no. 75), reflect the late Welsh watercolors of Cox. In his attempts to gain membership in the Society of Painters in Water-Colours, Collier was rejected as an imitator of Cox. The Society reasoned that it already had a resident exponent of the style in James Whittaker, not to mention the son of the originator of the style, David Cox, Jr. The Institute of Painters in Water Colours, as the New Society had now become, was more welcoming, electing Collier an associate in 1870. He was joined in the ranks of the Institute the following year by James Orrock and the year after that by Edmund Morison Wimperis.

These three watercolorists constituted a distinct stylistic group within the Institute and almost immediately moved to the forefront of landscape painting as it was practiced in that body. The *Art Journal*, reviewing the Institute's summer exhibition in 1877, commented, "Some of the leading landscape men, such as E. M. Wimperis, James Orrock, and Thomas Collier, base themselves upon Cox," but added, "we by no means wish to imply that there is anything slavish in their imitation."[32]

In review after review in the 1870s, the *Illustrated London News* drew attention to the anomaly that Cox's art found a fervent following in the Institute rather than in the Society of which the artist had been a long and loyal member.[33] By 1876 the Old Society acknowledged the revival of the watercolor landscape school that had once flourished in its own galleries by admitting Robert Thorne Waite to associate membership, although at the time it may have seemed that the Society was adding another Birket Foster rather than another DeWint or Cox to its ranks. Nevertheless, the *Spectator* could in 1879 greet the new addition:

Of all our young painters, Mr. Thorne Waite alone combines the effect of the old and the new schools of water-colour. His earlier works were little else than imitations of Cox, then De Wint obtained a great influence over his mind, and now he is like Cox in his skies and De Wint in his hills, though very much brighter and less heavy in his colouring than the latter. He is essentially a "sketcher," and his finished pictures are very seldom more than sketches, elaborated in workmanship, but not added to in detail. All you get in his finished work you get in his sketches, and get it fresher and more vividly.[34]

All these later followers of Cox and DeWint tended to be most at home in small-scale sketches. On his first appearance in the Institute's winter exhibitions, the *Art Journal* called Collier "a sketcher in the old and best sense of the word."[35] As the critic for the *Spectator* noted of Thorne Waite, the more finished pictures were simply sketches elaborated, generally not to their benefit, for definition or detail was frequently added at the expense of freshness. Attempts to translate simple compositions into large-scale exhibition pieces, as Cox had done so successfully in works such as *Keep the Left Road* (cat. no. 21), could easily result in empty, boring expanses of paper. Orrock's *On the Nith, Dumfriesshire* (cat. no. 116) risks just this emptiness, but in this instance achieves a monumental severity worthy of Cox.

The emergence of this new Cox school in the 1870s was part of a larger upsurge in interest in Cox and the artists of his generation, manifested in books, articles, exhibitions, and the sales room. As the initial impetus of Pre-Raphaelitism faltered and Ruskinian naturalism in its more extreme manifestations waned, the old school of Cox and DeWint presented an attractive alternative. But the rise of Cox and DeWint's critical fortunes was the result of more than a simple shift in stylistic fashions; it was fueled by the growing nostalgia in Victorian society.[36] The landscape art of the first half of the century, itself motivated by a nostalgic view of the countryside and rural life, now acquired an enhanced nostalgic value as the supposed documentation of a rustic past. Not only did the subject matter speak to this yearning, but the very manner of its representation was in itself nostalgic. The blunt brushstrokes of Cox and the broad clear washes of DeWint could be seen as artistic analogues for that simpler, more genuine, and more natural existence depicted in their watercolors.

Richard and Samuel Redgrave's *A Century of British Painters*, published in 1866, gave considerable coverage to the school of watercolor painters. J. M. W. Turner was one of the heroes of the account. Cox, though more limited in range, was judged to be without rival in the homelier aspects of landscape, with an idiosyncratic technique perfectly adapted to his subjects. The first book-length treatment of Cox's life and works was published in 1873: Nathaniel Neal Solly's *Memoir of the Life of David Cox*. (Solly followed this publication two years later with a similar *Memoir of the Life of William James Müller*.) Drawing on biographical material presented by Solly, an article in the *Magazine of Art* in 1878 sought to fashion Cox into the exemplary figure of artistic genius, unappreciated in his own time, whose true merit is only revealed to succeeding generations.[37]

Certainly the estimation of Cox's merit was currently on the rise. A succession of major sales set new levels for the monetary valuation of his, as well as DeWint's and Müller's, works. Most dramatic was the 1872 sale at Christie's of the collection of Joseph Gillott, the Birmingham pen manufacturer. His collection included important works by Turner, Constable, Müller, DeWint, and a sizable group by Cox. Its sale occasioned more excitement than the London art market had known for years. Prices reached heights that had previously been inconceivable, and the *Art Journal* commented that "it was enough to call up the shade of our good friend David Cox to protest against his pictures being sold for more than twenty times the sums he got for them."[38] Three years later, at the sale of William Quilter's collection, prices for works by Cox and DeWint were even higher. Late in 1870, a loan exhibition was held at the galleries of the Institute of Painters in Water Colours to benefit the National Hospital for Consumption. The assembled works surveyed the development of British watercolor through the century. The works of Cox, Turner, DeWint, and William Henry Hunt dominated the exhibition, and of them all Cox was judged preeminent.

In 1873 the Burlington Fine Arts Club sponsored an exhibition in London titled *Drawings and Sketches by the Late David Cox and the Late Peter DeWint Lent by John Henderson*. This was overshadowed by the massive retrospective exhibition of Cox's work mounted by the Liverpool Art Club in 1875. It included 448 works, of which fifty-seven were oils and almost three hundred were watercolors. The introduction to the catalogue was provided by William Hall, who would publish his own biography of Cox in 1880. While Hall acknowledged Turner as "the greatest of England's landscape painters," he ranked Cox just beneath him. Indeed, for Hall, in some respects Cox surpassed Turner. In rendering the everyday aspects of nature, Cox was more "natural," more "faithful," and more "English."[39]

At the end of 1877, an exhibition of 520 watercolors by "Deceased Artists of the English School" opened at the newly established Grosvenor Gallery. Turner and Cox were given special prominence at opposite ends of the gallery. The reviewer for the *Spectator* took the opportunity to pen a lengthy refutation of the view of Cox and DeWint's superiority to the modern school of landscape, thereby confirming that such a view had become a critical commonplace by the later 1870s.[40]

In this exhibition at the Grosvenor Gallery, as in the Redgraves' *A Century of British Painters* and in the sale of Gillott's collection, Turner was the dominant presence. In the pageant of watercolor's distinguished past, Turner was cast as the mercurial genius, Cox as the modest seeker after natural truth. Yet Turner was never adopted as the representative figure of his generation in the way that Cox came to be. The very uniqueness of his genius, as argued by Ruskin, set him apart from his contemporaries. While he was recognized as the greatest practitioner of water-

color painting, he was not a member of the watercolor societies and therefore stood outside their history.

Other factors, too, including the public's perception of his later work as beyond its understanding or even beyond the bounds of reason, made Turner seem less representative. The variety and complexity of his work enhanced his status but made him difficult to categorize and to appropriate as a symbol of a simpler past. Similarly, aspects of his style, such as his use of stippling and his brilliant chromaticism, were too close to modern practice to seem representative of the old school.

At the same time, it was Turner's range and the all-encompassing nature of his art that allowed artists of such disparate orientations as William Leighton Leitch and Alfred William Hunt to find in his work guiding principles for their own. A self-taught artist who made a living as a fashionable drawing master, Leitch put a premium on hard work and diligent study of the old masters. Consequently, he cultivated an image of Turner as a hardworking professional who had based his art squarely on the models of Claude and the other seventeenth-century masters of landscape painting. For Leitch, it was Turner's earlier paintings – the Carthaginian subjects and *Crossing the Brook* (Tate Gallery, London) – that constituted his claim to greatness. Leitch's *Kilchurn Castle, Argyllshire* (cat. no. 56) is a striking example of an exhibition piece in the grand manner of Turner's large-scale watercolors of the first decade of the century. Turner's later works were beyond Leitch's comprehension. "That there was genius in their conception may be true," he wrote, "but it was genius run mad."[41] In Leitch's view, the elderly Turner, whom he had met, had declined into eccentricity, an impression Leitch reinforced by his vivid account of an 1842 visit to Turner's filthy and cat-infested gallery in Queen Anne Street.

For the "New School," as Leitch referred to the Pre-Raphaelites and the followers of Ruskin, he had no time. Ruskin's overthrow of the great traditions of landscape art in favor of an untrammeled response to nature was to Leitch's mind woefully misguided, and Ruskin's appreciation of Turner's work of the 1830s and 1840s thoroughly wrongheaded.

One artist who shared Ruskin's enthusiasm for Turner's late watercolors was Alfred Hunt, an academic-turned-painter who gained Ruskin's attention with a series of works exhibited in the late 1850s and later became his friend. Where Leitch found "a fading vision of prismatic confusion,"[42] Hunt followed Ruskin in finding "the noblest landscapes ever yet conceived by human intellect."[43] The *Illustrated London News* in 1868 characterized Hunt's progress since his election as an associate of the Society of Painters in Water-Colours four years earlier: "After struggling through some Pre-Raphaelite crudity and vague emulation of Turner, [Hunt] takes the very front rank in this exhibition."[44] From that point Hunt was consistently recognized as one of the brightest talents and most original minds devoted to landscape in the Old Society. Yet the association of his landscape watercolors with Turner's

persisted. Not only was this a difficult standard to live up to, but the perceived connection between the works of these two artists could in itself be detrimental.

In 1873 a critic, after noting that Hunt's drawings recalled Turner's more advanced works in their elaborate and complex techniques, went on to complain that "although possessed of artistic and poetic instinct, Mr. Hunt has not yet digested and assimilated his observation and his method sufficiently to grasp, as was done in the master-mind of his prototype, the unity in diversity of nature."[45]

Writing of an exhibition of watercolor art by living masters at the Grosvenor Gallery in 1879, the *Spectator's* critic concluded:

The chief honours of this Water-colour room . . . decidedly fall to Alfred Hunt, an artist who, though well known to connoisseurs and artists, has never we think, been quite appreciated by the general public. The resemblance in manner between his better works and those of Turner has perhaps rather helped this neglect than the reverse, for there can be no doubt but that Turner is still by the great majority of the public distrusted, if not absolutely disliked.[46]

The following year Hunt made clear his allegiance to Turner in a remarkable essay in the periodical *Nineteenth Century*. Titled "Modern English Landscape-Painting," it set out the predicament of the landscape artist in the later part of the century.[47] Hunt began his essay by acknowledging that an observer looking back over the developments of his century "would see little in the work of today to set against the glories of the past." "We have no Turner," he wrote; "The long line of water-colourists, from Varley downwards – rich in such names as Cox, Havell, Robson, Prout, to take only some of the most famous – stands, some critics would say, to reproach their successors." Clearness, simplicity, swiftness of execution, poetical conception, and unity of design had all, Hunt admitted, been sacrificed.

Various influences of which the great men of the old school just lived to see the beginning – the inroads of the scientific spirit, the invention of photography, the writings of Mr. Ruskin, sympathy with the pre-Raphaelite movement in respect of its love of colour, of detail, and of mystic meaning in little things; and perhaps an increase in the number of those who, vexed with great questionings of heart beyond the range of science, turned for solace to the perfectly-ordered beauty of tree and flower – these and other causes combined to give a new force and direction to landscape-painting.

The tired formulas and conventions of the picturesque had been discredited. The gains in executive ability and in the understanding of natural detail were for Hunt undeniable, but they were not enough. Hunt looked at the brilliantly descriptive landscape art of his time and found it wanting:

Our hearts are not touched: we admire the artist's extraordinary skill, we are thoroughly grateful to him for reminding us of what he has copied so well; but the admiration and the gratitude and the intellectual joy of examining bit by bit such a picture, make up altogether

a pleasure different in kind from that which we derive from a great imaginative work of art.

For Hunt the antidote to this constrained reproductive cataloguing of natural fact lay not in the sketchy freshness of Cox but in the all-embracing art of Turner. Hunt found in Turner the imagination, the breadth of vision, and the critical understanding of the traditions of landscape that had been so thoughtlessly jettisoned by the artists of Hunt's generation.

Echoing Ruskin, Hunt tried to combat the public incomprehension of Turner's art. He aligned his own exploratory approach to landscape representation with Turner's, describing Turner's watercolors as "a series of experiments to discover with what system of colours it is possible to give the greatest amount of colour-truth consistently with truth of light and shade," and added that these works "will always remain more or less unintelligible to those who do not love landscape-colour passionately, and see in its strength, variety and infinite subtlety, means of representing distinct moods of thought and feeling."

While Hunt strove to maintain an optimistic vision of modern landscape painting, at the essay's conclusion he revealed his own sense of inadequacy: "It is only recently that a glimpse of the full scope of landscape art[,] which was gained by the genius of one man, has become the common property of all. We hardly yet perceive how great an equipment of gifts is required to enable any one to follow in his footsteps, and possess himself of any portion of the fair land which his eyes discerned."

For Albert Goodwin, an artist sometimes linked with Hunt as an outstanding exponent of poetic landscape, Turner's late watercolors were similarly at the heart of his own development as a watercolorist. Indeed, Goodwin's identification with Turner was so intense that in later years he wrote: "I wonder sometimes if the spirit of Turner makes use of my personality."[48] Goodwin started out in the Pre-Raphaelite camp. His teachers in the 1860s were Arthur Hughes and Ford Madox Brown, and in the following decade he profited from the advice and encouragement of Ruskin. To the end of his life, he acknowledged his debt to Ruskin and Hughes and wrote respectfully, if at times critically, of "the noble uprising" that had been Pre-Raphaelitism.[49] By the 1880s, however, he had moved beyond such Pre-Raphaelite works as *The River at Dusk* of 1865 and *A Pleasant Land* of 1875 (cat. nos. 63 and 82) to Turnerian effects of sunset and twilight, *A Sunset in the Manufacturing Districts* (cat. no. 99) for example, achieved by simpler means.

Whereas Alfred Hunt looked to Turner's finished watercolors and appropriated the full range of Turner's arsenal of techniques, Goodwin found Turner's less finished drawings with their spontaneous evocation of atmosphere more congenial. Turner's example provided a justification for moving away from the more onerous aspects of Pre-Raphaelite literalism. As the century drew to its close, Goodwin concentrated increasingly on achieving in

his landscapes a vaporous luminosity comparable to Turner's. He frequently adopted the combination of fluid watercolor washes with pen work in colored inks that had been so distinctive a feature of Turner's later style.

If Goodwin was temperamentally more attuned to the immediacy of the sketch, his Pre-Raphaelite training had inculcated standards of laborious finish that he found difficult to shake. His guilt over the facility and rapidity with which he produced watercolors is a recurrent theme of the diary he began in 1883. He contrasted his method with the more "virtuous" and painstaking process of Alfred Hunt.[50] While it was the example of Turner's watercolor sketches that served to liberate Goodwin from the more oppressive stylistic constraints of his Pre-Raphaelite training, Goodwin did appreciate Turner's more complex use of the medium. Near the end of his life, Goodwin pondered the contempt with which the technique of stippling was viewed by the "sketchy slap-dash school," when the "heretic" Turner had made tremendous strides in watercolor painting by its use.[51]

It was unquestionably the color studies of Turner rather than his more elaborate watercolors that appealed to the amateur Hercules Brabazon Brabazon and formed the basis for his radically simplified watercolors. Although he took instruction from the watercolorists James D'Egville and Alfred Downing Fripp (G. A. Fripp's brother), his free watercolor copies of other works of art attest to his wide sympathies and active gleaning of lessons from the achievements of a whole range of past and present artists. Among his "translations" (the term coined by the critic D. S. MacColl for these copies) of works by British and foreign contemporaries and old masters, there were over four hundred after Turner, as well as some forty after Cox and about twenty each after DeWint and Müller.[52] These translations frequently reinterpreted more elaborate works by these artists in a style reminiscent of their own freer and looser sketches.

Until he began exhibiting with the New English Art Club in the 1890s, Brabazon's watercolors were little known outside a small circle of friends. One of these friends, however, was Ruskin, who compared him with Turner as a colorist worthy of serious study.[53] More "modern" in appearance than the watercolors of Collier, Orrock, and Thorne Waite, closer to those of Whistler in their delicate color harmonies and freedom from naturalistic constraints, Brabazon's "stately blots," as the critic R. A. M. Stevenson called them,[54] were enthusiastically taken up by the younger artists associated with the New English Art Club, such as Walter Sickert and Philip Wilson Steer.

For artists and critics like these, who were receptive to French impressionism, Brabazon provided a valued bridge between the latest Continentally inspired developments and a venerable native tradition. MacColl, like Stevenson an ardent exponent of impressionist art, wrote of Brabazon: "He is the best watercolour painter we have had since Turner; he reaches back to the days of Cox; he has been quietly perfecting his art since that date, and at last condescends to let us see the result."[55] The connection between British watercolorists of the first half of the century and impressionism was made not only by those who sought to promote impressionism but also by those who resisted it as a pernicious foreign influence.[56] If it could be asserted that Turner and Constable and Cox were true impressionists, then the French variety was simply a bastardization of good British stock. The impressionist label could be readily attached, as it was by the Art Journal in 1881, to Thomas Collier.[57]

Collier still professed devotion to the naturalism in which the old school of British landscape watercolors had been grounded. For those artists who looked to James McNeill Whistler as the exemplar and arbiter of the new aesthetics, this simple naturalism was replaced by more purely formal concerns. But for those artists too, Cox and DeWint offered valuable models for the handling of the watercolor medium. As the century reached its close, some British watercolorists stubbornly clung to the example of the artists of the old school. Others, with their eyes directed to the future, nonetheless felt the need to glance back from time to time to these same worthy predecessors.

Notes

1. *Art-Union*, May 1, 1842, p. 100.
2. *Spectator*, April 24, 1858, p. 447.
3. *Art Journal*, June 1, 1855, p. 185.
4. *Spectator*, May 6, 1848, p. 446.
5. Ibid., May 5, 1849, p. 422.
6. Ibid., May 5, 1855, p. 462.
7. Ibid., May 3, 1845, p. 426; May 2, 1846, pp. 425–26.
8. See for DeWint, *Athenaeum*, May 8, 1847, p. 496, and *Art-Union*, June 1, 1846, p. 190; for Cox, *Art Journal*, June 1, 1852, p. 178; June 1, 1855, p. 185; and June 1, 1856, p. 176.
9. Letter to David Cox, Jr., November 18, 1842, quoted in N. Neal Solly, *Memoir of the Life of David Cox* (London: Chapman and Hall, 1873; London: Rodart Reproductions, 1973), p. 119. In the same letter, Cox described his brushwork as being "something like mosaic work."
10. *Art Journal*, June 1, 1852, p. 177.
11. *Spectator*, May 3, 1856, p. 490; *Art Journal*, June 1, 1856, p. 175.
12. *Spectator*, May 1, 1852, p. 423; May 2, 1857, p. 463.
13. *Athenaeum*, May 1, 1858, p. 568.
14. *Art-Union*, June 1, 1845, p. 197; June 1, 1847, p. 201.
15. *Athenaeum*, May 3, 1856, p. 559.
16. In 1853 Cox wrote of the watercolors he had sent to the Old Water-Colour Society exhibition, "It strikes me the committee thinks them too rough; they forget they are *the work of the mind*, which I consider very far before portraits of places (views)"; letter to David Cox, Jr., April 18, 1853, quoted in Solly, *Cox*, pp. 228–29.
17. *Athenaeum*, April 27, 1850, p. 454.
18. Ibid., May 24, 1851, pp. 560–62; May 6, 1854, p. 562.
19. *Art Journal*, June 1, 1871, p. 155.
20. *Spectator*, April 27, 1861, p. 445.
21. *Illustrated London News*, May 11, 1867, p. 479.
22. *Spectator*, May 8, 1869, p. 568.
23. Ibid., May 7, 1864, p. 537.
24. *Art Journal*, October 1, 1862, p. 199.
25. *Athenaeum*, December 5, 1863, p. 763.
26. *Art Journal*, June 1, 1863, p. 117.
27. Samuel Redgrave, *A Descriptive Catalogue of the Historical Collection of Water-Colour Paintings at the South Kensington Museum* (London: Chapman and Hall, 1877), pp. 55, 67.
28. *Spectator*, December 20, 1873, p. 1614.
29. DeWint, quoted in the *Spectator*, April 28, 1866, p. 466.
30. *Spectator*, May 25, 1878, pp. 667–68.
31. Orrock, quoted in Byron Webber, *James Orrock, R.I., Painter, Connoisseur, Collector*, 2 vols. (London: Chatto and Windus, 1903), vol. 2, p. 62.
32. *Art Journal*, June 1, 1877, p. 188.
33. *Illustrated London News*, May 2, 1874, p. 428; April 24, 1875, p. 391; and May 6, 1876, p. 451.
34. *Spectator*, June 7, 1879, p. 726.

35. *Art Journal*, February 1, 1871, p. 43.

36. Martin J. Wiener discusses Victorian nostalgia in the chapter "The 'English Way of Life'?" in his *English Culture and the Decline of the Industrial Spirit, 1850–1980* (Cambridge: Cambridge University Press, 1981), pp. 41–80.

37. Wyke Bayliss, "The Painter's Reward: A Study from the Life of David Cox," *Magazine of Art* 1 (1878): 62–65.

38. *Art Journal*, June 1, 1872, p. 165.

39. *Catalogue of the Loan Collection of the Works of the Late David Cox* (Liverpool: Liverpool Art Club, 1875), p. 17.

40. *Spectator*, December 15, 1877, pp. 1579–81.

41. The comment occurs within Leitch's account of his visit to Turner's gallery, quoted in A. MacGeorge, *Wm. Leighton Leitch, Landscape Painter: A Memoir* (London: Blackie and Son, 1884), pp. 81–86.

42. Leitch, quoted by MacGeorge, *Leitch*, p. 104.

43. This was how Ruskin characterized Turner's Swiss watercolors of the early 1840s in his pamphlet *Pre-Raphaelitism* (12.391).

44. *Illustrated London News*, May 2, 1868, p. 438.

45. Ibid., May 3, 1873, p. 422.

46. *Spectator*, January 25, 1879, p. 115.

47. Alfred William Hunt, "Modern English Landscape-Painting," *Nineteenth Century*, May 1880, pp. 778–94.

48. Goodwin, *The Diary of Albert Goodwin, R.W.S., 1883–1927* (privately printed, 1934), entry for February 18, 1911, p. 133.

49. Goodwin, *Diary*, entry for March 17, 1918, p. 389.

50. Goodwin, *Diary*, entry for August 1, 1910, p. 124.

51. Goodwin, *Diary*, entry for June, 1927, pp. 502–3.

52. Hilarie Faberman, *Hercules Brabazon Brabazon, 1821–1906*, exh. cat. (Queens College: Godwin-Ternbach Museum, 1985), p. 4.

53. C. Lewis Hind, *Hercules Brabazon Brabazon, 1821–1906: His Art and Life* (London: George Allen and Co., 1912), p. 6.

54. Stevenson, quoted in Hind, *Brabazon*, p. 105.

55. D. S. MacColl, "Mr. Brabazon's Water-Colours," *Spectator*, December 10, 1892, p. 851.

56. For the reception of impressionism in Britain and the development of British forms of impressionism, see Kate Flint, ed., *Impressionists in England: The Critical Reception* (London: Routledge and Kegan Paul, 1984), and Kenneth McConkey, *British Impressionism* (Oxford: Phaidon Press, 1989).

57. *Art Journal*, June 1881, p. 190.

Chapter Two

"The Innocence of the Eye": Ruskin and the Landscape Watercolor

JOHN RUSKIN came to prominence in English artistic life in 1843 with the appearance of the first volume of his monumental exploration of the art of landscape painting, *Modern Painters*. For at least the following four decades, he was perceived as the leading aesthetic philosopher of the age. In his early career his books were seized upon by a rising middle class, voracious for information and instruction about contemporary art;[1] later, in the 1860s, he withdrew somewhat from artistic affairs, preoccupied instead by social and economic questions. Later still, he sought to regain a practical authority in terms of the conduct and appreciation of art by teaching and lecturing; by means of the monthly open letters which he addressed to the population at large, known as *Fors Clavigera*; and through the Guild of Saint George, his model for an ideal community in which art was to be held dear. In the 1880s, increasingly beset by bouts of depression and fits of insanity, he was forced to give up his various official positions. Only in old age did he voluntarily resign the role of artistic patriarch, and even then the edifice of his prolific writings on art stood to remind a younger generation of the venerable position he had held in the cultural life of the Victorian age.

Throughout his long career, Ruskin was consistently interested in how landscape subjects might be treated in watercolor. He was himself a draftsman and watercolorist, habitually recording the physical characteristics of his surroundings, sometimes in meticulous detail, on other occasions with urgency and impatience. As a young man he was instructed in the medium by some of the best-

regarded watercolorists of the day, and in due course he assumed the responsibility of teaching others how to paint in watercolor. He had many friends who were professional watercolorists, and he frequently bought or commissioned works, many of which he gave to museum collections. Ruskin drew spiritual solace and intellectual stimulus from the landscape watercolors with which he surrounded himself, and he cared with all the passion of a partisan about the way in which the medium was used by his contemporaries.

His stance on watercolor notwithstanding, Ruskin, like most Victorians, regarded oil rather than watercolor as the appropriate medium of the professional artist, for landscape as for other subjects. Oil paintings tended to be larger and, in the mid-Victorian Royal Academy – the principal exhibition space of the day – were far more prominently displayed. In 1870 he concluded: "The extended practice of water-colour painting, as a separate skill, is in every way harmful to the arts: its pleasant slightness and plausible dexterity divert the genius of the painter from its proper aims, and withdraw the attention of the public from excellence of higher claim" (20.120).

Ruskin may have considered it unlikely that any watercolor could be regarded as one of the great works of contemporary art; nonetheless, he recognized many of the advantages of that less prestigious but often more spontaneous type of painting. For him watercolor was ideally suited to the purpose of getting and transmitting information – in the case of landscape painting, about nature and the physical world. As he said when comparing his draw-

ings with those of his teacher James Duffield Harding, whose vision of nature he came to regard as mannered and artificial, "his sketches are always pretty because he balances their parts together & considers them as pictures – mine are always ugly, for I consider my sketch only as a written note of certain facts, and those I put down in the rudest and clearest way, as many as possible."[2] Subsequently, he recommended a succession of artists to use watercolor and to work on a relatively small scale – partly so as to be able to address a range of different subjects and make stylistic experiments and adaptations, but also because he considered that by this means a painter's professional prospects were likely to be improved. In 1858 he besought Alfred William Hunt "to paint small saleable pictures," and the advice that he later gave to Albert Goodwin stressed the practical advantages of watercolor over oil, for "large canvasses mean the complete doing of what they contain, and the painting of not more than three or four in the year, while I think you have eyes to discern, every summer, three or four and forty, of which it is a treason to your genius to omit such record as would on a small scale be easily possible to you" (37.213).[3]

Ruskin's view of the possibilities of landscape painting in watercolor owed something to the various drawing masters who had instructed him as a boy – artists brought in by his father, John James Ruskin, who believed that the ability to draw was a fitting attribute of an educated gentleman. The first of these was Charles Runciman, whose teaching may have been ineffectual but who remained on friendly terms with Ruskin until the 1860s. In about 1835 Runciman was succeeded by Copley Fielding, who four years previously had become president of the Old Water-Colour Society and whose works the senior Ruskin had begun to collect. In his autobiography, Praeterita, Ruskin summoned up the impression that Copley Fielding made upon him and his father:

My father and I were in absolute sympathy about Copley Fielding, and I could find it in my heart now to wish I had . . . never seen any art but Prout's and his. We were very much set up at making his acquaintance, and then very happy in it: the modestest of presidents he was; the simplest of painters, without a vestige of romance, but the purest love of daily sunshine and the constant hills. (35.213)

For the time being Ruskin accepted the formulas of Copley Fielding's watercolor method. "Fielding taught me," he recalled,

to wash colour smoothly in successive tints, to shade cobalt through pink madder into yellow ochre for skies, to use a broken scraggy touch for the tops of mountains, to represent calm lakes by broad strips of shade with lines of light between them, . . . to produce dark clouds and rain with twelve or twenty successive washes, and to crumble burnt umber with a dry brush for foliage and foreground. (35.215)

Ruskin also received drawing lessons from David Roberts, from whom he learned, he later considered, "of absolute good, the use of the fine point instead of the blunt one; attention and indefatigable correctness in de-

tail; and the simplest means of expressing ordinary light and shade on grey ground, flat wash for the full shadows, and heightening of the gradated lights by warm white" (35.262). The longest-standing of Ruskin's masters was James Duffield Harding, who first instructed him during the winter of 1841–42. The following year Ruskin made a telling observation in his diary: "I had a delicious day altogether, counting a pleasant lesson from Harding, who says I yield a great deal too much to my feelings in drawing, and don't judge enough."[4] Ruskin was already looking for ways of expressing what he felt about the beauty of nature; painting and draftsmanship were for him means of emotional communication rather than mere technical accomplishments.

During the later 1830s and early 1840s Ruskin and his father haunted the rooms of the Old Water-Colour Society in Pall Mall East, making friends with professional artists and looking for drawings to add to the growing family collection. Ruskin reminisced with a hint of condescension about that outwardly friendly and hospitable institution:

I cannot but recollect with feelings of considerable refreshment . . . what a simple company of connoisseurs we were, who crowded into happy meeting, on the first Mondays in Mays of long ago, in the bright large room of the Old Water-Colour Society; and discussed, with holiday gaiety, the unimposing merits of the favourites, from whose pencils we knew precisely what to expect, and by whom we were never either disappointed or surprised. (14.389–90)

As Ruskin later said, it was not the technical or stylistic achievements of these watercolorists that he admired but the ingenuousness of their choice of subject and the delight with which they approached the landscape for its own sake:

The old water-colour room at that time, adorned yearly with the complete year's labour of Fielding, Robson, De Wint, Barret, Prout, and William Hunt, presented an aggregate of unaffected pleasantness and truth. . . . The root of this delightfulness was an extremely rare sincerity in the personal pleasure which all these men took, not in their own pictures, but in the subjects of them. (33.374)

A momentous event in the evolution of Ruskin's ideas about landscape painting occurred in 1832 when his father's business partner, Henry Telford, gave him as a birthday present a copy of the recently published illustrated edition of Italy, Samuel Rogers's book of poems, in which appeared a series of vignette plates by Turner. "This book was the first means I had of looking carefully at Turner's work: and I might, not without some appearance of reason, attribute to the gift the entire direction of my life's energies," Ruskin wrote in Praeterita (35.29). The significance of these plates for Ruskin lay in their dense and highly worked quality and the way in which textures within each of the compositions suggested the minute detail of landscapes. It was in a sense ironic that these particular plates should have so inspired Ruskin, for they represented a deliberately formalized solution to the problems of view painting on Turner's part, presumably

as the result of Rogers's specific instructions to the artist. Nonetheless, Ruskin lovingly copied and imitated them, and the vision of landscape they represented was never forgotten.

In the late 1830s Ruskin's father began occasionally to acquire watercolors by Turner from Thomas Griffith, Turner's agent, who was later to introduce the younger Ruskin to the painter. His first purchase was *Richmond Hill and Bridge, Surrey* (British Museum, London), his second a view of Gosport (private collection) which had also been engraved for the series *Picturesque Views in England and Wales*. For the son, there were few other opportunities to look at Turner watercolors. The principal collections in private hands, such as that formed by Walter Fawkes at Farnley Hall in Yorkshire, were not easily seen unless one happened to be a personal friend or member of the family, while the drawings Turner kept in his own possession were, as Ruskin said, "at the bottom of an old drawer in Queen Anne Street, inaccessible to me as the bottom of the sea" (35.216). There was, however, one passionate collector of Turner's watercolors who was prepared to share his prizes with the young enthusiast – Godfrey Windus, whose villa in the suburbs of north London was adorned with many fine drawings by Turner. Ruskin wrote fifty years later: "Nobody, in all England, at that time, and Turner was already sixty, – *cared*, in the true sense of the word, for Turner, but the retired coachmaker of Tottenham, and I" (3.235n).

Ruskin's appreciation of the qualities of Turner's watercolors, particularly what he felt to be the honesty of their representation of nature, was intensifying all the while. In due course he was to refute other interpretations of Turner's art on the basis of the conclusions he reached at this time. In the third volume of *Modern Painters*, he wrote: "I never said that [Turner] was vague or visionary. What I said was, that nobody had ever drawn so well; that nobody was so certain, so un-visionary; that nobody had ever given so many hard and downright facts" (5.174).

It was not only on the basis of the work of other artists that Ruskin formed his opinions of the possibilities of landscape painting in watercolor. His own direct experience of the countryside and the opportunity to study nature at close range played a vital part in the development of his ideas about landscape painting. Ruskin had been born in Bloomsbury in the heart of London, but while he was still very young his parents had moved to Herne Hill, a village in the city's southern outskirts. In *Praeterita* he described "a succession of quite beautiful pleasure-grounds and gardens, instantly dry after rain, and in which, for children, running down is pleasant play, and rolling a roller up, vigorous work" (35.47). It was a landscape, at least as it survived in its one-time inhabitant's memory, unblemished by the creeping urbanization and atmospheric pollution of the nearby metropolis. Ruskin's childhood experience of these "politely inhabited groves," which carried "the promise of all the rustic loveliness of Surrey and Kent" (35.47), colored his appreciation of landscape, whether viewed directly or in pictorial

form, for his lifetime, although he would consciously reject such a suburban environment as an appropriate subject for art.[5]

In fact the Ruskin family hardly saw themselves as Londoners but rather as lowland Scots who found it convenient to live in the south. The young Ruskin often accompanied his father on the travels that he made through England, Wales, and the Scottish Borders to take orders for the sherry that his company imported; as a result Ruskin grew up with a wide knowledge of the landscape characteristics of different regions and a familiarity with some of the most beautiful parts of the British Isles. From a young age his essential loyalty in terms of landscape as the subject for art was to Scotland and the north of England, and in later life he recalled the impression made upon him by the wild expanses of upland landscape. In the chapter of the third volume of *Modern Painters* entitled "The Moral of Landscape," he described "the intense joy mingled with awe, that I had in looking through the hollows in the mossy roots, over the crag, into the dark lake" at Friar's Crag on Derwent Water. Other experiences of the northern landscape brought him, he wrote, "a pleasure, as early as I can remember, and continuing till I was eighteen or twenty, infinitely greater than any which has been since possible to me in anything; comparable for intensity only to the joy of a lover in being near a noble and kind mistress, but no more explicable or definable than that feeling of love itself" (5.365).

Just as Ruskin had applauded the members of the Old Water-Colour Society for their sincere appreciation of the beauty of the landscape, he in turn regarded the physical world as something much larger and more important than just a subject for painting; as a young man he believed nature to be the creation of God, and the beauty he found in it an affirmation of a universal creation. To draw or paint these surroundings was tantamount to an act of faith, and one to be undertaken with the utmost reverence and humility.

In retrospect Ruskin viewed the year 1842 as a personal watershed; his preoccupation with Turner was gathering momentum – he had come to appreciate particularly that painter's later watercolor sketches, which were, he believed, "straight impressions from nature." As Ruskin was to recall: "I was by this time very learned in his principles of composition; but it seemed to me that in these later subjects Nature herself was composing with him" (35.310). The ideas that were to form the main theme of the first volume of *Modern Painters* were taking shape. Two events described in *Praeterita* in the terms of mystical revelation helped him to understand that artists must observe the forms of the natural world to discover the laws of composition essential to all works of art. "Considering of these matters," he wrote,

one day on the road to Norwood, I noticed a bit of ivy round a thorn stem, which seemed, even to my critical judgment, not ill "composed"; and proceeded to make a light and shade pencil study of it in my grey paper pocket-book, carefully, as if it had been a bit of sculpture, liking it more and more as I drew. When it was done, I saw that

I had virtually lost all my time since I was twelve years old, because no one had ever told me to draw what was really there! All my time, I mean, given to drawing as an art; of course I had the records of places, but had never seen the beauty of anything, not even of a stone – how much less of a leaf! (35.311)

Later in the summer of 1842, Ruskin visited Fontainebleau, where he was impressed with neither the famous rocks nor the palace and gardens. Instead, he "found [himself] lying on the bank of a cart-road in the sand, with no prospect whatever but [a] small aspen tree against the blue sky." He went on:

Languidly, but not idly, I began to draw it; and as I drew, the languor passed away: the beautiful lines insisted on being traced, – without weariness. More and more beautiful they became, as each rose out of the rest, and took its place in the air. With wonder increasing every instant, I saw that they "composed" themselves, by finer laws than any known of men. (35.314)

Whether or not these events really happened (no mention is made of either in the surviving parts of Ruskin's diary for 1842), they amounted to a resounding, if retrospective, declaration against the lingering picturesque, which directed artists to favored subjects and prompted them to treat the forms of nature according to established conventions.

It was clear that by the early 1840s Ruskin wanted to contribute to, and be involved in, the artistic life of the nation. What began as a spontaneous response to criticisms of Turner in *Blackwood's Magazine* metamorphosed into the five volumes of *Modern Painters*, published between 1843 and 1860, the first two dedicated "to the landscape artists of England . . . by their sincere admirer." This astounding edifice of ideas and enthusiasms – in places systematic and cogent, elsewhere rambling and incoherent, but consistently beautiful in its prose and always intensely felt – had seismic repercussions for landscape painters. The first volume, subtitled "Of General Principles and Truth," contained passages of direct relevance to the watercolorists of the day. Ruskin set out to demonstrate that Turner's art was rooted in the direct observation and understanding of nature and sought to persuade the reader that this experience should represent the essential training of all true artists. In a famous paragraph, entitled "The Duty and After Privileges of All Students," Ruskin pleaded for all young painters to "go to Nature in all singleness of heart, and walk with her laboriously and trustingly, having no other thoughts but how best to penetrate her meaning, and remembering her instruction; rejecting nothing, selecting nothing, and scorning nothing; believing all things to be right and good, and rejoicing always in the truth" (3.624).

These words were addressed to artists embarking on all types of subject and in every medium. Nonetheless, Ruskin had landscape watercolorists in mind as he ordered his thoughts about the necessity for meticulous observation of the forms of nature. He concluded one chapter with a rhapsodic appreciation of David Cox,

whose pencil never falls but in dew – simple-minded as a child, gentle, and loving all things that are pure and lowly – content to lie quiet among the rustling leaves, and sparkling grass, and purple-cushioned heather, only to watch the soft white clouds melting with their own motion, and the dewy blue dropping through them like rain, so that he may but cast from him as pollution all that is proud, and artificial, and unquiet, and worldly, and possess his spirit in humility and peace. (3.253n)[6]

Further eulogies were addressed to Copley Fielding and J. D. Harding, although neither watercolorist's drawings supported as well as those of Cox Ruskin's exhortation that the duty of an artist was to allow the spectator to savor the very experience of the countryside in his works. When writing the first volume of *Modern Painters*, Ruskin tried to look sympathetically on the older generation of landscape watercolorists, even though it included artists whose drawings were essentially dependent on the kind of formulas of composition and technique he was so dramatically overturning.

In the Pre-Raphaelite Brotherhood, formed in the autumn of 1848, Ruskin found a group of young artists who seemingly had the potential to fulfill his vision. When his attention was drawn to the Brotherhood, in the early 1850s, he was attracted by their anticonventionalist stance and their concern for truth to nature. The Pre-Raphaelites, for their part, had been stimulated by *Modern Painters*. Ruskin became their advocate, as he had been the champion of Turner; yet his letters to the *Times* in 1851 defending their work were full of criticisms, and he confessed "very imperfect sympathy with them" (12.320).[7] His pamphlet *Pre-Raphaelitism* actually had little to do with its ostensible subject, focusing instead on Turner. None of the original Pre-Raphaelites was specifically or even predominantly a landscape painter, and the radical naturalism that Ruskin isolated as the major thrust of the movement was in fact only one aspect of the group's program. Nevertheless, Ruskin's one-sided conception of Pre-Raphaelitism shaped the public perception of the movement; Pre-Raphaelitism and Ruskinian naturalism were widely held to be one and the same.[8]

In the early 1850s Ruskin suffered from a sense of intellectual and personal isolation brought on by the abstraction and theoretical remoteness of *Modern Painters*. As a young man he had enjoyed the company of artists and others with whom he could discuss the aesthetic questions with which his generation was preoccupied. Now he began to look for a practical opportunity to test the cultivation of the artistic sensibility through the study of nature, which he had previously expressed in *Modern Painters*. He wanted to share the excitement he felt about landscape as the subject of art directly with an audience, and to judge for himself its response.

An opportunity to show other people how to draw and paint occurred when Ruskin offered to teach at Frederick Denison Maurice's Working Men's College, founded in October 1854 to provide technical and philosophical education to men for whom no other educational facilities

were available. Ruskin was seized by the importance of this venture and was able to persuade Dante Gabriel Rossetti to join him in the teaching, which meant the sacrifice of one evening a week for four terms in the year. From Easter 1855 until the spring of 1858, Ruskin took charge of the landscape class, at the college building in Red Lion Square, or in the summer on outings into the countryside for the purpose of drawing directly from nature.

Ruskin threw himself into teaching at the Working Men's College with his customary enthusiasm. Various accounts survive of his programs of instruction. "Never without an afterglow of grateful memory will the first art-class of the Working Men's College be remembered by those . . . who were privileged to belong to it," wrote Thomas Sulman, one of his students:

He taught each of us separately, studying the capacities of each student. . . . For one pupil he would put a cairngorm pebble or fluor-spar into a tumbler of water, and set him to trace their tangled veins of crimson and amethyst. For another he would bring lichen and fungi from Anerley Woods. . . . At other times it was a splendid Albert Durer wood-cut, that we might copy a square inch or two of herbage, and identify the columbines and cyclamens. (5.xl)

These were the exercises by which Ruskin directed the attention of his students, who were mesmerized by the passion and intensity of his personal vision of nature, to an understanding of landscape in terms of its constituent details rather than the generality of its outlines.

Ruskin's eminently practical approach to the question of how to introduce younger artists to the principles of truth to nature, explored in his teaching at the Working Men's College, gained him a considerable reputation as a teacher; he found himself in demand by many people who sought his instruction in the art of drawing and painting in watercolor. Because he genuinely wanted to help all those who turned to him and believed that by doing so he might raise the standard of contemporary landscape painting, he resolved to devise a manual essentially for the use of amateur artists. The Elements of Drawing was published in 1857, and it proved to be highly influential not just among those whom Ruskin had had in mind when he wrote it (the full title of the book is The Elements of Drawing: In Three Letters to Beginners) but also among many young professional artists.

The three letters of The Elements of Drawing were designed to guide a person with no previous practical experience of painting and drawing to a stage of working proficiency in landscape subjects. The first part of the Elements differed markedly from the mass of artists' manuals of the period: Ruskin encouraged the reader to aim at a naturalistic representation of the landscape through close observation and a painstaking exploration of the medium's technical potential, in contradistinction to the generalized effects and compositional clichés to which readers were introduced in other drawing manuals. The text of the book is written in a lucid and powerful prose – evocative of the natural beauties of the countryside and rich in poetic

analogies, and yet direct in its meaning and free of anything arcane or unnecessarily elaborate. The opening letter, "On First Practice," conducted the student through a series of exercises designed to demonstrate the principles by which the eye perceives the physical world in terms of tone and color. As Ruskin explained in a footnote:

The perception of solid Form is entirely a matter of experience. We see nothing but flat colours; and it is only by a series of experiments that we find out that a stain of black or grey indicates the dark side of a solid substance, or that a faint hue indicates that the object in which it appears is far away. The whole technical power of painting depends on our recovery of what may be called the innocence of the eye; that is to say, of a sort of childish perception of these flat stains of colour, merely as such, without consciousness of what they signify, – as a blind man would see them if suddenly gifted with sight. (15.27n)

Perhaps remembering his own revelatory study of the Fontainebleau aspen, he directed the reader of the Elements to

choose any tree that you think pretty, which is nearly bare of leaves, and which you can see against the sky, or against a pale wall, or other light ground. . . . A wholly grey or rainy day is best for this practice. . . . You will see that all the boughs of the tree are dark against the sky. Consider them as so many dark rivers, to be laid down in a map with absolute accuracy. . . . You cannot do too many studies of this kind; every one will give you some new notion about trees. (15.39–41)

"On First Practice" concluded with a recommendation that the notional student should "look at Art as well as Nature, and see what means painters and engravers have actually employed." Ruskin suggested a close study of the engraved works of Turner (with particular reference to Rogers's Italy), Rembrandt, and Dürer.

In the second letter of the Elements, "Sketching from Nature," Ruskin dealt with different types of landscape and their suitability to the artist. He warned against choosing landscape subjects for their personal associations: "If you try to draw places that you love, you are sure to be always entangled amongst neat brick walls, iron railings, gravel walks, greenhouses, and quickset hedges; besides that you will be continually led into some endeavour to make your drawing pretty, or complete, which will be fatal to your progress" (15.107).

The built-up landscape of towns and their outskirts, where most of Ruskin's readers as well as he himself lived, was seen as a peculiarly difficult and hazardous subject – a watercolorist might be tempted to try to give information about a place derived from his own feelings of affection for it, rather than from an objective inspection of its physical characteristics. At this stage in the development of his ideas about the purposes and uses of landscape painting, Ruskin was not prepared to countenance watercolors tinged with personal sentiment.

Ruskin then launched into an evocative description of the quintessential components of the British countryside, classified in terms of their suitability as subjects for watercolor painting:

In general, all banks are beautiful things, and will reward work better than large landscapes. If you live in a lowland country, you must look for places where the ground is broken to the river's edges, with decayed posts, or roots of trees; or, if by great good luck there should be such a thing within your reach, for remnants of stone quays or steps, mossy mill-dams, etc. Nearly every other mile of road in chalk country will present beautiful bits of broken bank at its sides; better in form and colour than high chalk cliffs. In woods, one or two trunks, with the flowery ground below, are at once the richest and easiest kind of study: a not very thick trunk, say nine inches or a foot in diameter, with ivy running up it sparingly, is an easy, and always a rewarding subject. . . .

If you live in a mountain or hill country, your only danger is redundance of subject. Be resolved, in the first place, to draw a piece of rounded rock, with its variegated lichens, quite rightly, getting its complete roundings, and all the patterns of the lichen in true local colour. Till you can do this, it is of no use your thinking of sketching among hills; but when once you have done this, the forms of distant hills will be comparatively easy. (15.109–11)

These paragraphs seem to have made an almost immediate impact on a rising generation of watercolorists. In the present exhibition, drawings by Alfred William Hunt and Joseph Noel Paton (cat. nos. 31 and 32), both done the same summer *The Elements of Drawing* was published, show painters searching the face of the countryside, as it were on hands and knees, for the sake of a closer understanding of the forms of nature. Ruskin himself in watercolors such as *In the Pass of Killiecrankie* (cat. no. 30), again dated 1857, made a minute exploration of eroded rock and clinging vegetation with no reference to any topographical conventions. Artists who otherwise were not thought of as landscapists were drawn to the type of subjects Ruskin recommended: Paton for one, but also the young Albert Moore, who in 1857 made a minutely detailed drawing entitled *Trunk of an Ash Tree with Ivy* (fig. 3), which serves as an almost exact illustration of Ruskin's recommendation of "an easy, and always a rewarding subject."

The third letter of the *Elements*, entitled "On Colour and Composition," opened with detailed technical advice on the use of pigment: "Use hard cake colours, not moist colours: grind a sufficient quantity of each on your palette every morning, keeping a separate plate, large and deep, for colours to be used in broad washes, and wash both plate and palette every evening, so as to be able always to get good and pure colour when you need it" (15.136). Ruskin entered the debate, which was then arousing strong feeling in artistic circles, about the use of opaque color in watercolor painting as opposed to a technique that depended on the white of the paper to provide the highlights and areas of paler color within a composition. He gave clear instructions:

Use Chinese white, well ground, to mix with your colours in order to pale them, instead of a quantity of water. You will thus be able to shape your masses more quietly, and play the colours about with more ease; they will not damp your paper so much, and you will be able to

Fig. 3. Albert Moore, *Trunk of an Ash Tree with Ivy*, 1857. Watercolor and bodycolor with gum, 303 × 229 mm (11⅞ × 9 in.). Ashmolean Museum, Oxford.

go on continually, and lay forms of passing cloud and other fugitive or delicately shaped lights, otherwise unattainable except by time.

This mixing of white with the pigments, so as to render them opaque, constitutes body-colour drawing as opposed to transparent-colour drawing, and you will, perhaps, have it often said to you that this body-colour is "illegitimate." It is just as legitimate as oil-painting, being, so far as handling is concerned, the same process, only without its uncleanliness, its unwholesomeness, or its inconvenience. (15.137–38)

The central tenet of Ruskin's theory of painting in watercolor was that the artist should build into every area of the composition minute variations of light and shade as well as differing grades and intensities of color. By this means he could convey the infinite variety and subtlety of nature. Ruskin denied the possibility of even tones of unbroken color and besought his reader to avoid such in his compositions. The term Ruskin used to describe a method of painting that aimed at achieving a sense of the fluctuation of the forms of nature was "gradation" – color was to be applied in minute and independent touches, each tint meticulously prepared to match the colors the artist finds in the constituent details of the landscape. By this method watercolor paintings might be made luminous and vibrant, and the artist might simulate the way in which the eye receives information about the physical

world – by a sensuous appreciation of the textures and relative intensities of tone and color. By reference to the example of Turner, in whose works Ruskin insisted one does not find "one spot of colour as large as a grain of wheat ungradated," the reader is told to search for "brilliancy of hue," "vigour of light," and "the aspect of transparency in shade" by means of gradation of color (15.149).

In practical terms this was a new approach to landscape painting in watercolor. The older generation, who even in the late 1850s monopolized the wall space of the watercolor societies, clung to the traditional methods – whereby compositions were built up in broad layers of translucent color. The Elements of Drawing was received as a radical contribution to this debate and was particularly welcomed by young artists.

As a work of theory the book represents the highpoint of Ruskin's thinking on the abstract beauty of patterns and colors observed in the landscape, without their needing to depict anything in particular. As he wrote: "It is not enough that [lines and colors] truly represent natural objects; but they must fit into certain places, and gather into certain harmonious groups" (15.163).

The success of The Elements of Drawing resulted from Ruskin's fusion of practical advice and aesthetic theory, and the light that each shed on the other. On the one hand, Ruskin explored the fundamental attributes of good technique in drawing and painting and analyzed the way in which landscape subjects should be composed. On the other, he encouraged those who were seeking to master the media of drawing and painting simply to get out into the countryside and allow themselves to be inspired by the sheer beauty of the natural landscape. Ruskin felt quite confident that the student would find that "the best answerer of questions is perseverance; and the best drawing-masters are the woods and hills" (15.19).

The Elements of Drawing (which was joined by a sister volume, The Elements of Perspective, in 1859) was translated into German and Italian, pirated in the United States, and was recognized as most original by those people who at the time were beginning to investigate the way in which the eye perceives color and shape. The American scientist Ogden N. Rood was one who read and assimilated The Elements of Drawing; the book that he in turn wrote in 1879, Modern Chromatics, in which he quoted passages from the Elements, was a vital influence on the French post-impressionists and the theory that lay behind pointillisme.[9] Curiously, despite the great success of The Elements of Drawing, it remained in print only a few years. In 1861 Ruskin decided that he would make changes to the text of the Elements before allowing it to be reissued but found himself too busy with other schemes to be able to settle to the task. He incorporated parts of the Elements into The Laws of Fésole, which was published in 1879; a companion volume, dealing expressly with the treatment of color and to be entitled The Laws of the Rivo Alto, was abandoned.

During the second half of the 1850s, as has been seen, Ruskin enjoyed being regarded as an authority in all matters to do with the arts. The fame of his still incomplete Modern Painters and his prestige as a lecturer and teacher meant that increasing numbers of people turned to him for his opinions on the works of art displayed each year in London. Ruskin saw it as his duty not only to applaud those contemporary works that fulfilled his principles but also to upbraid any artist who he felt had diverged from the true path which he himself had determined that modern art should take. From 1855 to 1859 Ruskin issued commentaries on the art exhibitions of the day, which came to be known as Academy Notes.

Although Ruskin was primarily interested in the exhibitions of the Royal Academy, he drew attention to landscape paintings in which minute attention to detail was displayed, whatever the medium. From 1856 onward Ruskin also covered the exhibitions of the watercolor societies. Among the watercolorists whose works he saw fit to praise were Charles Davidson and George Arthur Fripp. At the New Society in 1858, Ruskin considered Edmund George Warren's In the Forest of Dean "a very interesting study," and then, in words echoing those of The Elements of Drawing, he went on to describe how "the dark side of the trunk [of one of the trees in the composition] is singularly consistent and right in its gradations; the effect of the whole as true as it is possible for anything to be which is not delicately colored, but depends for all its results on mere brown, grey, and green, laid in right chiaroscuro." Ruskin drew the conclusion: "I fear the success is mechanical; but I wish that the younger Pre-Raphaelite painters, who cannot yet bring their details into true balance of force, would take note how much appearance of truth to Nature has been obtained in this drawing merely by the consistent relations of its shade, and would try to give the same consistency to their own truer hues" (14.192).

Ruskin was becoming less insistent on meticulous truth to nature in the details of the landscape. In his review of the Old Water-Colour Society of 1858 he made a final comment on the career of David Cox: "Though Mr. Cox's work is every year broader in handling, and therefore further, as mere work, from the completeness I would generally advocate, it becomes always more majestic or more interesting in conception" (14.195). In 1859 Ruskin criticized an oil painting and a watercolor by Henry Clarence Whaite for their dependence on "minute and similar touches" throughout. Both Whaite's works and one of A. W. Hunt's, he felt, were "entirely well meant, but suffer under the same oppression of plethoric labour." Ruskin concluded: "I do not often, in the present state of the English school, think it advisable to recommend 'breadth'; but assuredly both Mr. Whaite and Mr. Hunt, if they wish to do themselves justice, ought to give up colour for a little while, and work with nothing but very ill-made charcoal which will not cut to a point" (14.229–30).

In 1859 Ruskin's mood of dissatisfaction with the type of painting offered at the two watercolor societies reached a new height. He was outraged by what he saw

as an appeal to the "insensitiveness and pretence" of the public:

insensitiveness, because no refined eye could bear with the glaring colours, and blotted or dashed forms, which are the staple of modern water-colour work; and pretence, because this system of painting is principally supported by the idle amateurs who concern themselves about art without being truly interested in it; and by pupils of the various water-colour masters, who enjoy being taught to sketch brilliantly in six lessons. (14.246)

On this sour note Ruskin withdrew from the forum of debate on the merits and demerits of current displays of paintings and drawings.[10]

Over the years a succession of landscapists, all of whom worked principally or occasionally in watercolor, came within Ruskin's orbit. The surviving correspondence between Ruskin and a wide circle of younger artists provides extraordinary insights into the way in which he encouraged and cajoled the painters he considered the most promising of the day and who, at least for a while, accepted his artistic principles. Among these landscape painters whose works Ruskin singled out for praise in *Academy Notes* and with whom he was, in the words of his editors, "for some years on terms of helpful friendship" (14.xxiii) were John William Inchbold and John Brett. He met up with each in turn in the Alps, for the purpose of what Ruskin saw as intensive reeducation in landscape painting according to his principles. A letter of August 1858 from Ruskin to his father gives an account of Inchbold's visit:

I stayed with him some time, or rather made him stay with me, at Bellinzona, in order to make him understand where he was wrong. He was vexed with his work and yet thought it was right, and didn't know why he didn't like it, nor why nobody liked it. It was a delicate and difficult matter to make him gradually find out his own faults (it's no use telling a man of them), and took me a fortnight of innuendoes. At last I think I succeeded in making him entirely uncomfortable and ashamed of himself, and then I left him. (14.xxiii)

Ruskin had taken a particular interest in Inchbold because of the microscopically detailed landscape oils he had painted in the early and mid-1850s (some of which were described in *Academy Notes*). Ruskin may have been disappointed with Inchbold's watercolors of 1856 and 1858 because Inchbold's style was tending to revert to the breadth and tonality of his early career; drawings such as his *Vesuvius and the Bay of Naples from Posilipo* (Victoria and Albert Museum, London) of 1857 are loose and spontaneous and depend on washes of color for their atmospheric effect rather than on the patient manipulation of gouache to achieve accuracy of detail. On the other hand, Ruskin may have been dissatisfied with Inchbold's Swiss drawings because he found them aesthetically decorative rather than objectively informative, and thus inadequate as geographical and anthropological records, whatever their degree of finish.

Brett was Ruskin's other guest in August 1858; Ruskin told his father: "I sent for him at Villeneuve, Val d'Aosta,

Fig. 4. John Brett, *Val d'Aosta*, 1858. Oil on canvas, 876 × 683 mm (34½ × 26⅞ in.). Private collection.

because I didn't like what he said in his letter about his present work, and thought he wanted some lecturing like Inchbold: besides that, he could give me some useful hints. He is much tougher and stronger than Inchbold, and takes more hammering" (14.xxiii–xxiv). Brett's "present work" was the oil painting *Val d'Aosta* (fig. 4), with which he was occupied throughout the summer of 1858. He also painted watercolors while in Switzerland; these were essentially experimental sketches recording the Alpine topography as well as the quality of light and atmospheric effects to be observed in the mountains, made as preparations for the finished picture. If Ruskin saw any of these drawings his reaction to them is not recorded. In 1859 *Val d'Aosta* was shown at the Royal Academy; in *Academy Notes* Ruskin seized upon it as "historical landscape painting, properly so called – landscape painting with a meaning and a use." He went on: "We have had hitherto plenty of industry, precision quite unlimited; but all useless, or nearly so, being wasted on scenes of no majesty or enduring interest" (14.234). For Ruskin, "standing before this painting is just as good as standing in that spot in Val d'Aosta, as far as gaining knowledge is concerned." *Val d'Aosta* had, however, according to Ruskin,

a strange fault, . . . it seems to me wholly emotionless. I cannot find from it that the painter loved, or feared, anything in all that wonderful piece of the world. There seems to me no awe of the mountains

there – no real love of the chestnuts or the vines. Keenness of eye and fineness of hand as much as you choose; but of emotion, or of intention, nothing traceable. . . . He has cared for nothing, except as it was more or less pretty in colour and form. I never saw the mirror so held up to Nature; but it is Mirror's work, not Man's. (14.236–37)

This comment, coupled with his criticisms of Whaite and A. W. Hunt and his guarded enthusiasm for Cox, indicates that by the late 1850s Ruskin knew the limitations of a strictly literal interpretation of the principle of truth to nature. The faithful and exact rendering of bits of nature, advocated in *The Elements of Drawing*, was no longer enough.

Ruskin required art of any kind to appeal to the imagination. "Well, but then, what becomes of all these long dogmatic chapters of yours about giving nothing but the truth, and as much truth as possible," he imagined the reader of the third volume of *Modern Painters* asking. The reply came: "The chapters are all quite right. 'Nothing but the Truth,' I say still, 'As much Truth as possible,' I say still. But truth so presented that it will need the help of the imagination to make it real" (5.185). Furthermore, Ruskin identified a vital quality on which the success of the representation of landscape subjects depended – he required above all else an indication of the feelings of awe or sentiment aroused by a particular place.

In 1860, in the fifth and final volume of *Modern Painters*, Ruskin reviewed the landscape painting of the Pre-Raphaelites and the other painters whose careers he had attempted to guide in the 1850s, and in the process made an implicit comparison with the work of Turner:

I was surprised at the first rise of that school, now some years ago, by observing how they restrained themselves to subjects which in other hands would have been wholly uninteresting: and in their succeeding efforts, I saw with increasing wonder, that they were almost destitute of the power of feeling vastness, or enjoying the forms which expressed it. A mountain or great building only appeared to them as a piece of colour of a certain shape. The powers it represented, or included, were invisible to them. (7.233)

These words unconsciously echo and contradict Ruskin's footnote in *The Elements of Drawing* concerning "the innocence of the eye." Ruskin now believed that works of art were to uplift and edify, and it was up to the artist to find subjects of suitable natural grandeur or historical association.

As a young man Ruskin had believed that the representation of landscape subjects in watercolor should be undertaken in a spirit of humility and reverence, but by the late 1850s his faith in God had been undermined. What he described as his "unconversion" had various consequences regarding the way he viewed his own and others' watercolor painting. In the first place, he began to find that his zest for the actual landscape was lessening. His letters and diaries of the period catalogue the disappointment he felt when faced with scenery that had previously thrilled him. Second, he found himself dissatisfied with the purposes of landscape painting and saw in the purely

aesthetic objective an escape from or avoidance of issues to do with the conditions of life and how these might be reflected in art. Increasingly, he considered landscape in terms of the hardships endured by its inhabitants rather than its suitability as a subject for art; as early as 1854 he found a landscape in northern France "exquisitely picturesque, and as miserable as picturesque, . . . [but] I could not help feeling how many suffering persons must *pay* for my picturesque subject, and my happy walk,"[11] while in volume five of *Modern Painters* he imagined a typical Highland landscape: "I see a man fishing, with a boy and a dog – a picturesque and pretty group enough certainly, if they had not been there all day starving. I know them, and I know the dog's ribs also, which are nearly as bare as the dead ewe's; and the child's wasted shoulders, cutting his old tartan jacket through" (7.269).

If Ruskin had become increasingly discontented with what he saw as the too limited ambitions of the generality of landscape painters – who he felt were principally concerned with satisfying a commercial demand from insufficiently critical collectors – it was because he believed that watercolor painting should be undertaken in a more serious spirit and that only those subjects that were authentic representations of places or that provided information about the way of life or condition of the landscape's inhabitants were ultimately worthwhile.

During the 1860s Ruskin was largely preoccupied with social and economic questions. He continued to paint in watercolor and to draw – indeed he was heard to say on one occasion that he intended to give up writing and lecturing and devote himself to painting.[12] As he suffered increasingly from moods of black despair – a prelude to the insanity that struck him intermittently in the last twenty years of his life – he found solace in the process of observation and the reconstruction of the forms of nature on paper. At a time when all else seemed alarming and threatening, his neurotic soul was comforted by a process that established certain absolute realities. Ruskin believed that small fragments of the landscape contained clues to the structure of the whole; as he had once written: "For a stone, when it is examined, will be found a mountain in miniature" (6.368). Kenneth Clark said of Ruskin's vision of nature: "He had stared fixedly at details all his life, and, as he grew older, to look into something intensively was like re-entering a lost Eden."[13] Few people appreciated, if they knew anything about, this private world of Ruskin's. An exception was the American Charles Eliot Norton, with whom Ruskin had been in touch since 1855 and who believed in the intrinsic value of Ruskin's drawings. Norton wrote to Ruskin on one occasion: "Do you think I urge you to draw and to give yourself to work that no man can do as well as you, in a light spirit? Not so: it is because I am sure your influence will be made deeper, more permanent, and more helpful by patient work of this kind, than by your impassioned and impatient appeals to men who will scoff at your words."[14]

For a decade Ruskin more or less gave up his attempts to encourage contemporary landscape painters, and generally he lost touch or fell out with most of the artists whom he had previously tried to assist. He occasionally expressed himself on the course that landscape painting was taking, one letter in particular to Norton in 1867 revealing the depth of his splenetic discontent:

Every great man's work – ([Turner's] preeminently) – is a digestion of nature. . . . All my first work in Modern Painters, was to show that one must have nature to digest. Not chalk & water for milk. Well, then I came to treat of the absorption and found I could'nt explain it to other people – and now a great deal of artists work – done as they suppose, on my principles – is merely gobbling good food and polluting it a little and sending it out at the other end of them – and asking the public to admire the faeces.[15]

In 1869 William Michael Rossetti considered the lessening influence in artistic matters of what he called "Ruskin and Ruskinism"; he found that

Mr. Ruskin, yet in the prime of life, and in masterly possession of all his splendid powers, has now, as compared with what was the normal condition of things but recently and for years together, few direct adherents in the art-world, and not many antagonists. A Japanese of a year ago might have said that Ruskin has ceased to be the Tycoon of art-theory, and has become, to some extent, its Mikado. His sway is now, to a considerable extent, remote, abstruse, and ceremonial. He no longer wields the practical powers of government, but remains a great unfamiliar abstraction of sovereignty. When the idea of authority has to be invoked, he is there for the purpose: but, when people want immediate instructions as to what they are to do next, it is not to him that they recur.[16]

Rossetti gave two reasons for this: "Mr. Ruskin has for years past almost wholly ceased to write or lecture about art, nor is he so actively engaged as he once was in the practical direction of the studies of beginners," and he "has, to a certain extent, already won the day. His theories have been embodied in practice which meets with popular acceptance."[17]

Where friendships survived, Ruskin was liable to be as hectoring and peremptory as ever. A. W. Hunt, whose decision to become a professional artist was prompted by Ruskin's enthusiasm for the paintings he showed at the Royal Academy in the 1850s, was one with whom Ruskin remained on amicable terms. In May 1873 Ruskin wrote to Hunt to ask him and his family to stay at Brantwood, Ruskin's house on Coniston Water in the Lake District, and to suggest that Hunt should look for landscape subjects in the vicinity to occupy him through the summer.[18] Ruskin continued to see Hunt as a disciple still learning the principles of landscape painting, and slowly he began to look for opportunities to exert his authority. Hunt wrote to his wife who had returned to London: "I am very much in love with my subject – it is very difficult, but I think I see how to manage it. It is just half an hour's walk from this house. . . . J. R.'s little bit of discipline will have done me much good even though altogether I get much less in quantity done than usual."[19] Hunt remained

in the Lakes right through the summer, but increasingly he and Ruskin found themselves at odds. In November Hunt wrote to Ruskin from London:

I have been at home long enough now to regard my Coniston life from a proper distance – a distance of time which makes me know how happy I was there and how much your kindness did to make me happy. Perhaps I may have to thank you yet for something that won't make me happier – but that will be just as I use it – namely an advance in Self-knowledge which makes me look back on all old work with a very calm seriousness.[20]

By the 1870s Hunt had abandoned the minute observation of detail in nature that had characterized his early watercolors. In his later career he sought to convey the effects of light on the landscape and the radiant or vaporous atmospheres of different times of day. It seems that Ruskin accepted these as legitimate purposes for the landscape watercolorist to follow but was perhaps put out by the confidence and aesthetic independence with which Hunt went about his painting. Nonetheless, Hunt was one of the very few among the Pre-Raphaelite generation of painters who continued to defer to Ruskin, which he did perhaps more out of loyalty to an old friend than because he truly valued Ruskin's advice and criticism.

As he grew older, Ruskin tended to dismiss purely aesthetic concerns in watercolor painting. Looking back, Ruskin insisted that he had understood the principles of *aesthesis* – the appreciation of works of art by the same senses as are normally used to perceive the external world – long before the cult of aestheticism had grown up, and that he had always recognized it as "pigs' flavouring of pigs'-wash" (25.122). In due course he was to rework the texts of various of his books to expunge references to the sensuous function of art.

During the 1870s Ruskin made an effort to regain the position of authority and influence in English artistic life that he had deliberately given up about 1860. His appointment in 1869 as Slade Professor of Art at Oxford University marked his renewed interest in education; he thus gained for himself a platform from which to pronounce on the course of contemporary art. Of direct relevance to the development of the landscape watercolor was Ruskin's work in the Oxford drawing school, which he endowed to provide a salary for the master and to which he presented large groups of Turner drawings. The Ruskin School, as it became known, offered two series of classes, "Educational" and "Rudimentary"; in each, landscape made up a significant part and was supplemented by the study of "Foliage," "Rocks, Water, and Clouds," "Grasses and Foreground Plants," and "Exercises in Tree-drawing" (21.xxxv), all of which reflect Ruskin's continued insistence on the close observation and accuracy of natural forms.

The same principle of painstaking and meticulous draftsmanship informed Ruskin's approach to the representation of buildings, whether seen at a distance as part of a wider urban setting or metaphorically dismantled into their constituent parts. He had long feared for the

safety of Europe's architectural heritage; since the 1850s he had been in the habit of proposing itineraries to painter-friends and acolytes about to embark on European travels – always directing them to places and buildings to which he was particularly attached and often reminding them of their duty to record architecture and landscapes which he thought were about to be destroyed or damaged beyond recognition by insensitive restoration. George Price Boyce, for example, sought Ruskin's directions before a trip to Italy in 1854 and was in turn pursued by a series of letters to poste restante addresses drawing his attention to specific architectural subjects and urging him to employ a more thorough and objectively informative approach.

As Ruskin grew older the painting of architectural subjects and townscapes came to seem an ever more important part of landscape painting; he had first explored the idea of buildings as a symbol and source of information about the activities and spiritual well-being of human beings in *The Poetry of Architecture*, published as a series of articles in 1837–38. In the 1850s he himself made many landscape drawings for the so-called Swiss Towns Project, which he planned as a cultural history of Switzerland based on an interpretation and exploration of that country's most characteristic buildings. When, in 1871, he established the Guild of Saint George – that protosocialistic scheme for cooperative living – one of its main purposes was to commission draftsmen and watercolorists to make views of buildings and landscapes in Britain and on the Continent, which might be used to instruct members of the guild who had no opportunity to travel. Ruskin demanded from these artists first and foremost a literal account of the given subject; buildings and their settings should be shown as clearly and at as close a range as possible, while their details were to be displayed on the sheet with mechanical accuracy. Painters were required to submerge their own artistic personalities in the interest of relaying the maximum amount of physical data about the subject. In 1882 Ruskin wrote to thank Frank Randal for a group of drawings sent from northern France:

They are nearly all I could desire, and much more than I expected you to accomplish after so short a time of study. Their quality of simple realism, and making one feel as if one was at the place, is a very high and unusual one; and, to my mind, worth any quantity of back composition or even delicate artistic dexterity, unaccompanied by this sense of substance and air (for the two go together in properly harmonised work). (30.lxvii)

The remarks that Ruskin made about Randal's drawings (a view of Verona was described as "entirely marvellous and delicious," while a street scene in the same town was considered "not massy nor gloomy enough")[21] seem to indicate that, in his case, Ruskin was prepared to allow some degree of poetic interpretation. Thomas Matthews Rooke was also considered sufficiently reliable as a copyist and recorder of architecture to be permitted a certain freedom of treatment and to be encouraged to take a greater delight in the landscape. In 1884, after a summer

painting architectural subjects in Italy, Rooke was instructed to return to England via Switzerland, so that he might enjoy and be invigorated by the Alpine scenery. Ruskin wrote to Rooke: "Don't do anything but what you entirely like yourself, and let there be a pretty foreground, always with a figure or two. Your figures are most perfect in truth and feeling" (30.lxv).

The project of documenting endangered buildings and landscapes on which Rooke and Randal were employed found a parallel in the less rigorous but nonetheless sincere attempts by Helen Allingham and Kate Greenaway to keep a record of the appearance of the vernacular architecture and undisturbed countryside of southern England, and of a rural way of life which they believed to be threatened. Ruskin was enthusiastic about the landscape watercolors of each of these artists, with whom he corresponded in the 1880s and to whom in 1883 he devoted a lecture entitled "Fairy Land" in the series *The Art of England*. He praised Allingham's "true gift . . . in representing the gesture, character, and humour of charming children in country landscapes" (33.340–41). He found in Kate Greenaway's drawings a vision of the type of landscape he seemed to remember from childhood, unmarked by commerce and industrialization:

There are no railroads in it, to carry the children away with, are there? no tunnel or pit mouths to swallow them up, no league-long viaducts – no blinkered iron bridges? There are only winding brooks, wooden foot-bridges, and grassy hills without any holes cut into them!

Again – there are no parks, no gentlemen's seats with attached stables and offices! – no rows of model lodging houses! no charitable institutions!! It seems as if none of these things which the English mind now rages after, possess any attraction whatever for this unimpressionable person. . . .

And more wonderful still, – there are no gasworks! no waterworks, no mowing machines, no sewing machines, no telegraph poles, no vestige, in fact, of science, civilization, economical arrangements, or commercial enterprise!!! (33.347)

Ruskin increasingly departed from the intellectual associations of landscape painting but relished with even greater intensity the artist's capacity to evoke the pleasant peacefulness of the countryside. Nostalgia played a part in his appreciation of the works of Allingham and Greenaway, but he was justified in seeing their watercolors as authentic representations of a threatened rustic environment. Having for a while been drawn toward a view of art in which abstract and formal qualities were preeminent, Ruskin returned to the belief that the principal purpose of art was to convey literal information, and the type of landscape watercolor that he favored in the last years of his active career was aimed at providing factual accounts of people, buildings, and places.

Ruskin's enjoyment of the beauties of nature, whether nostalgic or objectively analytical, was increasingly marred by what he came to believe was a process that would lead to the destruction of the landscape setting. When lucid, Ruskin was passionately concerned about the despoliation of the landscape and the effects of atmo-

spheric pollution which he saw around him; during the phases of mental disturbance which overtook him with greater frequency, he was seized with a neurotic dread that the physical world was suffering wholesale destruction. As early as the summer of 1871, in the aftermath of a mental breakdown, Ruskin described in *Fors Clavigera* how the sky had become "covered with . . . a dry black veil, which no ray of sunshine can pierce" (27.132). In 1883 he feared that "malignant aerial phenomena" were causing a "change in the relations of the sun and sky to organic life." He believed that a "plague-cloud and plague-wind" were sweeping the landscape. With sunlight veiled and all color drained from sky and land, and as unnatural winds destroyed vegetation and disturbed the surfaces of water, the face of nature seemed to him to be transformed into something virtually unrecognizable. The very landscape, which Ruskin saw as the fundamental source of inspiration for all painters, was, he believed, being desecrated; what, he asked, would be the "effect" of these terrible changes "on the artistic power of our time?" (33.399).

Watercolor landscape painting runs like a geological substratum through the terrain of Ruskin's mental life. Although a relatively small part of his life's work is given over to a discussion of the methods and purposes of watercolor landscape, it was nonetheless never far from his thoughts; he, after all, painted and drew landscape subjects practically every day – and the technical and aesthetic difficulties he encountered with both the medium and the subject had a close bearing on the evolution of his wider philosophy of art. What he said about the practical aspects of painting landscape watercolors, as well as his comments on the work of contemporary artists, is not a series of disconnected utterances but reflects an underlying structure of ideas.

Ruskin's specific preoccupations with how landscape and nature should be drawn and painted fluctuated and metamorphosed in the course of his long career. He was inconsistent, for example, regarding the expression of mood – as opposed to objective record making – a watercolorist might be expected to provide. He also changed his mind about the importance of the human element in landscape, which at one stage he dismissed but later regarded as essential. Even his concept of truth to nature – which for the most part meant to him a meticulous and minute observation of the details of the landscape and the avoidance of generalized or ambiguous effects and which is often seen as the most characteristic feature of so-called Ruskinian landscape painting – was by no means a constant. It is not even possible to fall back on Ruskin's own love of nature to explain his relentless interest in the artist's capacity to explore the face of the landscape, for there were times when he recoiled from the physical world. The factor uniting Ruskin's abstract theory of art, his instructions to and criticisms of painters, and his own work as a draftsman and watercolorist is the delight and fascination which he took in the very act of seeing; as he wrote of himself at the end of his life: "I had . . . a sensual faculty of pleasure in sight, as far as I know unparalleled"

(35.619). Ruskin was more open-minded about the styles and techniques of landscape painting than his pronouncements sometimes suggest; ultimately he wanted watercolor painters to forget everything they knew about how the landscape had been treated by previous artists and to use their own eyes to see clearly the forms of nature, as it were for the first time.

Notes

1. Ruskin's published works generally gained wide circulation and, notwithstanding critical hostility in certain quarters, were on the whole applauded by the public. As J. L. Bradley has written: "Considerable evidence supports [Ruskin's] position as a cultural influence beyond the rarefied intellectual circle of London. The plethora of reviews in journals, from the most dignified quarterlies down to daily newspapers, testify that his audience was a wide one growing wider all the time"; *Ruskin: The Critical Heritage* (London: Routledge and Kegan Paul, 1984), p. 15.
2. *Ruskin in Italy: Letters to His Parents, 1845*, ed. H. I. Shapiro (Oxford: Clarendon Press, 1972), p. 189.
3. The original letter is in the Beinecke Rare Book and Manuscript Library, Yale University.
4. *The Diaries of John Ruskin*, selected and ed. Joan Evans and John Howard Whitehouse, 3 vols. (Oxford: Oxford University Press, 1956–59), vol. 1, p. 241.
5. This view is shown in the famous exchange with Ford Madox Brown in 1855 when Brown showed Ruskin his view of Hampstead, *An English Autumn Afternoon*. The dialogue between Ruskin and Brown went: Ruskin – "What made you take such a very ugly subject, it was a pitty for there was some *nice* painting in it." Brown – "Because it lay out of a back window"; *The Diary of Ford Madox Brown*, ed. Virginia Surtees (New Haven and London: Yale University Press, 1981), p. 144.
6. This passage was deleted by Ruskin after the second edition of the first volume of *Modern Painters*.
7. This disclaimer appeared in the first letter, published on May 13, 1851. A second letter appeared in the *Times* on May 30, 1851.
8. The landscape elements in the art of the Pre-Raphaelites and the impact of Ruskinian naturalism on the artists of the Pre-Raphaelite orbit are fully treated in Allen Staley, *The Pre-Raphaelite Landscape* (Oxford: Clarendon Press, 1973).
9. For further information on the way Ruskin's color theory indirectly influenced the French impressionists, see Lawrence Campbell's introduction to the Dover edition of *The Elements of Drawing* (New York: Dover Publications, 1971); also see Martin Kemp, *The Science of Art* (New Haven: Yale University Press, 1990), pp. 305–6.
10. One further issue of *Academy Notes* appeared, in 1875. After that date Ruskin's criticism of contemporary works of art was incorporated in *Fors Clavigera*.
11. *Diaries*, vol. 2, p. 493.
12. G. P. Boyce recorded the remark, made by Ruskin at dinner at his family's house at Denmark Hill, on January 4, 1861; *The Diaries of George Price Boyce*, ed. Virginia Surtees (Norwich: Real World, 1980), p. 32.
13. Kenneth Clark, ed., *Ruskin Today* (London: John Murray, 1964), p. 351.
14. *Letters of Charles Eliot Norton*, ed. Sara Norton and M. A. DeWolfe Howe, 2 vols. (New York and Boston: Houghton Mifflin, 1913), vol. 2, pp. 45–46.
15. *The Correspondence of John Ruskin and Charles Eliot Norton*, ed. John Bradley and Ian Ousby (Cambridge: Cambridge University Press, 1987), p. 105.
16. W. M. Rossetti, quoted in Bradley, *Ruskin: The Critical Heritage*, pp. 319–20.
17. Ibid., p. 320.
18. Hunt's summer working under Ruskin's supervision in the Lakes is treated by Robert Secor, *John Ruskin and Alfred Hunt: New Letters and the Record of a Friendship* (Victoria, B.C.: University of Victoria, 1982), pp. 41–68.
19. Ibid., p. 53.
20. Ibid., p. 65.
21. Ruskin, quoted in Catherine W. Morley, *John Ruskin: Late Work, 1870–1890* (New York and London: Garland Publishing Inc., 1984), p. 154.

Chapter Three

Landscape in the Watercolor Societies

JOHN CONSTABLE'S long wait until 1829, when he was fifty-three, to be made an academician was indicative of the undervaluation of landscape painting in the Royal Academy. Yet landscape painting of that period was considered – and has continued to be regarded as – one of the greatest glories of British art. With the deaths of Constable in 1837 and Turner in 1851, the Royal Academy lost its foremost landscapists, and a profound indifference to landscape painting settled over that august body.

In 1856 the *Art Journal* commented:

Our school of landscape is superior to any other in Europe, but curiously enough there is this year no landscape by any member of the Academy, and those landscapes which have recently been exhibited by members have been much inferior to those in other exhibitions regarded as very subordinate in comparison with the Academy. We have frequently of late years remarked this – this year our assertion is forcibly illustrated – there is no landscape, essentially so-called, by an academician.[1]

In the following decade, the situation did not change much. The *Cornhill Magazine* noted in 1865 that in the Royal Academy exhibitions, "landscapes are being gradually excluded or placed in positions so unfavourable as to render them invisible."[2] The next year the *Spectator* drew attention to the view of an unnamed academician that "landscape painting is fast dying out in England."[3]

Nor did the position of landscape within the Academy improve in the ensuing years. In the mid-1870s controversy over the status of academic landscape painters raged in the correspondence and editorial columns of the daily press.[4] And in 1885 a critic sadly remarked: "It is, perhaps, allowable to give a regret to the purely national landscape art of which the Old Society was the founder, and which, had not the Royal Academy neglected its clearest duty, would be living and thriving to this day."[5]

If, throughout the second half of the century, the Royal Academy shirked its duty to the great national school of landscape, that did not result in the school's dying out. Landscape painting continued to flourish – where it always had – in the exhibitions of the Society of Painters in Water-Colours. As the *Spectator's* reviewer wrote of the Society in 1863, "this, whatever it may be besides, is the place where the English school of landscape-painting is best represented, and where, thanks to the catholic tastes of its members, the salient characteristics of its very various professors may most advantageously be studied."[6]

Ten years later, the same periodical sought the reasons for landscape's continued vitality within the Old Water-Colour Society and for its lack of recognition in the Academy:

It would hardly be too much to say that the history of Landscape painting, as we understand it now for the most part, runs side by side with that of the rise and development of the art of Water-colour painting; and our belief that this will continue to be the case is our ground for considering that any accession of strength to the leading Water-colour Society, which will enable it to exercise a wholesome influence over the progress of landscape art and to preserve its old traditions, is a matter of some public interest.

Certainly national pride in the achievements of Turner, Constable, Cox, and DeWint suggested that the future of landscape painting should be a matter of public concern. After rehearsing the argument that the medium of watercolor, with its transparency and the pure white of the paper as its ground, was better adapted than oils to the representation of light and color in landscape, the journalist turned to the Academy's attitude: "Now, the Royal Academy is hardly to be blamed, if, as we think, its traditions and leanings are not on the side of modern landscape." The academicians were by training and inclination simply unable to form a proper judgment of the merits of landscape painting: "The art which Turner and David Cox discovered for the world is still in its infancy, and years of toilsome labour must be gone through before any student can truly discern how much they have done, or how much they have left to do."[7]

The Society of Painters in Water-Colours did not stand alone in providing a home for artists interested in landscape. After midcentury, landscape gained increasing prominence in the New Society of Painters in Water Colours. According to the Art Journal: "The Old Watercolour Society was originally a body of landscape painters, and the New began life as a company of figure painters, by way of distinction from the senior body; but neither society has been able to sustain the character it assumed, and which was originally given to it."[8]

The distinctions were never as clear-cut as the Art Journal implied they had once been. The New Society had been formed in 1832 by a group of disgruntled watercolorists shut out by the Society of Painters in Water-Colours' exclusionist policy of limiting membership and restricting its exhibitions to the works of its members and associates. The new organization embraced an open exhibition policy; however, after several tempestuous years, the open policy was abandoned, and the New Water Colour Society reorganized itself on the model of the older body that it had come into existence to oppose. In the New Society's early years, there had been a noticeable, though far from complete, bias toward subject pictures in its exhibitions. This was partly, no doubt, to help distinguish it from its well-established rival and partly a reflection of that same prejudice in favor of subject pictures and against landscapes that held sway in the Royal Academy.

From the late 1840s, with the admission of new members including Charles Davidson, William Bennett, Aaron Penley, Thomas Charles Leeson Rowbotham, and David Hall McKewan, the New Society began to assert itself in landscapes. Although the Old Society retained its preeminence as the seat of British landscape painting throughout the Victorian period, the New Society was frequently seen as challenging it on that very ground.

The New Society's exhibition in 1849 was, in the opinion of both the Spectator and the Art Journal, unusually strong in landscapes. The Spectator felt the same about the following year's exhibition, and the Illustrated London News noted: "In the landscape branch of water-colour art, the New Society has made a stride forward."[9] Although the Athenaeum detected weakness in the landscapes of the 1850 exhibition, by 1853 that periodical shared the view that the strength of the New Society now lay in its landscape painters. In 1851 the Spectator went so far as to claim that the New Society "shows somewhat less . . . of receipt-mannerism [meaning work done according to accepted recipes or formulas] than its competitor, where whole groups of landscapes seem as familiar to us as are the names of their artists."[10]

Landscape continued to dominate the exhibitions of the Society of Painters in Water-Colours, a situation that in itself drew a degree of criticism. The Art Journal's complaint in 1851 of "an undue preponderance of landscape subjects in the old society"[11] was fairly typical. As already noted in chapter 1, there was widespread dissatisfaction with the Old Water-Colour Society in the 1850s and growing fears about the decline of watercolor art. The problems with landscape in the Old Society were overfamiliarity, repetitiveness, and the "receipt-mannerism" remarked by the Spectator. The recent or imminent loss of the strongest of the Society's landscape painters, such as DeWint and Cox, threatened to leave the field in the possession of manipulators of picturesque formula such as Thomas Miles Richardson, Jr., or William Collingwood Smith.

At that moment the most exciting new blood in landscape painting seemed to be flowing into the New Society. From the mid-1850s, Edmund George Warren's meticulously painted scenes of sun-dappled woodlands came to the fore in that body. In 1859 the Athenaeum observed: "The drawings most looked at and most admired this year are, beyond question, the landscapes of Mr. E. G. Warren. They are full of that excellent observation of nature which is increasingly the fashion of the time."[12] Although the Art Journal had its reservations – "never was untruth more fascinating"[13] – the Athenaeum went on the following year to describe Warren's advent as marking a new era in the New Society:

"But the old order changeth, yielding place to new" – and the ever-whirling wheel of mutability shook the steadfast foundations of this association two years ago, by suddenly casting among them a painter, a young man of the name of Warren – Edmund G. Warren, – a painter who painted what he saw, and left the immemorial brown trees to themselves. . . . With this advent the wave of life reached the Society, and it was fairly afloat. Like good men and true, the stronger and the better at once bent themselves to new work, and have done well since – others still continue to produce the curious trees which seemed to bear tea-leaves.[14]

Warren was the first landscape painter in either of the watercolor societies whose work seemed to embody the Pre-Raphaelite qualities of high color, keen observation, and painstaking detail. In 1856 a Warren landscape was singled out as the only Pre-Raphaelite work in the New Water Colour Society exhibition,[15] and in 1863 the Art Journal noted that Warren "has, for some years past, represented in this exhibition the cause of so-called Pre-Raphaelite landscape."[16]

Yet Warren had no connections with the Pre-Raphaelite Brotherhood. Ruskin, who called Turner a Pre-Raphaelite, denied the applicability of the term to Warren. Ruskin claimed that the appearance of truth to nature in Warren's landscapes resulted not from careful observation but from a cleverly deceptive technique that would not stand up to close scrutiny.

Despite Ruskin's critical strictures, Warren's shady groves and lanes enjoyed tremendous popularity in the late 1850s and early 1860s. They were among the highest-priced watercolors in the New Society's exhibitions.[17] Within a few years, however, a steady diet of woodland scenes had sated the appetites of reviewers at least, and attempts by Warren at other types of landscape were deemed failures. In 1865 the *Spectator* objected that Warren "deals out his drawings with the regularity and monotony of a brickmaking machine, and his pattern is false to nature."[18]

The only landscape painter with true Pre-Raphaelite credentials to join the watercolor societies was George Price Boyce, who became an associate of the Old Society in 1864 and a full member in 1878. Although not a member of the Pre-Raphaelite Brotherhood, Boyce was a close friend of Dante Gabriel Rossetti and others in the group. William Holman Hunt, an original member of the Brotherhood, was specially asked to join the Old Society in 1869. He accepted, and, although not predominantly a landscape painter, he did use the Society exhibitions as an opportunity to present to the public his idiosyncratic landscape watercolors.

In 1865, just as Warren's critical fortunes were beginning to wane in the New Society, Boyce was coming into his own in the Old, where it was remarked that "his style is known to be peculiar, the manner he adopts is that commonly called 'Pre-Raphaelite,' and it is his privilege to be a leader in the landscape school which bears that misplaced name."[19]

Boyce had been preceded in the Old Society by Myles Birket Foster, Alfred Pizzey Newton, and Alfred William Hunt in announcing a new vision of landscape that was to some degree related to Pre-Raphaelite principles. On Birket Foster's first appearance with the Society in 1860, the *Spectator*'s critic wrote enthusiastically: "Never in our recollection has high finish been carried to such a pitch of microscopic effect, as for example in the landscapes of Mr. Birket Foster." He was commended for "imitating nature absolutely" and his technique was described as "a sort of micro-mosaic done with the finest point of the brush."[20] Newton, whose reputation was the least durable of the three, was classed as a Pre-Raphaelite when he took the public by storm with highly detailed, and undoubtedly Ruskin-inspired, mountain subjects.

In 1863, the *Illustrated London News* predicted that Alfred Hunt "will have many partisans among those who, seeing some crudity of colour and photographic hardness in his works, will at once set them down as possessing the magical qualities of a something in which they be-

lieve, or fancy they believe, and which they style Pre-Raphaelitism."[21] A year later the same critic expressed the hope that Hunt was growing out of his Pre-Raphaelite phase: "After passing through what we may call a course of photographic and Pre-Raphaelite drill, and though still too fond of the contrasts of lilac and pale green, [Hunt] is developing the higher qualities of breadth and keeping and a Turneresque feeling in composition."[22]

Although the Pre-Raphaelite Brotherhood did not exist as such after 1853, conceptions of Pre-Raphaelitism, both positive and negative, were very much abroad in the 1860s. Almost certainly because of Ruskin's influence, these conceptions often had to do with landscape painting. A waggish journalist in 1861 suggested: "There would in water-colour art be nothing more extraordinary in the sudden formation of a sect of Pre-Sandbyites than there is in oil-painting in the institution of an association of Pre-Raffaelites."[23] The comment was unusual in focusing on the archaizing rather than the naturalistic aspects of Pre-Raphaelitism. No watercolor artists followed up this suggestion, with the possible exception of Edward Lear, whose topographical views with carefully penned in outlines and notes and pale washes of color, such as *The Dead Sea* (cat. no. 36), looked back to the "stained" or "tinted" drawings of the eighteenth century.

In the late 1850s, when plans were being made to move the Royal Academy from its quarters with the National Gallery in Trafalgar Square to a new home in Burlington House, the two watercolor societies petitioned the government to be included in the move. They were to remain separate bodies; the Old Society in particular was resistant to any union either with the Royal Academy or with the other group of watercolor painters. It may have been the failure to act jointly that resulted in rejection of both societies' applications. When it became clear that they would not be moving to Burlington House, the Old Society turned its attention to enlarging and improving its existing premises in Pall Mall East. The new gallery space led to a rethinking of the use to be made of the gallery apart from the annual spring exhibitions. Previously the space had been let to other organizations and individuals. The future president, John Gilbert, now proposed a winter exhibition of sketches and studies by the Society's members and associates. The first such exhibition opened in November 1862.[24]

The immediate motivation for the establishment of these exhibitions devoted to sketches was financial and institutional. A second annual exhibition was the most profitable use that could be made by the Society of its renovated gallery. This is not to downplay the contemporary awareness of the need for an alternative to high finish or what the *Art Journal* would term a few years later the "school of detail."[25] Even Ruskin, who as much as anyone was responsible for promoting microscopic naturalism, could argue in the late 1850s against "plethoric labour." But in the Old Society in the early 1860s, the "school of detail" was just gathering momentum. The

recognition of the inherent value of artists' sketches and studies was not a reaction, certainly not a backlash, against excesses of finish and detail.

The institution of winter exhibitions did give a new focus to arguments over sketch versus finish and a cluster of related oppositions (old versus new, bodycolor versus transparent watercolor) that have already been examined in chapters 1 and 2. In a lengthy introduction to his review of the second winter exhibition, the critic for the *Spectator* attempted to refute the idea of the sketch as a truer picture of the artist's genius, as well as closer to the artist's source in nature and thus truer to nature, but he did allow its interest as a glimpse into the artist's working method.[26]

The winter exhibitions gave artists such as John Gilbert and Joseph John Jenkins (see cat. nos. 72 and 68) the freedom to experiment with types of subjects, especially landscapes, other than those on which their popular reputations in the spring exhibitions were founded. The exhibitions of sketches and studies proved popular and became a permanent fixture of the London exhibition scene. The New Society followed the lead of the Old and in 1866 inaugurated its own series of winter exhibitions of sketches. To a number of watercolor aficionados the winter exhibitions were actually "preferable to the summer gatherings of finished pictures"; the open-air landscape studies displayed a "freshness and sweetness, which in very many cases far excel the best qualities of the studio drawings by the same hands."[27]

A fundamental problem with these exhibitions lay in what was accepted as a sketch or study. In the very first of the Old Society's winter exhibitions, it was pointed out that Birket Foster's highly worked contributions "have no right to be sent in among what are professed to be sketches."[28] From the outset, critics expressed fears that the winter exhibitions would degenerate into collections of finished pictures, and within a few years there were complaints that just that had happened. It was said that the only difference between winter exhibition sketches and summer exhibition finished pictures was in the way they were framed.[29] Works in the summer exhibitions had traditionally hung in gold frames like oil paintings; as sketches, the works in the winter exhibitions were usually presented in white mats.

Critics felt the need to reassert the true principles of sketching. "Artists now spend days and weeks over a study, when formerly they would have knocked off a sketch in a couple of hours," wrote one. Citing the "sketchers of the Müller school" as his standard, he continued:

It must be gone through with a dash, or not at all. A rapid hand, a keen eye, a mind bold in generalisation, a purpose to decide what to do, and then to do not doubting – such are the powers needed to grapple with elements of earth, air, and water. Transient effects can alone thus be transcribed, and it is in such dramatic passages that the earlier masters of the Water-Colour Art are likely for many a day to remain unsurpassed.[30]

Arguments over sketch versus finish in watercolor continued unabated through the rest of the century, as did arguments over whether the winter exhibitions were fulfilling their stated intention. In a review of the Old Society's winter exhibition in 1880, the *Magazine of Art* set out its position on both issues:

A transparent wash of colour almost in monochrome, with the pencil marks of the first outline unerased, is a better – nay a more perfect – expression of water-colour art than the stippled, caressed, many-tinted and mellow little painting with which an aquarellist can now vie in strength, solidity, and fulness of colour with the oil-painter. These principles are by no means yet fully established or revived, and for their better propagation we look to the head-quarters of the art – that "Old Society" which has boasted such illustrious names. We should especially desire, and we might naturally expect, a return to legitimate principles in the winter show, which disclaims finish and picture-making. But the truth is that these annual collections are in no real sense exhibitions of sketches and studies. The members have never had the courage to show their work from nature in all the frank and graceful simplicity of its incompleteness.[31]

When in the early 1860s the Old Water-Colour Society revamped both its bylaws and its premises, the *Art Journal* protested that had the Society modified its restrictions to absorb all the rising talent, there could have been "one great academy of water-colour painters, embodying without question every distinguished professor of the art," which would have been "more dignified and influential" than the competing organizations that currently existed.[32] Calls for a merger of the two watercolor societies, claiming that the present division fostered not healthy rivalry but an excess of second-rate work and warning that the supremacy of English watercolor was at risk, were voiced periodically throughout the period.[33]

In 1863 a royal commission looked into the relations between the two societies and the Royal Academy. The Old Society's president, Frederick Tayler, resisted any suggestion of a union with either the Academy or the New Society. Clearly the Old Society risked the loss of both status and independence in any juncture with either its more powerful or less powerful sister institution. Of the amalgamation with the New Society, Tayler protested: "The one would not be willing to admit its great inferiority to the other, and on equal terms a fusion could not fairly take place."[34]

Rather than consolidation, within two years yet another annual watercolor exhibition had been launched in London. In the spring of 1865, the first General Exhibition of Water-Colour Drawings was held in the Dudley Gallery of that venerable exhibition space in Piccadilly, the Egyptian Hall. Like the Associated Artists of 1807 to 1812 and the New Society before it, the organization behind the exhibition was founded by artists excluded from the established societies; the exhibition was to be open to all artists in the medium rather than to members only. The Dudley Gallery exhibitions, as they were commonly known, continued until 1882, when they were subsumed

into the New Water Colour Society, by then known as the Institute of Painters in Water Colours.

Although much of the exhibited work was by non-professionals and much was decidedly amateurish, the Dudley Gallery provided a start for young watercolorists and a refuge for those with unconventional tendencies. It became, in the words of the Old Society's historian, "the natural feeder" for the Society.[35] Many of the participants in its exhibitions did become members of the Old Society or the Institute. Among the artists represented in the present exhibition, the following were Dudley exhibitors: Helen Allingham, Barbara Bodichon, Hercules Brabazon Brabazon, Walter Crane, Albert Goodwin, Henry Holiday, William Holman Hunt, John William Inchbold, Joseph Knight, Edward Lear, Henry Moore, John William North, Alfred Parsons, Wilmot Pilsbury, Edward J. Poynter, Robert Thorne Waite, and Edmund Morison Wimperis.

In 1866 the Art Journal emphasized the experimental nature of the work on exhibit, though it later referred to the Dudley exhibition as "an indiscriminate mob and medley." By 1868, however, it reported that the Dudley Gallery was "now looked upon as one of the most interesting exhibitions of the year."[36] In that same year the Illustrated London News placed the Dudley Gallery exhibition on a par with that of the Institute and warned the Old Society to look to its laurels.[37]

As with the exhibitions of the two watercolor societies, those at the Dudley Gallery came to be dominated by landscapes. But they were landscapes of "an anomalous character," according to the Art Journal. "The Dudley brotherhood approach nature with a foregone conclusion – in other words, they are mannerists. And yet they are not agreed upon any one manner to the exclusion of all other forms of eccentricity. Thus, in satire, it has been said that the room contains everything but nature."[38] Near the end of the Dudley Gallery's existence as an independent entity, the Spectator dismissed its exhibitions, accusing the Dudley Committee of having become ingrown and of mismanaging the gallery's affairs. It found the 1881 exhibition "one of the worst general collections of water-colour drawings which we ever remember to have seen in the metropolis."[39] However, the more sympathetic Magazine of Art noted with approval: "Fresh ideas, styles in vogue, the ephemeral but taking phases of the fashion, the touch of Continental influence, are felt here in all their pleasant freshness more quickly than elsewhere."[40]

The winter exhibitions of the Old Society and the Institute provided – or were at least meant to provide – a showcase for simply and boldly rendered watercolor drawings. The Dudley Gallery showed landscapes in which "a wooly touch or a thin dusky wash, which may be supposed symbolic of poetry," was said to prevail.[41] But in the Old Society's and the Institute's main summer exhibitions of the mid-1860s, high finish and bright color were unquestionably the order of the day.

Surveying the Old Society's 1863 summer exhibition, the Athenaeum noted that, "compared with the works of twenty, or even ten years ago, the improvement in technical results is extraordinary," and, commending the growth of careful study from nature, concluded: "Among the landscapes here a world of beauty is to be found, and examples of many methods of producing it."[42] The Art Journal was in no doubt about which methods were in favor:

We may note a growing desire for detail and high elaboration; to these predilections must be added forced and fervid colour . . . in striking contrast with the sober quietism of the early school. . . . Yet while we put in this semi-protest, we must frankly acknowledge that water-colour art was never greater in power or resource than at this moment, and that, with the exception of Turner, and perhaps Copley Fielding, our English school, which in renown has been blazoned throughout the world, could never show a company of painters more highly gifted or more thoroughly trained than those which at present fill the ranks of this Society.[43]

The revolution in techniques and in taste pioneered in the 1840s and 1850s by William Henry Hunt, John Frederick Lewis, and John Ruskin bore its full fruit in the watercolor societies in the 1860s. Even artists with a conservative bent adapted their styles to bring them more into line with the current fashion, as one review noted: "The effect of the modern tendency in water-colour painting towards brilliancy and vigour of colour is more obvious now than heretofore, and many of the long-established artists send works which, in these qualities, far surpass what of yore they gave us, and must astonish the producers."[44]

As the decade progressed, Alfred William Hunt, George Price Boyce, and Myles Birket Foster formed a triumvirate leading the landscape section of the Old Society, though Boyce was frequently criticized for the ugliness of his subjects and Birket Foster was taken to task for the mechanical quality of his stipple technique and the drawing-room prettiness of his subjects. Edmund George Warren was still the pillar of the Institute, even if the critical encomiums were beginning to be outweighed by the brickbats. The addition of two new members – George Shalders, who was seen as the Institute's answer to Birket Foster, and Henry George Hine, reminiscent of Copley Fielding but also comparable in some respects to Boyce – kept the level of achievement in landscape high and up-to-date.

Two very different artists whose eccentric landscapes, exhibited at the Old Society, stood apart from any of the prevailing trends – except perhaps the predilection for "forced and fervid colour" – were Samuel Palmer and William Holman Hunt. At the time of Palmer's election as an associate in 1843, he had pursued a detailed and intense naturalism. His elevation to full membership did not occur until 1854. Within a few years he had begun to move toward a more overtly poetic landscape, derived from Claude and those old masters of the seventeenth century who had provided the groundwork for the landscape tradition in Britain in the eighteenth century and the romantic period. But with Palmer, this was

seventeenth-century ideal landscape heightened to the level of a fever dream.

Reviewers at first ignored his works, then expressed consternation at the violence of his color. In 1850 the *Athenaeum* asked: "What shall we say to Mr. Palmer, who, with certain evidences of talent and a dream of truth, offers us such eccentricities of prismatic colour run mad?"[45] However, it was not until the 1860s, with such works as *Sunset* (cat. no. 45), that the full brilliance and extravagance of Palmer's color became apparent. The *Art Journal* noted: "Mr. Palmer may rush into chromatic regions where other artists fear even to breathe. But still in the midst of madness there is a method which reconciles the spectator to the result."[46] Finally in the 1870s, in response to works such as *Tityrus Restored to His Patrimony* (cat. no. 85), exhibited at the Old Society in 1877, Palmer received his due as one of the great poets of the medium and the last real exponent of the classical tradition. As one critic put it: "It is good in these days of literal prose to see an Arcadian shepherd, lute in hand, whiling away the weary hours with plaintive melody."[47]

Holman Hunt joined the Old Society at the very end of the 1860s and proceeded to send to its exhibitions landscapes that appeared so bizarre in color, in composition, and in the light effects he attempted to represent that reviewers could not even accommodate them comfortably under the rubric of the watercolor-society brand of Pre-Raphaelitism. The *Art Journal* described his contributions as "the greatest novelty" of the summer exhibition of 1870, calling them "extraordinary phenomena both in Nature and Art."[48]

By the beginning of the 1870s, the state of current watercolor art had become a cause for some concern. The watercolor societies were perceived as being in general decline. It was argued that the drain of two annual exhibitions, particularly when many of the artists were contributing elaborate works to both, was having a deleterious effect on both the Old Society and the Institute. Criticism of the overproduction of works of what was derisively termed "art manufacture"[49] echoed the criticisms leveled at the Old Society by Ruskin and others in the 1850s. Watercolorists were either taking up oils, following the example set by John Frederick Lewis a decade earlier, or trying their fortunes in the Royal Academy's watercolor galleries.[50] The long-inviolate claims of English superiority in watercolors were contested or stood on their heads. Rather than being a source of pride, the unique cultivation of watercolor painting in England was now viewed as a symptom of the endemic weakness of English art.

The heyday of the "new landscape" was coming to an end. Its marvels of technique and finish began to seem excessive, and strict adherence to natural fact came to seem a limiting doctrine. In 1874 the *Art Journal* sized up the situation of the landscape watercolor:

English landscape is not now so sure of its purpose as it once was. A revolution of technical method has left the art in a somewhat dis-turbed state, so that young painters of the present time seem scarcely decided as to the way in which outward nature is to be interpreted. The attempt after a completely realistic landscape can only bring success to painters highly gifted with artistic sense, and who are thus kept safe from the dangers which beset the lesser followers of the school. There are too many men who strive after an elaborate presentation of scenery without the power to combine the different fragments of their work into one harmonious result. They can paint the separate flowers in the grass, or trace carefully the intricate curves of the dead branches of a leafless tree; but when so much has been done, they have no skill to carry their achievement further, and render it serviceable to the cause of Art. Thus it happens that we have now a number of landscapes wherein the general effect is inharmonious and incomplete. Different incidents of the chosen scene are carefully realised, but they are not combined under one governing artistic spirit, and so fail of the influence that a genuine work of Art should possess.[51]

Despite the shortcomings of contemporary landscape painting, the astounding prices fetched by works of the earlier English school at the Gillott sale of 1872 (see chapter 1, p. 25) demonstrated a strong taste for landscape watercolors. The question for many artists, critics, and dealers was whether these prices represented an ongoing process of rising value from which the current practitioners of the art would also eventually benefit. Or, by asserting the value of earlier landscape painting, were these prices an indirect indictment of current practice?

It was against this backdrop of dissatisfaction with the newer styles of watercolor landscape and of monetary vindication of the older styles that the new "Cox school" came into being in the Institute. The appearance of Thomas Collier, Edmund Wimperis, and James Orrock seemed to revitalize the landscape wing of that body. The Old Society, despite the acquisition of acknowledged new talent in the persons of Fred Walker, John William North, Albert Goodwin, Henry Clarence Whaite, and Helen Allingham, as well as continued strong showings by established members such as Alfred Hunt, Boyce, and Birket Foster, was unable to shake off the impression of staleness. It was seen as losing ground to its younger rival.

Part of the problem, as perceived by the critics, was that so many of the Old Society's major figures shared a background as illustrators. The president, John Gilbert, as well as Birket Foster, Walker, North, and Allingham, had begun their careers working in black and white for the wood engravers. The *Spectator* lamented the "corrupting influence on our Water-colour school" of the coarse mechanical nature of wood engraving, describing the style thus promoted, with particular reference to North's landscapes:

Its practitioners are willing to content themselves with imitating, sometimes with considerable fidelity as to form, the details of a piece of foreground, painting it in a laboured manner, and never with much feeling of space; and in the midst of this, often undigested mass, they imbed one or more rustic figures, so as to look for all the world like the organic remains in a geological formation.[52]

As the watercolor societies grew and matured through the middle decades of the century, critical discussion of the art of current members tended to draw its standards of comparison from the work of former members. From the 1870s, however, it became increasingly common to find critical yardsticks outside the native tradition.

A decade earlier, after conceding the superiority of the French as oil painters, the *Illustrated London News* asked, "Where is the art of the water-colourist practised so extensively and so successfully as at home?"[53] There could be no doubt as to the answer. But a decade or so later, critics had become more aware of Continental developments in both landscape and watercolor. Comparisons of British landscape watercolors with foreign models were often not to the credit of the native school and undermined the mythology of watercolor as the great national art.

In 1879 the *Illustrated London News* saw the less than satisfactory condition of British watercolor "rendered more exigent by the very successful cultivation of water colours by foreign artists, and more particularly the body of highly trained French artists who have lately formed themselves into a society of Aquarellistes, and are now holding an exhibition of admirable works at Paris."[54] Plans for a French watercolor society had actually been broached much earlier. In 1856 the Old Water-Colour Society, at the request of the French ambassador, provided details of its organization and regulations to provide a model for a comparable society to be set up in Paris. As it turned out, however, the Société d'Aquarellistes Français was not founded until 1878.[55] The other notable foreign watercolor society, the Société Belge des Aquarellistes, had been active in Brussels since 1856 – but in Britain little note was taken of its existence until the 1870s.

Continental watercolorists, especially those associated with the Hague School or continuing the traditions of the Barbizon School, were considered to have an advantage in matters of tonality and color harmony; they were masters of gray. After castigating "the distinctively English faults of colour," their "violence and excitement," the *Magazine of Art* in 1878 concluded: "We have much to learn from the modern French and Dutch schools of landscape in this respect."[56]

London artists and public would have the chance to learn in the next few years thanks to the Grosvenor Gallery, opened by Sir Coutts Lindsay in 1877. The gallery was intended as a showplace for aesthetically advanced oil paintings, sculpture, and watercolors that were not sufficiently represented in the exhibitions of the Royal Academy. The Grosvenor Gallery's real contribution to watercolor art lay in its two exhibitions devoted to an overview of the historical development of British watercolor (the first hundred years was surveyed in the winter of 1877–78; the next winter concentrated on living artists, although it included examples by Turner, Cox, and the more recently deceased Walker) and its exhibitions of contemporary Dutch and French watercolors.

In the winter of 1880, the gallery displayed a selection of watercolors by artists of the Hague School. Although the reviewer in the *Spectator* found these works "distinctly and for the most part utterly bad,"[57] his was a minority opinion. The following year the winter Grosvenor exhibition featured French watercolors, the most notable works being those of Henri-Joseph Harpignies. The exhibition occasioned these reflections on watercolor and the French temperament from the *Magazine of Art*:

Our readers are aware that French landscape-painters have until lately eschewed water-colours almost entirely, but that a beginning has been made in recent years by the establishment of a special exhibition in Paris, and the more general cultivation of an art which is most peculiarly adapted to the vivid, visual and impressionary genius of France. Water-colour, as properly conceived and practised, is an art of impulses; this has been thoroughly understood by some English artists, though the tendency of the majority has been to sophisticate water-colour with the imitativeness, laboriousness, and "body" which are the properties of oils. . . . Now Englishmen have generally aimed at the completeness of comprehension rather than at the completeness of rejection and selection; and they have attained to very great perfection in their own method. Frenchmen, on the other hand, have aimed at the other kind of completeness. They have exercised and perfected the art of choosing from the nature before them precisely what will serve their purpose. . . . It is strange, then, that water-colour has not been long ago a French art; and that it is so now is a matter of congratulation to the world.[58]

The rise of foreign watercolor societies made it seem to many observers more imperative than ever that the British societies put aside their rivalry and enmity and join forces to ensure the continued supremacy of British watercolor art. In April 1881 the Institute, having arranged for new, considerably expanded galleries in Piccadilly, proposed to the Old Society that it join in the undertaking. An initial rebuff led to assurances that the Institute was willing to submerge its identity in the interests of union. The new organization would take the name of the elder body – by this time it had become the Royal Society of Painters in Water-Colours – and members of the Institute were willing to accept associate status in the new order.[59] This overture was rejected as well, to a chorus of disapproval in the press and questions as to the wisdom of the crown's conferring the honor of the appellation "Royal" on the Society at the very moment when it was obstructing the advancement of watercolor art by refusing combination with the Institute.

The Dudley Committee was much more agreeable to such a combination, and prior to the opening of the Institute's lavish new premises in 1883, an amalgamation between these groups had been effected, with the Institute reverting to the open policy of its earliest years to bring it into line with the Dudley. The vastly expanded exhibition that opened with much fanfare in the new galleries attracted great crowds and much favorable press, though some critics worried that the new policies promoted too much second-rate work. The year was crowned by the sanction of royalty – the organization be-

ing henceforth known as the Royal Institute of Painters in Water Colours. The Royal Academy seemed to have taken notice as well, for it began to prepare a new gallery for the special display of watercolors in its summer exhibitions.

With its new building, its new, enlarged exhibitions, and a number of strong new artists added to its ranks – James Aumonier, John Fulleylove, and George Clausen in the late 1870s; Walter Crane, Alfred Parsons, and Joseph Knight all in 1882 – the Institute was in good shape in the early 1880s. The *Spectator* asserted that it had finally surpassed the Old (now Royal) Society and assumed a commanding position with regard to watercolor art equal to that of the Royal Academy in oil painting. This opinion was not generally shared, but a lack of freshness and novelty in the older organization was commonly noted. The *Art Journal* in 1887 detected in the Institute "an altogether robuster kind of water colour art than at the Royal Society."[60]

Over the years the death knell of the "old school" had been sounded a number of times within the Old Society. In some form or other it had managed to survive. Now in 1882, with the passing of Samuel Palmer, the death knell was heard again. And as the "old school" passed away yet once more, the "new school" gained a new representative in Wilmot Pilsbury (elected an associate the previous year). Unfortunately, as Pilsbury's detractors were quick to point out, in the 1880s the "new school" no longer seemed so new. The criticisms leveled at Pilsbury and the type of landscape he was seen as embodying had an all-too-familiar ring:

To take a little bit of meadow, or woodland, or stream, and to fidget it about with little spots of pretty colour, till the whole is a sort of harmonious mosaic, is not to paint landscape at all; and this is what Mr. Pilsbury does, and what many of the other members of the Society are tending towards. There seems to be coming over English landscape-painting a most lamentable lack of all largeness of impression, of all grandeur of style.[61]

In the 1880s and 1890s, phrases such as "largeness of impression" gained a new prominence in the critical vocabulary as the nature of impressionism became a significant issue in Britain: was it a positive force for change or a threat from abroad? A new phenomenon or the principle behind some of the greatest achievements of earlier British art?

British varieties of impressionism appeared in the Grosvenor Gallery and from 1886 were showcased in the exhibitions of the New English Art Club. The Royal Society of Painters in Water-Colours gave a nod to impressionism by electing two Scottish impressionists as associates: Arthur Melville in 1888 and James Paterson ten years later. The year before Melville's election, Robert Weir Allan, a Scottish painter of landscapes and marines, was also made an associate. Though not an impressionist, Allan did share with his compatriots a taste for plein-air painting and a French orientation.[62] Nonetheless, the basic tenor of both the Royal Society and the Royal Institute

as they entered the 1890s was retrospective rather than forward-looking. Characterizing the works exhibited there as "respectable memories of the early Victorian days," the *Art Journal* wrote of the Institute:

How worthy and how dull it is! One longs for a little daring even if the enterprise failed, for a little novelty of subject or treatment. But, for the exhibitors as a body, Barbizon has yet to be discovered, the Dutchmen have painted in vain, the Impressionists worked to no purpose, and the great English School of the pre-Raphaelites are totally unknown.[63]

The Royal Society, which had always traded on its long and distinguished history, assumed more fully the role of upholder of the grand traditions of British watercolor, although it was justly pointed out that "the oldest tradition that gains a considerable following in this Society is that of Fred Walker."[64] Nevertheless, the epithet "Old Society" took on added emphasis. Criticism of its exhibitions was disarmed by the "gentle air of antiquity" that pervaded its galleries. D. S. MacColl noted the few attempts by members to follow recent fashions but concluded: "The charm of the place is in what lingers of a bygone artlessness, not in the more modern and more disagreeable forms of the same quality."[65]

Affectionate nostalgia now mingled with quiet derision in the reviews of its exhibitions. The *Illustrated London News* found a haven from the new and a bastion of the old and beloved: "Modern art may have its charms and votaries – of whose good faith we have no reason to doubt – but English water-colour painting as handed down and perfected by successive generations of adepts is always to be seen at its best at the 'Old Society.' "[66] The *Art Journal* drew a similar contrast but with a more condescending air:

After the more piquant banquets of galleries less inaccessible to the influences of modernity, the old Royal Society of Painters in Water Colours is apt to pall on the jaded palate of the critic. It is so hard to put oneself in the position of the Early Victorian connoisseurs. Still a patient search reveals much to praise, and not a good deal to condemn once you accept the standpoint of the society.[67]

But the *Spectator* grasped the real significance of the situation when it expressed the concern that the Royal Society "runs every risk of having very little part in the future of English painting."[68]

Sifting through a half-century of reviews in an attempt to understand developments within the watercolor societies and the contemporary perceptions of those developments, one must continually be aware of the limitations of the evidence. These are the opinions of a small and not necessarily representative group of individuals, and they were writing not for the ages but for immediate consumption. While one sometimes finds thoughtful commentary, one is just as likely to encounter prejudice, contradiction, and easy point scoring. Yet, from this welter of opinion, one can glean some overall sense of the progression of styles and issues, of which artists were important and why. While the criticism was seldom either profound or subtle, it provides invaluable access to the

environment in which these watercolors were produced and first appreciated.

As observers sought to make sense of the works on display in the watercolor societies, they adopted various schemes of categorization. One of the most frequently employed was generational; there were the old school and the new school of landscape watercolors. What was meant by the new school shifted ground as the century progressed. What was meant by the old school remained fairly constant: it was the heroic generation of Turner, Cox, and DeWint.

Using the generational scheme, the *Spectator* in 1880 lumped together Birket Foster, G. A. Fripp, T. M. Richardson, Edward Duncan, and David Cox, Jr., as a sort of lost generation in the Old Water-Colour Society: "Great as is the individual ability of each, they are undoubtedly, taken as a whole, artists of a period of decline in water-colours. They stand between Cox and DeWint, on the one hand, and Walker, Pinwell, and Boyce on the other." The reviewer concluded, "They possess neither the rough truth of the old water-colour men, nor the thought and delicate beauty of the new school."[69] Attempts to isolate schools of watercolor painting along the lines of technique and the use of the medium also had a large generational component. The old school depended on flat washes of transparent color and broad strokes; the younger men relied on bodycolor and stippling.

In some reviews there surfaced a recognition – sometimes explicit, at times only hinted at – of issues broader than those of technique or generation or of labels like Pre-Raphaelite or impressionist. In a review of the collection of English watercolors at the International Exhibition of 1862, J. Beavington Atkinson divided the painters of landscape watercolors into "romanticists" and "naturalists." The romanticist saw nature with the eyes of the poet. Turner was the great romanticist hero, and the foremost living exponents were James Baker Pyne, Palmer, Richardson, and Rowbotham. The naturalists, "more literal and less imaginative," included Warren, Davidson, Newton, and Birket Foster.[70]

According to the *Art Journal*, in its review of the Old Water-Colour Society summer exhibition in 1864, "Landscape Art, speaking generally, may be divided between schools of detail and of effect."[71] The *Art Journal* continued to employ this distinction in reviews through the rest of the decade, finally in 1869 adding a third school, that of poetry.[72] The outstanding representatives of the school of detail were Boyce, Birket Foster, and Warren; the painters of effect included Palmer, Richardson, and Rowbotham. Davidson occupied a middle ground between detail and effect in 1864, but by 1869 he was grouped with the delineators of detail. Alfred Hunt was seen as the preeminent poet.

Although other periodicals were not as insistent in their categorization, a general distinction between realist landscape and poetic landscape could be discerned throughout their watercolor society reviews. Certain artists were shunted from one category to another, depending on the orientation of the critic. The landscapes of Palmer, Alfred Hunt, and Albert Goodwin were fairly consistently cited as the most poetical in the Old Water-Colour Society. The *Illustrated London News* in 1864 was expressing the generally accepted view of Boyce's work when it described his exhibited watercolors as "direct, literal, and unselective as photography itself."[73] Yet writing of the same watercolors, the *Athenaeum* maintained that "their fidelity is poetical" and, comparing Boyce and Alfred Hunt, found Hunt to be the one with "less perception of poetic effect."[74] Detail was by no means synonymous with realism, nor was it necessarily inimical to poetry.

The struggle to find a balance between the claims of an exacting fidelity to nature and the need for landscape to rise above the simple transcript of natural detail – to be poetic – was central to thinking about landscape painting in the period. It was this issue with which Ruskin continually grappled and on which he was widely misunderstood. And it was this issue which Alfred Hunt addressed in his article on modern landscape painting in the *Nineteenth Century*.

The occasional inclusion of artists such as Richardson and Rowbotham in the poetical camp points up one of the difficulties attendant on this issue – distinguishing between original and thoughtful generalization and rote picturesque convention. Throughout the period, watercolors by artists such as Richardson in the Old Society and Leitch in the New provided a constant backdrop of conventionally picturesque landscape to the ongoing developments and debates over technique, subject matter, and truth to nature that occupied center stage.

In 1865 John William North was accused of "a morbid fear of conventionalism."[75] It was a comment that could have been applied with some justification to a number of the most interesting watercolorists of the second half of the century, including Boyce, Goodwin, and both Alfred and Holman Hunt. Shortly after his election as an associate of the Old Society, it was noted that Goodwin "studiously rejects those features and forms that are ever *desiderata* in picturesque composition. But on the other hand, the end is attained, and becomes the more valuable from the difficulties of its attainment."[76] This need to be original and to explore aspects of nature hitherto ignored by artists and considered resistant to artistic representation was partly a response to Ruskin's antagonism to the picturesque and his devotion to nature, partly a reaction to the towering achievements of the watercolor masters of the first half of the century, and partly a reflection of broader uncertainties in the culture and society.

Given Ruskin's forays into geology and meteorology and the taste for popular science in the Victorian period, it should not be surprising that the efforts of these artists at times took on scientific overtones. The *Art Journal* noted that Alfred Hunt's watercolors "seem to try, and sometimes to solve, the most recondite of chromatic experiments," and that his winter exhibition sketches "elucidate

the chemical composition of light."[77] The *Spectator* wrote of his work: "Always original and refined[,] it is yet no wonder that constantly striving as he is to extort some new secret from nature, his work should sometimes halt between success and failure."[78] When Holman Hunt's landscape watercolors began to appear in the Old Society exhibitions, one of them garnered this grudging acknowledgment: "As an earnest endeavour to paint what is unpaintable, this strange and startling attempt is not unworthy of respect." The reviewer speculated: "His mistakes sometimes arise but from perversity, in other instances from the more excusable desire to strike out new paths and to realise truths hard to attain."[79] And in the 1880s, Goodwin's watercolors were criticized as "becoming scientifically interesting rather than artistically" and as being "too purely phenomenal."[80]

These artists were seeking to explode narrow and outmoded conceptions of the beautiful; to more conservative observers, it seemed that they wanted to overthrow the notion of beauty altogether. Boyce was commonly criticized for forsaking the prerogatives of the artist to embrace the mechanical objectivity of photography. And photography, at least when mentioned in the context of criticism of the traditional arts, was emphatically not art. According to the *Illustrated London News*, reviewing the Old Water-Colour Society summer exhibition of 1867, Boyce "attains, as usual, a rare amount of truth, but truth (setting aside the fine though often exaggerated colour) of a kind which could be better conveyed by photography; it is regrettable also to see an artist of power selecting and drudging over subjects which, if worthy of record at all, should be relegated to the camera."[81]

Certainly landscape artists employed photography – John Brett and Thomas Seddon both used photographs as they would studies in working up finished pictures – and just as certainly some landscape paintings reflected characteristics of photographic images.[82] But photographic influence was not necessary to explain the avoidance of typical compositions, the sensitivity to detail rather than to general form, and the seeming lack of artistic selectivity which characterized a certain class of landscape watercolors. On the other hand, the photographic analogy was a useful critical device for writers trying to come to terms with such watercolors. If a critic claimed that a watercolor by Warren was done with the aid of a calotype, that might or might not be true, but it suggested both the quality and the limitations of the watercolor.[83] Similarly, when the *Spectator* wrote that "the most noticeable characteristic" of the Old Society's 1860 exhibition "is the disposition to follow the teaching of the photograph in studying to delineate every minute and trifling object which contributes to the general beauty of nature's pictures,"[84] it indicated both a high level of technical skill and a deficiency of artistic vision.

The association of photography with a particular type of landscape watercolor supplied a useful way of discussing watercolors of that type. The characterization of various artists' styles as masculine or feminine provided a similarly useful shorthand, but with implications that touched the very basis of watercolor art as a professional enterprise.

The distinction between the manly style of Cox and the effeminate style of Copley Fielding was mentioned in chapter 1. Such distinctions were commonly drawn. Following Cox, William Bennett was described as having a "large and masculine style."[85] John Gilbert's watercolors were seen as having "a big, genial manliness."[86] By contrast, Birket Foster's manner of painting was perceived as feminine, though it was noted with approval in 1865 that he seemed to be aiming at a "manlier style of execution."[87] This characterization of style by reference to gender must be viewed in the light of concerns by the overwhelmingly male watercolor societies to establish their professional credentials. Watercolor art was frequently thought of as a feminine and therefore not a serious pursuit. In discussing the ascendancy of watercolor over oil painting in English art, the *Spectator* in 1876 began: "Whatever truth there may be in the unchivalrous saying, 'Water-colours for women, oils for men,' it is certain that the former branch of the painter's art is now-a-days less disappointing than the latter."[88]

There were a handful of critically respected women artists in the watercolor societies. The landscapes of Fanny Steers, now almost entirely forgotten, were consistently praised when they appeared in the New Water Colour Society exhibitions of the 1840s and early 1850s, as were the rustic scenes of Helen Allingham and the Venetian views of Clara Montalba in the Old Society from the mid-1870s. However, until the revision of the Old Society's bylaws in 1861, women could only be admitted into the Society in a special category that allowed them to exhibit but denied them the other privileges of membership. It was not until 1889 that the rules were changed to allow women to become full members, and Allingham was elected to that rank the following year.

General prejudice against women artists combined with the notion that watercolor's feminine associations had posed a continual obstacle to the advancement of the art. When, in the 1890s, the watercolor societies seemed in danger of drifting into a backwater of artistic irrelevance, D. S. MacColl in the *Spectator* harped on the past and present connection between watercolor and women, his tone ranging from condescending amusement to virulent diatribe:

Water-colour, as the grand-aunts of our generation understood and practised it, is still practised here; but too soon the last bonnet will have flitted from our fields and lanes, and from the foreign streets and squares. . . . The old-maidenly water-colour will be dead, and the grand-nieces will be upon us with horrible new tricks learned in French studios, and executed in oils.

The practice of water-colour in Albion is very grievously vexed by Feminine Delusions, and the Royal Institute makes a pride of exposing yearly in its three large galleries the consequences of that afflic-

tion. *This is not to say that all the deluded are women, though many of them actually are. It is to assert that hardly anywhere on those walls are to be found the more masculine virtues of largeness and strength, whether in the relating of forms or of colours or of emotions; the qualities of dignity and of tranquillity, of controlling, adjusting, excluding, summoning, marshalling thought, are absent indeed.*[89]

Whether couched in terms of manliness or effeminacy, the influence of photography, bodycolor or transparent washes, high finish or sketchiness, poetry or prose, commentary on landscape painting in watercolor was almost exclusively concerned with questions of form and style. Discussions of content rarely went beyond simple description, or, as in the case of Boyce, questions of whether a subject provided appropriate material for a picture. The focus on form and style was only to be expected with an art that defined itself by its medium and set itself apart in societies devoted to the practice and presentation of work in that medium. It was also true that the limited narrative element in landscape art seemed to offer little opportunity for critical exegesis and to encourage formal and stylistic approaches.

Nonetheless, landscape painting was hardly without content. Landscape, at least that branch of it that depicted rural England, was inescapably related to the actual countryside and the life lived in it. Yet the relationship received scant comment within the criticism directed at landscape watercolors. Only occasionally in the *Spectator* were there glimmers of a cynical awareness of the market-driven falsities in the presentation of rustic England.

The countryside was changing, with agriculture growing more mechanized and industrialization encroaching on the land. After the prosperous decades of the 1850s and 1860s, agriculture was in depression for much of the rest of the century. But little of this is apparent from the landscape watercolors of the period. Signs of industrialization did appear, as in Boyce's *Autumn Landscape with Colliery* (cat. no. 65) and Goodwin's *Sunset in the Manufacturing Districts* (cat. no. 99), or in the steam train chugging across the foreground of Gilbert's view of Worcester (cat. no. 72), but these were exceptional. Almost completely absent were depictions of the harsher realities of rural life. The *Spectator* wrote in 1874 that the only things required of landscape artists were "sunny glimpses of green fields and flowery brook-sides; stretches of breezy moorland; wave-washed beaches, and sea-girt cliffs; reminders, in short, of pleasant summer sojourns or wanderings, or generally of life beyond brick walls and smoky streets."[90] The comment at least implied a criticism of the blinkered outlook of the urban audience for whom most landscape painting was produced.

The goal of the landscape painter was generally not an engagement with the actual life of the English countryside but the creation of images of a timeless and idyllic rural England. The *Spectator* criticized Robert Thorne Waite for the patent artificiality of his vision: "To real life, his works bear almost as much likeness as a Chelsea china shepherdess bears to the peasant of reality, – but that, af-

ter all, does not matter. We do not want to be shown how things and people really are: they might wound our delicate nineteenth-century susceptibilities."[91]

It was the *Spectator* once again that took on the popular rustic subjects of Birket Foster:

No one who knows what English men and English homes are truly like, will believe in Mr. Birket Foster's cottages and cottagers. . . . Directly truth began to be sought for in landscape art [the reference here seems to be to Walker and Boyce], all such representations as these were practically doomed, and it is only from the feeling which prompts the kindly reception of old stage favourites, that they are allowed to linger among us, and gain from toleration what they once demanded as a right.[92]

But even in the works of artists such as Walker and North and Clausen, who were devoted to an unsentimentalized depiction of rural life, those aspects of farming and country life which suggested change and modernization were avoided. In an article in the *Magazine of Art* in 1882, the noted writer on rural themes, Richard Jefferies, complained: "So many pictures and so many illustrations seem to proceed on the assumption that steam-plough and reaping-machine do not exist, that the landscape contains nothing but what it did a hundred years ago. These sketches are often beautiful, but they lack the force of truth and reality."[93]

Truth and reality were the central, but slippery, concepts around which all discussion of landscape watercolors turned. Not truth to contemporary social or technological realities – these were commonly seen as ephemeral – but truth to the unchanging realities of the natural world. If the timelessness of the landscape was a fiction, it was for many Victorians a necessary fiction. Through all the changes of style and technique and all the debates over the appropriate use of the medium, it was watercolor's ability to convey the timeless truth and reality of the natural world that mattered to the artists, the critics, and the audiences of the watercolor societies.

Notes

1. *Art Journal*, June 1, 1856, p. 161; quoted by Robert Secor, *John Ruskin and Alfred Hunt: New Letters and the Record of a Friendship* (Victoria, B.C.: University of Victoria, 1982), p. 17.
2. "The Present Position of Landscape Painting in England," *Cornhill Magazine* 11 (1865): 291. This is quoted by Ann Bermingham, *Landscape and Ideology: The English Rustic Tradition, 1740–1860* (London: Thames and Hudson, 1987), p. 157, as evidence not of a decline in landscape painting – she notes the concurrent increase in the watercolor societies – but of a change in the course of landscape painting. However, she fails to pursue the association of Victorian landscape painting with the watercolor societies.
3. *Spectator*, June 16, 1866, p. 664.
4. See Secor, *Ruskin and Hunt*, pp. 15–21; Secor published a version of this section of his text under the title "Landscape Painters, Pre-Raphaelites, and the Liverpool Academy," in *The Journal of Pre-Raphaelite Studies* 3, no. 2 (May 1983): 96–101.
5. *Spectator*, May 16, 1885, p. 643.
6. Ibid., July 11, 1863, p. 2232.
7. Ibid., March 1, 1873, p. 278.
8. *Art Journal*, June 1, 1861, p. 175.
9. *Spectator*, April 28, 1849, p. 399; *Art Journal*, June 1, 1849, p. 178; *Spectator*, April 27, 1850, p. 403; *Illustrated London News*, April 27, 1850, p. 290.
10. *Athenaeum*, April 27, 1850, pp. 453–54; April 23, 1853, p. 505; *Spectator*, May 3, 1851, p. 427.

11. *Art Journal*, June 1, 1851, p. 162.

12. *Athenaeum*, April 23, 1859, p. 555.

13. *Art Journal*, June 1, 1859, p. 175.

14. *Athenaeum*, April 28, 1860, pp. 585–86.

15. Ibid., April 26, 1856, p. 526.

16. *Art Journal*, June 1, 1863, p. 120.

17. Warren's "*Rest in the Cool and Shady Wood*" (cat. no. 46) at £400 was by far the most expensive watercolor in the New Water Colour Society exhibition of 1861. Only a handful of watercolors in the exhibition had asking prices of over two digits.

18. *Spectator*, June 10, 1865, p. 642.

19. *Art Journal*, June 1, 1865, p. 175.

20. *Spectator*, May 5, 1860, p. 432.

21. *Illustrated London News*, May 2, 1863, p. 494.

22. Ibid., April 30, 1864, p. 430.

23. *Art Journal*, July 1, 1861, p. 200. The reference was to Paul Sandby (1731–1809), known from the time of his death as the father of British watercolor painting.

24. John Lewis Roget, *A History of the "Old Water-Colour" Society*, 2 vols. (London: Longmans, Green and Co., 1891), vol. 2, pp. 100–108.

25. *Art Journal*, June 1, 1864, p. 170.

26. *Spectator*, December 12, 1863, p. 2854.

27. *Art Journal*, January 1, 1864, p. 4; January 1, 1865, p. 8. The appearance of Aaron Penley's *Sketching from Nature* in 1869 and Philip Henry Delamotte's *The Art of Sketching from Nature* in 1871 was presumably in response to a renewed vogue for sketching stimulated by the winter exhibitions. While Delamotte's volume contained much practical information on equipment and materials, neither book included the sort of detailed instruction in drawing from nature to be found in Ruskin's *Elements of Drawing*. Both Penley and Delamotte reverted to the format of the progressive lessons favored by drawing manuals at the beginning of the century.

28. *Art Journal*, January 1, 1863, p. 16.

29. *Spectator*, November 17, 1866, pp. 1283–84.

30. *Art Journal*, January 1, 1867, p. 18.

31. *Magazine of Art* 3 (1880): 158–59.

32. *Art Journal*, June 1, 1861, p. 175.

33. For two examples, see *Art Journal*, June 1874, p. 167, and *Spectator*, June 7, 1879, pp. 725–26.

34. Tayler, quoted in Roget, *"Old Water-Colour" Society*, vol. 2, p. 113.

35. Ibid., p. 114.

36. *Art Journal*, March 1, 1866, p. 70; June 1, 1866, p. 173; and March 1, 1868, p. 45.

37. *Illustrated London News*, May 2, 1868, p. 438.

38. *Art Journal*, March 1, 1871, pp. 85–86.

39. *Spectator*, March 12, 1881, p. 348.

40. *Magazine of Art* 3 (1880): 265.

41. *Art Journal*, March 1, 1869, p. 81.

42. *Athenaeum*, May 2, 1863, p. 591.

43. *Art Journal*, June 1, 1863, p. 117.

44. *Athenaeum*, April 30, 1864, p. 617.

45. Ibid., May 11, 1850, p. 510.

46. *Art Journal*, June 1, 1866, p. 174.

47. Ibid., June 1, 1870, p. 174.

48. Ibid.

49. *Athenaeum*, May 3, 1873, p. 571.

50. As noted in the *Art Journal*, January 1, 1871, p. 25.

51. *Art Journal*, March 1874, p. 68.

52. *Spectator*, December 20, 1873, p. 1615.

53. *Illustrated London News*, April 23, 1864, p. 399.

54. Ibid., May 3, 1879, p. 422.

55. Roget, *"Old Water-Colour" Society*, vol. 2, pp. 91–93.

56. *Magazine of Art* 1 (1878): 82.

57. *Spectator*, January 31, 1880, p. 142.

58. *Magazine of Art* 4 (1881): 177–78.

59. Transcripts of the correspondence on the matter are given by Roget in *"Old Water-Colour" Society*, in an appendix, vol. 2, pp. 433–36.

60. *Spectator*, May 16, 1885, pp. 642–43; *Art Journal*, August 1887, p. 284.

61. *Spectator*, May 27, 1882, p. 692.

62. See Mrs. Arthur Bell, "Robert Weir Allan and His Work," *Studio* 23 (1901): 229–37.

63. *Art Journal*, May 1895, p. 159.

64. *Spectator*, April 27, 1895, p. 579.

65. Ibid., April 28, 1894, p. 584.

66. *Illustrated London News*, June 9, 1894, p. 723.

67. *Art Journal*, June 1895, p. 192.

68. *Spectator*, May 2, 1891, p. 626.

69. Ibid., December 18, 1880, p. 1624.

70. *Art Journal*, October 1, 1862, pp. 198–200.

71. Ibid., June 1, 1864, p. 170.

72. See the *Art Journal*, June 1, 1865, p. 174; March 1, 1866, p. 71; June 1, 1866, p. 176; and June 1, 1869, p. 174.

73. *Illustrated London News*, April 30, 1864, p. 430.

74. *Athenaeum*, April 30, 1864, p. 618.

75. *Spectator*, March 4, 1865, p. 243.

76. *Art Journal*, June 1, 1872, p. 157.

77. Ibid., June 1, 1866, p. 174; January 1, 1866, p. 12.

78. *Spectator*, April 29, 1865, p. 468.

79. *Art Journal*, June 1, 1870, pp. 173–75.

80. *Spectator*, December 8, 1883, pp. 1580.

81. *Illustrated London News*, May 4, 1867, p. 447.

82. For an extensive consideration of the fascinating relationships between Pre-Raphaelitism and photography, see Michael Bartram, *The Pre-Raphaelite Camera: Aspects of Victorian Photography* (London: Weidenfeld and Nicolson, 1985).

83. *Athenaeum*, May 6, 1854, p. 562. Ruskin also associated Warren's work with "photographic effect"; see Bartram, *Pre-Raphaelite Camera*, p. 39.

84. *Spectator*, May 5, 1860, p. 432.

85. *Illustrated London News*, May 11, 1867, p. 478.

86. *Spectator*, May 15, 1886, p. 655.

87. *Illustrated London News*, April 29, 1865, p. 410.

88. *Spectator*, April 29, 1876, pp. 559–60.

89. Ibid., April 28, 1894, p. 584; March 23, 1895, p. 393.

90. Ibid., February 14, 1874, p. 208. This attitude reflects what Bermingham refers to as the "Victorian suburban experience of landscape" in *Landscape and Ideology*, pp. 157–93.

91. *Spectator*, May 25, 1878, p. 668.

92. Ibid., December 18, 1880, p. 1624. The image of the cottage in Victorian literature and art is discussed by George H. Ford, "Felicitous Space: The Cottage Controversy," in *Nature and the Victorian Imagination*, ed. U. C. Knoeplmacher and G. B. Tennyson (Berkeley and Los Angeles: University of California Press, 1977), pp. 29–48.

93. Richard Jefferies, "New Facts in Landscape," *Magazine of Art* 5 (1882): 471.

Chapter Four

Innovation and Conservatism in the Later Victorian Period

IN THE course of the Victorian period the two water-color societies did much to raise the prestige of water-color as a medium and, through the success of their annual exhibitions, disseminated a wider knowledge and appreciation of their members' works among the public at large. Most professional watercolorists found that they could support themselves and their families from the sale of drawings, although very few enjoyed a standard of living to compare with that of the grandees of the Royal Academy. However, in certain quarters an attitude persisted that watercolor painting was best suited to amateurs and that artists with a serious professional purpose should paint in oils. For many years it seemed that the Royal Academy itself – a far more powerful organization than even the combined forces of the Old and New Water Colour Societies – was deliberately discriminating against watercolorists in the selection of its exhibitions, and thus effectively restricting their prospects. A feeling of resentment against the vested interests that seemed to operate against the medium, akin to that which had first led to the establishment of the watercolor societies, affected many watercolor specialists. Some artists partially or completely abandoned watercolor for the more remunerative practice of painting in oils. Others, who regarded watercolor as their principal medium, attempted to ensure that they were at least known to a wider audience by submitting oils to the Royal Academy, seeking an academic recognition which that institution did not readily accord to watercolorists.

In the latter part of the century, however, a more liberal attitude came about, which acknowledged the professional claims of watercolorists. The Royal Academy summer exhibitions, although they remained principally displays of oil paintings, became somewhat more welcoming to watercolorists' works. Indeed, eventually an entire room was allocated to the medium, where drawings might be shown in a sympathetic way, and it was as part of this annual display that a number of works in the present exhibition were first seen. This new friendliness on the part of the Royal Academy was perhaps a response to the proliferation of exhibition spaces in which watercolors were shown. During the 1860s and 1870s first the Dudley and then the Grosvenor Gallery encouraged both younger and more advanced watercolorists to participate, and in the last quarter of the century exhibitions of watercolors became standard fare at various dealers' galleries, including the Fine Art Society, Dowdeswell, and Goupil. A voracious appetite for watercolor exhibitions grew up, and all types of work – figurative, portrait, and, above all, landscape – were enthusiastically received by collectors and critics alike. The medium was seen to have come in from the cold when academicians and artists with academic aspirations took to exhibiting watercolors. Artists such as Edward John Poynter, whose Academy exhibits were increasingly impersonal and remote, regularly showed watercolors that were infused with the delight he felt for the landscape. Walter Crane, whose oil paintings at the Grosvenor and New galleries were for the most part

grandiose allegories, also submitted poignantly beautiful watercolors to contemporary exhibitions. Even an artist such as Fred Walker, who in the course of a short career gravitated toward the Royal Academy and increasingly depended on oil as his principal medium, never transcended the immediacy and directness of his watercolors of rustic subjects.

Painters of all types had come to recognize watercolor as a medium ideally suited to the processes of technical and aesthetic experiment and the adaptation of familiar subjects to new styles of representation. The ease with which the materials might be assembled and prepared recommended the practice to anyone who sought to explore pictorial ideas or to make studies of color and shape, whether or not the resulting drawing was considered a work of art in its own right or served merely as a preparation for a more elaborate work, perhaps in another medium. As the concept of "finish" as an arbitrary artistic standard was increasingly eroded, the previously sacrosanct division between the completed watercolor and the study began to break down. In the 1880s James McNeill Whistler was derided by old-fashioned critics for exhibiting watercolors that an earlier generation would have considered mere studies or sketches, lacking the qualities of clarity and legibility by which watercolors had formerly been judged. However, his delicate and subtle drawings explored ways of transmitting information about the physical world by abstract and sensuous pictorial means. There were many among Whistler's contemporaries who were similarly attracted to the tonal and atmospheric effects to be found in the landscape. In their aesthetic modernity, the watercolors of Daniel Alexander Williamson, John William Inchbold, and Alfred William Hunt outdistance the works of the generality of contemporary oil painters, some far better known than they were themselves.

In the absence of an aesthetic orthodoxy, rapidly evolving ideas about the purposes and possibilities of landscape painting on the part of a wide range of artists gave rise to a great variety of treatments. Artistic movements and groupings succeeded and eclipsed one another. The influence of European schools of painting had a major impact but was eventually subsumed in the rediscovery of what was considered to be an indigenous tradition in which the forms of landscape were treated with breadth and freedom. At the same time the late century witnessed a revival of a style of landscape painting dependent on minute observation and the painstaking handling of color.

Certain characteristics may, however, be regarded as quintessential attributes of late Victorian painting. The detachment and objectivity with which Pre-Raphaelite watercolorists viewed the landscape gave way to a feeling of greater involvement with the subject. It was no longer sufficient for a painter to provide literal information about the physical world. Watercolorists sought to convey their emotional response to the landscape, the feelings of sentiment that reveal the painter's involvement with the scenery represented. The means adopted to achieve this

end were many and various, from the evocation of the poetic mood of landscape as observed at dusk to the description of a laborer's strenuous experience of his surroundings while hedge cutting or mowing. The concept of "truth to nature" was superseded in a way that Ruskin himself had anticipated. Watercolorists of the late Victorian period sought to reveal the landscape in terms of human experience, and the products of their art were judged according to the authenticity and honesty of that representation.

Among the artists who were seen as the inheritors of the technical objectives of the Pre-Raphaelites but who at the same time sought to bring sentiment into landscape painting were many who had previously depended for their livelihood on the engraving trade. John Gilbert, a prominent member of the Old Society and eventually its president, served a long probation making designs for black-and-white illustrations; even when he was established as a professional watercolorist, he could not quite bring himself to relinquish this lucrative sideline. Birket Foster, similarly, seemed to delay beginning his career as a watercolor painter, continuing through the entire 1850s to work as an illustrator. Even many members of the next generation – those born in the 1840s who came to prominence as watercolorists in the late 1860s – had trained as illustrators and produced engraved plates for books and magazines.

The experience of designing illustrations influenced the subsequent landscape painting of these artists. They had been encouraged to think in terms of an unfolding narrative and to devise means by which a static image would illuminate a text. Whereas the landscape painters in the Pre-Raphaelite circle – John Brett, J. W. Inchbold, Thomas Seddon, A. W. Hunt – generally conveyed no more than a hint of story or of esoteric literary or historical allusion in their landscape watercolors, the works of most painters who had trained as illustrators lent themselves to narrative interpretation or were carefully orchestrated to highlight picturesque motifs. In Birket Foster's rustic subjects, for example, groups of children and working figures are artfully placed to enliven the scene and engage the viewer's sympathies. Fred Walker may have had Birket Foster's example in mind when he began to paint watercolor landscapes; however, Walker's figures are central to his purpose in a way that the more decorative and sentimental figures of Birket Foster seldom are. Walker wanted his audience to identify with these figures and through them understand and appreciate the reality of the countryside. Such a figure is the young Highland woman carrying her washing in *Stream in Inverness-shire* (cat. no. 67). Walker was concerned to portray her habitual interaction with her physical surroundings rather than the landscape itself. He tried to endow his figures with a casualness that conveyed the figures' indifference to, or unawareness of, the artist's intrusion on the scene. Equally, the arrangement of pictorial elements was not to appear contrived or too carefully considered but should convey something of the haphazard quality of the real world. Composition

was, according to Walker, "the art of preserving the accidental look."[1]

Walker was one of the artists who served an apprenticeship as an illustrator – in his case to the engraver J. W. Whymper. Until about 1864, Walker spent most of his time designing illustrations; plates by him appeared in many of the popular periodicals of the day, such as *Once a Week* and *Cornhill Magazine*. In the mid-1860s he began to make oil versions of compositions which he had previously invented as illustrations, and at the same time he developed the type of small-scale figurative landscape subject that was his most characteristic work.

From the time he became an associate of the Old Water-Colour Society in 1864, reviewers saw Walker's exhibited landscape watercolors as something quite new in the context of London exhibitions. In 1868, the year in which he exhibited *Stream in Inverness-shire*, the critic of the *Art Journal* concluded: "The artist has an original way of looking at a subject. The background is so treated as to be at once subservient and complete; opaque colour is so used as to gain transparency, atmosphere, and daylight."[2] By the beginning of the 1870s Walker was widely regarded as one of the most talented and original younger artists of the day. Increasingly critics talked of a Walker school, of which John William North, George John Pinwell, and various other younger artists were the putative members. For example, in 1875, the year of Walker's early death, a watercolor by Robert Walker Macbeth in the Old Society's winter exhibition was recognized by the *Art Journal's* critic as bearing "tribute, like many other works here exhibited, to the good influence of Mr. Walker's teaching."[3]

After his death, Walker's reputation only tended to increase. A memorial exhibition of about 150 of his works, organized at the French Gallery in New Bond Street, prompted the *Art Journal* to summarize his achievement by comparing him to Jean-François Millet and claiming that, like Millet's, "his sympathies went forth to what was lowly and familiar, and his genius sublimed common things into the region of poetry and Art."[4] An exhibition of Walker's watercolors mounted by Robert Dunthorne in 1885 drew the attention of Vincent van Gogh:

I just read an article in the Graphic on an exhibition of twenty-five drawings by Fred Walker. Walker died some ten years ago, you know. Pinwell too – while I'm on this subject, I'm thinking of their work too, and how very clever they were. How they did in England exactly what Maris, Israëls, Mauve, have done in Holland, namely restored nature over convention; sentiment and impression over academic platitudes and dullness.[5]

In 1895, on the occasion of an exhibition in Birmingham of paintings, drawings, and prints by George Heming Mason, Pinwell, and North, the term "idyllist" was first used to describe the group of painters that had formed around Walker. His work was found to possess "the finest qualities of good art; it is at once delightful, original, and sincere; it extracts the kernel of beauty from the husk of the commonplace: it is in touch with the fine work of the past, and yet is absolutely modern."[6] A year later Edward Burne-Jones expressed himself more simply: "I think for an absolute representation of what a scene in a story would be like F. Walker's drawings are perfection."[7]

The works of Walker, North, and the other idyllist watercolorists who shared their outlook and their background in illustration seemed to have much in common with the watercolor landscapes of the more purely Pre-Raphaelite painters: a sometimes excessive attention to detail, a frequent reliance on bodycolor, a taste for unusual compositional schemes, and a dedication to the principle of working, and indeed finishing, in the open air. The similarities grew perhaps from a common source in Ruskin's writings and the works of the first generation of Pre-Raphaelites, but they also arose independently from the nature of the illustrative processes in which the younger artists were trained.

Whereas Pre-Raphaelite landscape painters were committed as a matter of principle to a uniform clarity and precision of detail across the surface of their compositions, the illustrators often achieved apparently analogous effects that simply reflected the practical exigencies of wood engraving. On the one hand, the illustrator was restricted to a small pictorial area into which all the elements of the composition must be compacted, and on the other, the patterns of line making up these forms had to be spread across the entire space to achieve maximum legibility. Large areas of sky, for example, were not easily conveyed in line, whereas the representation of the rectilinear shapes of buildings or the indented horizon of hill country were well suited to engraving. Many illustrators who turned to watercolors continued to look for subjects in which they could spread a uniform pattern over the entire expanse of the sheet.

Both Walker and North were capable of prodigies of minute natural detail. On one occasion when visiting his friend in Somerset, Walker found North "doing capital work (water colour), he is most sincere over it, each inch wrought with gem-like care."[8] However, neither Walker nor North considered meticulous finish a worthwhile artistic objective in its own right, and they feared that an overemphasis on technique would distract from their fundamental purpose, which was to transmit to the spectator the actual experience of the countryside. Honest craftsmanship in drawing and in the use of color was central to their art, but the display of technical virtuosity was not considered by them an end in itself.

In his early career, Walker was known for his liberal use of bodycolor. Ruskin, as always torn between his advocacy of a fine stipple technique in bodycolor and his fondness for the simpler manner of an earlier generation of British watercolorists, chided Walker for

inventing a semi-miniature, quarter fresco, quarter wash manner of his own – exquisitely clever, and reaching, under such clever management, delightfullest results here and there, but which betrays his genius into perpetual experiment instead of achievement, and his life

into woful vacillation between the good, old, quiet room of the Water-Colour Society, and your labyrinthine magnificence at Burlington House. (14.340)

Walker caricatured himself squeezing white gouache from a gigantic tube, asking: "What would 'The Society' say if it could only see me?"[9] In the early 1870s both he and North gradually reduced their dependence on bodycolor; North claimed that "the uncertain character of the paper led Walker into excessive use of Chinese white in his earlier water colours. This use of white he gradually diminished, until in some of his later work in water colours there is scarcely a trace."[10] North's biographer, Herbert Alexander, made a comparison between the two artists' approaches to these questions of technique: "While Walker's feverish energy for creation . . . could not stay to grapple with problems of methods and materials, North, inarticulate, slow, with a mind for minuteness as if he were creating the universe, was gradually perfecting a water-colour technique which eliminated the use of body colour, at the same time giving pure colour greater depth and range of tone."[11] North gave a detailed account of his friend's working method:

Walker painted direct from nature, not from sketches. His ideal appeared to be to have suggestiveness in his work; not by leaving out, but by painting in, detail, and then partly erasing it. This was especially noticeable in his water colour landscape work, which frequently passed through a stage of extreme elaboration of drawing, to be afterwards carefully worn away, so that a suggestiveness and softness resulted – not emptiness, but veiled detail. His knowledge of nature was sufficient to disgust him with the ordinary conventions which do duty for grass, leaves, and boughs; and there is scarcely an inch of his work that has not been at one time a careful, loving study of fact.[12]

North similarly wrestled with the conflicting claims of detail and atmosphere, in the course of which struggle he evolved a highly individual landscape style of his own. From the meticulous detail of his early work, he gravitated toward a looser and more animated handling of color. Walker claimed that the Old Water-Colour Society cited "want of finish in parts of [his] work" as grounds for not electing North in 1868, which was, Walker added, an "opinion I am not at all sure I share."[13]

In his later career North turned from the naturalism that he and Walker commanded in the 1860s toward a more abstract evocation of the landscape. He learned to build up his compositions in broad masses of muted color, semitransparent and constantly fluctuating in intensity of tone. On this ground he laid dense patterns of minute hatching, sometimes drawn with a pen or fine brush, but also frequently scratched with the butt end of a brush into areas of wet color, or cut with a knife into the underlying paper. By this method North achieved effects in which the forms of nature blend organically into overall masses and which suggest the gentle hum of movement and sound in the living landscape. In 1880 the critic for the *Spectator* noted that North still owed a debt to Walker's type of painting, but concluded:

Nothing could be much more unlike the perfectly definite and clearly brilliant touch of Mr. Walker, than Mr. North's rapid, irregular manner of working, a manner which gives the effect of wandering from place to place in his picture, working now here, now there, and finally, that seeing so much more beauty than he can compass, he stays his hand altogether, and sends his picture out to exhibition as little finished or as much so, as one of Turner's wilder fancies.[14]

Both Walker and North were highly influential in the evolution of a type of pastoral landscape aimed at an authentic representation of rustic life. Londoners by birth, they found that they craved the tranquility and what they perceived as the poetry of the countryside. Not satisfied with anything that was generalized or blandly picturesque in their painting, they became serious observers of the realities of country life. For them, and for the artists who followed them, the countryside was subdivided into myriad localities, each with its own landmarks and types of landscape, as it had its distinctive regional customs and dialects.

The watercolors of Walker and the idyllists echoed the literary descriptions of the landscape in an age that had invented a new type of fictional account of rural life, based on acute observation of the real countryside. However, few watercolorists were willing to document unflinchingly the changes that were overtaking what was fondly regarded as the timeless rural world and to follow Thomas Hardy when he presented his readers with "a Wessex population living under Queen Victoria; – a modern Wessex of railways, the penny-post, mowing and reaping machines, union workhouses, lucifer matches, labourers who could read and write, and National school children."[15]

In his later career, North became friends with Richard Jefferies, whose prose descriptions of the English countryside and its way of life correspond in mood and manner to North's own watercolor landscapes. Each loved to observe and describe detail in the landscape, and each was fascinated by the characteristics – geological, botanical, architectural, linguistic, and agricultural – that subtly distinguished one locality from another; furthermore, they had a bond of sympathy with the country people who were their neighbors at a time of agricultural depression. North loved everything that was timeworn and undisturbed, and, although he well understood the practical aspects of farming, evidence of new agricultural methods seldom appears in his work.

One of the best-known purveyors of the Victorian pastoral scene was Helen Allingham. She too had worked as an illustrator, as well as occasionally exhibiting watercolors at the Dudley Gallery, until her election as an associate of the Old Water-Colour Society in 1875. Birket Foster and Fred Walker were the two dominant influences on her emerging style of watercolor landscape. From the former she derived her characteristic subject, the vernacular cottage architecture of southern England and the surrounding landscape. In the opinion of Walford Graham Robertson, a fellow painter and illustrator, "Her

lovely little transcripts of the Surrey lanes and woodlands, of the school of Birkett [sic] Foster [were] fresher, more fragrant and close to Nature than the works of the elder painter."[16] Birket Foster himself denied her debt to him, believing her work to have "much more modernity in it" than his own.[17] Of her debt to Walker, Allingham admitted: "I *was* influenced, doubtless by his work. I adored it, but I never consciously copied it. It revealed to me certain beauties and aspects of Nature, as . . . North's and others have since done, and then I saw like things for myself in Nature, and painted them, I truly think, in my own way – not the best way, I dare say, but in the only way I could."[18]

Allingham was quite deliberate in her use of watercolor to give a documentary account of a type of domestic architecture she saw being wantonly destroyed and of a rural way of life she feared would not survive. Exodus from the land, as a result of agricultural mechanization and the prospects of better employment in the expanding cities, meant that many of the ancient cottages in which tenants and farm laborers had lived were now abandoned. All across the country these buildings were allowed to fall into ruin, or were deliberately demolished. Allingham's watercolors were made to provide a record of these buildings, but she was not above prettifying her subjects by turning back the clock: to present the structures in what she considered to have been their original form, she restored to cottages their original thatched roofs or diamond-pattern lattice windows that had been replaced by modern glass.

Two other watercolorists who toward the end of the century worked in the pastoral tradition were Lionel Percy Smythe and Wilmot Pilsbury. Smythe was brought up in London and began his training as an artist at Heatherley's School but spent most of his working career at Wimereaux in Normandy, where he became utterly absorbed in the task of honestly representing the way of life of the peasants of that region. According to the painter and writer on art A. L. Baldry, he even bested Walker in his authentic portrayal of country people. Baldry made a distinction between Walker's figures, who appeared as "Greek gods in smock-frocks or fairy princesses in rags," and Smythe's, who struck him as "plain, out-of-door people who are in the landscape because they belong to the soil and are at home in the fields. His fishermen are healthy, open-air workers, natural and without self-consciousness. . . . They all come into his artistic scheme just as they are, and they please him because they have much of nature's unaffectedness and joy of life."[19] Most of Smythe's watercolors are populated with working figures, as in the *Field of the Cloth of Gold* and *Mowers with Elm Trees* (cat. nos. 102 and 103), but these are generally subsidiary to the overall sense of the breadth and brightness of the landscape.

Pilsbury was rigorous in the careful observation of the points of detail that identify the specific localities represented in each of his watercolors. He painted mostly in the east Midlands, within range of Leicester, where he

was the headmaster of the School of Art, and his views of closely confined meadows and farmyards speak of his intimate knowledge and direct experience of that region. However, neither his knowledge nor his experience counted for much with the *Spectator's* critic in the 1880s. When Pilsbury was elected an associate of the Old Water-Colour Society in 1881, the *Spectator* was outraged that the honor should have gone to a painter of haystacks and farmyards in a miniaturist style. Over the next few years the periodical kept up its attacks, writing in 1885 that his works

should be noted, if only as showing, in the highest possible degree, the defects which the French and all foreign nations regard as being inseparable from English painting. They are laboured, minute and dull; they are pretty, trivial and commonplace. They are true in detail, they are false in mass; they are bright in colour, they are wrong in value. They have, crudely speaking, no subject, no composition, and no object.[20]

For those who identified with the emerging avant-garde associated with the aesthetic movement or Continental impressionism, Pilsbury's watercolors, or those of Hubert Coutts (cat. no. 117) or William Fraser Garden (cat. no. 108), were anathema.

Most landscape artists lived, or at least originated, in the cities, and it was to the metropolitan forum of exhibitions and critical comment that they looked for professional acclaim. They were, however, in business to satisfy a widespread interest in the appearance and way of life of the countryside, to which so many urban Victorians owed their origins and of which they had living memories and affiliations. On the whole, the watercolorists of rural subjects of the late century may be regarded as having served their patrons and posterity well; they subsumed their own aesthetic preoccupations – the belief that the work of art was itself more important than the associations of its subject – in favor of an honest and literal account of what they saw in the landscape. A capacity for objective representation, inherited from the Pre-Raphaelites, was fused with an appreciation of the ties of sentiment which bind individuals to their native landscape. The outcome was not, as with so many oil paintings of the period, an abstract backdrop to some anodyne stage show of rustic manners but was instead an authentic representation of the landscape based on the artist's own experience and his sympathy for the way of life that was led there.

If Birket Foster, Walker, Allingham, and Pilsbury were seen as a sort of Pre-Raphaelite succession, they were by no means the only heirs to the Pre-Raphaelitism of the 1850s. A separate line of development, concerned less with the representation of country life and more with the purely aesthetic possibilities of landscape, claimed legitimate descent from the precepts and theory of the Pre-Raphaelites. Those watercolorists born around 1830, who had once wholeheartedly subscribed to Ruskinian theories of landscape, eventually led the reaction against minute realism. They were the ones who first faced the

question of how to treat landscape when the mental and physical resources required for painstaking observation were exhausted, and for them the more flexible notion of authenticity replaced literal and precise representation as the cornerstone of their artistic doctrine.

New techniques were developed or older ones resurrected by watercolorists who now sought breadth and cohesion for their compositions and who no longer felt bound to the laborious processes by which Ruskin-inspired artists had learned to build up landscape views from small areas of carefully drawn detail. In 1857, the very year in which Ruskin's *Elements of Drawing* inspired a host of scrupulously detailed nature studies, the *Art Journal* responded to the historical display of English watercolor painting that formed part of the Manchester Art Treasures Exhibition by deploring "what Mr. Ruskin calls the 'pestilent' practice of sponging."[21] Within a decade or so the technique of using a sponge to wipe away color and soften forms, along with various other methods associated with the earlier English school, had been enthusiastically revived. North's description of Walker's practice of sponging away areas of laboriously achieved detail in the interest of atmosphere has already been mentioned. Alfred William Hunt's method was recalled by his daughter Violet: "I have seen delicately stained pieces of Whatman's Imperial subjected to the most murderous 'processes,' and yet come out alive in the end. He scrupled not to 'work on the feelings of the paper.' . . . He sponged it into submission; [and] he scraped it into rawness and a fresh state of smarting receptivity."[22] The results of these "murderous processes" can be seen both in Hunt's *Tynemouth Pier – Lighting the Lamps at Sundown* (cat. no. 69) and in *Loch Maree* (cat. no. 79).

Daniel Alexander Williamson, once a thoroughgoing Pre-Raphaelite, looked back on his early minutely drawn watercolors and "attributed to them the knowledge which enabled him in after life to become an impressionist, and to treat nature in a broad and free style."[23] In his watercolors of the 1860s, such as *A Grey Day* (cat. no. 59), he allowed strokes of bright color to become blurred and indefinite, fusing together and overlapping while still wet on the surface of the paper and then being further unified by a system of lines drawn through the moist pigment with the butt end of a brush. In the following decade, his manner became still more loose and fluid, as is evident in *White Pike* (cat. no. 87), in which the forms of the landscape are almost entirely dissolved.

Similarly, though less dramatically, G. P. Boyce in the late 1860s gravitated from minute detail toward tonal and atmospheric effects, achieved by a subdued use of color and a rougher handling of textures. Most remarkable of all was the rediscovery of painterliness by John William Inchbold, in whose works a veil of subjectivity seemed to be drawn over the landscape. P. G. Hamerton responded in 1874 to a series of Inchbold's atmospheric views of the River Thames and the London skyline at night: "Mr. Inchbold interprets his subjects with great taste and feeling, idealising always to some extent, so that his draw-ings tend rather to a spiritual and not quite substantial conception of things, than to a material solidity; but in times of a vulgar yet powerful realism, this refinement is like poetry after prose."[24]

The evolution from the precepts of Pre-Raphaelite or Ruskinian landscape to a representation of nature which accorded with the philosophy of the aesthetic movement – seen in the unfolding careers of A. W. Hunt, Williamson, Boyce, and Inchbold – represented a deep-rooted shift toward a style of watercolor that was both looser in its technical requirements and more concerned with the mood and human associations of landscape than with geographical descriptiveness. If the essentially conservative members of the Old Water-Colour Society marked a change toward a more spontaneous approach to landscape subjects, at the Dudley Gallery, which was, in a sense, the first home of the English aesthetic movement, many younger artists exhibited landscape watercolors that combined strains of poetic escapism and remoteness from the physical realities of the actual countryside. A faction whose first loyalty was to Edward Burne-Jones and the ongoing tradition of romantic Pre-Raphaelitism (the side of Pre-Raphaelitism that Ruskin had dismissed as irrelevant to landscape painting) showed figure subjects in outdoor settings as well as pure landscapes. Walter Crane and others sought to represent "a twilight world of dark mysterious woodlands, haunted streams, [and] meads of deep green starred with burning flowers, veiled in a dim and mystic light."[25] Here, then, was another group of artists with clear connections to Pre-Raphaelitism who were vehemently opposed to the literal cataloguing of natural detail. In 1869 the *Art Journal* found that "for the most part, indeed, there is in these Dudley landscapes, dreaminess instead of definiteness and smudginess in place of sentiment."[26]

The convenience and portability of the materials of watercolor painting made the medium an invaluable means of record to travelers. Since the early eighteenth century, generations of professional and amateur artists had toured the British Isles, sketching buildings and landscape, explored the Continent, and on occasion ventured farther afield. The topographical tradition was maintained in the Victorian period by the many artists who made their livings visiting foreign parts and supplying collectors at home with watercolor views that were both artistically pleasing and geographically informative. This had been a major part of Turner's stock-in-trade; the drawings that he made of his Continental excursions provided engravings for books sold to a wide audience of people who wanted to know more about foreign countries. Later in the century artists such as John Fulleylove and Walter Tyndale specialized in views of places and ways of life which were compelling in their exoticism to the contemporary art-collecting public, despite the availability of photographic records.

Of all foreign countries, it was perhaps Italy that exerted the greatest hold on the imagination of British artists and gallery-going public. From the middle of the

eighteenth century onward, droves of painters and watercolorists had been drawn to Italy, and in the Victorian period a large number of professional artists were known for their devotion to Italian subjects. So much a staple of British watercolor did the landscape of Italy become that certain parts of the Italian Alps, the Campagna, Tuscany, and the south of the country were immediately familiar to an audience who for the most part had never left Britain. The watercolors of William Leighton Leitch, Thomas Miles Richardson, Jr., and Thomas Charles Leeson Rowbotham were often hackneyed and repetitive, but they demonstrated the power that the landscape of Italy had over the British public.

As the century proceeded various English artists went beyond such picturesque conventions to give highly personal accounts of the Italian landscape which combined topographical accuracy with poignant and evocative effects of light and atmosphere. In the 1860s John Collingham Moore lived in Italy, sending back watercolor views of Rome and the Campagna to the Dudley summer exhibitions. In Moore's obituary in the *Art Journal*, these watercolors were praised "not only for their poetic conception, but for their breadth and dignified simplicity of treatment."[27] Walter Crane and his wife, Mary, enjoyed a prolonged Italian honeymoon in the early 1870s, when Crane developed a style of watercolor landscape which, in its suppression of detail, avoidance of strong local color, and frequent use of pronouncedly horizontal formats, was deliberately adapted to the broad expanses and bleached colors of the southern countryside. Both Moore and Crane encountered the Italian painter and patriot Giovanni Costa, whose approach to landscape painting influenced theirs.[28] Costa did not paint in watercolor himself, maintaining that the medium lacked the expressive power of oil, and he therefore tended to discourage its use among the English artists who gathered around him and who came to be known as the Etruscans. Accordingly, George Howard and Matthew Ridley Corbet, each of whom was a close friend of Costa and who painted with him on many occasions, produced their larger and more ambitious views of Italian scenery in oils, yet they also painted panoramic landscapes and topographical subjects in watercolor, and these display their characteristically sensuous appreciation of the forms and colors of the Italian landscape.

Costa's influence on English painting was profound. He believed that the very purpose of representing landscape subjects was to explore the feelings of sentiment that attach an individual to his native country or that inspire emotions of awe on the part of visitors. "Art must express the sentiment of the artist's own country,"[29] Costa pronounced to Howard. In his memoirs the same fundamental belief was distilled into the words: "Il vero non dice nulla se non è veduto attraverso il sentimento del pensiero" (Nature is meaningless if it is not interpreted with sentiment)[30] – the process of artistic interpretation, according to the painter's emotional response to the landscape, was what made his representation of nature

important. It was no longer sufficient merely to observe the landscape naturalistically; the artist was required to select and arrange its elements both to maximize pictorial effect and to point up symbolic and personal associations. Landscape was understood as an expression of the artist's inner sensibility.

The American painter James McNeill Whistler was influential both as a spokesman for the fundamental principles of aesthetic philosophy and for the watercolor landscapes he painted in the 1880s. The theoretical basis of the aesthetic movement was to a great extent introduced from France, where the principle of "l'art pour l'art" had been expounded by Théophile Gautier and Charles Baudelaire. When in 1859 Whistler came to live in London he brought with him from Paris the latest ideas on the purely decorative and sensuous properties of art, and from that point he served as a conduit through which the precepts of French avant-garde painters and theorists were transmitted to English artistic circles. In 1887 the critic Walter Armstrong reviewed Whistler's role in introducing the English public to the possibilities of art: "For years past his work has been a sort of touch-stone wherewith to distinguish the real lover of Art for Art's sake from the much more ordinary person who regards it for its didactic, its narratory, or its moralizing power."[31] Only slowly did any of this have a bearing on contemporary watercolor painting. Whistler's nocturnes, which date from the late 1860s and early 1870s, represent a brilliant contribution to an established genre in English art – the representation of the city landscape at night; it is an open question whether Whistler influenced, or was influenced by, various watercolorist contemporaries who drew similar subjects, notably Boyce and Inchbold.[32]

Whistler had used watercolor occasionally as a young man, usually for figurative subjects, but it was only in 1879–80, in Venice following his libel action against John Ruskin and the bankruptcy that he suffered as a consequence, that he took up the medium seriously. It has been suggested that the experiments he was making with color lithography at the time may have encouraged him to try watercolor for its own sake.[33] In any case, the works that survive from his Venetian sojourn are quite small and consist of thinly mixed washes of pure color, placed in single layers across the surface of coarsely grained paper. Colors were allowed to blend together while still wet on the sheet, and elsewhere the jagged edges of untouched white paper offer patterns that seem to project from the plane of the composition. From this point on Whistler became an habitual watercolorist – indeed, the technique and scale of his late oil landscapes, in which he used pigment thinly and on a smaller format, came to approximate the experiments he was making in watercolor. Few of Whistler's watercolors are dated, and he himself was vague about when specific drawings might have been done. It is difficult, therefore, to determine at what stage he gained complete mastery of the medium. However, in 1884 he included a group of watercolors in an exhibition titled "*Notes*" – "*Harmonies*" –

"*Nocturnes*," which was staged at Dowdeswell's gallery. This was the first occasion when the public at large, as well as most of Whistler's fellow artists, was able to see the type of watercolor he was by then painting – mostly done, according to the *Art Journal*, in the course of a visit he had recently made to Cornwall.[34] P. G. Hamerton disparaged the drawings as mere "hints and memoranda" and suggested they were too slight to merit an exhibition: "Most painters keep such material for private use in their folios; Mr. Whistler is more confiding, and invites the curiosity of the general public."[35] Other critics, more sympathetic to Whistler's artistic objectives, looked upon them as a radical new departure.

The apparent simplicity of Whistler's watercolor landscapes made them an exact fulfillment of his own aesthetic principles. In the catalogue of the 1884 exhibition he published his *Propositions – No. 2*, in which he stated:

A picture is finished when all trace of the means used to bring about the end has disappeared.

To say of a picture, as is often said in its praise, that it shows great and earnest labour, is to say that it is incomplete and unfit for view. . . .

The work of the master reeks not of the sweat of the brow – suggests no effort – and is finished from its beginning.[36]

For Whistler, high finish and minute detail were no measures of virtuosity but only tended to distract from the true artistic virtues he believed lay in the harmonious arrangement of line and color. The appeal of watercolor lay in its spontaneous and unpredictable quality. He had learned how to allow shapes and colors suggestive of the effects of nature to emerge almost of their own accord and with a minimum of intervention, but what seemed arbitrary or accidental was actually the result of extraordinary dexterity and understanding of the physical properties of the medium. It was virtually impossible to correct any clumsiness of form or crudeness of color; the intensities of tone were determined by the exact quantity of pigment floated on the drawing's wet surface, and the means available to reduce these – sponging, wiping, or further dilution with pure water – were fraught with difficulty. Whistler's watercolors of coastal landscapes, such as *Beach Scene with Two Figures* (cat. no. 104), and of street scenes are not only testimony to this mastery, they are among his most personal and intimate works.

During the 1880s a whole range of artistic variants of impressionism gained ground in Britain. Paintings and watercolors of a recognizable impressionist type – usually landscapes or figurative subjects in the open air – began to appear, notably at the exhibitions of the New English Art Club, which was founded in 1886, and at the final summer exhibition of the Grosvenor Gallery, which took place in 1890. Some artists took Whistler as their chief model; others were shaped by periods of study on the Continent; a few others seem to have arrived at an indigenous impressionist style of their own quite independently.

The watercolors of coastal and marine subjects done by the Scottish painter William McTaggart in the 1870s and 1880s represent a highly original adaptation of the medium. McTaggart found in watercolor a means of exploring the shapes, textures, and luminosity of the landscape and in the process gained insights into the way in which the eye receives information about the physical world, which he put to use in his larger oil paintings. He devised a technique of extraordinary robustness and flexibility, laying pure, bright color onto sheets of coarse-grained cartridge paper, using heavy brushes and perhaps sponges, and working always with great expansiveness. At a later stage he enlivened the surfaces of his drawings by dabbing strokes of darker, but still translucent, color into complex and dense patterns to create the effects of dappled light or the broken textures of water or shingle. This was an especially radical departure in the context of Scottish watercolor painting, which in the 1870s was generally concerned with finish rather than expression. McTaggart made no particular distinction between the media of oil and watercolor, and as his career advanced, the work that he did in each looked more and more alike; nonetheless, it seems that he regarded watercolor as particularly appropriate to the processes of experiment.

McTaggart both preceded and remained apart from the foremost group of Scottish painters who professed allegiance to the principles of impressionism – the artists known as the Glasgow Boys. When, in 1894, James Caw pondered the debt that Scottish art owed to the different Continental schools of painting for its assimilation of an impressionist style, he pointed out that

the Glasgow men . . . use [a] method, which they need not have left their own country to acquire, for Mr. McTaggart, before impressionism as a thing per se was even heard of in Scotland, had evolved a style for the expression of his individual and very beautiful conception of nature, which exceeds in vividness and suggestion that formed by the French masters, but they use it as he does for the manifestation of personal feeling.[37]

Caw went on to list the influences that operated on the impressionist landscape painting of the Glasgow artists; he mentioned McTaggart and the Barbizon school, which for the Scots, as well as for many impressionists in England, was more significant than the work of the French impressionists themselves. But, without doubt, "the most powerful individual factor in the formation of our artistic aims and technical methods has been the genius of Mr. Whistler."[38] This perhaps overstated the case, for various Scots seemed to arrive at a wet technique, known to some of its critics as "blottesque," at about the same time that Whistler was first experimenting with the method. Arthur Melville, who was in fact not a Glaswegian but who had close contacts with that school, was one artist whose watercolor landscapes combine these various influences. In 1878 he went to train in Paris at the Académie Julian and later settled at Grez-sur-Loing, near Fontainebleau, where he painted low-toned oil land-

scapes and fluid, blotchy watercolors. By 1880 his style of watercolor painting closely approximated Whistler's own use of the medium. Melville also painted portraits and figure subjects, but his most characteristic works are watercolor landscapes and topographical records of the places he visited in the course of a short but peripatetic career. James Paterson also studied in Paris, principally under Jean-Paul Laurens, from 1877, and on his return to Glasgow in 1882 he joined what Caw described as "the little group of slightly younger men then gathering there under a banner of artistic revolt"[39] – the Glasgow Boys. Paterson went to live at Moniaive in the remote lowland countryside of Dumfriesshire, where he painted many landscape watercolors, including the present number 110. It is not clear where, or indeed whether, Paterson saw Whistler's own landscape drawings; a clear affinity nevertheless exists between the works of the two artists.

A lecture given by Paterson sometime in the 1890s testified to Whistler's continuing influence in Scotland. It was reported that "Mr. Paterson, going on to speak of aims in landscape painting, said he firmly believed there was at present a very marked revival of more hopeful tendencies in this country. Absolute truth to nature was impossible. A selection from and suggestion of the tones and tints and forms which we saw in the landscape was the only course open to the painter."[40] This was a clear echo of Whistler's own view, expressed in his *Ten o'Clock* lecture of 1885:

Nature contains the elements, in colour and form, of all pictures, as the keyboard contains the notes of all music.

But the artist is born to pick, and choose, and group with science, these elements, that the result may be beautiful – as the musician gathers his notes, and forms his chords, until he bring forth from chaos glorious harmony.[41]

In 1893 a flurry of excitement was caused in artistic circles by an attack in the press by Sir George Reid, president of the Royal Scottish Academy, on "so-called impressionists" who, he believed, were influenced by "the modern French school of painting." He asked, "what is this impressionism except, among the younger artists, 'the offerings of admiring incapacity in the shape of more or less dexterous imitation' of some of the better-known leaders of the movement in France?"[42] The Scots, who were the main objects of his attack, forbore to reply, but the furious response of various English painters indicated their belief in impressionism as an integral and essential part of the contemporary art scene. Francis Bate, a member of the New English Art Club, expressed a not uncommon view when he wrote: "English impressionism is not an imitation of anything French. It is no mushroom growth of to-day. It is animated by an enduring truth clearly traceable in its evolution from the beginning of art."[43] Bate's statement joined those of Edward Stott and Hercules Brabazon Brabazon, who invoked Turner, among others, to demonstrate the long continuity of an impressionist style in British art.[44]

Although Whistler's professed contempt for English artistic traditions (coupled perhaps with his antipathy for

Ruskin) made him deny any debt to Turner, in reality he had a lingering respect for that greatest of English landscape painters, whose works he had copied even before he left the United States as a very young man and whose drawings he certainly studied.[45] The affinity of certain of his landscape watercolors, both in technical terms and in their choice of subject, to Turner's own watercolor sketches and color studies supports the idea of an indigenous impressionist style. Brabazon, who for decades had occupied himself as an amateur painting watercolors of great freedom and painterly expressiveness, was seen in the 1890s as the heir to an artistic tradition that descended from Turner. In 1891 he was persuaded by John Singer Sargent to allow a group of his watercolors to be included in a New English Art Club exhibition. Critics were happy to applaud an artist who came to symbolize national artistic independence. The following year Sargent helped to organize and hang the first of a series of exhibitions of Brabazon's drawings at the Goupil Gallery, events that ensured Brabazon's revered position in English artistic circles for the remaining fourteen years of his life. In 1892, D. S. MacColl lambasted the prevailing standard of watercolor painting as represented at the Old Water-Colour Society and turned to Brabazon as a savior, recognizing his origins in long-standing traditions of English art. MacColl believed that Brabazon had "gathered from Turner the hints that extraordinary genius flung out of a technique partly transparent, partly opaque, embracing the full range of resource in the medium, and adapted to express by its speed and suggestiveness the most fleeting actions and exquisite surprises of colour."[46]

In addition to the growth of a cult of admiration for Turner, a renewal of interest in the work of David Cox gathered momentum through the last decade or so of the century, and Thomas Collier, E. M. Wimperis, and James Orrock, among others, modeled their own styles of watercolor painting on Cox's. The last quarter of the eighteenth and the first quarter of the nineteenth century were seen to represent the golden age of British watercolor painting, and the essential achievements of the high Victorian age began to be disparaged. Conservative and progressive painters alike found in the work of an earlier generation endorsement of their preference for breadth and atmosphere, and the diversity of aesthetic objectives of the British watercolor tradition provided the basis for artistic revival and retrospection. English insularity was reassured by such signs of consistency and continuity; landscape watercolor painting, which the British prized so highly and regarded as something so peculiarly their own, was seen to have come through unscathed and more or less free of contamination from European styles and fashions.

When in the 1860s a division had been drawn between "schools of detail and effect," the latter category represented the established approach against which younger artists associated with Pre-Raphaelitism were reacting. By the last decade of the century the situation was reversed; conservative opinion clung to a workmanlike representa-

tion of the physical world, while a progressive aesthetic stance allowed the forms of nature to be dissolved in favor of an emotional rendition of the effects of light. The poles of the stylistic schism are represented on the one hand by the microscopic realism of William Fraser Garden's *A Hayfield, Bedfordshire* (cat. no. 108), or the urbane literalism of Edward John Poynter's *Isola San Giulio, Lago d'Orta* (cat. no. 120), or by Henry Holiday's *Hawes Water* (cat. no. 126); and on the other by the watercolors of McTaggart and Brabazon, which evoke landscape subjects in an abstract and spontaneous way.

The validity of subjective response was at the root of most discussion and criticism of landscape watercolor by Victorian painters and critics. Painters resorted to a variety of techniques and styles to give different moods or associations to their work. Many of the more advanced painters of the period felt free to select and abstract details from the landscape in the interest of emphasizing an aspect of the scene that seemed particularly poetic or delightful or for the sheer pleasure of observing conjunctions of color or harmonious patterns of line. In this process they believed that they might reveal the purer essence of nature. Others returned to a form of painting concerned with the minute inspection of the landscape, but even these perhaps less sophisticated artists succeeded in introducing a strange, sometimes even hallucinatory, quality to the hyper-realist representations which goes far beyond the Pre-Raphaelite abasement before nature. The emergence of these different aesthetic responses was a complex phenomenon; conflicting viewpoints were adopted and dismissed by successive generations and artistic cliques, and individual artists' careers carried within them evolutions from one extreme to another.

Despite its being an epoch of aesthetic experiment during which the mere replication of the forms of the physical world came increasingly to seem a prosaic form of art, British watercolorists of the Victorian period continued to observe an essential humility before nature. Painters across the board accepted the value of the direct experience of landscape – many actually chose to live in remote parts of the countryside so as to be in closer touch with their subject, while others traveled in search of places and specific views that they held to be particularly significant or found especially conducive to their art. Most of the artists in the present exhibition worked out of doors, savoring the very smell and sound of the open landscape, meditating on its physical forms and effects of light, and enduring the vicissitudes of the British weather. Painters regarded the knowledge which came from living and working in the landscape as a vital source of inspiration and considered its representation as a fundamental purpose of art. The watercolors that resulted remain fresh and compellingly immediate because they derived in the first place from the artist's heartfelt communion with the elements of nature.

Notes

1. Claude Phillips, *Frederick Walker* (London: Seeley and Co., 1894), p. 72.
2. *Art Journal*, June 1, 1868, p. 111.
3. Ibid., March 1875, p. 92.
4. Ibid., March 1876, p. 85.
5. Ronald Pickvance, *English Influences on Vincent van Gogh*, exh. cat. (London: Arts Council of Great Britain, 1974), p. 20.
6. *A Catalogue of Pictures and Sketches by George Mason, A.R.A., and George John Pinwell, A.R.W.S., Exhibited at the Royal Society of Artists, Birmingham, March 1895*, p. 8.
7. *Burne-Jones Talking*, ed. Mary Lago (London: John Murray, 1981), p. 79.
8. Walker, quoted in John George Marks, *Life and Letters of Frederick Walker, A.R.A.* (London: Macmillan and Co., 1896), p. 165.
9. Reproduced in Marks, *Walker*, p. 56.
10. North, quoted in Marks, *Walker*, p. 169.
11. Herbert Alexander, "John William North, A.R., R.W.S.," *Old Water-Colour Society's Club* 5 (1927–28): 42.
12. North, quoted in Marks, *Walker*, p. 168.
13. Walker, quoted in Marks, *Walker*, p. 121.
14. *Spectator*, May 8, 1880, p. 594.
15. Thomas Hardy, preface, *Far from the Madding Crowd* (London: Macmillan and Co., 1912), p. vii. Hardy's comment about giving his novel a contemporary setting comes from a preface supplied for later editions of the work. The novel originally appeared in monthly installments in *Cornhill Magazine* in 1874, with illustrations by Helen Allingham.
16. W. Graham Robertson, *Time Was* (London: H. Hamilton, 1931), p. 292.
17. Birket Foster, quoted in Marcus B. Huish, *Happy England, as Painted by Helen Allingham, R.W.S.* (London: Adam and Charles Black, 1909), p. 185.
18. Allingham, quoted in Huish, *Happy England*, p. 184.
19. A. L. Baldry, "Lionel P. Smythe, A.R.A., R.W.S.: An Appreciation of His Work and Methods," *Studio* 49 (1910): 177.
20. *Spectator*, December 5, 1885, p. 1615.
21. *Art Journal*, November 1, 1857, p. 344.
22. Violet Hunt, "Alfred William Hunt, R.W.S.," *Old Water-Colour Society's Club* 2 (1924–25): 32.
23. H. C. Marillier, *The Liverpool School of Painters* (London: John Murray, 1904), p. 238.
24. P. G. Hamerton, *Portfolio* 5 (1874): 181.
25. Walter Crane, *An Artist's Reminiscences* (London: Methuen and Co., 1907), p. 84.
26. *Art Journal*, March 1, 1869, p. 81.
27. J. C. Richmond, "Obituary. John Collingham Moore," *Art Journal*, October 1880, p. 348.
28. For a full account of Costa and his English followers, see Christopher Newall, *The Etruscans; Painters of the Italian Landscape, 1850–1900*, exh. cat. (Stoke-on-Trent Museum and Art Gallery, 1989).
29. Costa, quoted in Olivia Rossetti Agresti, *Giovanni Costa, His Life, Work, and Times* (London: Grant Richards, 1904), p. 121.
30. Giovanni Costa, *Quel che vidi e quel che intesi*, ed. Giorgina Costa Guerazzi (Milan: Fratelli Treves Editori, 1927), p. 121.
31. Walter Armstrong, "Victorian Fine Art," *Art Journal*, June 1887, p. 174.
32. Allen Staley, *The Pre-Raphaelite Landscape* (Oxford: Clarendon Press, 1973), p. 110, cites G. P. Boyce's *Thames by Night from the Adelphi* (Tate Gallery, London) of 1862 as an instance of his anticipating Whistler's interest in nocturnal Thames subjects. In addition, Inchbold's Venetian subjects, which include evening views of the city, also precede Whistler's vespertine views of London (p. 120).
33. David Park Curry, *James McNeill Whistler*, exh. cat. (Washington, D.C.: Freer Gallery of Art, 1984), p. 180.
34. *Art Journal*, June 1884, p. 191.
35. *Portfolio* 15 (1884): 144.
36. Reprinted in James McNeill Whistler, *The Gentle Art of Making Enemies* (London: William Heineman, 1892; New York: Dover Publications, 1967), p. 115.
37. James Caw, "A Phase of Scottish Art," *Art Journal*, March 1894, pp. 75–76.
38. Ibid., p. 76.
39. James Caw, "James Paterson, P.R.S.W., R.S.A., R.W.S.," *Old Water-Colour Society's Club* 10 (1932–33): 48.
40. Ibid., p. 53.
41. Whistler, *Gentle Art*, pp. 142–43.
42. Sir George Reid's article first appeared on February 4, 1893, in the columns of the *Westminster Gazette*; an extract (from which this quotation is taken), together with replies by various artists and critics, subsequently appeared in the *Art Journal*, April 1893, pp. 103–4.
43. Ibid., p. 104.
44. Ibid., pp. 103–4.
45. Whistler had an opportunity to study Turner's watercolors in 1858 when a group from the Turner Bequest was exhibited at Marlborough House. For information on Whistler's early attempts to copy works by Turner, I am indebted to Margaret MacDonald.
46. D. S. MacColl's article first appeared in the *Spectator* and was subsequently reprinted in C. Lewis Hind, *Hercules Brabazon Brabazon* (London: George Allen and Co., 1912), pp. 87–91.

Victorian Landscape Watercolors

Catalogue

1

WILLIAM HENRY HUNT
(1790–1864)
Pollard Elm and Village Pound, Hambledon, 1833
Watercolor and bodycolor
762 × 559 mm (30 × 22 in.)
Signed and dated lower right: *W. Hunt / 1833*
Harris Museum and Art Gallery, Preston

In the years immediately following his election as a member of the Society of Painters in Water-Colours in 1826, Hunt began a radical reconfiguration of his art. His earlier concentration on watercolor landscapes in transparent washes and strong outlines, which he had developed during his apprenticeship with John Varley and his association with the circle of Dr. Thomas Monro, was now succeeded by genre and still-life subjects in an elaborate bodycolor technique.[1]

Pollard Elm and Village Pound, Hambledon falls within the period of transition from Hunt's earlier to his later style, representing a foray into a type of landscape painting that the artist would not further pursue. The pollard elm was a standard element of picturesque composition, frequently isolated in the drawing manuals of the early nineteenth century as a motif to be copied; however, the scale of Hunt's treatment and the way the tree dominates the composition mark this as something new. In its narrowness of focus and its affectionate concentration on the tree's gnarled forms and the textures of its bark, the work anticipates later Ruskinian naturalism.

John Ruskin, who took lessons with Hunt, was a great admirer of Hunt's later still lifes, recommending their study in *The Elements of Drawing* (15.64, 152–53).[2] It was the meticulous bodycolor technique evident in a work such as *A Bird's Nest with Sprays of Apple Blossoms* (see fig. 1, p. 19) that appealed to Ruskin. Such works were both influential among artists and wildly popular with the public.

Pollard Elm and Village Pound, though it gives the impression of careful detail, is actually quite vigorous in the handling of paint. This impressive work does not appear to have been exhibited with the Society of Painters in Water-Colours, and seems to have remained in the artist's studio. The work may be identical to "A Study of a Pollard, near a Pond [Pound?]," which was included in the sale of the contents of Hunt's studio after his death.[3] SW

1. For Hunt's life and art, see *William Henry Hunt, 1790–1864*, exh. cat. (Wolverhampton Art Gallery, Eng., 1981), and John Witt, *William Henry Hunt, 1790–1864: Life and Work* (London: Barrie and Jenkins, 1982).
2. Ruskin frequently mentioned Hunt in his writings; in 1879–80 he provided an extended appreciation in his *Notes on Samuel Prout and William Hunt* for an exhibition of works by the two artists at the Fine Art Society, London.
3. London, Christie's, May 16–17, 1864, lot 308.

WILLIAM TURNER OF OXFORD
(1789–1862)

*Scene near Shipton on Cherwell, Oxfordshire –
Study from Nature*, exhibited 1835
Watercolor with bodycolor over pencil
546 × 752 mm (21½ × 29⅝ in.)
Inscribed and signed verso: *No. 5 / Scene near
Shipton on Cherwell, Oxfordshire – a study from nature. /
W. Turner. / Oxford.*; also inscribed verso: *T. Pearce*
Yale Center for British Art, Paul Mellon Fund

Exhibited with the Society of Painters in Water-
Colours in 1835, this was the first of a series of
watercolors depicting the River Cherwell cov-
ered with water lilies that Turner sent to the
Society's exhibitions over the next two decades.[1]
It was a subject with strong personal associa-
tions for Turner. The estate of Shipton-upon-
Cherwell near Oxford was owned by an uncle
who had looked after Turner following the
death of his father and who had arranged for the
young man's artistic training.[2]

Like William Henry Hunt, Turner was appren-
ticed to John Varley in London. By 1808, when
Turner became the youngest associate and later
in the same year a full member of the Society of
Painters in Water-Colours, he was considered by
critics and fellow artists as showing exceptional
promise. Within a few years he moved back to

Oxford, where he resided for the rest of his life.
Although he remained a member of the Society
and contributed works to its annual exhibitions
every year until his death, he never achieved
that prominence within the Society that his early
career had augured. Ruskin referred to him as
"a patient and unassuming master" whose con-
tributions to the Society were not sufficiently
valued (3.472).

Of the Cherwell water-lily subjects at the
Society, this is the only one identified in its title
as "a study from nature." It does, indeed, have a
greater freshness and naturalness than the later,
more enclosed, views of the Cherwell, such as
the one he exhibited in 1849 (Collection of the
Royal Society of Painters in Water-Colours,
London). In that impressive catalogue of the
river's plant and bird life, a degree of calculation
is apparent in the profusion of natural forms,
and the strong greens and twilight purples seem
more expressive than natural.

Although Turner did not enjoy in his later
years a status comparable to that of Cox,
DeWint, and William Henry Hunt, the acknowl-
edged giants of his generation in the Society, his
watercolors of the Cherwell form a brilliant
coda to the exhibition-manner naturalism of the
early nineteenth century. At the same time, their
bright, if idiosyncratic, color and the precision,
if at times stiffness, of their natural detail pro-

vide important markers on the road to the new
landscape. SW

1. The inscriptions on the verso of the drawing make
 clear that it was no. 219 in the 1835 exhibition. The
 title in the catalogue matches exactly that on the
 back of the drawing. A note by Turner in his copy
 of the catalogue (Turner's annotated set of Society
 of Painters in Water-Colours exhibition catalogues
 is in the National Art Library at the Victoria and
 Albert Museum, London) records the sale of the
 work to Mrs. Pearce, a frequent purchaser of his
 work in the 1830s. The other Cherwell water-lily
 subjects were exhibited in 1837, 1846, 1849, 1851,
 and 1854.
2. For Turner's life and art, see A. L. Baldry, "William
 Turner of Oxford, Watercolour Painter," *Walker's
 Quarterly*, no. 11 (April 1923); Martin Hardie,
 "William Turner of Oxford," *Old Water-Colour Society's
 Club* 9 (1931–32): 1–23; and Timothy Wilcox and
 Christopher Titterington, *William Turner of Oxford,
 1789–1862*, exh. cat. (Woodstock: Oxfordshire
 County Museum, 1984).

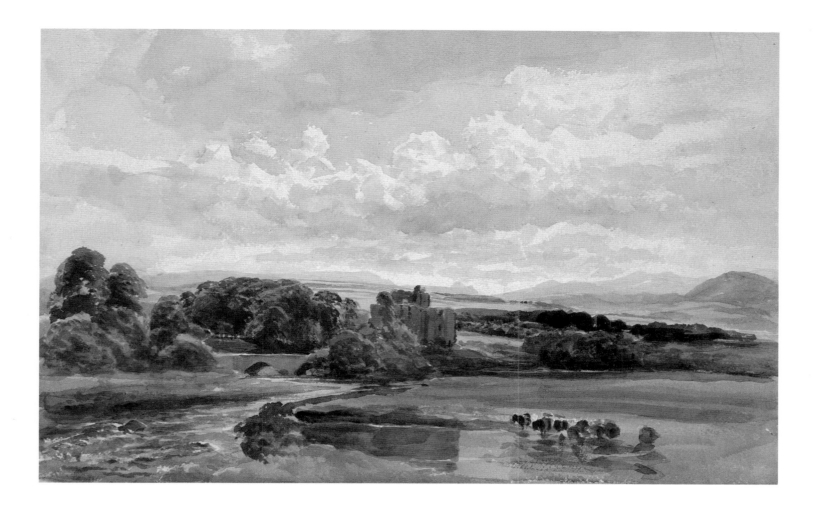

3

PETER DEWINT (1784–1849)
Brougham Castle, ca. 1840–45
Watercolor with gum over pencil
291 × 459 mm (11⁷⁄₁₆ × 18¹⁄₁₆ in.)
Inscribed verso: *Brougham Castle / 424*
The Syndics of The Fitzwilliam Museum,
Cambridge

A week after DeWint's death, his obituary in the *Athenaeum* commented on the constant nature of his art: "He sent his first works to the Old Water-Colour Exhibition of the year 1810. These were in character and feeling not unlike the works which he contributed to the Exhibition still open."[1] DeWint had at the outset of his career fashioned an approach to landscape and a water-color technique which served him with only slight alterations to the end of his life. Grounded in the styles of Thomas Girtin and John Varley, from whom DeWint took lessons in 1806, his art emphasized horizontal sweep, fluid brushwork, and rich, warm color.[2]

There was a distinction between sketches like *Brougham Castle* and more elaborate finished works, of which *On the Dart* (cat. no. 15) is the last and one of the greatest examples. Although the large-scale exhibition pieces were unquestionably the major public statements of his art, DeWint's sketches, like those of David Cox and William James Müller, occupied an especially valued niche in the artist's work. When Ruskin referred to DeWint's landscapes in the first volume of *Modern Painters*, he drew specific attention to the sketches (3.199).[3]

DeWint's power of generalization – "how much detail may be indicated by slight means if the execution be bold and broad" is how one critic put it[4] – was celebrated as his greatest strength. It was this generalizing quality in his art rather than any similarity of subject matter or reliance on classical landscape formats that led the reviewer for the *Athenaeum* to evoke the eighteenth-century painter Richard Wilson, calling DeWint "the very Wilson of water-colour painters."[5] SW

1. *Athenaeum*, July 7, 1849, p. 699.
2. For DeWint, see David Scrase, *Drawings and Watercolours by Peter De Wint*, exh. cat. (Cambridge: Fitzwilliam Museum, 1979), and Hammond Smith, *Peter DeWint, 1784–1849* (London: F. Lewis, 1982).
3. Ruskin wrote infrequently of DeWint's watercolors; when he did so, he unfailingly acknowledged their truthfulness (see cat. no. 4).
4. *Athenaeum*, May 8, 1847, p. 496.
5. Ibid. This association of DeWint with Wilson obviously struck the *Athenaeum*'s reviewer as particularly apt, for he repeated it on May 6, 1848, p. 466, and again on May 12, 1849, p. 496.

4

PETER DEWINT (1784–1849)
Cornfield, Windsor, 1841
Watercolor with gum and scraping out over pencil
290 × 461 mm (11⁷⁄₁₆ × 18¹⁄₈ in.)
Inscribed and dated verso: *Windsor / August 1841*
The Syndics of The Fitzwilliam Museum,
Cambridge
Exhibited at Yale and Cleveland only

The *Spectator*'s critic in 1845, attempting to characterize DeWint's landscapes, cited two basic types – one of which corresponds with *Cornfield, Windsor*, the other with *Brougham Castle* (cat. no. 3):

Dewint's corn-fields and hay-fields, with harvest-men at work under a moist and clouded yet sultry atmosphere – and his river-scenes with bosky foliage and empurpled ground, showing a ruined abbey, distant church, or village roofs nestling among trees – are equally charming; save when his mannerism intervenes to remind us that the tone of his pictures – deep, rich, and verdantly fresh as it is – is artificial in its uniformity.[1]

The charge of mannerism dogged DeWint, as it did Cox. It was in a sense the obverse of the acclaim for the sketchlike aspects of their work. The bold and obvious evidence of the artist's hand invited such criticism, yet the mannerist accusation was countered by assertions of the essential truthfulness of DeWint's watercolor art.

Ruskin wrote to a friend in 1840 that DeWint was "a most ardent lover of truth – hardly ever paints except from nature, attends constantly

4

5

and effectually to colour and tone, and produces sketches of such miraculous truth of atmosphere, colour and light, that half an hour's work of his, from nature, has fetched its fifty guineas." A few lines later, Ruskin summed up: "DeWint is always true, always wonderful, and always ugly" (1.427).

The provocatively jarring "ugly" in Ruskin's statement must reflect a widely held perception that, while DeWint's watercolors were unexcelled in truthfulness, they were deficient in higher poetry. His art was described by another critic as employing a "lucid prose style, plain, neat, and truthful."[2] SW

1. *Spectator*, May 3, 1845, p. 426.
2. *Spectator*, May 6, 1848, p. 446.

WILLIAM CALLOW (1812–1908)
Wallenstadt from Wesen, exhibited 1842
Watercolor with bodycolor and scraping out over pencil
445 × 645 mm (17½ × 25⅜ in.)
Signed lower left: *W. Callow*
Yale Center for British Art, Paul Mellon Collection

In the 1830s, Callow, residing in Paris, was encouraged by John Frederick Lewis to join the Society of Painters in Water-Colours.[1] When he submitted drawings to the Society in 1838, he was promptly made an associate. In the autumn of the same year, he also made his first sketching expedition into Switzerland. During the trip he visited Lake Wallenstadt and made the study (also in the Yale Center for British Art) on which this exhibition watercolor was based.[2] *Wallenstadt from Wesen* was exhibited at the Society of Painters in Water-Colours in 1842, the year after Callow returned to England and settled in London. Later in 1842 he exhibited the work again at the Royal Liverpool Academy.

From 1838 until his death, Callow was a contributor to every exhibition of the Society, of which he became a member in 1848. His exhibited works were predominantly Continental subjects, like the *Wallenstadt*. The dashing execution which was noted when Callow first exhibited in London was tempered by the demands of producing large studio works for the Society.

Yet the influences of Richard Parkes Bonington and J. M. W. Turner, imbibed during Callow's years in France in the 1830s, continued to resonate in his work right into the early years of the twentieth century. SW

1. For Callow, see his *Autobiography*, ed. H. M. Cundall (London: Adam and Charles Black, 1908), and Jan Reynolds, *William Callow, R.W.S.* (London: B. T. Batsford, 1980).
2. Until the study, which is inscribed "Lake Wallenstadt / from Wesen," surfaced in 1978, the exhibition watercolor was erroneously identified as *The Ferry, Glenelg* and dated ca. 1849. See Jane Bayard, *Works of Splendor and Imagination: The Exhibition Watercolor, 1770–1870*, exh. cat. (New Haven: Yale Center for British Art, 1981), p. 80.

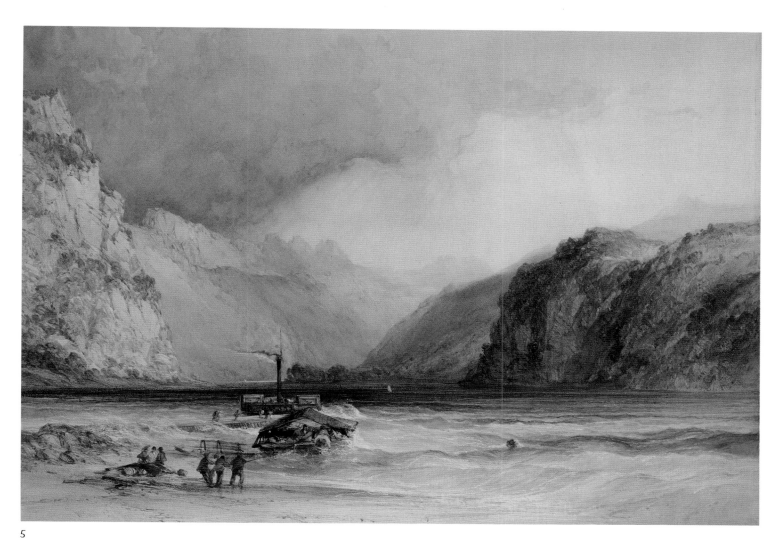

5

6

SAMUEL PALMER (1805–1881)
View from Rook's Hill, Kent, ca. 1843
Watercolor with bodycolor and pen and ink
over pencil
520 × 416 mm (20½ × 16⅜ in.)
Yale Center for British Art, Paul Mellon
Collection

Palmer was elected an associate of the Old
Water-Colour Society in 1843. This recognition
came a year after the birth of his eldest child
and a year before the birth of a second. It was a
time when Palmer, faced with new family re-
sponsibilities, approached the business of mak-
ing a living from his art with a new seriousness.[1]

In the 1820s, as one of a band of young artists
who styled themselves the Ancients, Palmer had
sought mystical communion with nature and
found inspiration in the works of William Blake
and the early German prints of Albrecht Dürer
and his contemporaries. Under pressure from
his father-in-law, the successful portrait and
landscape painter John Linnell, Palmer put aside
the highly individual landscape style of those
early years. His work showed no lessening in the
intensity of his response to nature, but that in-
tensity was channeled into a mode of expres-
sion that was less idiosyncratic.

Palmer wrote to his fellow Ancient George
Richmond, early in 1843, asking: "Would you be
kind enough to look me out those sketches of

rock which you had when painting the group of
children one of whom was sitting on a rock –
and a pen and ink sketch of the Underriver dis-
tance – seen in a slice between the banks of the
rooks hill lane – I am painting a subject of this
kind and a reference to the above would be very
valuable."[2] The Yale watercolor seems to be the
painting on which Palmer was at work. SW

1. For Palmer's life and art, see the memoir by his
son, A. H. Palmer, *The Life and Letters of Samuel Palmer*
(London: Seeley and Co., 1892). Among the many
useful volumes on Palmer and his associates by
Raymond Lister, two of the more recent are *Samuel
Palmer: His Life and Art* (Cambridge: Cambridge
University Press, 1987) and *Catalogue Raisonné of the
Works of Samuel Palmer* (Cambridge: Cambridge
University Press, 1988), both of which have up-to-
date bibliographies.
2. Palmer, letter to George Richmond, [January 1843],
in *The Letters of Samuel Palmer,* ed. Raymond Lister,
2 vols. (Oxford: Clarendon Press, 1974), vol. 1,
p. 419. In both the annotations to this letter and the
entry for this watercolor in his *Catalogue,* Lister
identifies the location as Rook's Hill Beacon in
Sussex; however, Palmer's reference to the
"Underriver distance" would seem to place the
view in the vicinity of Under River in Kent, the
subject of many Palmer drawings of the period.

7

WILLIAM JAMES MÜLLER
(1812–1845)
Leigh Woods, 1844
Watercolor and bodycolor over pencil
517 × 340 mm (20⅜ × 13⅜ in.)
Inscribed, dated, and signed lower left: *Leigh
Woods / May 44 WM*
The Trustees of the Tate Gallery, London

By the time of his death at the age of thirty-
three, Müller had gained a reputation as a mas-
ter of the sketch in both watercolors and oils.
His biographer, Nathaniel Neal Solly, wrote in
1875 that Müller's stature as an artist rested on
his sketches rather than his finished works.[1]
Joseph John Jenkins, who introduced Müller to
the informal association of artists known as the
Clipstone Street Academy in 1840, recalled that
"as a sketcher he had few if any equals in the ra-
pidity, quantity, or quality of his work."[2]

Müller grew up in Bristol, participating in the
active art life of that city. He was apprenticed to
the Bristol landscape painter James Baker Pyne,
and in 1833 he joined with other young Bristol
artists in forming a sketching club. He made his
first journey abroad in 1834, traveling to the
Continent with his friend George Arthur Fripp.
After an extended visit to Greece and Egypt in
1838 and 1839, he settled in London and began
to make his mark on the London art scene. In
1843 he returned to the Middle East, accom-

6

7

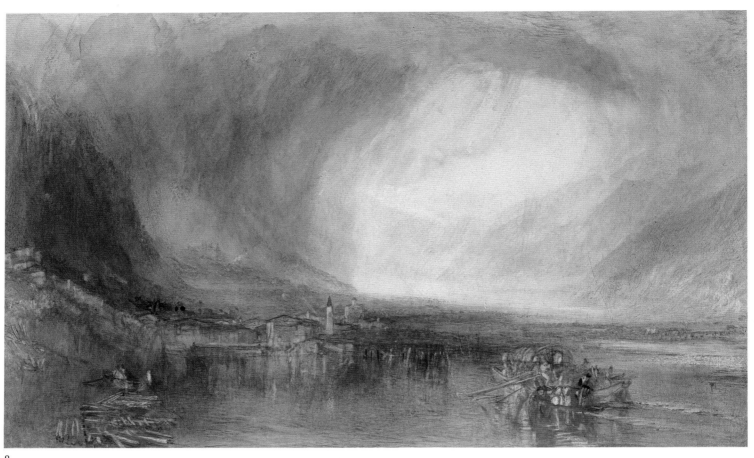

8

panying Sir Charles Fellows's archaeological expedition to Lycia.

Back in England in May 1844, he traveled to Bristol to stay with his brother. There he spent time with John Harrison, his physician and a frequent sketching companion. When Solly was compiling his biography of Müller in 1874, Harrison wrote to him, recounting a visit to Leigh Woods near Bristol in which he and Müller were joined by Müller's brother and another longtime friend of Müller, the Reverend John Eagles (whose criticism of Turner in *Blackwood's Magazine* prompted Ruskin's initial defense of the artist). Harrison, interested in the changes that had occurred in Müller's style, described in detail the creation of what must be the Tate's drawing:

Müller made a magnificent sketch, the background indicated by a wash in the old way; the nearer trees put in magically with the camel-hair, but with rather a drier, crisper touch, I thought. A large ash-tree stood upon a marly rocky bank; the earth had crumbled away, and the roots were exposed in snake-like contortions of various lengths and colour; he outlined them all, giving every twist and turn backwards and forwards, scarcely moving his pencil from the paper. In colouring he separated them with rapid dark touches from each other: it seemed almost impossible to avoid damage, in this network of angles and circles, to the narrow outline — but no, in a few minutes he had compassed all. This sketch (half imperial) on white Harding paper, large trees in the foreground, with rockwork and details of roots, &c., and the background of trees in gradations of distance indistinctly characterized, occupied him about the usual two hours. His rapid precision was wonderful; all was done upon the spot. Müller rarely touched upon his sketch after he left the ground. I thought

his power of drawing was, if possible, increased. His sketch, like his other works, always beautiful in subdued tone and in the absence of strong colour, was even more grey and silvery than before he left.[3]

Over the following winter, spent in London, Müller's health declined. He returned to Bristol in the summer and it was there that he died on September 8. sw

1. N. Neal Solly, *Memoir of the Life of William James Müller* (London: Chapman and Hall, 1875), p. 233. Solly's is the most complete account, but see also Cyril G. E. Bunt, *The Life and Art of William James Müller of Bristol* (Leigh-on-Sea: F. Lewis, 1948), and Francis Greenacre and Sheena Stoddard, *W. J. Müller, 1812–1845*, exh. cat. (Bristol Museums and Art Gallery, 1991).
2. Jenkins, letter to Solly, November 7, 1874, quoted in Solly, *Müller*, p. 94. The Clipstone Academy was formed about 1824 by eight or nine artists who met to draw beggars and other street people of picturesque appearance who were recruited to model. Jenkins was the honorary secretary of the group. Edward Duncan and later George Price Boyce and Thomas Seddon were also members.
3. Harrison, quoted in Solly, *Müller*, pp. 248–49.

8

JOSEPH MALLORD WILLIAM TURNER (1775–1851)
Fluelen, from the Lake of Lucerne, 1845
Watercolor with scraping out
290 × 476 mm (11⅜ × 18¾ in.)
The Cleveland Museum of Art,
Mr. and Mrs. William H. Marlatt Fund

In the summer of 1841 Turner toured Switzerland for the first time since his earliest Continental visit in 1802. According to Ruskin, the trip had a reinvigorating effect on the artist: "The faculties of imagination and execution appeared in renewed strength; all conventionality being done away by the force of the impression which he had received from the Alps, after his long separation from them" (12.390).[1] As he traveled, Turner made quantities of watercolor sketches, and from these he created a set of watercolors unlike any he had done before both in their appearance and in the manner in which he offered them to the public.

Early the following spring, Turner deposited with the dealer Thomas Griffith fifteen sample studies taken from the sketchbooks used on his Swiss tour. From the fifteen studies, Turner proposed to make ten finished watercolors. He had worked up four already, which he also left with Griffith to show what the finished works would be like. Griffith was to find purchasers, but, in the event, only three turned up: John Ruskin and two of the major patrons of Turner's later years, Hugh Munro of Novar and Elhanan Bicknell. Between them they took nine.[2]

For the next three summers, Turner returned to Switzerland. In 1843 and 1845 he proposed

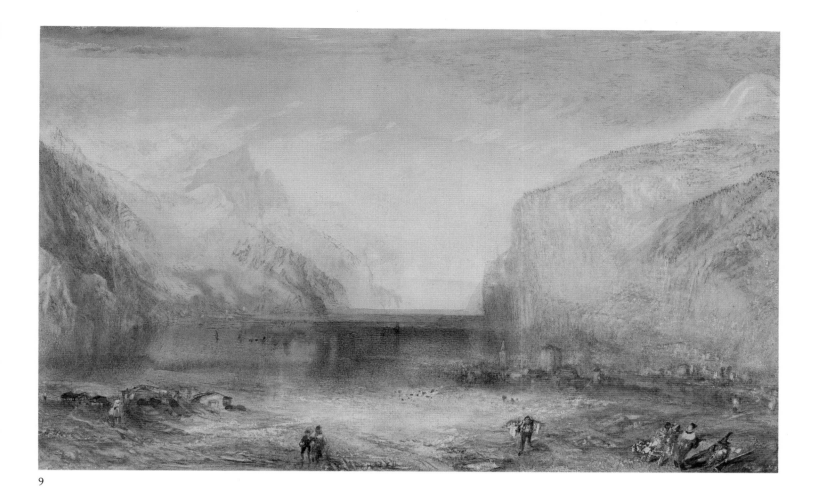

9

further sets of Swiss watercolors, offered through Griffith on the same arrangement as the previous set. Of the ten offered in 1843, only six were ordered and completed. These were purchased by Munro of Novar and Ruskin. All ten of those offered in 1845 were completed, again with Munro of Novar and Ruskin as the principal purchasers. *Fluelen, from the Lake of Lucerne* was one of three from the 1845 set bought by Munro of Novar.

The dark, overarching clouds of this watercolor recall those of Turner's great oil painting of 1812, *Snowstorm: Hannibal and His Army Crossing the Alps* (Tate Gallery, London), and an earlier strain of sublime imagery. Yet the tenor of the watercolor is neither retrospective nor valedictory. It shares with the other late Swiss watercolors a light-filled expansiveness and a flexible, almost intuitive, sense of touch shifting seamlessly from the delicate to the bold, the precise to the amorphous.

Although the initial response to the late Swiss watercolors was limited to a small coterie of sympathetic patrons, Ruskin predicted at the beginning of the 1850s that these drawings "will be recognized, in a few years more, as the noblest landscapes ever yet conceived by human intellect" (12.391). Although Ruskin's enthusiasm got the better of his predictive power, the drawings have come to be seen as the great culmination of Turner's work as a watercolorist.[3] sw

1. John Gage considers the historical and ideological motivation for Turner's Swiss visits of the 1840s in *J. M. W. Turner: "A Wonderful Range of Mind"* (New Haven and London: Yale University Press, 1987), pp. 62–65.

2. Ruskin gave a detailed account of the arrangement with Griffith and the early history of the Swiss watercolors in the notes he provided for the exhibition of his collection of Turner's drawings at the Fine Art Society in 1878 (13.475–85). See also Andrew Wilton, *Turner in His Time* (London: Thames and Hudson, 1987), pp. 223–28. The finished Swiss drawings of 1842–45 are nos. 1523–49 in the catalogue of Turner's watercolors in Andrew Wilton, *J. M. W. Turner: His Art and Life* (New York: Rizzoli, 1979), pp. 482–86.

3. Gage, for instance, refers to the Swiss works as "the most important series of painting in Turner's later career"; "*A Wonderful Range of Mind*," p. 62.

9

JOSEPH MALLORD WILLIAM
TURNER (1775–1851)
Fluelen: Morning (Looking towards the Lake), 1845
Watercolor with scraping out
299 × 481 mm (11¾ × 18¹⁵⁄₁₆ in.)
Yale Center for British Art, Paul Mellon
Collection

By 1845 Turner's health was deteriorating. Illness had cut short his Swiss tour in 1843 and precluded any further visits to Switzerland after 1844. Although Turner continued to paint watercolors late into the decade, for Ruskin his career effectively ended with the series of Swiss watercolors he produced in 1845.[1]

Fluelen: Morning (Looking towards the Lake) was one of this series, purchased originally by Munro of Novar but later traded to Ruskin for another of the set. When Ruskin exhibited his Turner watercolors at the Fine Art Society in 1878, he wrote of this as "the last Alpine drawing Turner ever made with loving power; – not unabated power, – for it was painted in 1845, the year of his failure; and it shows, in the foreground work, incipient conditions of fatal decline" (13.459). Certainly the distortions of scale evident throughout the Swiss watercolors of the 1840s are particularly extreme in this example. The elements of the composition seem to float across the sheet, giving the work a strangely disembodied quality, described by Ruskin as "fading away into a mere dream of departing light." sw

1. Ruskin did, however, purchase two later watercolors from Turner in 1848. See Andrew Wilton, *J. M. W. Turner: His Art and Life* (New York: Rizzoli, 1979), p. 242.

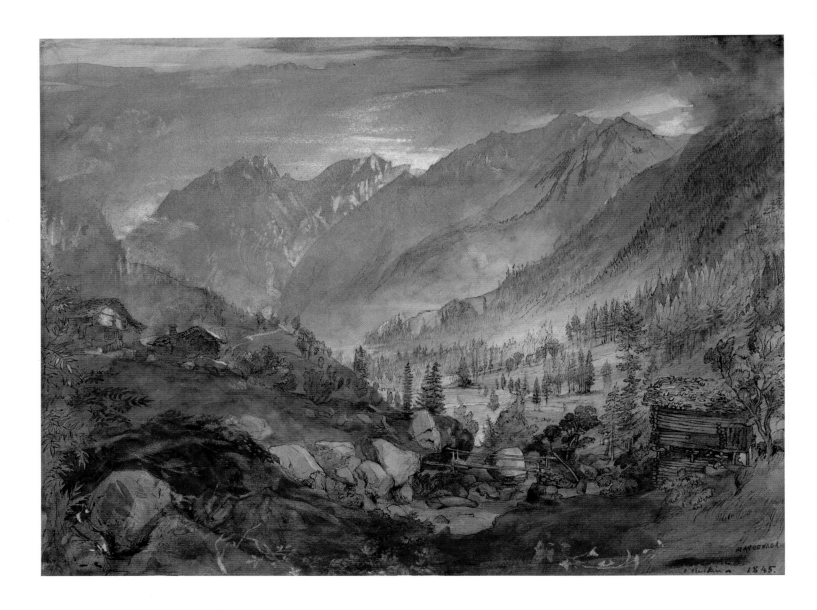

JOHN RUSKIN (1819–1900)
Mountain Landscape, Macugnaga, 1845
Brown and gray wash with pen and brown ink
and scraping out over pencil
298 × 405 mm (11¾ × 15⅞ in.)
Inscribed, signed, and dated lower right:
MACUGNAGA / J Ruskin 1845
Yale Center for British Art, Paul Mellon
Collection

Ruskin spent most of 1845 on the Continent.
Two years had passed since the first volume of
Modern Painters was published, and the author was
searching for new ideas and studying paintings
and architecture before embarking on the sec-
ond and, as he then envisaged, final volume. In
the high summer of 1845, after a period of inten-
sive work in Tuscany, he wrote to his father: "I
begin to feel the effects of the violent excitement
of the great art at Florence – nothing gives me
any pleasure at present, and I shall not recover
spring of mind until I get on a glacier."[1] For this
purpose he rented a chalet at Macugnaga in the
Piedmontese Alps at the foot of Monte Rosa.
There he attempted to relax, making records of
the mountain landscape such as the present
watercolor, involving himself in the local hay-
making, and reading Shakespeare.

Ruskin's landscape sketching was not simply a
holiday pastime but a means of investigation. He
spent long hours making detailed studies of
clouds, vegetation, and rock formations and per-
fected a drawing technique which served both
aesthetic and scientific purposes – not only rep-
resenting the forms of nature by means of rich,
rhythmic, curving lines and dense, vibrant pat-
terns but also providing literal documentation
of the landscape.

Late in the summer Ruskin met his old draw-
ing master, J. D. Harding, in Baveno on Lago
Maggiore. The different objectives each pursued
were by now obvious to Ruskin. Writing to his
parents, Ruskin contrasted Harding's pretty and
artfully composed sketches with his own, which
he characterized as ugly but factual: "Harding's
are all for impression; mine all for information"
(3.201n). CN

1. *Ruskin in Italy: Letters to His Parents, 1845*, ed. Harold
 I. Shapiro (Oxford: Clarendon Press, 1972), p. 148.

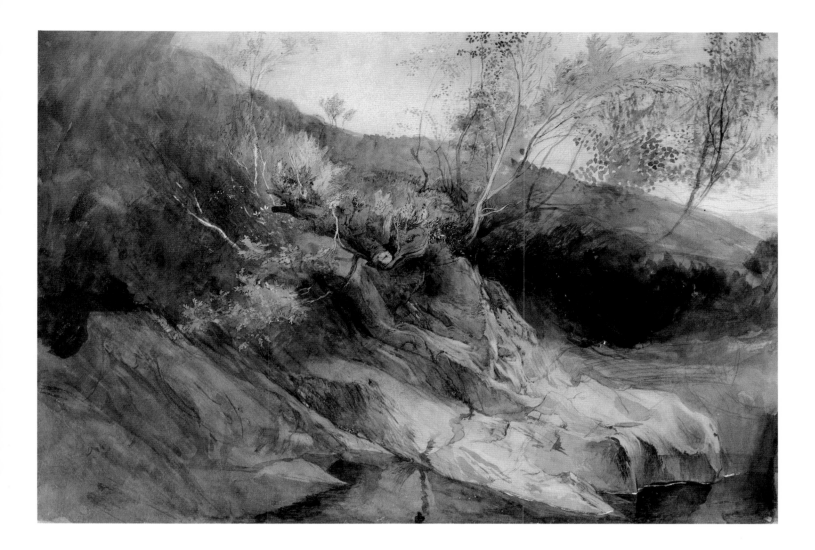

11

JOHN RUSKIN (1819–1900)
The Rocky Bank of a River, ca. 1845–50
Gray wash with pen and black ink and
bodycolor over pencil
325 × 473 mm (12¾ × 18⅝ in.)
Verso: a plant study in pen and brown ink
over pencil
Yale Center for British Art, Paul Mellon Fund

Neither the location of this subject nor the precise date of the drawing has been established. On stylistic grounds, it may be associated with the type of drawing Ruskin was doing on his European tour of 1845, discussed in connection with *Mountain Landscape, Macugnaga* (cat. no. 10), and in the following years in Britain, France, Italy, and Switzerland. The masses of the landscape are built up from a combination of washes placed over rapidly drawn pen lines. A comparison with drawings such as *Stone Pine at Sestri* (Ashmolean Museum, Oxford), securely dated to 1845, reveals a similar conjunction of closely focused detail with surrounding undefined areas. Paul Walton has written of this style of drawing:

These designs are essentially "foreground studies," where tree trunks and branches form flowing arabesques interwoven with the contours of rock and cloud, nervously outlined by the pen in flat patterns of considerable decorative elegance. Yet the effect is not simply decorative, for there is *a flame-like agitation in the rhythm of pen and brush stroke that conveys intense emotional excitement.*[1]

In the case of the Oxford drawing a sense is given of the artist working outward from a central area of precise draftsmanship, with subsidiary areas more perfunctorily treated. In the present drawing the initial conception of the overall shapes and masses of the composition can be seen, freely drawn in soft pencil. This more generalized approach is by no means incompatible with Ruskin's work in the 1840s and is particularly evident in the drawings he made after other artists' works, for example, his copy of the central portion of Tintoretto's *Crucifixion* (Bembridge School, Isle of Wight).

The representation of rocks and water either in stream beds or along the coast became one of Ruskin's favorite motifs of the later 1840s. In 1847 he traveled to Scotland, where he drew *Coast Scene, near Dunbar* (Birmingham Museum and Art Gallery), which has a volumetric quality similar to that of *The Rocky Bank of a River*. The consummation of this particular interest came in his *Gneiss Rock at Glenfinlas* (Ashmolean Museum, Oxford) of 1853 and *In the Pass of Killiecrankie* (cat. no. 30) of 1857. CN

1. Paul H. Walton, *The Drawings of John Ruskin* (Oxford: Clarendon Press, 1972), pp. 58–60.

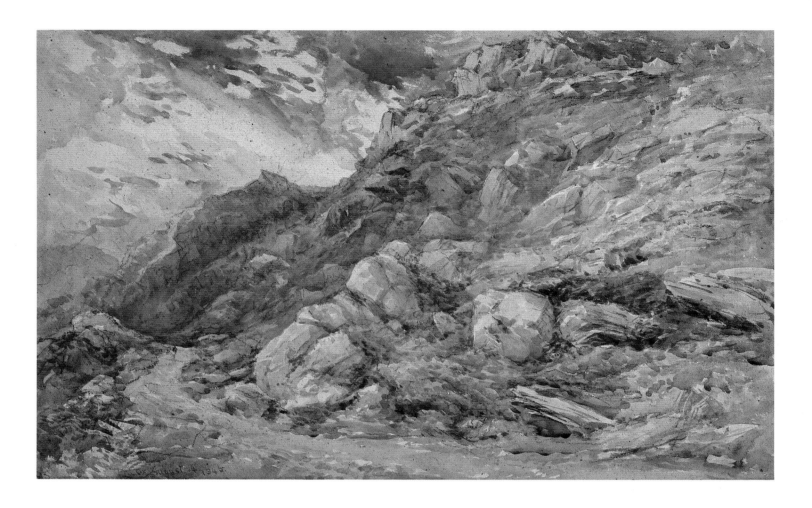

12

DAVID COX, SR. (1783–1859)
View near Bettws-y-Coed, 1846
Watercolor over black chalk on rough
"Scotch" paper
464 × 737 mm (18¼ × 29 in.)
Signed and dated lower left: *D. Cox August 14 1846*
Birmingham Museum and Art Gallery

From 1812 until his death, Cox was a regular ex-
hibitor with the Society of Painters in Water-
Colours. He was elected a member in 1813, hav-
ing previously been a member and briefly presi-
dent of the short-lived Associated Artists in
Water-Colours. From an early date he was also
well known as the author of popular drawing
manuals: *A Treatise on Landscape Painting and Effect in
Water Colours* (1814), *Progressive Lessons on Landscape
for Young Beginners* (1816), and *The Young Artist's
Companion* (1825). Yet his most distinctive
achievements as a watercolor painter and his
reputation as a major figure in the British water-
color school belong to the last two decades of
his life.

After many years' residence in London, he re-
turned to his native Birmingham in 1841, taking
a house in Harborne, then a quiet village on the
southwestern outskirts of the city. He gave up
the teaching that had until then provided a sig-
nificant part of his livelihood and devoted much
of his time to oil painting, which he had taken
up seriously several years before.

Between 1844 and 1856 he made yearly pil-
grimages in the summer or autumn to the
Welsh village of Bettws-y-Coed. Although lo-
cated amid the celebrated mountain scenery of
North Wales, the village was little frequented in
the years before Cox began his visits. During the
thirteen years that he was a regular visitor, it be-
came something of a summer artist's colony,
with Cox as the presiding genius.

Cox's days at Bettws-y-Coed were largely de-
voted to working outdoors in both oils and wa-
tercolors. The increased importance he attached
to plein-air sketches in this period coincided
with the greater freedom of handling in his stu-
dio productions for the Society of Painters in
Water-Colours exhibitions. Yet Cox was con-
cerned that the distinction between his sketches
and his finished drawings be maintained.
George Popkin, an admirer of Cox and a visitor
to Bettws-y-Coed, recorded him as saying: "I am
only showing you how I *sketch*. These are three
sketches I have just done for you, they are not
drawings [presumably Cox used 'drawing' to
mean finished watercolor]. I have done the same
for other people, and they have sold them after-
wards as my drawings."[1]

View near Bettws-y-Coed is one of four such
sketches, commissioned in the summer of 1846
by T. N. Sherrington of Yarmouth, who was a
guest at the Royal Oak, the inn at Bettws-y-Coed
where Cox habitually stayed.[2] The watercolor is
on the rough Scottish wrapping paper Cox dis-
covered in 1836 and frequently used for both
sketches and finished drawings. This "Scotch"
paper was ideally suited to a bolder, more
sketchlike approach, its rough texture encourag-
ing a broad handling and its absorbency contrib-
uting a softening effect. SW

1. George Popkin, letter to Nathaniel Neal Solly,
 quoted in Solly, *Memoir of the Life of David Cox*
 (London: Chapman and Hall, 1873; London: Rodart
 Reproductions, 1973), p. 174. Solly's is one of two
 biographies of Cox by men who knew him; the
 other is William Hall, *A Biography of David Cox*
 (London: Cassell, Petter, Galpin, 1881). These re-
 main the most complete and reliable accounts of
 the artist's life. For more recent treatments of the
 artist, see Stephen Wildman et al., *David Cox,
 1783–1859*, exh. cat. (Birmingham Museum and Art
 Gallery, 1983), and Scott Wilcox, "David Cox: His
 Development as a Painter in Watercolors" (Ph.D.
 diss., Yale University, 1984).
2. For a summary of the correspondence concerning
 this commission, see Wildman et al., *Cox*, cat.
 no. 123.

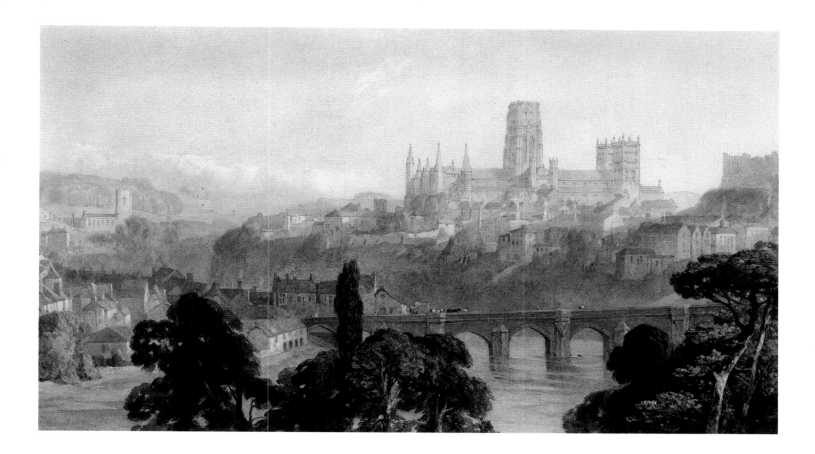

13

GEORGE ARTHUR FRIPP
(1813–1896)
Durham Cathedral, 1846
Watercolor with scraping and rubbing out and
touches of bodycolor over pencil
358 × 628 mm (14⅛ × 24¾ in.)
Signed and dated lower right: *G A Fripp / 1846*
Yale Center for British Art, Paul Mellon Fund

Durham, with its Norman cathedral dramati-
cally perched above a bend in the River Wear,
was one of the preeminently picturesque sites in
northeast England, the subject of notable water-
colors by Edward Dayes, Thomas Girtin, J. M. W.
Turner, John Sell Cotman, and a host of lesser
topographical watercolorists. George Arthur
Fripp treated the subject frequently in his exhib-
ited works of the 1840s. He contributed Durham
views to the Society of Painters in Water-Colours
in 1843, 1845, 1846 (presumably the Yale water-
color), and 1849, and showed an oil painting of
the city at the Royal Academy in 1844.

Fripp's view in this instance is from the north-
east, looking over the Elvet Bridge toward the
cathedral with the castle visible on the right. In
its soft, rubbed appearance with the architec-
tural detail clearly picked out in pencil, the wa-
tercolor is reminiscent of the work of Fripp's
teacher, the Bristol artist Samuel Jackson.

A native of Bristol, Fripp grew up in that city's
thriving art community.[1] In addition to his
studies with Jackson, he took lessons in oil
painting from another prominent Bristol artist,
James Baker Pyne. During his early years in
Bristol, Fripp was a close friend of William
James Müller, and in 1834 they traveled together
for seven months on the Continent.

Fripp began his professional career in Bristol
as a portraitist in oils, but he soon abandoned
his portrait practice to paint landscapes in wa-
tercolor. By 1838 he had moved to London.
He was elected an associate of the Society of
Painters in Water-Colours in 1841, becoming a
full member three years later. A faithful member
of the Society until his death, he served as its
secretary from 1848 to 1854 and again briefly in
1864 and 1865.

Considered one of the most promising young
landscape painters of the 1840s, he went on to
establish a reputation as one of the foremost ex-
ponents of the older school of pure landscape.
In 1874 the *Spectator's* critic wrote of him:

*We have no greater landscape painter. A veteran of the
Society, and possessed of many of the traditions of the best
school of landscape that the world has seen, he happily
does not follow the example of some of the most eminent
of his predecessors [the reference here is undoubtedly to
David Cox] by adopting in his later years what is popu-
larly called a broader style, but which generally means
more slovenly handling and slighter work. Breadth, in the
artistic sense, is one great characteristic of Mr. Fripp's
painting, but it is obtained neither by dash and impulse,
nor by a discipline which has become mechanical, but by
an increase of refinement.*[2] SW

1. See H. Stuart Thompson, "George A. Fripp and
 Alfred D. Fripp," *Walker's Quarterly* 7 (1928–29).
 George Fripp's younger brother, Alfred Downing,
 also became a watercolorist of note, specializing in
 genre subjects.
2. *Spectator*, April 25, 1874, p. 402.

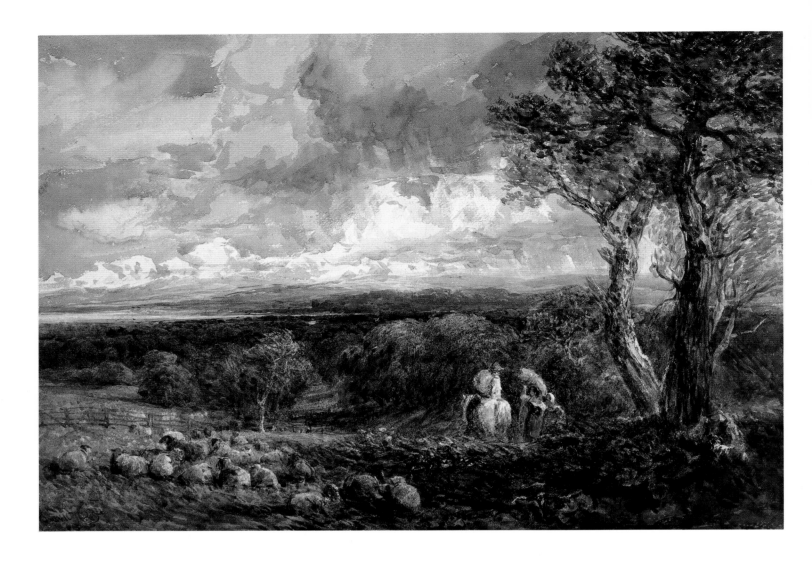

14

DAVID COX, SR. (1783–1859)
Vale of Clwyd, 1848
Watercolor with scraping out and bodycolor
473 × 679 mm (18⅝ × 26¾ in.)
Signed and dated lower left: *David Cox / 1848*
The Trustees of the British Museum, London

In 1839 Cox received lessons in oil painting from William James Müller. Perhaps reflecting his experience with oil painting, Cox's watercolors gained in richness and density while displaying a greater boldness of touch. In heavily worked watercolors such as the *Vale of Clwyd*, the forms of the landscape are softened but given added weight by a process of adding color, then rubbing and scraping out, and adding further touches of color.

During a tour of Wales with Harry John Johnson, a pupil of Müller, in 1844, Cox visited the Vale of Clwyd, sketching the view from Sir John Williams's park near Rhyl. The vale provided Cox with the subject for a number of his most ambitious works in both watercolors and oils over the next five years. This is one of two watercolor versions painted in 1848, probably the one shown at the Society of Painters in Water-Colours exhibition for that year. It reproduces the composition of an oil painting of 1846 (Towneley Hall, Burnley). Cox returned to the subject for a last major work in 1849, when he painted another oil (Fitzwilliam Museum, Cambridge), widely regarded as one of his greatest achievements in that medium. SW

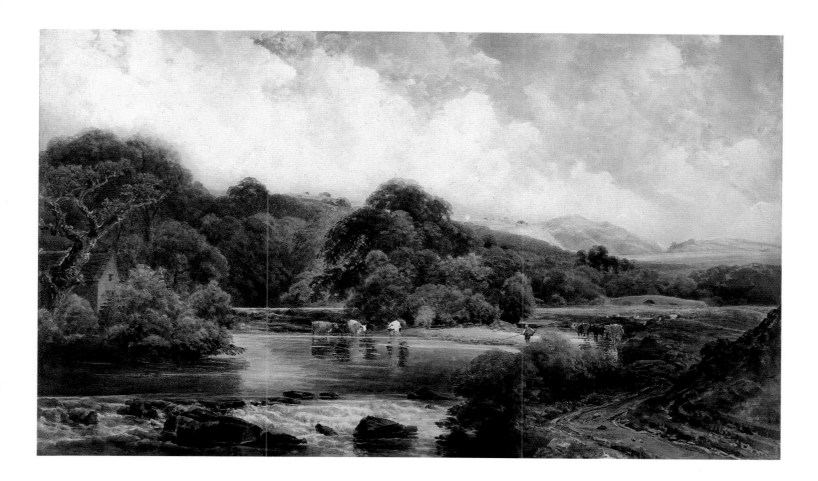

15

PETER DEWINT (1784–1849)
On the Dart, exhibited 1849
Watercolor with gum, bodycolor, and
wiping out
557 × 946 mm (21¹⁵⁄₁₆ × 37¼ in.)
The Syndics of the Fitzwilliam Museum,
Cambridge

In the autumn of 1848, DeWint made his last
sketching expedition into the countryside, vis-
iting Devonshire. A study for this, the last major
exhibition piece he completed, bears an inscrip-
tion in the artist's hand: "Holne Chase on the
River Dart, Devonshire / 9th Sept. 1848."[1]

When *On the Dart* was exhibited at the Society
of Painters in Water-Colours the following
spring, it was recognized as one of DeWint's
outstanding works. The reviewer for the
Athenaeum considered it the high point of his
career:

*Mr. De Wint's drawings this year are as remarkable for
breadth and mastery of handling as any we have hitherto
seen by him. He has never surpassed the large view on the
River Dart – Devonshire (38). The breadth of its
light and shade is admirable. The water is delicious; and
the drawing is expressive of all the best attributes of
Mr. De Wint's art.[2]*

While not quite as enthusiastic, the *Art Journal*
stressed the simplicity and lack of rhetoric in
DeWint's conception and linked *On the Dart* with
past excellences of the watercolor tradition:
"The subject, like all those of this artist, is by no
means remarkable for any striking picturesque
association. The components are ordinary, but
they are treated with decision, and the colour is

unexceptionable. The manner of this work re-
minds us of the best qualities of the old school
of water-colour."[3]

Although the critic for the *Spectator* did not sin-
gle out *On the Dart* for specific comment, he
wrote of the artist, who was by that time gravely
ill and less than two months from his death, that
"his eye seems to grow more clear with age and
his hand more faithfully vigorous." Taking up
the theme of DeWint's straightforward, truthful
approach to landscape, the critic concluded,
"he takes plain English nature in her everyday
aspect, and by the sheer force of knowledge and
skill, he transfers the distinct forms, the vivid
sobriety, to his paper."[4] SW

1. This watercolor, along with two other studies
 for *On the Dart*, is in the Fitzwilliam Museum,
 Cambridge.
2. *Athenaeum*, May 12, 1849, p. 496.
3. *Art Journal*, June 1, 1849, p. 177.
4. *Spectator*, May 5, 1849, p. 422.

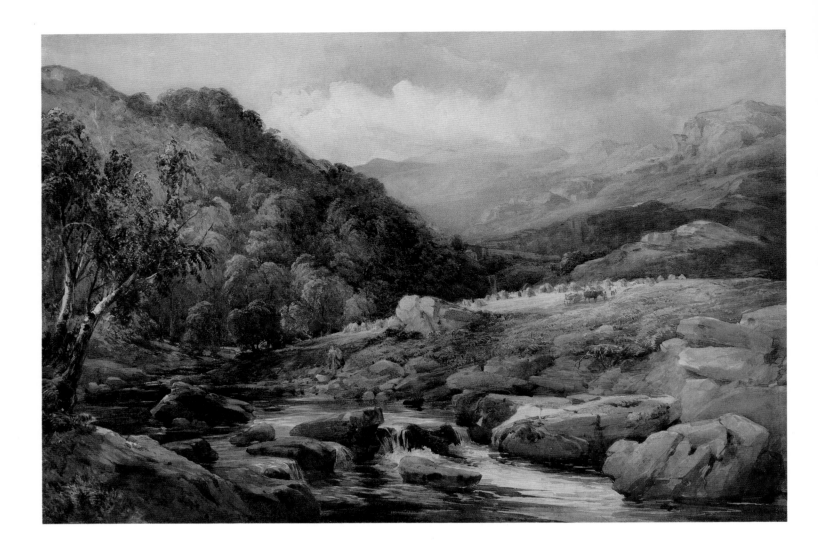

16

DAVID HALL McKEWAN (1817–1873)
*Landscape with Stream and Haymakers near
Bettws-y-Coed*, ca. 1850–55
Watercolor with rubbing out and bodycolor
over pencil
508 × 750 mm (20 × 29⁹/₁₆ in.)
Yale Center for British Art, Paul Mellon
Collection

Like William Bennett, his like-minded colleague
in the New Water Colour Society, McKewan was
supposedly a pupil of David Cox. Whether he
enjoyed the formal tutelage of Cox is uncertain,
but he did know the older artist in the years just
before he began exhibiting watercolors with the
New Society that were immediately recognized
as similar to Cox's. In several letters to his son
in July 1847, Cox described meeting both
McKewan and Bennett on one of his sketching
excursions in North Wales and spending several
days with them at Bettws-y-Coed.[1]

McKewan was already familiar with the pic-
turesque attractions of the area. Two years ear-
lier, Louisa Stuart Costello's *Falls, Lakes, and
Mountains of North Wales* had been published with
lithographs by Thomas and Edward Gilks after
drawings by McKewan. After becoming an asso-
ciate of the New Society in 1848 and a full mem-
ber in 1850, McKewan made views of Welsh
streams and cascades a staple of his contribu-
tions to the Society's annual exhibitions. In the

late 1860s his subject matter shifted from land-
scapes to country-house interiors in the manner
of Joseph Nash's plates to his *Mansions of England
in the Olden Time*. Although McKewan's exhibition
landscapes seldom had quite the brio or the
dark grandeur of Cox's late Welsh watercolors,
works such as this view of Cox's familiar haunts
had an appealing freshness, which made
McKewan seem for a time one of the leading
new interpreters of the old style of landscape
painting in watercolor. sw

1. Cox, letters to his son, July 21 and 25, 1847, quoted
 in N. Neal Solly, *Memoir of the Life of David Cox*
 (London; Chapman and Hall, 1873; London: Rodart
 Reproductions, 1973), pp. 167–68.

17

GEORGE PRICE BOYCE (1826–1897)
A Road near Bettws-y-Coed, 1851
Watercolor over pencil
378 × 530 mm (14⅞ × 20⅞ in.)
Signed in monogram and dated lower left:
GPB 1851
Yale Center for British Art, Paul Mellon Fund

Between the ages of seventeen and twenty-three, Boyce served as an apprentice in various architects' offices. When in August 1849 he first encountered David Cox, he determined to abandon architecture in favor of landscape painting. Boyce was one of many young watercolorists who made pilgrimages to Bettws-y-Coed in North Wales to work with Cox. Boyce's earliest drawings show the clear influence of Cox in his spontaneous brushwork and use of transparent washes. In August 1851 Boyce was back in Bettws-y-Coed: "While sketching, David Cox came and shook hands with me. . . . After dinner I made an evening sketch on grey wrapping-up paper. David Cox saw it and approved."[1] In subsequent diary entries, he identified the colors Cox used and described a lesson given by him.

Other influences were operating on Boyce's developing landscape style. Later that same August he showed Cox a watercolor he had painted from the church at Bettws-y-Coed; Cox's

reaction was that it "looked like a Pre-Raffaelite drawing." *A Road near Bettws-y-Coed*, from about the same time, indicates Boyce's sympathy for the emerging Pre-Raphaelite landscape style, which was to a great extent inspired by the early volumes of Ruskin's *Modern Painters*. Boyce has drawn the foliage and vegetation carefully and bathed the composition in bright sunlight so that the colors of the landscape appear in their full intensity. The watercolor shows Boyce poised between the waning influence of Cox and the more modern style of Ruskinian, or Pre-Raphaelite, landscape painting.

As is always the case in Boyce's landscapes, the figures are carefully placed to introduce a living quality to the subject. The woman on the road wears traditional Welsh garb. On the right a man perches in the branches of a tree. This last detail may be a whimsical allusion to the inn where Boyce and Cox were staying, the Royal Oak. As a favor to the landlord, Cox had painted a sign for the inn depicting the legendary incident of King Charles II eluding his pursuers by hiding in the branches of an oak tree. CN

1. This and the following quotation come from *The Diaries of George Price Boyce*, ed. Virginia Surtees (Norwich: Real World, 1980), pp. 1–3; this is a reprint, with a new introduction and notes, of "Extracts from Boyce's Diaries: 1851–1875," *Old Water-Colour Society's Club* 19 (1941): 1–71. For an account of Boyce's life and art, see Christopher Newall and Judy Egerton, *George Price Boyce*, exh. cat. (London: Tate Gallery, 1987).

DAVID COX, SR. (1783–1859)
Penmaen Bach, 1852
Watercolor with scraping out and bodycolor
over pencil on rough "Scotch" paper
572 × 826 mm (22-½ × 32½ in.)
Signed and dated lower left: *David Cox 1852*; label
on the back of the frame in the artist's hand: *N 1
Peanmaen Bach, on the Coast between Conway & Bangor
David Cox*
Birmingham Museum and Art Gallery

Penmaen Bach is typical of Cox's dark and boldly
painted watercolors that most fully captured the
imagination of reviewers in the 1850s. Critics de-
scribed his work as "remarkable for solemn
depth" with "an aspect of portentous gloom."
They joked about his never seeing the sun.[1]

Thomas Roscoe, in his book *Wanderings and
Excursions in North Wales* of 1836, referred to this
stretch of coastline as having "a gloomy gran-
deur of character which I should in vain en-
deavour to describe."[2] This dramatic scenery
provided the subject for one of Cox's illustra-
tions to Roscoe's book, and this watercolor of
1852 repeats the basic composition of the earlier
illustration.

Critical reaction to *Penmaen Bach* when it was
exhibited at the Society of Painters in Water-
Colours in 1852 was decidedly favorable. The
Spectator's critic wrote:

But the great old man of the tribe of "well-known land-
scape habitués of the Old Society" is, as ever, David Cox.
In his works there are power and insight enough to swamp
all the others put together. "Peanmean Beach, on the
Coast between Conway and Bangor", is wonderful. All
dim and solemn through a lowering atmosphere loom the
scattered coast rocks; heavy masses of cloud striking across,
and sheep winding stragglingly among them.[3]

The review in the *Athenaeum* noted that "Mr.
David Cox, unsurpassed for the freedom of his
pencil, is this year more daring than ever," and
characterized *Penmaen Bach* as "remarkable for
vigour and largeness of style."[4]

Two years later, the critic for the *Spectator*
summed up Cox's achievement in such dark and
powerful works:

Mr. Cox deserves to appropriate the Homeric epithet of
Zeus – "cloud-compelling." His clouds are very queer af-
fairs in themselves, it is true – arbitrary splashes and
dashes of colour. They mean nothing, and yet mean every-
thing; for somehow he gets the wind into his picture like
no other man, and with the wind a solemn brooding grief
out of the very depths of nature.[5] SW

1. These examples are from *Spectator*, May 3, 1851,
p. 427; *Art Journal*, June 1, 1853, p. 153; and *Art-Union*,
June 1, 1848, p. 181.
2. Thomas Roscoe, *Wanderings and Excursions in North
Wales* (London: C. Tilt and Simpkin and Co.;
Birmingham: Wrightson and Webb, 1836), p. 190.

3. *Spectator*, May 1, 1852, p. 423.
4. *Athenaeum*, May 1, 1852, p. 492.
5. *Spectator*, April 29, 1854, p. 463.

19

WILLIAM BENNETT (1811–1871)
The Pass of Glencoe, 1852
Watercolor with rubbing out over pencil
552 × 769 mm (21¾ × 30¼ in.)
Signed and dated lower left: *WBennett / 1852*
The Board of Trustees of the Victoria and Albert
Museum, London

In 1850 Bennett, who had become a member of
the New Society of Painters in Water Colours
just the previous year, dominated the landscape
section of the New Society's exhibition. Both the
Spectator and the *Athenaeum* accorded him pre-
eminence among the landscapists, and the *Art
Journal* praised his style as "wonderfully vigorous
and full of nature."[1] The *Spectator* commented
on his sudden rise to prominence,[2] while the
Athenaeum noted:

*He seems to have taken as his models De Wint and Cox;
sometimes leaning to the style of one, and sometimes to
that of the other. We would not imply by this that he has
not a style of his own; he has a genuine feeling for the
beauties of Nature and looks at her with his own eyes, –
appearing instinctively, and that only occasionally, to refer
to the works of those whom he admires.*[3]

Bennett may actually have been taught by Cox.
Certainly he knew Cox and sketched with him
in North Wales in the later 1840s.

Bennett's reputation as a watercolorist of
power and feeling and as a worthy inheritor of
the landscape style of David Cox was consoli-
dated in the New Society exhibitions of the next
few years. *The Pass of Glencoe* was exhibited at the
New Society in 1852 and purchased after the ex-
hibition by one of Bennett's neighbors in the
London suburb of Clapham Park, William
Heptenstall. At Bennett's request, it was lent by
Heptenstall to the Paris Universal Exposition of
1855. If *The Pass of Glencoe* has little of Cox's bold-
ness and freedom of handling, the watercolor
does share something of the dark, brooding
quality of Cox's Welsh mountain landscapes of
the late 1840s and 1850s. SW

1. *Art Journal*, June 1, 1850, p. 180.
2. *Spectator*, April 27, 1850, p. 403.
3. *Athenaeum*, April 27, 1850, p. 454.

ANTHONY VANDYKE COPLEY
FIELDING (1787–1855)
The Close of Day, 1853
Watercolor with scraping out and gum
over pencil
552 × 959 mm (21¾ × 37¾ in.)
Signed and dated lower left: *Copley Fielding 1853*
Phillips and Deans

In 1831 Copley Fielding, a member of the
Society of Painters in Water-Colours since 1812,
succeeded Joshua Cristall as its president. He
would remain in office until his death twenty-
four years later. Throughout his association with
the Society, he was one of its most prolific and
most popular exhibitors. Although his later
works were sometimes criticized for being re-
petitive, the grand watercolors of his last years
show no slackening of his artistic powers. *The
Close of Day* (the title is not his) would seem to
be a major exhibition piece, yet it cannot be
convincingly connected with any of the titles
that he exhibited with the Society in his
final years.

An idealized view of Richmond Castle in
Yorkshire, the watercolor is a late representative
of the sort of classical landscape derived from
Claude. This tradition, central to the rise of
imaginative landscape in Britain and at the heart
of J. M. W. Turner's art, would scarcely survive
into the second half of the nineteenth century.
Despite his devotion to Turner and his fondness
for his former drawing master, Copley Fielding,
Ruskin excoriated the tradition to which they
were so indebted as false and pernicious. To
many others, the standard elements of classical
landscape, such as the elegant framing trees and
the diffused sunset light so evident in this water-
color, simply seemed outmoded. Only in the
highly individual interpretations of Samuel
Palmer, such as *Tityrus Restored to His Patrimony*
(cat. no. 85), did the classical tradition retain
any currency. SW

21

DAVID COX, SR. (1783–1859)
Keep the Left Road, 1854
Watercolor with scraping out and bodycolor on
rough "Scotch" paper
724 × 1003 mm (28-½ × 39½ in.)
Signed and dated lower left: *David Cox 1854*
Birmingham Museum and Art Gallery

On June 12, 1853, Cox suffered a stroke which
left his coordination, memory, and eyesight im-
paired. It is evident from his letters that he con-
tinued to paint in both watercolors and oils until
at least 1857, and his contributions to the exhibi-
tions of the Society of Painters in Water-Colours
continued relatively undiminished until his
death. There is, however, some question about
the extent to which the exhibited watercolors
were earlier works given finishing touches by
the infirm artist.

David Cox, Jr., writing to a friend of his father
in 1855, commented on his father's limited artis-
tic activity two years after the stroke:

*The doctors will not allow mental exertion, and his paint-
ing is to be merely an occupation & an amusement so that
although his pictures are much sought after, and realize
four times the amount he charged originally, he takes no
commissions, and finishes but little. His ideas however
seem to be as vigorous as ever, and his feeling for air &
space and skies, perhaps, never better.*[1]

Cox exhibited a watercolor titled *Keep the Left
Road* in 1854 and one titled *Asking the Way* the fol-
lowing year. A critic's description of the work
exhibited in 1854 as a "small drawing" makes it
highly unlikely that it was the Birmingham wa-
tercolor, although his statement that "there is lit-
tle in the drawing but a description of breadth
and distance melting into air"[2] could apply
equally well to the Birmingham watercolor or
any number of Cox's late works.

At the time of his death, the *Illustrated London
News* mourned the loss of "a great genius of
modern British landscape." The periodical eulo-
gized him as

*pre-eminent among landscapists, and the founder of a
school of landscape painting purely English, but new to
England itself when he created it. He was the last survivor
of that worthy fraternity (including Girton [sic], Turner,
Prout, and others) who made water-colour what it was,
not what it is; for, since their time, it has in the hands of
some become deteriorated and disfigured by the introduc-
tion of new-fangled concepts foreign to its nature and
calling.*[3]

Standing apart from midcentury fashions in
both watercolor and landscape, Cox's late work
coupled the breadth and weight of the water-
colors of the founding generation of the Society
of Painters in Water-Colours with a sketchlike
boldness and freedom of handling that
seemed to point the way to an indigenous
impressionism. SW

1. David Cox, Jr., letter to William Turton, February
 19, 1855, quoted in Thomas B. Brumbaugh, "David
 Cox in American Collections," *Connoisseur* 197
 (February 1978): 88.
2. *Art Journal*, June 1, 1854, p. 174.
3. "Sketch of the Life of the Late David Cox," *Illustrated
 London News*, July 9, 1859, p. 42.

22

THOMAS SEDDON (1821–1856)
The Mountains of Moab, 1854
Watercolor and bodycolor
252 × 352 mm (9¹⁵/₁₆ × 13⅞ in.)
The Trustees of the Tate Gallery, on loan to the
Ashmolean Museum, Oxford

The son of a London cabinetmaker, Seddon
himself embarked on a career designing furni-
ture. His true ambition, however, was to be a
painter. By 1850 he had begun to work in the
studio of his friend and contemporary Ford
Madox Brown. From 1849 he visited country
areas to paint, going first to North Wales and
later to France.[1]

As a landscape painter, Seddon aimed at a me-
ticulous observation of detail. His brother de-
scribed the artist's working method on his
painting expeditions: "He would stoutly main-
tain that it was far better to secure but two or
three good studies during the usual stay which
each artist was able to make, than to confine
their practice, as was usual, to mere sketching."[2]
In the early 1850s Seddon became a familiar fig-
ure in the Pre-Raphaelite circle and was be-
friended by Dante Gabriel and William Michael
Rossetti.

In the course of his short life, Seddon was in-
creasingly preoccupied by a penitent religiosity,

and he shared with William Holman Hunt a be-
lief in the importance of visiting and recording
the sacred places of the Holy Land to help him
better understand and illustrate biblical events.
In the winter of 1853 he traveled to the Middle
East, where he remained for a year or so, part of
the time in company with Holman Hunt. In the
autumn of 1856 Seddon returned to Egypt,
where he died in November of that year.

Seddon described the subject of this water-
color in a letter written from the camp he set up
on a hillside south of Jerusalem:

*Today I have been going on with a watercolour drawing of
the mountains of Moab, beyond the Dead Sea, looking
down the Valley of Hinnom. I have taken them half an
hour before sunset, when they are bathed in a mist of rosy
light, while the valley in front is in shadow. It never does
to be too confident, but, if it is finished as it is begun, it
will be the best watercolour landscape that I have done.*[3]

Elsewhere Seddon described the atmospheric
effect that caused the sky to appear green, as he
showed it in the finished watercolor. Equally de-
liberate is his careful representation of the pur-
ple tones in the shadowed valley sides and the
dark foliage of the olive trees in the advancing
gloom.

It seems likely, as Allen Staley has suggested,
that the present watercolor was worked on by
Holman Hunt. In his autobiography Hunt stated

that he had finished one of Seddon's drawings
after Seddon had left Jerusalem,[4] and certainly
The Mountains of Moab is conspicuously similar to
watercolors by Hunt such as *The Plain of Rephaim
from Mount Zion* (Whitworth Art Gallery,
University of Manchester) or *The Dead Sea from
Siloam* (cat. no. 24).　　　　　CN

1. The principal source of biographical information
 for Seddon is John Pollard Seddon, *Memoir and
 Letters of the Late Thomas Seddon, Artist, by His Brother*
 (London: J. Nisbet and Co., 1858). Allen Staley de-
 votes chapter 7 of *The Pre-Raphaelite Landscape*
 (Oxford: Clarendon Press, 1973) to Seddon. See
 also Ann C. Colley, "Edward Lear and Thomas
 Seddon: The Paradox of Inquiry," *Journal of Pre-
 Raphaelite Studies* 5 (November 1984): 36–48, and
 George P. Landow, "Thomas Seddon's 'Moriah' and
 His Jerusalem and the Valley of Jehosophat," *Journal of Pre-
 Raphaelite and Aesthetic Studies* 1 (Fall 1987): 59–65.
2. J. P. Seddon, *Thomas Seddon*, p. 7.
3. Thomas Seddon, quoted in J. P. Seddon, *Thomas
 Seddon*, p. 94.
4. William Holman Hunt, *Pre-Raphaelitism and the Pre-
 Raphaelite Brotherhood*, 2 vols. (London: Macmillan
 and Co., 1905), vol. 2, p. 128. Staley, *Pre-Raphaelite
 Landscape*, p. 102.

23

THOMAS SEDDON (1821–1856)
The Well of Enrogel, 1854
Watercolor and bodycolor
247 × 349 mm (9¾ × 13¾ in.)
Harris Museum and Art Gallery, Preston

Seddon was deeply moved by the biblical associations of the Palestinian landscape. He wrote: "Besides the beauty of this land, one cannot help feeling that one is treading upon holy ground."[1] Seddon searched the countryside around Jerusalem for interesting and meaningful subjects:

After visiting every part of the city and surrounding country to determine what I should do, I have encamped upon the hill to the south, looking up the valley of Jehosophat; I have sketched the view which I see from the opening of my tent. I am painting from one hundred yards higher up, where I see more of the valley, with the Tombs of the Kings and Gethsemane.[2]

The Well of Enrogel, which was begun at the same time as *The Mountains of Moab* (cat. no. 22), may well be the view from Seddon's tent. The particular significance of the view lay in its archaeology: the well of En-rogel was referred to in the book of Joshua as a frontier point of the territory held by the tribe of the children of Judah; it was mentioned again in Samuel II; and at the be-

ginning of the first book of Kings, Adonijah, King David's son who hoped to succeed him, "slew sheep and oxen and fat cattle by the stone of Zoheleth, which is by En-rogel"(1 Kings 1:9). Seddon called the place "Joab's well,"[3] presumably in reference to the commander of King David's army, who sided with Adonijah and was killed on the instructions of King Solomon.

During his short career, Seddon gained a considerable reputation. In 1855, back in London from the Holy Land, he put on an exhibition of his paintings and watercolors at 14 Berners Street. In 1856 a second exhibition was held, in Conduit Street, presumably to raise money for the artist's second Middle Eastern journey. After his death yet another exhibition was staged to provide for his widow, and a fund was established to buy a painting by Seddon for the nation.[4]

The combination of truth to nature and spiritual associations made Seddon's landscapes particularly potent. Ruskin considered Seddon's works to be

the first which represent a truly historic landscape art; that is to say, they are the first landscapes uniting perfect artistical skill with topographical accuracy, being directed with stern self-restraint to no other purpose than that of giving to persons who cannot travel trustworthy knowledge of the scenes which ought to be most interesting to them. . . . In

Mr. Seddon's works the primal object is to place the spectator, as far as art can do, in the scene represented, and to give him the perfect sensation of its reality, wholly unmodified by the artist's execution. (14.465n) CN

1. Thomas Seddon, quoted in John Pollard Seddon, *Memoir and Letters of the Late Thomas Seddon, Artist, by His Brother* (London: J. Nisbet and Co., 1858), p. 85.
2. Thomas Seddon, quoted in Ruskin (14.464n).
3. J. P. Seddon, *Thomas Seddon*, p. 94.
4. In fact, his *Jerusalem and the Valley of Jehosophat* (Tate Gallery, London) was for many years the only Pre-Raphaelite painting in a public collection.

24

WILLIAM HOLMAN HUNT
(1827–1910)
The Dead Sea from Siloam, 1854–55
Watercolor and bodycolor over pencil
248 × 348 mm (9¾ × 13¾ in.)
Birmingham Museum and Art Gallery

Holman Hunt was born in London, the son of a
warehouse manager. He began his career as a
clerk but in 1843 persuaded his father to let him
enroll in the Royal Academy Schools, to which
he was admitted on the third attempt. Hunt
knew John Everett Millais from about 1844, and
Dante Gabriel Rossetti from 1848; in September
1848 the three formed the Pre-Raphaelite
Brotherhood. In the early 1850s Hunt spent
most of each summer painting in the open air
to provide landscape settings for his figurative
subjects such as *Valentine Rescuing Sylvia*
(Birmingham Museum and Art Gallery) and *The
Hireling Shepherd* (Manchester City Art Gallery).
Occasionally he painted pure landscapes.[1] The
most painstaking in technical terms of all the
Pre-Raphaelites, and the one most conscious of
the symbolic associations of his chosen subjects,
Hunt maintained the theoretical basis of Pre-
Raphaelitism to the end of the nineteenth
century.[2]

At the beginning of 1854 Hunt set off to join
Thomas Seddon in Egypt. The two later traveled
through the Holy Land, absorbed in the possi-
bilities of representing the settings of biblical
events in a way that was true to both Christian
teaching and the archaeological evidence. At the
time that Hunt started working on his oil paint-
ing *The Scapegoat* (Lady Lever Art Gallery, Port
Sunlight) on the shore of the Dead Sea in
November 1854, he also began this watercolor.
In 1861 the critic of the *Athenaeum* described the
view taken as

*rolling country, dipping down into deep valleys, showing,
over its many levels, purple shadows and zones of light,
stark and tawny terraces of rock cropping up through the
scanty, ruddy-tinted soil and sparse verdure, with a bar of
faintest white in the mid-distance indicating the Dead Sea,
whose mist intervenes like a trembling veil between us, and
the mountains of Moab that hide the horizon.*[3]

In a letter of September 7, 1855, Hunt de-
scribed his preparations for the completion of
the watercolor: "Tomorrow I am to rise ere the
sun, to go out to finish a sketch which I com-
menced on the Mount of Offence, the hill above
Siloam, last year about this time."[4] *The Dead Sea
from Siloam* was first exhibited in 1861,[5] along
with four other Middle Eastern watercolors,[6] as
an accompaniment to his oil *The Finding of the*

Saviour in the Temple (Birmingham Museum and
Art Gallery) at the German Gallery in New Bond
Street, where the entire group, including the oil,
was bought by Thomas Plint. The five water-
colors seem to form a series; each shows the
landscape at a different time of day, from the
dawn of the present watercolor through night in
Jerusalem by Moonlight.[7] CN

1. Such as *Fairlight Downs – Sunlight on the Sea* (private
 collection), begun in 1852, and reproduced in *The
 Pre-Raphaelites*, exh. cat. (London: Tate Gallery, 1984),
 cat. no. 52.
2. For biographical information on Holman Hunt, see
 F. G. Stephens, *William Holman Hunt: A Memoir of the
 Artist's Life* (London: James Nisbet and Co., 1860),
 and Hunt's autobiography, *Pre-Raphaelitism and the
 Pre-Raphaelite Brotherhood*, 2 vols. (London: Macmillan
 and Co., 1905). See also Tate Gallery exhibition cat-
 alogue cited above and chapter 5 of Allen Staley,
 The Pre-Raphaelite Landscape (Oxford: Clarendon
 Press, 1973).
3. *Athenaeum*, May 4, 1861, p. 603.
4. Holman Hunt, letter to Thomas Combe, in the
 John Rylands Library, University of Manchester.
5. It has been suggested by Mary Bennett, *William
 Holman Hunt*, exh. cat. (Liverpool: Walker Art
 Gallery, 1969), p. 78, that the present watercolor is
 identical with Hunt's 1856 R.A. exhibit, *View from the
 Mount of Offence Looking towards the Dead Sea and the
 Mountains of Moab*. This seems unlikely, however, as

Stephens, Hunt: A Memoir, p. 80, adds "Evening" to that watercolor's title.
6. The four other watercolors were *Nazareth, The Plain of Rephaim from Mount Zion, Cairo: Sunset on the Gebel Mokattum,* and *Jerusalem by Moonlight.* All four are in the Whitworth Art Gallery, University of Manchester.
7. This point is made by Judith Bronkhurst in *Pre-Raphaelites,* exh. cat., p. 269.

25

WILLIAM SIMPSON (1823–1899)
Graves of the Officers in the Fort on Cathcart Hill,
1854
Watercolor and bodycolor with scraping out over pencil
207 × 349 mm (8⅛ × 13¾ in.)
Signed and dated lower right: *W T Simpson /*
16 Dec 1854
Yale Center for British Art, Paul Mellon Collection

With the rise of illustrated periodicals, a new breed of artist-reporter came into existence. Simpson established his reputation as one of the leading representatives of this new profession with his popular images of the Crimean War and maintained that reputation for years by covering major world events for the *Illustrated London News.* Yet Simpson also sought recognition as a landscape painter, and, even within his works of reportage, he demonstrated a sensitivity to the expressive potential of landscape.[1]

A lithographic draftsman for the firm of Day and Son, Simpson was sent by the publisher Colnaghi to the Crimea in 1854 to provide on-the-spot representations of the scenes of the fighting. He arrived in November, two weeks after the Battle of Inkerman. This watercolor shows the graves of the British officers who died in that encounter. The site, overlooking the British position before Sebastopol, was named for one of the heroes of Inkerman, Sir George Cathcart, who died while rallying his troops after the Russians overran the British positions. His grave (marked by the cross to the left) is at the center of Simpson's composition.

W. H. Russell, the correspondent for the *Times* in the Crimea, described Inkerman as "the bloodiest struggle witnessed since war cursed the earth."[2] Simpson endowed his view of the burial ground with a lurid sunset that seems to reflect the recent carnage and lifts the scene above mere documentary interest.

Graves of the Officers in the Fort on Cathcart Hill was one of the watercolors Simpson sent back to London to be lithographed by Day and Son and published by Colnaghi as *The Seat of War in the East.* The ninety-plate collection was a tremendous popular success and gained for the artist the nickname "Crimean" Simpson. The original watercolors were exhibited at Gambart's French Gallery in Pall Mall in 1856 and were subsequently shown in Manchester and Glasgow. It was even proposed in Parliament that the set of watercolors be acquired for the nation.[3] SW

1. In the late 1880s and early 1890s Simpson composed his memoirs. They were published after his death as *The Autobiography of William Simpson, R.I.,* ed.

George Eyre-Todd (London: T. Fisher Unwin, 1903).
2. W. H. Russell, *The War: From the Landing at Gallipoli to the Death of Lord Raglan* (London: George Routledge and Co., 1855), p. 249.
3. The proposal was rejected by the Palmerston ministry, partly on the ground of the impermanence of the watercolor medium. For a more detailed account of Simpson's Crimean illustrations, see Matthew Paul Lalumia, *Realism and Politics in Victorian Art of the Crimean War* (Ann Arbor, Mich.: UMI Research Press, 1984), pp. 68–74.

BARBARA LEIGH SMITH BODICHON (1827–1891)
View of Snowdon with a Stormy Sky, ca. 1854
Watercolor with gum over pencil
226 × 345 mm (8⅞ × 13⅝ in.)
Inscribed verso: *Frantic remains of a Sunday walk
never to be forgotten* [word illegible] *N Book / BLSB*;
stamp verso: *Scalands Gate / Robertsbridge /
Hawkhurst*
Yale Center for British Art, Paul Mellon Fund

Barbara Bodichon is best remembered as a tire-
less campaigner for women's rights and a co-
founder of Girton College for women. She was
also a proficient amateur artist, whose home at
Scalands in Sussex was a gathering place for
artist friends, including Dante Gabriel Rossetti
and her fellow amateur Hercules Brabazon
Brabazon. Rossetti, with amused admiration for
her dedication to plein-air painting, wrote that
she "thinks nothing of climbing up a mountain
in breeches, or wading through a stream in
none, in the sacred name of pigment."[1]

In 1849 she took art classes at Bedford
College. She also studied with William Henry
Hunt and may have received instruction from
David Cox, Peter DeWint, and either John or
Cornelius Varley. Certainly she knew Cox and, at
the time of his death, referred to him in a letter
to her friend George Eliot as "dear old David
whom I loved much."[2]

View of Snowdon with a Stormy Sky shows the in-
fluence of Cox in both its subject and technique.

Through the mid-1850s Barbara Leigh Smith
made extended excursions throughout the
British Isles with family and friends. Her first ex-
hibited pictures, shown at the Royal Academy in
1850, were views in Wales. She spent a long holi-
day in North Wales in 1854, and the eight Welsh
scenes that were among the works she contrib-
uted to the American Exhibition of British
Painting in 1857–58 (shown in New York,
Philadelphia, and Boston) probably originated
in that holiday. Two of these were *Thunder Storm
near Festiniog, N. Wales* and *Mountains in N. Wales,
Thunder Shower*, titles that suggest a similarity to
the present watercolor.[3]

If, as seems likely, this watercolor, too, derives
from the holiday in 1854, then the inscription
on the verso, signed "BLSB," was added at a later
date, following her marriage in 1857 to a French-
Algerian physician, Eugène Bodichon. The refer-
ence to "N Book" in the inscription remains ob-
scure. In subsequent years Bodichon divided
her time between Algeria and England.

Cox's influence on her watercolors in the
early 1850s was succeeded by a spell of Pre-
Raphaelitism. William Michael Rossetti pro-
nounced a coastal scene by her, exhibited at
the Crystal Palace in 1856, "full of *real* Pre-
Raphaelitism, that is to say, full of character and
naturalism in the detail."[4] Pre-Raphaelitism was,
in turn, supplanted by the Barbizon School. In
the 1860s she spent several seasons studying in
France with Jean-Baptiste-Camille Corot and
added Charles-François Daubigny to her wide
circle of friends. Open to a variety of influ-

ences but constant in her devotion to nature,
Bodichon was, along with Brabazon and George
Howard, one of those Victorian amateurs whose
nonprofessional status belied the seriousness of
their art and the high regard in which they were
held by their fellow artists. sw

1. Dante Gabriel Rossetti, letter to Christina Rossetti,
 [November 8, 1853], *The Letters of Dante Gabriel Rossetti*,
 ed. Oswald Doughty and John Robert Wahl, 2 vols.
 (Oxford: Clarendon Press, 1965), vol. 1, p. 163.
 For Bodichon as an artist, see *Barbara Bodichon,
 1827–1891*, exh. cat. (Cambridge: Girton College,
 1991), and two articles by John Crabbe, "Wild
 Weather in Watercolour," *Country Life*, March 2,
 1989, pp. 100–101, and "Hidden by History: Barbara
 Bodichon, An Artist Obscured by Her Feminist
 Image," *Watercolours and Drawings*, Spring 1991,
 pp. 13–17.
2. Barbara Leigh Smith, letter to George Eliot, un-
 dated, Beinecke Rare Book and Manuscript Library,
 Yale University; published and dated June 30–
 July 1, 1859, in *The George Eliot Letters*, ed. Gordon S.
 Haight, 9 vols. (New Haven: Yale University Press,
 1954–78), vol. 3, p. 108.
3. I am indebted to Sara Dodd for identifying the sub-
 ject of the drawing and to John Crabbe for suggest-
 ing its association with Barbara Leigh Smith's 1854
 holiday and her exhibited works of the 1850s.
4. William Michael Rossetti, "Art News from
 England," *The Crayon*, August 1856, p. 245.

27

27

JOHN HENRY MOLE (1814–1886)
Mountainous Landscape with Bridge, 1855
Watercolor with touches of bodycolor
over pencil
355 × 533 mm (14 × 21 in.)
Signed and dated lower left: *J. H. Mole / 1855*
Yale Center for British Art, Paul Mellon Fund

From the 1820s to the early 1840s, Newcastle upon Tyne hosted a succession of exhibition societies and schemes for the promotion of local art. At the center of this activity was the landscape painter Thomas Miles Richardson, Sr., who dominated the Newcastle art scene in the period.[1] Despite the efforts to establish Newcastle as an active center for northern art, or perhaps because by the 1840s political and economic factors had scuttled such efforts, promising local artists such as Richardson's son, Thomas Miles Richardson, Jr., and John Henry Mole sought their reputations in the south.

Mole was born at Alnwick in Northumberland. While working as a clerk in a solicitor's office in Newcastle, he joined an informal artist's society in the city and began painting portrait miniatures.[2] A regular contributor to exhibitions in Newcastle, he began sending works to London exhibitions in 1845, becoming an associate of the New Water Colour Society in 1847 and a full member the following year. In 1884 he was elected vice-president of the Society.

About the time of his joining the New Society, Mole turned from portrait miniatures to a form midway between landscape and genre, in which figures – most often children – are presented in landscape settings. *Mountainous Landscape with Bridge*, which is probably a view in his native Northumberland, is unusual in both the absence of figures and the vigorous handling of the medium. Mole's landscapes more typically show a meticulous touch which was perhaps the legacy of his days as a miniature painter. SW

1. See Paul Usherwood, *Art for Newcastle: Thomas Miles Richardson and the Newcastle Exhibitions, 1822–1843*, exh. cat. (Newcastle upon Tyne: Tyne and Wear County Council Museums, 1984).
2. Marshall Hall, *The Artists of Northumbria*, rev. ed. (Newcastle upon Tyne: Marshall Hall Associates, 1982), pp. 123–24.

28

HENRY MOORE (1831–1896)
Mer de Glace, 1856
Watercolor over pencil
263 × 369 mm (10⅜ × 14½ in.)
Inscribed, signed, and dated lower right: *Mer de Glace. H. Moore. Augt 18th 1856.*
Yale Center for British Art, Paul Mellon Collection

Moore was a member of a family of artists from York. His father was a portraitist, and his half-brother William – from whom Henry received early artistic instruction – and his two brothers, John Collingham and Albert Joseph, were also painters. In 1851 Henry Moore enrolled at the York School of Design, and two years later he moved to London to join his brother John and to study briefly at the Royal Academy Schools and the Langham School. As a young man Moore made frequent sketching tours in the English countryside and, from 1855 onward, to France and Switzerland.[1] He devoted the early years of his career to landscape painting, largely in watercolor. In 1881 the *Art Journal* characterized his early subjects as "glimpses of Cumberland waters and leafy nooks in Devon; pleasant stretches of Swiss meadow, beautiful with sainfoin and plantain, flooded with summer air and summer light; quiet scenes of pastoral and forest life, and the labour of woodmen or of hay-makers."[2]

28

Ruskin's fourth volume of *Modern Painters*, subtitled "Of Mountain Beauty" and first published in 1856, caused Moore, along with a number of others, notably John Brett and John William Inchbold, to travel to the Alps to make geological studies and to paint views of the great mountain ranges.

Since the early 1840s theories of glaciation put forward by the Swiss geologist Louis Agassiz and the Englishmen Sir Charles Lyell and James Forbes had been the focus of much debate. In the same summer that Moore was painting this watercolor, two English scientists, T. H. Huxley and John Tyndall, were in Switzerland making the studies of glaciers that led in the following year to the publication of their paper, "On the Structure and Motion of Glaciers."[3] Ruskin later summarized modern theories of glacial action in *Fors Clavigera*, when he stated that "glaciers were not solid bodies at all, but semi-liquid ones, and ran down in their beds like so much treacle" (27.639).

The glacier known as the Mer de Glace, drawn by Ruskin himself on a number of occasions,[4] lies close to Chamonix in the French Alps. Moore's *Mer de Glace* shows the glacier as it passes over a saddle of hard rock, which causes it to break into crevasses and standing pinnacles of ice. Although more generalized and consciously sublime than Ruskin would have countenanced, Moore's watercolor shows the same interest in the processes of physical geography that Ruskin himself evinced.

In his *Academy Notes* for 1857, Ruskin enthused about an oil painting by Moore of a Swiss subject (14.104). Ruskin later wrote to the artist to advise him on landscape painting. Moore, however, was disinclined to join the ranks of Ruskin's acolytes. His only recorded response to Ruskin's uninvited observations was to say that "he hates gorse."[5] CN

1. For biographical information on Moore, see Elizabeth Ruhlmann, "Henry Moore: His Family and His Art," *The Moore Family Pictures*, exh. cat. (London: Julian Hartnoll, 1980), and Frank Maclean, *Henry Moore, R.A.* (London: The Walter Scott Publishing Co., 1905).
2. "Henry and Albert Moore," *Art Journal*, June 1881, p. 162.
3. This debate and its bearing on contemporary landscape painting are discussed in Kenneth Bendiner, *An Introduction to Victorian Painting* (New Haven and London: Yale University Press, 1985), pp. 47–61.
4. A watercolor of the glacier done by Ruskin in 1850 is in the British Museum, London, and his famous *Mer de Glace, Chamonix* of 1860 is in the Whitworth Art Gallery, University of Manchester.
5. Moore, quoted by Ruhlmann, "Moore," p. 13.

29

ALFRED WILLIAM HUNT
(1830–1896)
Mountain Landscape – Cwm Trifaen, 1856
Watercolor and bodycolor
267 × 387 mm (10½ × 15 in.)
Signed and dated lower left: *AWH 56*
The Robertson Collection, Orkney

The son of Andrew Hunt, a prominent Liverpool landscape painter and drawing master, from early boyhood Alfred showed a propensity for landscape painting and drawing. He attended the Liverpool Collegiate School and in 1848 went up to Oxford University with a scholarship to read classics at Corpus Christi. In 1851, following in Ruskin's footsteps, he won the Newdigate Prize for poetry.[1] In 1852 he took his degree and the next year became a fellow of his college, presumably with the intention of pursuing an academic career. Although he was painting only part time in the mid-1850s, he assimilated Pre-Raphaelite principles and in 1856 and 1857, on the occasion of his exhibiting at the Royal Academy, was commended by Ruskin for the truth to nature of his works.

The present watercolor shows a cwm, or cirque – a bowl-shaped valley hollowed out by the action of glaciers – littered with boulders and other morainic deposits; the jagged ridge visible

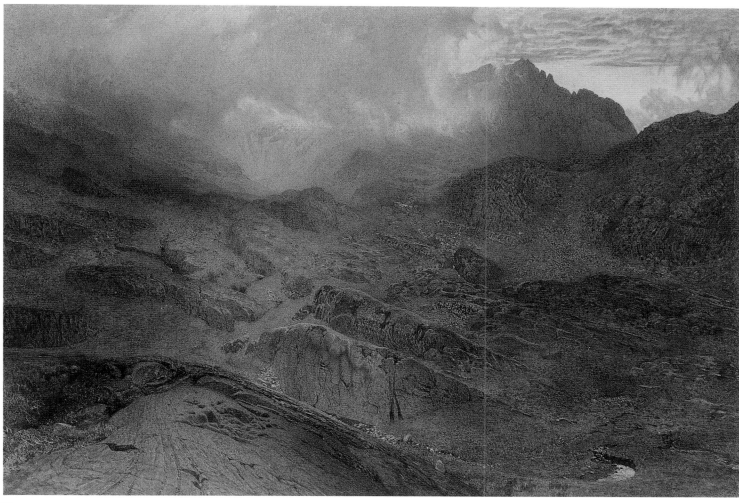

29

through the mass of swirling clouds is Trifaen or the neighboring Glyder Fach. This particular spot was famed for its desolate character and the clear evidence it provided of the physical origins of Snowdonia. Thomas Roscoe, in his *Wanderings and Excursions in North Wales*, described the terrain:

It seemed as if it had been washed by a tremendous sea; the stones lay loose and strewn at hazard, as on some wild coast; rocks, bare, cloven, and jagged, lay crossing each other in different directions; while the huge, pointed Trifaen, with its sharp, angular projections, height above height, seemed like some huge monster with human aspect strangely distorted, scowling upon the Carnedd y Gwynt, the Shepherd's Hill of Storms.[2]

The early history of this watercolor remains uncertain. It does not appear among Hunt's exhibited work of the late 1850s and early 1860s, which are in any case mostly oil paintings. Hunt's oil of the same view, *The Track of an Ancient Glacier – Cwm Trifaen* (Tate Gallery, London), was rejected by the selection committee of the Royal Academy in 1858. The very title of the painting refers to Ruskin's description of glacial action, as given in the fourth volume of *Modern Painters*.[3] Ruskin wrote Hunt a letter of consolation and advice: "Your picture is of course a wonderful one – *very* wonderful and gave me intense pleasure in looking at it, bit by bit. But it is painted under several mistaken principles." These he proceeded to itemize: the falsity of giving equal interest to areas of light and shade, overdepen-

dence on minuteness of handling, and the fundamental impossibility – as Ruskin had come to see it – of the type of subject Hunt had chosen. He ended with the postscript: "It is a great mistake in general to work on such large canvases. Paint small easily saleable pictures."[4] In fact Hunt was already moving toward watercolor as his principal medium, finding that the drawings he made out of doors gave a more authentic sense of the landscape than anything he had achieved in oils. CN

1. Hunt's entry to the competition was entitled "Nineveh." Ruskin had won the Newdigate on his third attempt in 1839.
2. Thomas Roscoe, *Wanderings and Excursions in North Wales* (London: C. Tilt and Simpkin and Co.; Birmingham: Wrightson and Webb, 1836), pp. 158–59. A second edition appeared in 1853.
3. "Over the whole of the rounded banks of lower mountain, wherever they have been in anywise protected from the injuries of time, there are yet visible the tracks of ancient glaciers" (6.211).
4. Ruskin, letter to Alfred William Hunt, May 16 [1858], Cornell University Library, Ithaca, N.Y. The full text of the letter is quoted in Robert Secor, *John Ruskin and Alfred Hunt: New Letters and the Record of a Friendship* (Victoria, B.C.: University of Victoria, 1982), pp. 22–23.

30

JOHN RUSKIN (1819–1900)
In the Pass of Killiecrankie, 1857
Watercolor and bodycolor with pencil, pen, and colored inks
282 × 248 mm (11⅛ × 9¾ in.)
Inscribed on a note attached to the old backboard: *In the pass of Killiecrankie / J. R. 1857*
The Syndics of the Fitzwilliam Museum, Cambridge
Exhibited at Yale and Cleveland only

In 1857 Ruskin had recently completed and published the fourth volume of *Modern Painters*, in which he gave poetic descriptions of different types of mountain landscape viewed from the perspective of an artist and scientist. He had arrived at a theory of natural beauty in which particular landscape forms were seen as possessing an inherent aesthetic significance. In certain drawings of the late 1850s, he combined his intense focus on natural detail with a concern for decorative completeness. As Allen Staley observed, watercolors such as *In the Pass of Killiecrankie* "represent the height of Ruskin's pictorial ambitions."[1]

In the Pass of Killiecrankie was painted during the summer of 1857. Having given his lecture series, *The Political Economy of Art*, in Manchester, Ruskin and his parents went to stay with the Trevelyans at Wallington Hall in Northumberland. They continued into Scotland, remaining there from

30

31

July to October. The Pass of Killiecrankie, between Blair Atholl and Pitlochry, was the southeastern gateway to the Highlands, known to the majority of Victorian travelers as a place of awesome grandeur. Ruskin, however, found the subject for his drawing in an enclosed and rocky foreground which fills his sheet, leaving only a glimpse through the trees to distant hills at the upper right.

In the Pass of Killiecrankie was an important drawing to Ruskin, and one that he was proud to see exhibited, in contrast to the mass of his works which were put away or given to friends once their immediate purpose had been fulfilled. He lent the watercolor to the Dudley Gallery summer exhibitions in 1881 and 1882. Furthermore, in the decade after Ruskin's death, it was exhibited on a number of occasions,[2] becoming one of the best-known examples of his work as a draftsman. CN

1. Allen Staley, The Pre-Raphaelite Landscape (Oxford: Clarendon Press, 1973), p. 162.
2. It was shown at the Royal Water-Colour Society Ruskin Memorial Exhibition of 1901, in Manchester in 1904, and at the Fine Art Society in 1907.

31

ALFRED WILLIAM HUNT
(1830–1896)
Rock Study: Capel Curig – The Oak Bough, 1857
Watercolor
257 × 372 mm (10⅛ × 14⅝ in.)
Signed and dated lower right: *A.W. Hunt / 1857*
Private collection

Hunt's father knew David Cox, and Cox is supposed to have said of Alfred: "He will carry on what I have been unable to do, for his hands have the delicacy that mine lack."[1] The breadth of handling of Hunt's early drawings seems the result of Cox's influence, and it is probable that he chose the mountainous countryside of North Wales as his early painting ground following the example of Cox, who spent his summer months at Bettws-y-Coed – a few miles to the east of Capel Curig. Later, after Hunt had adopted a technique that depended on minute observation and brilliant local color, he frequently returned to the region. He received further encouragement to paint and draw in Snowdonia from James Wyatt, the Oxford print dealer and supporter of the Pre-Raphaelites, who commissioned him to go to Wales, reserving the resulting works for sale in his shop. The present watercolor, which shows the eroded and lichenous rocks of an upland stream bed with light filtering through the canopy of early summer fo-

liage, does not appear to have been exhibited before 1884, when it was included in a retrospective of Hunt's works at the Fine Art Society.[2]
CN

1. Cox, quoted in H. C. Marillier, *The Liverpool School of Painters* (London: John Murray, 1904), p. 157.
2. Where it appeared as no. 92, *Rock Study – Capel Curig*, from the collection of the Rev. W. Kingsley.

32

JOSEPH NOEL PATON (1821–1901)
Study from Nature, Inveruglas, 1857
Watercolor and bodycolor
368 × 521 mm (14½ × 20½ in.)
Signed in monogram and dated lower left:
Aug. 21 NP 1857
The Robertson Collection, Orkney

Born at Dunfermline on the Firth of Forth,
Paton moved to London to study at the Royal
Academy Schools and subsequently entered and
became a prizewinner in the competition for
the decoration of the Palace of Westminster.[1] As
a student in 1843 he commenced an enduring
friendship with John Everett Millais. Although
somewhat older than the members of the Pre-
Raphaelite Brotherhood, and despite his even-
tual withdrawal from the metropolitan artistic
sphere, Paton maintained a connection with Pre-
Raphaelitism and may be regarded at least in his
early career as a follower of that movement.
Paton's debt to Millais is revealed in his painting
The Bluidie Tryste (Glasgow Art Gallery and
Museum) of 1855, with its minute observation
of the overgrown banks and rocky pools of the
foreground burn.[2] If Millais's treatment of land-
scape elements offered a practical example to
Paton, Ruskin provided a theoretical basis for his
approach to nature. In 1853 Ruskin wrote to his
father from Scotland mentioning Paton as one of

a group of Scots artists who were eager to meet
him (12.xxvii). It may be presumed that Paton
had absorbed the early volumes of *Modern Painters*
when he painted his *Study from Nature, Inveruglas* in
1857, and he had perhaps also studied the text
of *The Elements of Drawing*, which was published
earlier the same summer. Certainly the promi-
nence given the foreground and the painstaking
observation of the textures and shapes of rocks
and vegetation are quintessentially Ruskinian.

Study from Nature, Inveruglas and another water-
color with the same title (Glasgow Art Gallery
and Museum) show the bed and banks of a
Highland burn, presumably the Inveruglas
Water, which flows into Loch Lomond at the vil-
lage of Inveruglas. The two were exhibited to-
gether at the Royal Scottish Academy in 1858,
along with *The Mouth of the Wild Water, Inveruglas*
by Paton's brother, Waller Hugh Paton. The *Art
Journal* found a "wonderful resemblance both in
the excellences and defects of these two very
clever brothers." Their landscapes were "painted
with infinite care and marvellous finish."[3] CN

1. For biographical information on the artist, see
 M. H. Noel-Paton and J. P. Campbell, *Noel Paton,
 1821–1901*, ed. Francina Irwin (Edinburgh:
 The Ramsay Head Press, 1990).
2. Allen Staley, *The Pre-Raphaelite Landscape* (Oxford:
 Clarendon Press, 1973), p. 90.
3. *Art Journal*, April 1, 1858, p. 100.

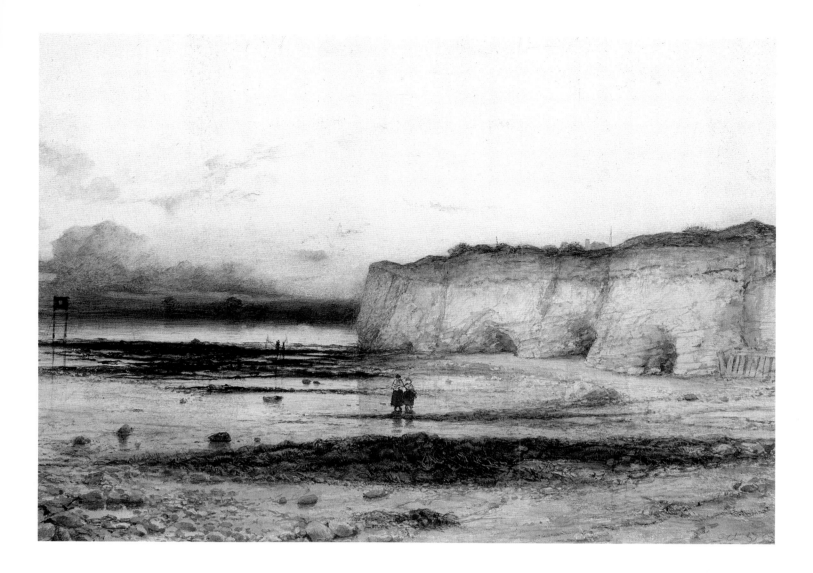

33

WILLIAM DYCE (1806–1864)
Pegwell Bay, 1857
Watercolor
247 × 348 mm (9¾ × 13¹¹⁄₁₆ in.)
Dated lower right: Oct 57
City of Aberdeen Art Gallery and Museums
Collections

Dyce painted this watercolor during a family holiday at Ramsgate, Kent, in the autumn of 1857. It provided the compositional framework for his oil painting *Pegwell Bay: A Recollection of October 5th, 1858*, exhibited at the Royal Academy in 1860.[1] In the oil, Dyce altered somewhat the line of the cliffs, placed figures (members of the artist's family) prominently across the foreground, and made the light correspond to a slighter later moment in the evening. The most significant, if not the most immediately striking, addition to the composition is the presence in the sky of Donati's Comet. The appearance of the comet prompts the reference to a specific date in the title of the oil painting – a date one year later than the watercolor on which the painting was based.

A native of Aberdeen who had studied in Italy, Dyce was predominantly a painter of religious and historical subjects. His links with the German Nazarenes and his adoption of a style based on quattrocento painting made him an

important precursor of certain aspects of Pre-Raphaelitism. His occasional landscape watercolors of the 1830s and 1840s, by contrast, show little of the detailed naturalism that would become a keynote of Pre-Raphaelite landscape painting. When such concerns did surface in the late 1850s and 1860s, in works such as both the oil and watercolor versions of *Pegwell Bay*, they presumably reflected the Pre-Raphaelite example.[2]

When the oil painting of Pegwell Bay was exhibited in 1860, Dyce was accused of painting from photographs. In an article in the *Art Journal* in the same year, James Dafforne denied the charge: "We happen to know that it was done from memory, aided by a slight and hasty sketch, in pencil of the locality."[3] Dafforne does not seem to have been aware of this watercolor, which, though clearly related to the oil, stands on its own as a subtle and effective work of landscape art. SW

1. For a more complete discussion of the watercolor, see Francina Irwin, "William Dyce 'at Home' in Aberdeen," *National Art Collections Fund Review*, 1991, pp. 137–43; for a discussion of the oil as a meditation on time and memory, see Marcia Pointon, "The Representation of Time in Painting: A Study of William Dyce's *Pegwell Bay: A Recollection of October 5th, 1858*," *Art History* 1 (March 1978): 99–103. The most complete account of Dyce's life is Marcia

Pointon, *William Dyce, 1806–1864: A Critical Biography* (Oxford: Clarendon Press, 1979).
2. See Allen Staley, "William Dyce and Outdoor Naturalism," *Burlington Magazine* 105 (November 1963): 470–76.
3. J. Dafforne, "William Dyce, R.A.," *Art Journal*, September 1, 1860, p. 296.

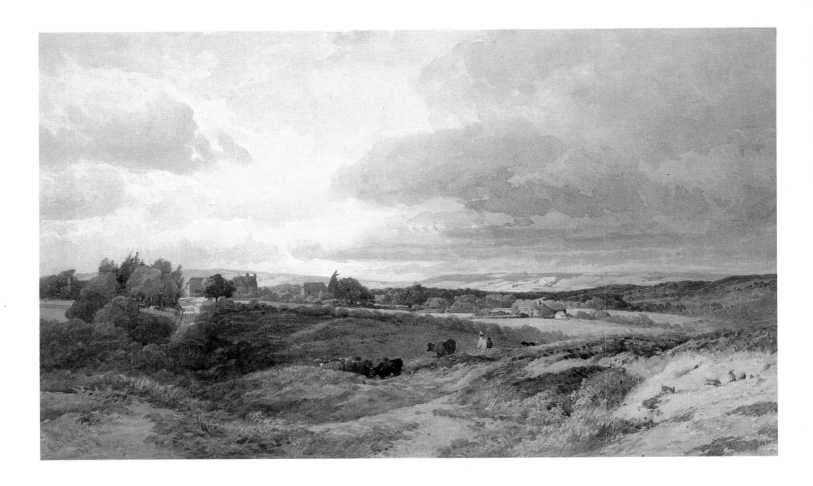

EDWARD DUNCAN (1803–1882)
Fawke Common, near Sevenoaks, Kent, 1857
Watercolor with touches of bodycolor
over pencil
307 × 511 mm (12⅛ × 20⅛ in.)
Signed and dated lower left: *E. Duncan / 1857;*
inscribed verso: *Fork Common / near Seven Oaks,
Kent / E. Duncan*
The Syndics of the Fitzwilliam Museum,
Cambridge

In the later 1850s and 1860s, Edward Duncan,
like George Arthur Fripp, espoused the old
methods of watercolor without, however, main-
taining a stylistic affiliation with Cox, DeWint, or
any other of the major figures of the old school.
In the face of the vogue for painting with body-
color, Duncan relied almost entirely on trans-
parent colors. While full of charming detail,
such as the rabbits on the right in *Fawke Common,*
his drawings have a breadth and fluidity that be-
speak the earlier tradition of British watercolor.
 As a youth, Duncan was apprenticed to the
aquatint engraver Robert Havell and was em-
ployed as an engraver by the firm of Fores of
Piccadilly.[1] Under the influence of Havell's
brother, the watercolorist William Havell,
Duncan took up painting in watercolors. In 1826
a project to engrave seapieces after paintings by
William John Huggins sparked Duncan's interest
in marine subjects. Throughout a long career as

a watercolor painter, Duncan specialized in
coastal scenes and the landscape of the southern
counties. He was elected a member of the New
Society of Painters in Water Colours in 1833 but
resigned in 1847 to become in the following
year an associate – and a year after that a full
member – of the Old Society. SW

1. For Duncan's life, see Frank L. Emmanuel,
 "Edward Duncan, R.W.S.," *Walker's Quarterly* 4,
 no. 13 (October 1923).

JOSEPH NASH (1808–1878)
Trees and Figures, 1857/60
Watercolor and bodycolor on brown paper
488 × 340 mm (19³⁄₁₆ × 13⅜ in.)
Signed and dated lower left: *J Nash* 1857; signed
and dated lower right: *J Nash / 1860*
National Galleries of Scotland, Edinburgh

A pupil of the architectural draftsman Augustus
Charles Pugin, Nash was noted for his period
costume pieces in historic settings. These pro-
vided the mainstay of his contributions to the
exhibitions of the Society of Painters in Water-
Colours, of which he became an associate in
1834 and a member in 1842. They were also
brought before the public in a succession of
highly popular lithographs, his greatest success
being *The Mansions of England in the Olden Time,* four
series of colored lithographs of Tudor and Jaco-
bean houses published between 1839 and 1849.
 Trees and Figures, with a group of woodcutters
resting beneath a giant oak,[1] is uncharacteristic
in that it is neither historic nor architectural;
however, the venerable tree shares the same
qualities of antiquity and picturesqueness that
Nash sought in the ancient buildings he regu-
larly depicted. Nash was an early exponent of
the fashion for a liberal use of bodycolor, but, as
is evident in the present drawing, he used it in a
fluent and sketchy manner quite unlike the fine
stipple technique with which bodycolor came
to be associated. SW

1. The shape and bark of the tree suggest an oak;
 however, the generalized leaf forms more closely
 resemble those of the beech.

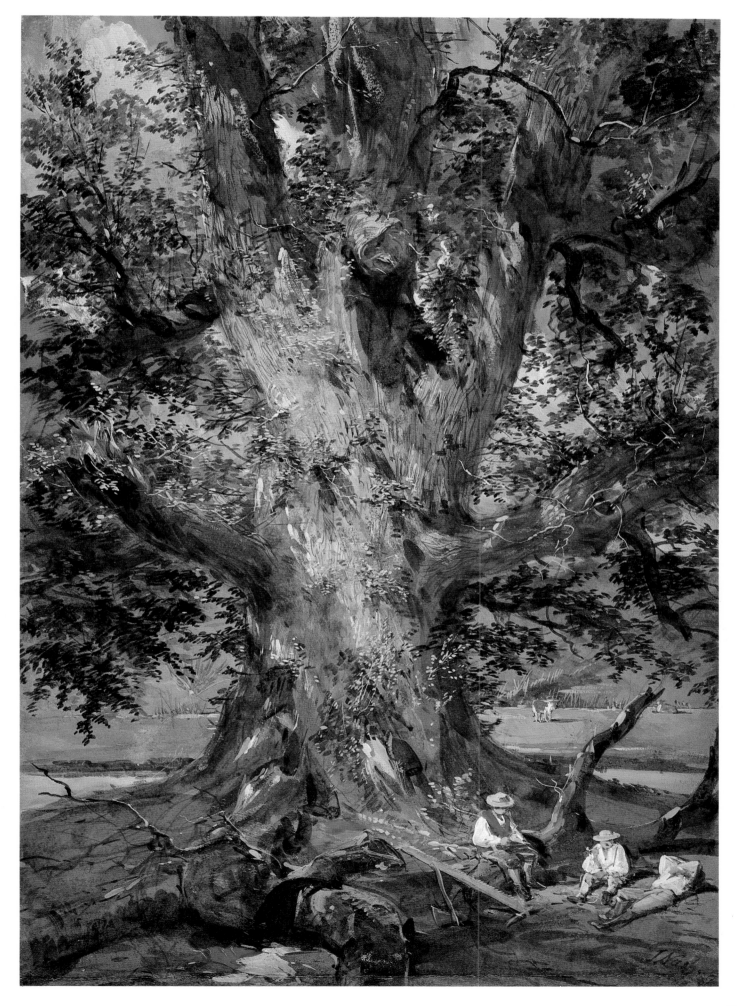

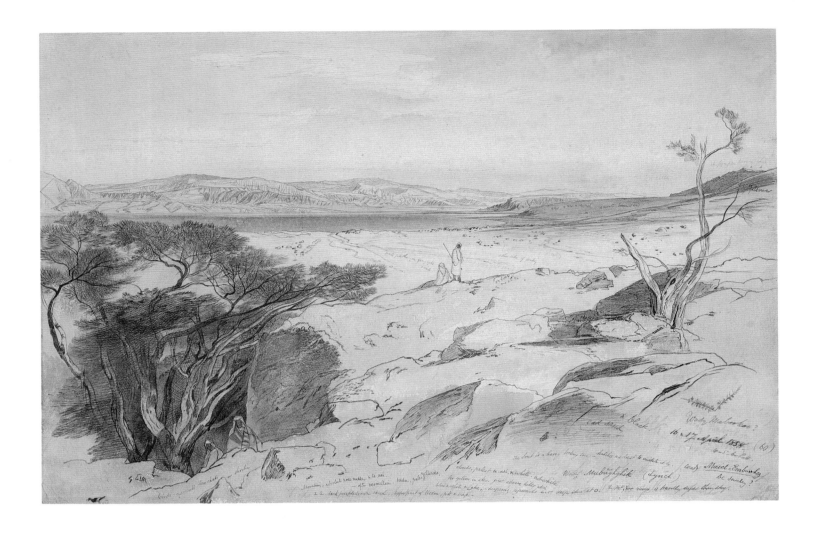

36

EDWARD LEAR (1812–1888)
The Dead Sea, 1858
Watercolor with pen and brown ink over pencil
368 × 553 mm (14½ × 21¾ in.)
Inscribed with various color notes and
observations and dated lower right:
16 & 17 April 1858
Yale Center for British Art, Paul Mellon
Collection

Best known as a writer of nonsense verse, Lear
was also a dedicated and prolific topographical
draftsman.[1] He produced a number of illus-
trated volumes documenting his travels around
the Mediterranean, his professed goal being "to
topographize and topographize all the journey-
ings of my life, so that I shall have been of some
use after all to my fellow critters besides leaving
the drawings and pictures which they may sell
when I'm dead."[2]

Working from pencil sketches done on the
spot and carefully annotated with location,
color, date, the number of the drawing in the se-
quence of works of that sketching campaign (the
"60" in parentheses following the date in this ex-
ample), and other comments, Lear elaborated
these sketches in a process he called "penning
out." He traced the pencil outlines in pen and
ink, adding pale washes of color. In this process
of finishing his sketches, he incorporated the
original annotations, even strengthening them in

pen and ink. The notes became an integral part
of the composition, fostering the appearance of
spontaneity and directness.

Lear made his third visit to Palestine in the
spring of 1858, arriving in Jerusalem during
Holy Week. Finding the city crowded and un-
pleasant, he quickly set off for Petra, Masada,
and the Dead Sea, which he described tersely as
"a wonder in its way."[3]

This sketch records the view looking south-
east across the southern end of the Dead Sea,
with the salt mountain of Usdum (Sodom) ris-
ing at the far right. Among his inscriptions are
several attempts to identify the location in this
region still rarely visited by westerners. "Wady
Mabookos?" is perhaps Lear's own tentative at-
tempt at a place name. "Wady Mubughgik
(Lynch)" and "Wady Maiet-Embarrheg / de
Saulcy?" show Lear trying to relate his position
to the two accounts that served as his authorities
on the geography of the region: William Francis
Lynch's *Narrative of the United States' Expedition to the
River Jordan and the Dead Sea* (1849) and Louis
Félicien Joseph Caignart de Saulcy's *Narrative
of a Journey round the Dead Sea, and in the Bible
Lands* (1853).

In the autumn of 1858, the sculptor Thomas
Woolner met Lear at the home of Holman Hunt.
Lear showed his Palestinian sketches, which
Woolner declared "the most beautiful things he
has ever done," interesting "not only for the
mystery and history attached to the places them-

selves but also for the excessive fineness, tender-
ness and beauty of the art displayed in them."[4]

sw

1. Vivien Noakes, *Edward Lear, 1812–1888*, exh. cat.
 (London: Royal Academy of Arts, 1985), and by the
 same author, *The Painter Edward Lear* (London: David
 and Charles, 1991), are good recent accounts of
 Lear as an artist. They also provide full bibliog-
 raphies.
2. Lear, letter to Lady Waldegrave, January 9, 1868,
 Later Letters of Edward Lear, ed. Lady Constance
 Strachey (London: T. Fisher Unwin, 1911), p. 91.
3. Lear, letter to Lady Waldegrave, May 27, 1858,
 Letters of Edward Lear, ed. Lady Constance Strachey
 (London: T. Fisher Unwin, 1907), p. 108.
4. Woolner, letter to Emily Tennyson, October 22,
 1858, quoted in Noakes, *Lear* (1985), p. 112.

GEORGE PRICE BOYCE (1826–1897)
Streatley Mill at Sunset, 1859
Watercolor
397 × 515 mm (15⅝ × 20¼ in.)
Inscribed with title and date of 1859 on the
artist's label attached to the backing
The Robertson Collection, Orkney

Although Boyce lived in London – where he was part of the semibohemian circle of painters and writers of which Rossetti and later Whistler were the most conspicuous members – he was an habitual traveler. In the 1850s and early 1860s he made extended visits to both Italy and Egypt, and many watercolors by him survive to document these journeys. When in England, he spent part of each summer roaming about the countryside in search of interesting painting subjects, lodging in picturesque cottages, and leading a pleasant rustic existence. From 1859 onward for about a decade, he was entranced by the landscape and architecture of the Thames valley. In the summer months he made frequent visits to the villages along the river to the west of Reading – Mapledurham, Pangbourne, and

Streatley – and those farther upriver and closer to Oxford – Shillingford and Dorchester.

The watercolors that he painted in 1859 and 1860, of which this and *The Mill on the Thames at Mapledurham* (Fitzwilliam Museum, Cambridge) are the best-known examples, represent the high point of Boyce's dedication to the principles of Pre-Raphaelite landscape painting. In the present watercolor Boyce recorded the ancient structure of Streatley Mill with minute and painstaking detail. The different materials of its construction are observed and itemized, and the complexities of its outline and surfaces are carefully delineated. Yet this is not at the expense of atmosphere; the watercolor is radiant with evening light and seems alive with sounds of distant conversation, bird song, the plashing of water, and the rumble of machinery. Boyce employs a characteristic device in placing a line of trees across the foreground, their trunks like sentinels, dividing the composition into compartments.

Neither of Boyce's two views of mills on the Thames was exhibited in his lifetime. Boyce showed just twelve works at the Royal Academy between 1853 and 1861, of which several were

probably oils. He participated in the 1857 Pre-Raphaelite Exhibition at Russell Place and probably also lent pictures to the American Exhibition of British Painting in 1857–58 (shown in New York, Philadelphia, and Boston). In 1858 he was a founding member of the Hogarth Club and exhibited there during the four-years of its existence. Otherwise there was no obvious showcase for his production as a painter except the Old Water-Colour Society, and for some reason not absolutely clear, he had to wait until 1864 to become even an associate of that professional body. CN

38

EDWARD JOHN POYNTER
(1836–1919)
Near Argelès-Gazost at the Foot of the Pyrenees,
ca. 1859
Watercolor with bodycolor and scraping out
140 × 213 mm (5½ × 8⅜ in.)
Signed in monogram lower right: EJP
Yale Center for British Art, Paul Mellon Fund

Poynter was born in Paris, the son of an English architect and the great-grandson of the sculptor Thomas Banks. His training as an artist, and specifically his introduction to the art of watercolor painting, began in about 1852, when his father placed him in the studio of Thomas Shotter Boys, who was a family friend. In the winter of 1853–54 the young Poynter went to Rome, where he met Frederic Leighton – whose work and ideas on art were to be a powerful and lasting influence on him. Later Poynter studied at Leigh's School and the Royal Academy Schools in London, and finally in Paris, where he enrolled in the studio of Charles Gleyre and joined the circle of English-speaking painters described by George du Maurier in his novel *Trilby* (1894).

Poynter was to become one of the principal painters of historical, neoclassical, and genre subjects of the age, perhaps second only to Leighton himself. He was a stalwart of the Royal Academy and eventually became its president.

In the course of his career he held a range of other official positions – he served as Slade Professor of Art at University College, London, and was subsequently director of the art schools at the South Kensington Museum. From 1894 to 1906 he was director of the National Gallery.[1]

Poynter used the medium of watercolor mainly for landscapes and portraits. The resulting works are among his most personal and seem to indicate his enjoyment of the physical processes of painting, a feeling generally lacking in his more grandiose oil paintings. It was his habit to paint views of the countryside when traveling abroad. The present watercolor, from relatively early in his career, was probably painted during a visit that Poynter made to the Pyrenees in November 1859. Another watercolor of a Pyrenean subject, *Pic du Ger* (British Museum, London), dated 1859, is similar in technique.[2] A group of thirteen sketches of views in the Pyrenees, some dated November 1859, are in the Ashmolean Museum, Oxford.

CN

1. For biographical information on Poynter, see James Dafforne, "The Works of Edward J. Poynter, R.A.," *Art Journal*, January 1877, pp. 17–19, and Herbert Sharp, "A Short Account of the Work of Edward John Poynter, R.A.," *Studio* 7 (1896): 3–15. For his work as a watercolorist, see Lewis Lusk, "Sir E. J. Poynter as a Water-colourist," *Art Journal*, June 1903, pp. 187–192, and Isabel G. McAlister, "Some Water-colour Paintings by Sir Edward Poynter, P.R.A.," *Studio* 72 (1917): 89–100.

2. This watercolor was sold by Julian Hartnoll, whose catalogue, *A Selection of Drawings, Oil Paintings, and Sculptures* (London, 1989), provided information on the drawings of the 1859 visit to the Pyrenees.

39

DAVID COX, JR. (1809–1883)
Welsh Mountain Stream
Watercolor with scraping out over charcoal
368 × 527 mm (14½ × 20¾ in.)
Signed lower left: *David Cox Junr*
Yale Center for British Art, Paul Mellon
Collection

When his father quit giving drawing lessons and
moved away from London in 1841, David Cox,
Jr., took over his father's pupils.[1] The change of
instructor presumably caused little disruption to
the teaching, as David Jr., having been taught by
his father, modeled his own watercolor style
closely on that of the older artist. In the same
year David Jr. was elected an associate of the
New Society of Painters in Water Colours, gain-
ing full membership in 1845 but resigning from
the organization the following year. He became
an associate of the Old Water-Colour Society in
1848, and for a decade works by both the father
and the son hung together in the Old Society's
annual exhibitions.

The younger Cox wandered farther afield in
his search for subjects, finding them in Scottish
and Continental scenery that his father had
never felt the need to experience. Yet the Welsh
landscapes so beloved of the father also occu-
pied a special place in the work of the son. It
has been suggested that the mountain range

that encloses this view is Crib Goch, below
Snowdon. In the watercolor, the younger Cox
successfully achieves the same effect of bold,
gloomy grandeur that was so typical of his fa-
ther's late Welsh mountain scenes. sw

1. The fullest account of the younger Cox remains
 that given by John Lewis Roget, *A History of the "Old
 Water-Colour" Society*, 2 vols. (London: Longmans,
 Green and Co., 1891), vol. 2, pp. 326–28; but see
 also Stephen Wildman et al., *David Cox, 1783–1859*,
 exh. cat. (Birmingham Museum and Art Gallery,
 1983), pp. 133–34.

DAVID HALL McKEWAN (1817–1873)
Mountain Rocks
Watercolor with scraping out over pencil
243 × 422 mm (9⁹⁄₁₆ × 16⁵⁄₈ in.)
Signed lower right: *D H McKewan*
Yale Center for British Art, Paul Mellon
Collection

While McKewan's work was consistently linked
with that of David Cox, the style of the younger
artist, particularly in watercolor sketches such as
Mountain Rocks, was often closer to the crisp and
dashing watercolor manner of William James
Müller. It was this Müller-like use of the me-
dium – with clusters of bladelike brushstrokes
defining grasses and foliage, and areas of rich,
wet color combined with areas in which drier
pigment had been dragged across the paper to
leave sparkling highlights – that McKewan sche-
matized for general use in his book of 1859,
Lessons on Trees in Water Colours.

The brief introductory text emphasized the
student's development of "a bold and vigorous
touch, so essentially necessary in painting from
nature." It also recommended the use of moist
colors in tubes – in this McKewan differed from
both Cox and Müller, who had always remained
faithful to the old cake colors – claiming that "it
would be almost impossible to obtain some of
the effects in the present style of Water Colour
drawing with ordinary Colours."[1]

In addition to similarities evident in their
sketches, McKewan may also have shared with
Müller some experience of the Middle East. A
number of watercolors of Middle Eastern sub-
jects suggest that McKewan, like Müller before
him, may have traveled in that region in the late
1850s. McKewan's trip was possibly made in
connection with the noted engineer Thomas
Russell Crampton's work on the Ottoman
Railway, as watercolors by McKewan showing
the railway belonged to Crampton.[2] SW

1. David Hall McKewan, *Lessons on Trees in Water Colours,
 from Drawings Made Expressly for This Work by M'Kewan*
 (London: Dufour, 1859).
2. *Building the Railway between Aidin and Smyrna, Turkey,*
 dated 1860, and *A Steam Train on the Ottoman Railway,*
 dated 1859, were sold at Sotheby's, London,
 November 16, 1989, lots 130 and 131. The prove-
 nance given for both was Thomas Russell
 Crampton.

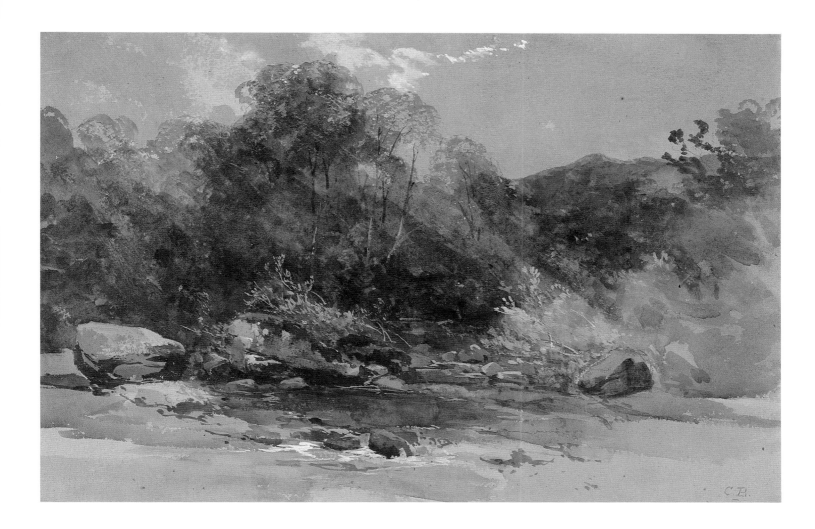

41

CHARLES BRANWHITE (1817–1880)
Landscape: A Rocky Stream with Wooded Banks
Watercolor with bodycolor over pencil on
tan paper
349 × 527 mm (13¾ × 20¾ in.)
Signed lower right: C. B.
The Board of Trustees of the Victoria and Albert
Museum, London

Branwhite was a lifelong resident of the city of
Bristol. He was taught by his father, the min-
iaturist Nathan Cooper Branwhite, but began his
career not as a painter but as a sculptor. When
he later turned to painting, the influence of his
fellow townsman William James Müller was
most evident in his work. Branwhite was elected
an associate of the Society of Painters in Water-
Colours in 1849. Although he never achieved full
membership, he was a prolific exhibitor with
the Society until his death.[1]

Like Müller, Branwhite was more successful in
his sketches than in his finished works. Both his
quality as a sketcher and his debt to Müller are
evident in this study of a woodland stream.
Branwhite's studio works, though impressive,
show little of the vitality evident in such a study
and frequently have an air of picturesque arti-
fice. In his compositions and his handling of the
medium, he clearly belonged to the older
school of watercolor landscape, yet to advocates
of pure watercolor his use of bodycolor seemed
excessive. SW

1. John Lewis Roget, *A History of the "Old Water-Colour"
 Society*, 2 vols. (London: Longman, Green and Co.,
 1891), vol. 2, pp. 335–36.

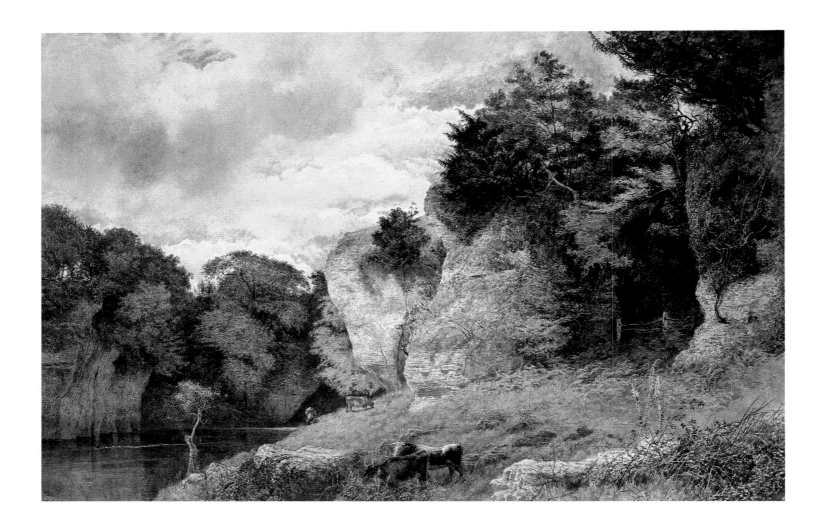

WILLIAM HENRY MILLAIS
(1828–1899)
A View in Yorkshire
Watercolor with bodycolor and varnish
305 × 466 mm (12 × 18⅜ in.)
Signed lower left: *W. H. Millais*
The Visitors of the Ashmolean Museum, Oxford

William Henry Millais was the older brother of John Everett Millais, member of the Pre-Raphaelite Brotherhood and later president of the Royal Academy. The two were brought up together in Jersey until the Millais family moved to London so that John, whose precocious talent for painting must have overshadowed that of William, might enroll in the Royal Academy Schools.

William Millais was the first artist deliberately to apply the principles of Pre-Raphaelitism to landscape subjects. William Michael Rossetti recorded that in November 1849 John Millais encouraged his brother to try landscape subjects. By the end of the year, again according to Rossetti, "John is to bully him into doing nothing all summer but paint in the fields." Rossetti considered the work that resulted "excellent and most promising."[1] In the early 1850s William Millais was part of the inner Pre-Raphaelite circle; in 1852 he joined his brother and Holman Hunt at Ewell in Surrey, where they were painting respectively *Ophelia* (Tate Gallery,

London) and *The Hireling Shepherd* (Manchester City Art Gallery). The following year he joined the party that included John and Effie Ruskin as well as his brother at Brig o' Turk in the Scottish Highlands, where John Millais painted Ruskin's portrait and William made a highly detailed study of the banks of the Glenfinlas River (collection Lord Sherfield). William turned increasingly to watercolor. During the late 1850s he painted mostly coastal views, and during the following decade he evolved his characteristic treatment of riparian subjects. *A View in Yorkshire* probably derives from this latter period.

It is not clear to what extent William Millais regarded himself as a professional artist. His name crops up occasionally as an exhibitor – even as late as 1888 at the Royal Institute of Painters in Water Colours. Although relatively few works by him have survived, some of them, most notably his extraordinary panorama *The Valley of the Rocks, Lynton, North Devon, Showing Lee Abbey* (private collection) of 1875, are highly ambitious. Later in life, when John Millais was established as one of the most sought-after portraitists of the age, William received from him a degree of professional assistance. He was permitted to hang groups of his landscape watercolors in the lobby of his brother's studio, in the hope that they might find buyers among John's clients.[2] CN

1. William Michael Rossetti, *Praeraphaelite Diaries and Letters* (London: Hurst and Blackett, 1900), pp. 243, 277–78.
2. Mary Luytens, *Millais and the Ruskins* (London: John Murray, 1967), p. 36n.

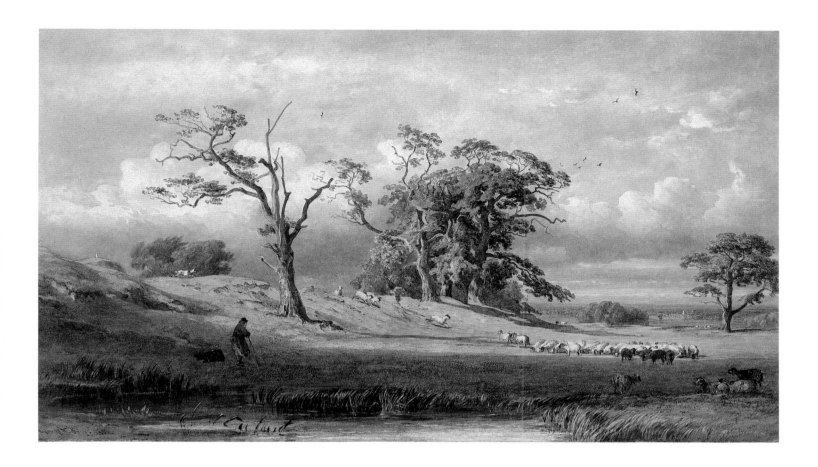

43

GEORGE ARTHUR FRIPP
(1813–1896)
Old British Camp in Bulstrode Park, 1860
Watercolor with scraping out and touches of
bodycolor over pencil
352 × 615 mm (13⅞ × 24¼ in.)
Signed and dated lower left: *George Ar. Fripp 1860*
Yale Center for British Art, Paul Mellon
Collection

Because of their proximity, the counties sur-
rounding London were popular sketching
grounds for London-based artists. Fripp, in par-
ticular, made a specialty of quiet views in the
Thames valley. This watercolor of Bulstrode Park
in Buckinghamshire was exhibited at the Old
Water-Colour Society in 1860.

Bulstrode, the seat of the duke of Somerset
from 1810 to 1885, had extensive grounds en-
compassing the remains of an Iron Age hill fort.
Its oak-studded earthworks form the subject of
Fripp's watercolor. SW

44

WILLIAM HOLMAN HUNT
(1827–1910)
Helston, Cornwall, 1860
Watercolor with scratching out
193 × 257 mm (7⅝ × 10⅛ in.)
Signed and dated lower left: *W.hh 1860*
Whitworth Art Gallery, University of Manchester

In September 1860 Holman Hunt shared a holiday in Devon and Cornwall with Val Prinsep, Alfred Tennyson, and Francis Turner Palgrave. They arrived in Penzance from Saint Mary's in the Scilly Isles, and from there traveled via Land's End, where Tennyson and Palgrave hired a trap while Prinsep and Hunt walked, to Helston. From Helston, where the present watercolor was painted, they went on to the Lizard on the Cornish coast, remaining there for several days and sketching Asparagus Island. Tennyson and Palgrave left the party there, while Hunt and Prinsep went on to stay with friends in Falmouth.[1] Hunt was clearly more in earnest in his artistic pursuits than his companions, as Palgrave's words reveal: "We were sorry not to have more of Hunt's company, but as he preferred his Art to our honourable society, what could be done?"[2]

The watercolor landscapes from this expedition are among the most personal of all Hunt's works, done, as Judith Bronkhurst has written,

"for the artist's own enjoyment rather than in the hopes of an immediate sale."[3] The muted color of Hunt's view at Helston, while different from most of Hunt's watercolors, represents a carefully controlled response to soft and moist atmospheric conditions that is essentially naturalistic and truthful. CN

1. An account of this holiday appears in William Holman Hunt, *Pre-Raphaelitism and the Pre-Raphaelite Brotherhood*, 2 vols. (London: Macmillan and Co., 1905), vol. 2, pp. 203–15.
2. Palgrave, manuscript in the Tennyson Research Centre, Lincoln.
3. Judith Bronkhurst, in *The Pre-Raphaelites*, exh. cat. (London: Tate Gallery, 1984), p. 293.

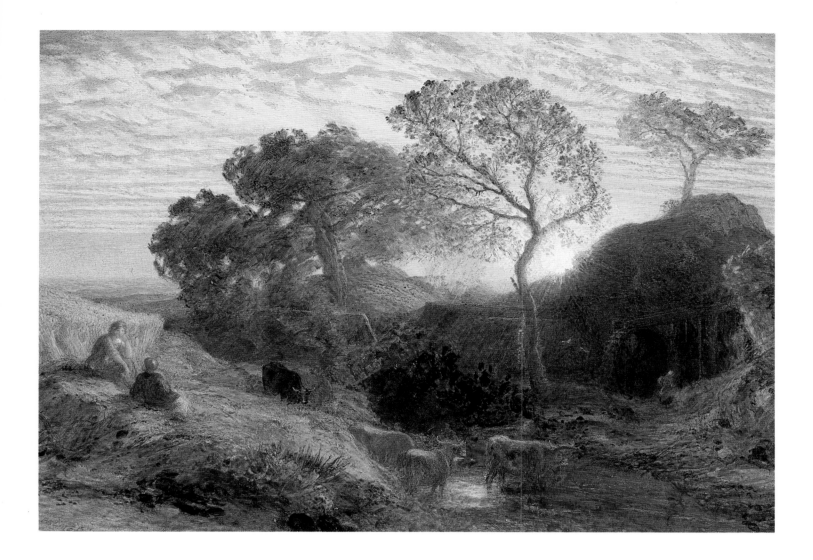

45

SAMUEL PALMER (1805–1881)
Sunset, 1861
Watercolor, bodycolor, and gum over pencil
on card
270 × 387 mm (10⅝ × 15¼ in.)
Dated and signed lower left: 1861 / S PALMER
Yale Center for British Art, Paul Mellon
Collection

By the late 1850s Palmer was moving away from
the strict naturalism that he had somewhat un-
comfortably adopted to a more idyllic vision
and a more brilliant and expressive use of color.
Although the critics sometimes found his color
unsettling, they were generally disposed to over-
look the shortcoming for the sake of the "deep
poetic feeling"[1] of landscapes such as *Sunset*. A
few acknowledged that Palmer's intense color
had value in itself: "Such preternatural blazes do
certainly great service in an exhibition, by their
matchless power of diffusive light and heat."[2]
The *Athenaeum* in 1860 commented more simply:
"There is not a better painter of sunsets in
England than Mr. Samuel Palmer."[3]

The poetic element in Palmer's landscapes be-
came more explicit from 1864 onward in two
extended series of works illustrating Milton's
L'Allegro and *Il Penseroso* and Virgil's *Eclogues*. In let-
ters of the mid-1870s to Leonard Rowe Valpy,
who commissioned the Milton watercolors,
Palmer made clear his allegiance to the classical
landscape of Claude and Poussin, an allegiance
readily apparent in his watercolors. With the lin-
gering taste for Ruskin-inspired exactitude in
mind, Palmer wrote: "Geological drawing is not
art drawing, though the latter includes as much
of it as may be wanted." Claude and Poussin
knew what to omit: "They addressed not the
perception chiefly, but the IMAGINATION,
and here is the hinge and essence of the whole
matter."[4] SW

1. This phrase comes from the *Spectator*, May 4, 1861,
 p. 475, which also warns that Palmer's landscapes
 "may startle at first by their brilliant orange
 colour."
2. *Art Journal*, June 1, 1863, p. 118.
3. *Athenaeum*, May 5, 1860, p. 623.
4. Palmer, letter to Leonard Rowe Valpy, May 1875, *The
 Letters of Samuel Palmer*, ed. Raymond Lister, 2 vols.
 (Oxford: Clarendon Press, 1974), vol. 2, pp. 912–13.

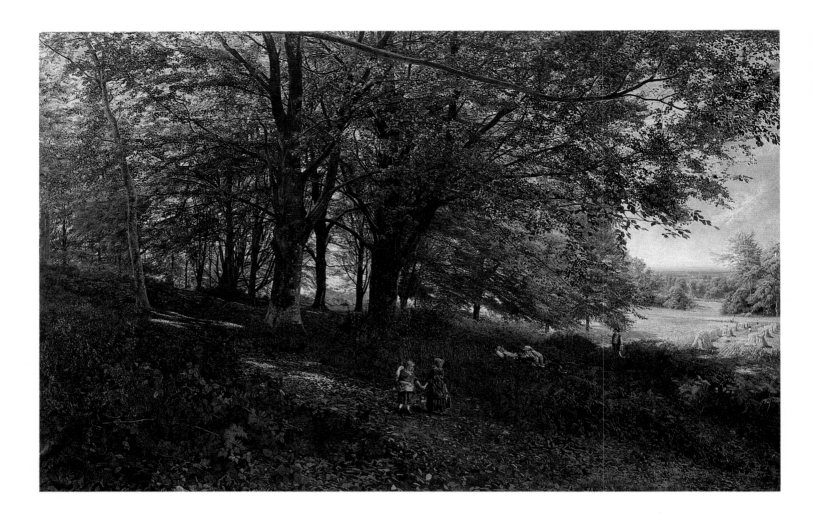

EDMUND GEORGE WARREN
(1834–1909)
"*Rest in the Cool and Shady Wood*," 1861
Watercolor and bodycolor with gum
775 × 1204 mm (30½ × 47⅜ in.)
Signed and dated lower right: *Edmund G Warren*
1861.
The Board of Trustees of the Victoria and Albert
Museum, London
Exhibited at Birmingham only

The woodland landscapes that Warren exhibited
in the late 1850s created a sensation in the New
Society of Painters in Water Colours roughly
comparable to that occasioned by John
Frederick Lewis's oriental subjects at the Old
Society in the preceding years. Warren's water-
colors, with their seemingly photographic real-
ism, their minute touches of brilliant greens,
yellows, and golds, and their almost palpable ef-
fects of sunlight filtering through trees, gal-
vanized both the audiences and the artists of the
New Society. Warren became an associate of the
group in 1852 and a full member in 1856. The
president at the time was his father, Henry
Warren, a popular painter of genre and histori-
cal subjects, frequently with Eastern themes.

"*Rest in the Cool and Shady Wood*" was one of the
major showpieces of the 1861 exhibition of the
New Society of Painters in Water Colours. It had
the highest price tag of any watercolor in the ex-
hibition, an astonishing four hundred pounds.
The *Spectator* described the work in glowing
terms but also made clear that problems with its

physical condition, visible today in the surface
of the work, were already apparent on its first
exhibition:

> It is large in size, and must have occupied the painter some
> time, so full is it of detail. The delicate tracery of boughs
> in shade telling against the sunny green beyond, the holly,
> the brambles, and ground of dead leaves, are all wrought
> with assiduous veracity. The shade appears too dark, it
> would surely be more illumined with reflected light. In all
> other respects this drawing may be pronounced perfect,
> though . . . Mr. Warren is too much addicted to unstable
> mediums. I regret to find this beautiful work is already
> cracking.[1]

The following year the work was included in
the selection of English watercolors at the
International Exhibition in London, where J. B.
Atkinson in the *Art Journal* noted it as a "prodigy
of manual skill" belonging to "the so-called
school of landscape 'Pre-Raphaelites.'"[2]

Warren was neither a Pre-Raphaelite nor a
member of any other school, but his woodland
scenes were influential. Charles Davidson's
"*In the Leafy Month of June*" – Burnham Beeches
(cat. no. 71) is clearly indebted to Warren's ex-
ample. James Thomas Watts may well have been
following Warren's lead when he based his own
career on woodland subjects, although in his
case Warren's summer sunlight and leafy greens
were exchanged for the steely gray skies and
russet tints of autumn. sw

1. *Spectator*, April 27, 1861, p. 445.
2. J. Beavington Atkinson, "International Exhibition,
 1862," *Art Journal*, October 1, 1862, p. 200.

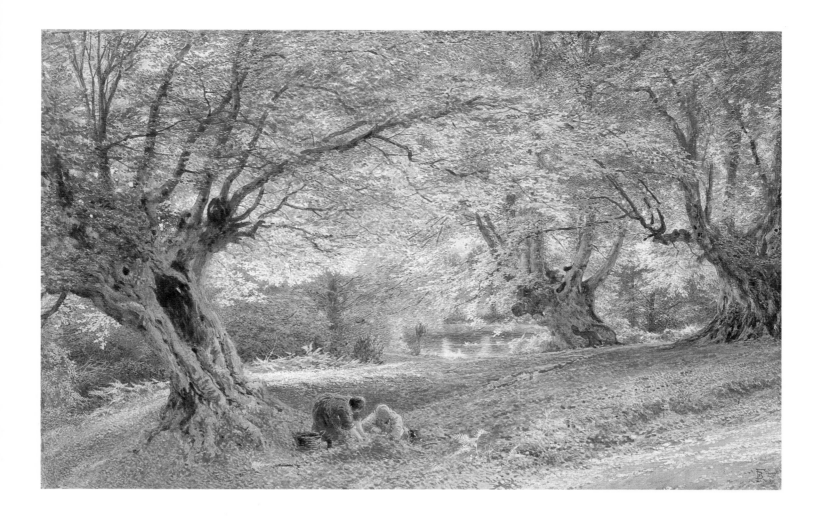

MYLES BIRKET FOSTER (1825–1899)
Burnham Beeches, exhibited 1861?
Watercolor with bodycolor
210 × 330 mm (8¼ × 13 in.)
Signed in monogram lower right: *BF*
Private collection

In 1859 Birket Foster, a popular illustrator noted for his vignettes of rustic life, submitted three watercolors to the Society of Painters in Water-Colours in the hope of being elected an associate. He failed but tried again a year later, when he was successful. He wrote to his brother-in-law informing him of the outcome and of his hopes for the future:

The gallery at Pall Mall East is the best place to have Water Colour drawings exhibited and it has been a great desire of mine to get into the Society that I might be enabled to send pictures there. I am only an Associate at present which entitles me to send 8 pictures to the Exhibition – more than I shall ever do. The members of course fill up their numbers from the Associates according to their merits that sometime I hope that I shall take the higher step – and that at present is as far as a Water Colour painter can go.

He went on to announce that he would no longer design wood engravings: "I have entirely given up the old work. I have given notice to all my friends that I have given up all drawing on wood. It is a bold step but commissions for pictures pour in – and it is far more delightful working in colour."[1]

From his first appearance in the Society exhibition the following spring, Birket Foster was one of the group's most popular artists. Queen Victoria sought to purchase one of the watercolors he sent to that 1860 exhibition. He was elected a full member two years later.

Birket Foster exhibited watercolors with the title *Burnham Beeches* in 1861 and in both the summer and winter exhibitions of 1870. The *Spectator*'s description of the work shown in 1861 as "very rich in its autumnal tints and glowing sun"[2] suggests that it was the present watercolor. The ancient beech trees and oaks at Burnham Beeches in Buckinghamshire provided a notable subject for artists – a treatment by Charles Davidson is also in the present exhibition (cat. no. 71) – as well as a popular place of recreation within easy reach of London.[3] SW

1. Birket Foster, letter to Robert Spence, February 19, 1860; the letter, in the Newcastle upon Tyne City Libraries, is published in Jan Reynolds, *Birket Foster* (London: B. T. Batsford, 1984), p. 66. For Birket Foster's life, see, in addition to Reynolds, H. M. Cundall, *Birket Foster, R.W.S.* (London: Adam and Charles Black, 1906), and Frank Lewis, *Myles Birket Foster, 1825–1899* (Leigh-on-Sea: F. Lewis Publishers, 1973).
2. *Spectator*, May 4, 1861, p. 475.
3. In 1879 the land was put up for sale by public auction, and the future of the great trees seemed in jeopardy. The land was purchased by Sir Henry Peek and resold to the Corporation of London. See Millicent Garrett-Fawcett, "Burnham Beeches," *Magazine of Art* 8 (1885): 485–92.

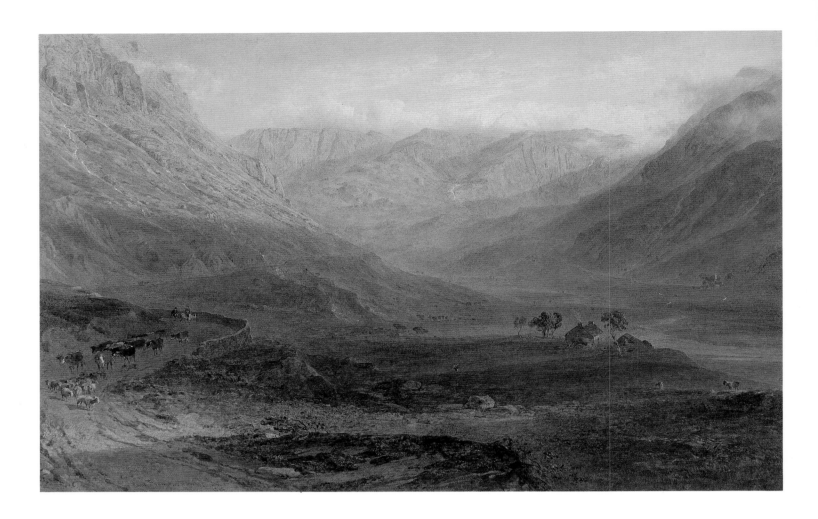

GEORGE ARTHUR FRIPP
(1813–1896)
Nant Ffrancon, North Wales, 1862
Watercolor with gum, scraping out, and touches
of bodycolor over pencil
466 × 729 mm (18⅜ × 28-¾ in.)
Inscribed, signed, and dated lower left: *Nant
Frangon. George. A Fripp / 1862*
Yale Center for British Art, Paul Mellon Fund

Although mountain scenery, in both its
Continental and native varieties, had long been a
staple of British landscape painters, it assumed
increased prominence in the aftermath of
Ruskin's fourth volume of *Modern Painters*, which
appeared in 1856 with the subtitle "Of Mountain
Beauty." Watercolorists such as Alfred P. Newton
and George F. Rosenberg made a specialty of
carefully delineated alpine scenes. In 1862
Newton actually exhibited a watercolor with the
title *Mountain Glory*, echoing the title of the last
chapter of Ruskin's volume.

While Fripp was better known for his views
of the Thames valley and the Dorset coast, he
began in the 1850s and 1860s to paint the moun-
tainous regions of Scotland and, to a lesser ex-
tent, North Wales. He sent a number of views of
Nant Ffrancon to the exhibitions of the Society
of Painters in Water-Colours in the early 1860s.
Works of that subject appeared in 1860 and 1861,
but not in 1862, the date of the Yale watercolor,
or in the following year. In 1864, however, he re-
turned to the subject with *Scene at the Head of the
Pass of Nant Frangon, from the Old Road – Evening*. This

may well have been the Yale watercolor. In the
view of the *Art Journal*, the watercolor was "spe-
cially to be commended for the exquisite tone
preserved by allegiance to transparent colour,
and for the keeping of the relative distances in
their severally allotted places, qualities in which
this landscape is without a rival."[1] The *Spectator*
also singled out the work with its "great hills
standing apart in the evening sun" for special
praise. The review went on to characterize
the style:

*Mr. G. Fripp's method deserves particular commendation
for its resolute suppression of immaterial facts and details:
– suppression, not excision, – so that the spectator feels the
presence of each variety of rock and heather, grass and
"screes," but is not by unrestrained expression of them dis-
tracted from the main idea and design of the picture.*[2]

The careful, delicate detail with which Fripp
rendered the rocky landscape shows an ap-
proach to such scenery that, if not directly
shaped by reading Ruskin on "mountain
beauty," at least reflected a climate in which
Ruskin's writings were a determining factor.
Fripp, however, was constitutionally incapable
of the microscopic detail attempted by some
Ruskin followers. In 1860 Fripp wrote concern-
ing a portfolio of Scottish watercolors that
had been commissioned from him by Queen
Victoria. He explained that "owing to the weak-
ness and shortness of my sight (though I ever
carried a small opera glass with me) I am not
able to do justice to subjects requiring much
careful drawing, and of great range."[3] sw

1. *Art Journal*, June 1, 1864, p. 170.
2. *Spectator*, May 7, 1864, p. 537.
3. Fripp, letter to Sir Charles Phipps, November 8,
 1860, quoted in Delia Millar, *Queen Victoria's Life in the
 Scottish Highlands, Depicted by Her Watercolour Artists*
 (London: Philip Wilson Publishers, 1985), p. 100.

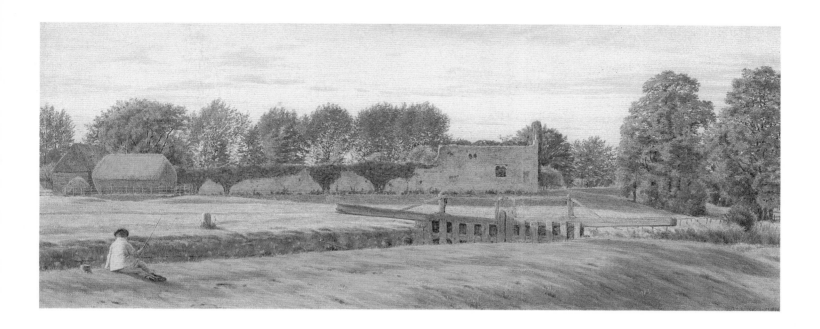

49

GEORGE PRICE BOYCE (1826–1897)
Godstow Nunnery, Oxfordshire, 1862
Watercolor
225 × 556 mm (8⅞ × 21⅞ in.)
Signed and dated lower right: *G. P. Boyce Septr
1862*; inscribed, signed, and dated verso: *Godstow
Nunnery near Oxford, G Boyce, August 1862, 6.15 pm*;
inscribed on the artist's label: *3. Godstow Nunnery,
Oxfordshire, / Where Fair Rosamond Died*
Private collection

Boyce stayed at Godstow on the Thames near
Oxford for about two months in the late
summer and early autumn of 1862. During
September Boyce painted the present watercolor
as well as *At Binsey, near Oxford* (Cecil Higgins
Art Gallery, Bedford). Early in October he pro-
duced a third watercolor, a slighter drawing of
Godstow, and later in the month – certainly by
the 22nd – he returned to London.[1] Each of
these watercolors was presumably finished dur-
ing Boyce's stay in Oxfordshire. He inscribed
very precise dates on his works, and it may be
assumed that, had he worked on them further
when back in London, he would have appended
a second date.

On February 1, 1864, Boyce took with him
"to the Old Water Colour Society's Gallery 4
drawings with a view to election on the list of
Associates."[2] *Godstow Nunnery, Oxfordshire* was one
of the four watercolors upon which his ambi-
tion to join the Society rested. On February 8 it
was announced that he had been successful,
and the four were eventually included in the
Society's summer exhibition. Although Boyce
complained that his works were hung where
they were difficult to see, his watercolors were

noticed in the reviews. The *Art Journal* concluded
that Boyce "cherishes a single eye for simple na-
ture, which, in the reverence of deep feeling, he
ventures not to alter, or even to compose. The
art of this artist, one of the newly-elected associ-
ates, is artless."[3]

In this watercolor Boyce depicts the ruins of
the Benedictine nunnery on the banks of the
river Thames or Isis to the northwest of Oxford.
In the foreground is a lock gate, presumably the
Godstow lock, which allowed boats and barges
to bypass weirs on the river at Wolvercote.

According to legend, Fair Rosamund, mistress
of King Henry II, was buried at Godstow follow-
ing her murder at Woodstock in 1176 by Henry's
wife, Queen Eleanor. Arthur Hughes painted
the subject in 1854, the same year that Edward
Burne-Jones made a pilgrimage to Godstow.
With the publication in 1860 of Algernon
Swinburne's play *Fair Rosamund*, an intense inter-
est in both the place and the historical events
associated with it occupied artistic and literary
circles. CN

1. For Boyce's movements in the autumn of 1862, see
 The Diaries of George Price Boyce, ed. Virginia Surtees
 (Norwich: Real World, 1980), pp. 35, 96–97.
2. Ibid., p. 39.
3. *Art Journal*, June 1, 1864, p. 171.

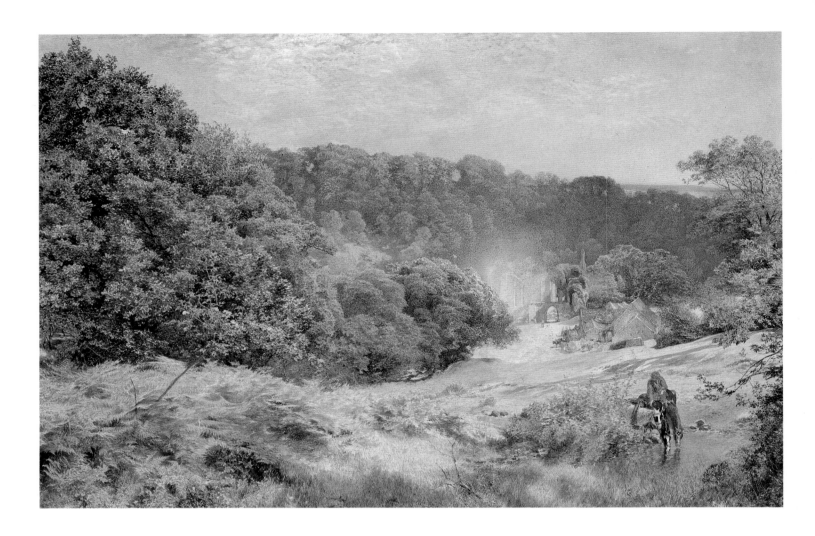

ALFRED WILLIAM HUNT
(1830–1896)
Finchale Priory, exhibited 1862
Watercolor and bodycolor with scratching out
324 × 483 mm (12¾ × 19 in.)
Private collection

In 1861 Hunt gave up his fellowship at Corpus Christi, Oxford, ostensibly so that he might marry (college fellows were required to remain unmarried) but also because he had by this time resolved to support himself by painting. Soon afterward he went to live in Durham, his wife Margaret's native city, and from that time forward he made frequent painting expeditions in the northeastern counties of England. In 1860 he had exhibited at the Society of British Artists an oil of Brignal Banks (Walker Art Gallery, Liverpool), close to Greta Bridge in North Yorkshire. It was presumably during the early summer of the following year that he painted the present watercolor of the ruins of Finchale Priory, which stand among woods on a bend of the river Wear two or three miles north of Durham. It was probably his wife's father, the Reverend Dr. James Raine, who drew Hunt's attention to Finchale.[1] The priory church had been founded at the end of the twelfth century to commemorate Saint Godric, who had been a hermit close by and was buried there.

Violet Hunt, the artist's daughter, described the oil of Brignal as a "unique picture done in

[her father's] best Pre-Raphaelite period, after he had got rid of his *David Coxiness* – and had his good eyesight, to give even the small dogroses in the foreground, as it were, all their petals."[2] The same might be said of *Finchale Priory*, which represents Hunt's watercolor style at its most painstaking and literal, and in which – as it happens – dog roses again appear. The hazy effect around the distant buildings represents the spray rising from the rapids of the unseen river. In spite of its highly elaborate technique, the watercolor was probably largely painted out of doors; however, there is a sepia drawing of the subject (Ashmolean Museum, Oxford) that may have served as a trial run in the arrangement of the compositional elements.

In 1862 Hunt was elected an associate of the Old Water-Colour Society. *Finchale Priory*, shown at the Society's summer exhibition that same year along with four other drawings by him, stands as one of his first contributions to the professional association of which he was a distinguished member and a devoted supporter for the rest of his life. CN

1. The Rev. Dr. James Raine was rector to a succession of parishes in Durham and Northumberland and was at one time the librarian to Durham Cathedral; his work *The History and Antiquities of North Durham* was published in 1852. Although he died in 1858, three years before the marriage of his daughter, he had known Hunt since 1855, the date of the painter's first visit to Durham.
2. Violet Hunt, letter to E. Rimbault Didben,

December 4, 1914, Washington University Library, St. Louis, quoted in Robert Secor, *John Ruskin and Alfred Hunt: New Letters and the Record of a Friendship* (Victoria, B.C.: University of Victoria, 1982), p. 24.

51

MYLES BIRKET FOSTER (1825–1899)
The Hay Rick, ca. 1862
Watercolor and bodycolor with scraping out
777 × 680 mm (30⅝ × 26¾ in.)
Signed in monogram lower right: BF
Yale Center for British Art, Paul Mellon Collection

After Birket Foster's announcement in 1860 that he would undertake no more work as an illustrator, he did complete one major project that had been commissioned by the wood-engraving firm Dalziel Brothers several years earlier. This was his *Pictures of English Landscape*, which was published in time for the Christmas season in 1862. Alfred Tennyson had been approached to write poems to accompany Birket Foster's images but declined; instead Tom Taylor provided the verses which, as Taylor put it, "illustrated" the pictures.[1]

In his preface Taylor noted that Birket Foster had "carried suavity and grace to the very point to which they can be carried without falling into

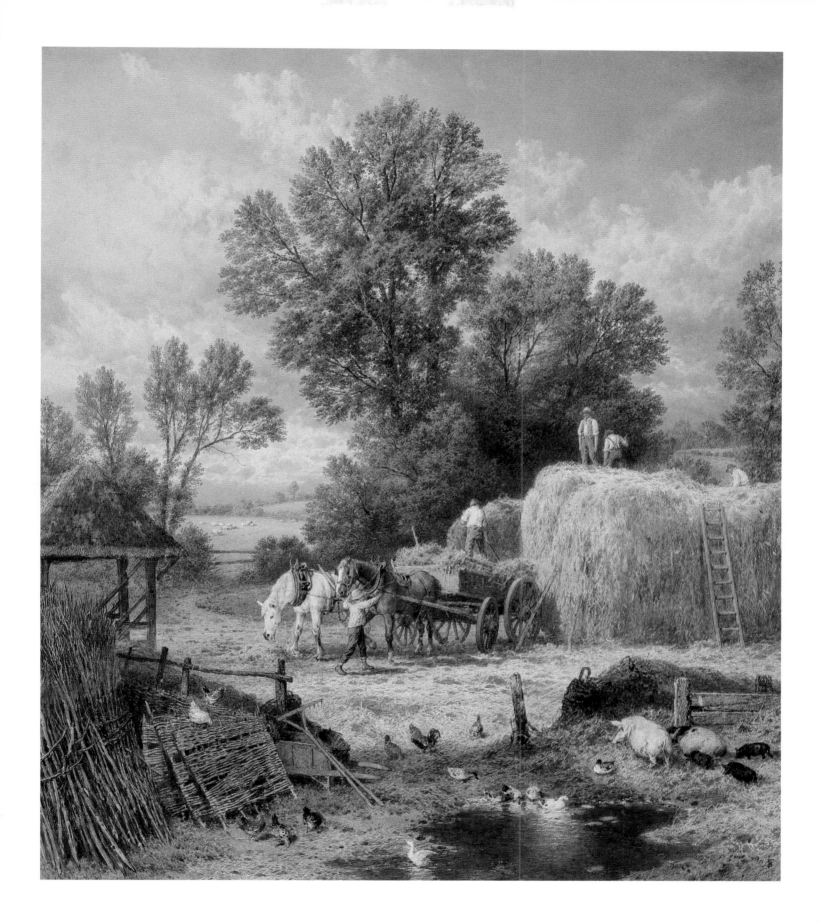

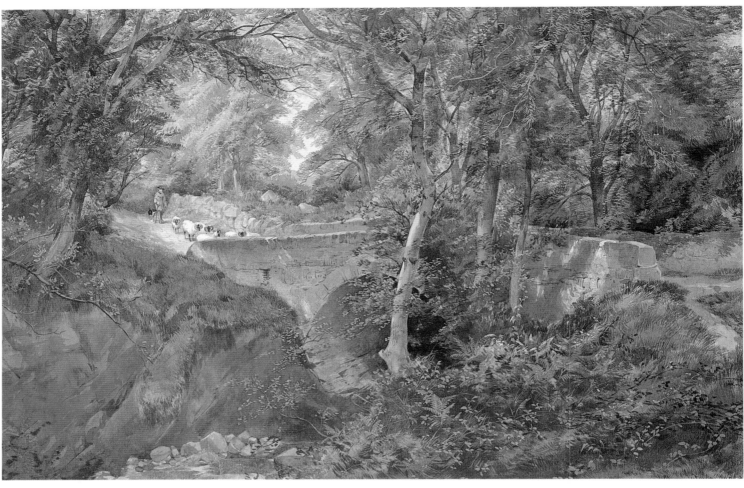

52

effeminacy."[2] When the Dalziels sent a set of proofs to Ruskin, he replied: "They are superb specimens of the kind of Landscape which you have rendered deservedly popular, and very charming in every respect. I wish, however, you would devote some of your wonderful powers of execution to engraving Landscape which should be better than 'charming', and which would educate the public taste as well as meet it."[3]

The Dalziels offered Birket Foster three thousand pounds to make watercolor versions of the volume's pictures. This was ten times the amount that had been offered for the designs originally. Birket Foster refused but did produce a few finished watercolors of compositions from the book, including the present large-scale work. SW

1. For an account of the genesis of the work, see *The Brothers Dalziel: A Record of Fifty Years' Work, 1840–1890* (London: Methuen and Co., 1901), pp. 139–56.
2. Tom Taylor, preface, *Birket Foster's Pictures of English Landscape* (London: Routledge, Warne, and Routledge, 1863).
3. Ruskin, letter to the Messrs. Dalziel, August 12, 1862, quoted in *Brothers Dalziel*, p. 154.

52

HENRY JUTSUM (1816–1869)
Wooded Landscape with Sheep Crossing a Bridge, 1863
Watercolor, bodycolor, and ink over pencil
344 × 509 mm (13½ × 20 in.)
Signed and dated lower right: *Henry Jutsum 1863*
Birmingham Museum and Art Gallery

A Londoner by birth, Jutsum developed his art by drawing the trees in Kensington Gardens, which he described as his "academy."[1] Although he exhibited works at the Royal Academy from the mid-1830s, he sought professional tuition from the Norwich landscape painter James Stark in 1839. Jutsum's woodland scenes, a lifelong preoccupation, are often reminiscent of those of another Norwich School artist, John Middleton, but with a degree of elaboration and suggestion of detail that comes closer to the popular style of E. G. Warren (see cat. no. 46).

In 1843 Jutsum was elected an associate of the New Society of Painters in Water Colours, but he resigned four years later when he turned his attention more fully to painting in oils. As this work demonstrates, he did not entirely give up painting finished watercolors. SW

1. J. Dafforne, "Henry Jutsum," *Art Journal,* September 1, 1859, pp. 269–71.

53

WILLIAM SIMPSON (1823–1899)
The Ganges, 1863
Watercolor with bodycolor over pencil
364 × 511 mm (14¼ × 20⅛ in.)
Inscribed, signed, and dated lower left:
The Ganges. Wm. Simpson 1863
Yale Center for British Art, Paul Mellon Collection

The popularity of Simpson's illustrations of the Crimean War and the widespread interest in India engendered by the events of the Indian Mutiny of 1857 prompted William Day of the London lithographic firm of Day and Son to send Simpson to India. He was to make drawings for an ambitious volume on India modeled on David Roberts's massive *Holy Land,* published in parts from 1842 to 1849.

Between October 1859 and February 1862 Simpson traveled throughout India, sketching and gathering material for his great work. According to his own calculations, he traveled 22,570 miles for the project.[1] After his return to London, he devoted three to four years of constant work to producing from his sketches 250 watercolors.[2] *The Ganges* was one of these watercolors, which as a group provided an unparalleled panorama of the land and life of India.

Simpson was justly proud of his achievement. Unfortunately, lithography, which had been at the height of popularity when Simpson first went to London in 1851 and began to work as a

53

lithographer for Day and Son, was now being superseded by wood engraving as a means of popular reproduction. The financial collapse of Day and Son in 1867 brought the Indian project to an abrupt end. Simpson's drawings were sold to the firm's creditors, and the fifty lithographed plates that had already been made from the drawings were hastily brought out in a poorly produced volume. As Simpson put it: "So the great work on India, on which I had bestowed so much time and labour, never came into existence, and I lost the honour and reputation which would have been due to me if such a work had been properly produced and published."[3]

He had intended to use the profits from the book to free himself to paint for the annual exhibitions. The bankruptcy of Day and Son and the failure of the India volume forced him to continue in the role of artist-reporter. He went to work for the *Illustrated London News*, covering, among other stories, the Abyssinian Expedition of 1867, the opening of the Suez Canal in 1869, the Franco-Prussian War in 1870, the wedding of the emperor of China in 1872, and the Afghan War of 1878. He eventually became an associate of the Institute of Painters in Water Colours in 1874 and a member in 1879. sw

1. William Simpson, *The Autobiography of William Simpson, R.I.*, ed. George Eyre-Todd (London: T. Fisher Unwin, 1903), p. 173.

2. A selection of Simpson's Indian sketches, together with a few of the finished watercolors, are reproduced in Mildred Archer, *Visions of India: The Sketchbooks of William Simpson, 1859–62* (Topsfield, Mass.: Salem House Publishers, 1986).

3. Simpson, *Autobiography*, p. 178.

54

JOHN BRETT (1830–1902)
Near Sorrento, 1863
Watercolor and bodycolor
245 × 335 mm (9⅝ × 13⅛ in.)
Signed and dated lower right: JB / Oct / 1863
Birmingham Museum and Art Gallery

Brett was born near Reigate in Surrey, the son of an army veterinary surgeon. As a boy he received some instruction in drawing in Dublin, where his father had been posted, and in 1851 he had lessons from James Duffield Harding. In 1853 he entered the Royal Academy Schools, at the same time studying the works of Ruskin and making contact with members of the Pre-Raphaelite circle, particularly Holman Hunt.

Brett's early drawings are conventional enough. The impact of Pre-Raphaelitism and of Ruskin's evocation of the beauties of mountain landscape in the fourth volume of *Modern Painters* was first seen in his oil of 1856, *The Glacier of*

Rosenlaui (Tate Gallery, London). While working on that painting, Brett met J. W. Inchbold, who was also working in the Alps that season. The latter's technique was a revelation to Brett, who "there and then saw that I had never painted in my life, but only fooled and slopped, and thenceforward attempted in a reasonable way to paint all I could see."[1] Brett went on to paint various figurative subjects, such as *The Stonebreaker* (Walker Art Gallery, Liverpool) and *The Hedger* (private collection), but came to prefer pure landscapes, of which the oil *Val d'Aosta* (fig. 4, p. 36) is the primary example.

If Brett's most ambitious works were oil paintings, he also exhibited watercolors on a number of occasions and relied on the medium for more private and experimental purposes. Ruskin, who was a friend for a time, encouraged him to paint on a smaller scale.[2] In 1863 Ruskin told his father about the advice he had given Brett: "I've written to him repeating what I told him three years ago – that painting large studies by way of pictures was simply ridiculous – that he must make small ones first, saleable, and learn to choose subjects" (36.441). Ruskin's advice – which more or less repeated what he had already said to A. W. Hunt and anticipated similar exhortations to Albert Goodwin and Fred Walker – may have carried some weight with Brett, for in the 1860s he did tend to work on a more manageable scale and for a while regarded watercolor as his principal medium.

54

In the early 1860s Brett made frequent visits to Italy. He spent the winter of 1861–62 in Florence and was there again the following year to paint his panoramic *Florence from Bellosguardo* (Tate Gallery, London). From August 1863 through the following winter, he visited the south of Italy, and it was during this stay that he painted *Near Sorrento*. The expanse of water seen from above and the carefully observed fishing boats anticipate the marine paintings of his later career. His use of color is rich and evocative of the quality of Mediterranean light; however, despite his painstaking attention to the coloristic and atmospheric aspects of the view, the overall impression is one of curious detachment. The deliberate exclusion of any foreground or indication of the artist's vantage point gives the spectator a sensation of being suspended above the landscape and makes the scene seem peculiarly remote and inaccessible. CN

1. Brett, quoted in Allen Staley, *The Pre-Raphaelite Landscape* (Oxford: Clarendon Press, 1973), pp. 124–25. See Staley's chapter 10 for an account of Brett's career; also Allen Staley, "Some Watercolours by John Brett," *Burlington Magazine* 95 (February 1973): 86–93; and chapter 3 of Kenneth Bendiner, *An Introduction to Victorian Painting* (New Haven and London: Yale University Press, 1985).
2. Brett's relations with Ruskin are considered further in chapter 2 of the present publication.

55

JOHN WILLIAM NORTH (1842–1924)
The Haystack: Halsway Manor Farm, Somerset,
1864
Watercolor and bodycolor
257 × 190 mm (10⅛ × 7½ in.)
Signed and dated lower left: JN / 64
Private collection

North first visited Halsway in 1860 while taking a walking holiday in Somerset with Edward Whymper, to whose father, Josiah Wood Whymper, North was then apprenticed as an illustrator.[1] Halsway Manor dated in part from the fifteenth century and had once been a hunting box of Cardinal Beaufort, half-brother of Henry IV.[2] The rambling and decrepit house, built of honey-colored stone and made especially romantic by its castellated towers and grotesque gargoyles, stood on the edge of the Quantock Hills not far from the Severn estuary. The architecture and historical associations of the house, as well as the agreeable rustic life that was led in what was then a relatively inaccessible part of the country,[3] appealed enormously to North, who had been born in Walham Green in Brixton and who had spent almost his entire childhood in different parts of London. North returned to Halsway on a number of occasions, sometimes in the company of his artist friends

George John Pinwell and Fred Walker.[4] The old house and its garden and the topography of the surrounding countryside appear frequently in North's illustrations and watercolors of the period.

From 1862 to 1866 North worked principally as an illustrator for the Dalziel brothers.[5] He rapidly gained a reputation for his sensitive interpretation of landscape subjects in black-and-white woodblock engraving, and many of the illustrated volumes of the period contain his works. This watercolor shows a girl watching a thatcher at work on a rick of hay beside one of the old fishponds in the manor's large and neglected garden; the main front of Halsway Manor is seen beyond an ivy-clad wall. This particular view originated as a black-and-white illustration to an edition of Jean Ingelow's poems.[6] The watercolor retains the rectilinear arrangement and minute detail of the original design but depends for its effect on a richness of color and warmth of evening light which are characteristic of North's watercolor painting in the 1860s. CN

1. The most complete account of North's life is given by Herbert Alexander in *Old Water-Colour Society's Club* 5 (1927–28): 35–52.
2. For the history of Halsway Manor and its representation in drawings by North and Fred Walker, see

56

R. M. Billingham, "A Somerset Draw for Painters," *Country Life*, August 18, 1977, pp. 428–30.

3. The West Somerset Railway Company opened a line from Taunton to Williton in March 1862. North and his friends could thenceforth travel between London and Halsway within a day and could receive letters and parcels from London by overnight delivery.

4. Watercolors by North showing the buildings and landscape of Halsway are dated 1864, 1865, and 1867; it may be assumed that North was there at least in each of those years. Pinwell visited in 1867, and Walker in 1868.

5. For a complete list of the work that North did for the Dalziels, see *The Brothers Dalziel: A Record of Fifty Years' Work, 1840–1890* (London: Methuen and Co., 1901).

6. Jean Ingelow, *Poems* (London: Longmans, Green Reader and Dyer, 1867).

56

WILLIAM LEIGHTON LEITCH
(1804–1883)
Kilchurn Castle, Argyllshire, 1865
Watercolor with bodycolor and scraping out over pencil
659 × 1015 mm (25⅞ × 39⅞ in.)
Signed and dated lower right: *W. L. Leitch 1865*
Yale Center for British Art, Paul Mellon Collection

Shortly after his death, Leitch was described as "one of the last great fashionable 'drawing masters.'"[1] His rise from humble beginnings as a sign painter in Glasgow to become by dint of hard work and careful study the drawing master to Queen Victoria and a respected landscape painter in watercolors was a quintessential Victorian success story. Leitch was largely self-taught. In the 1820s he worked as a scene painter at the Glasgow Theatre Royal, where he had been preceded by Alexander Nasmyth and David Roberts. Examples of their stage scenery, which were still in use at the theater, formed the school in which Leitch learned the principles of his art. In London in the early 1830s he continued scene painting but also began to turn his attention to producing watercolors and oil paintings.

His work impressed a stockbroker who bankrolled a trip to Italy in 1833. Leitch remained there until 1837, studying the old masters, sketching from nature, and teaching drawing to English residents. He returned to London with a large collection of sketches and finished watercolors, extensive teaching experience, and a number of introductions to aristocratic families. He rapidly gained a reputation as a clear and thorough teacher, and in 1846 he became the drawing master of the queen and other members of the royal family.[2] Other pupils included James Orrock and Sir Coutts Lindsay.

After an unsuccessful candidacy for admission to the Old Water-Colour Society, Leitch was invited by the officers of the New Society to join them. He was unanimously elected to that body in 1862 and was from that date one of the prominent but more conservative contributors to their annual exhibitions. From 1873 until his death he served as the group's vice president.

Leitch's exhibited landscapes, which were generally of Italian subjects or scenes of his native Scotland, employ the well-worn formulas of classical and sublime landscape. As his former pupil Orrock later recalled:

He constantly spoke of the art of painting – meaning by that the treatment of a subject in beauty of lines, disposition of light and shade, and balance of parts, together with the artistic selection and placing of incidents which ought to form characteristic features of the scene or subject. He was also a classic painter. He made selections from nature and composed them into pictures, but he never placed even the most trifling incident which was not in character with the subject.[3]

The imposing *Kilchurn Castle, Argyllshire,* which was exhibited at the New Society in 1865, demonstrates the perils of such a method of con-

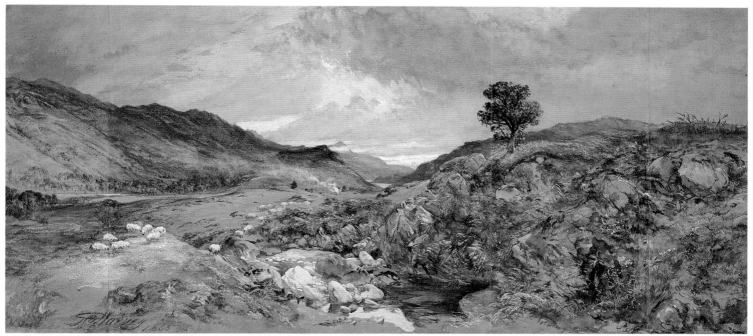

57

structing ideal landscapes. While the effect is undoubtedly grand and splendidly atmospheric, the various elements of the composition, such as the cattle on the left and the bridge at center, do not cohere and are indeed of comically disparate sizes. SW

1. This remark appeared in the *Magazine of Art* 7 (July 1884): xi, in a review of A. MacGeorge, *Wm. Leighton Leitch, Landscape Painter: A Memoir* (London: Blackie and Son, 1884). MacGeorge remains the best source on Leitch.
2. Leitch was granted an annuity by the queen in 1864 and gave his last lesson to her in 1865. For Leitch's employment by Victoria, see Delia Millar, *Queen Victoria's Life in the Scottish Highlands, Depicted by Her Watercolour Artists* (London: Philip Wilson Publishers, 1985).
3. Quoted in MacGeorge, *Leitch*, p. 93.

57

GEORGE HARVEY (1806–1876)
Glenfalloch, 1865
Watercolor and bodycolor on brown paper
355 × 762 mm (14 × 30 in.)
Signed and dated lower left: *Geo. Harvey / 1865*
National Galleries of Scotland, Edinburgh

As a young man, Harvey was involved in the founding of the Royal Scottish Academy, becoming an associate at its inauguration in 1826. He attained full membership in 1829, and from 1864 until his death he served as its president. He was knighted in 1867.

Harvey's reputation was based on his oil paintings of Scottish genre and historical subjects. He was also a sensitive observer of the landscape of his native Scotland, and in his later years he turned more and more to pure landscapes, executed in both oils and watercolors. This study of Glenfalloch in Perthshire is almost Ruskinian in its combination of carefully wrought detail and passionate vigor. SW

WILLIAM BELL SCOTT (1811–1890)
Landscape with a Gate and Water Meadow, 1865
Watercolor and bodycolor
250 × 352 mm (9⅞ × 13⅞ in.)
Signed in monogram and dated lower left:
BS 1865
Maidstone Museums and Art Gallery, Allen
Grove Collection

Scott was half a generation older than most of
the artists who were drawn into the broad
movement of Pre-Raphaelitism. Dante Gabriel
Rossetti befriended him as a poet whose work
he admired, and through Rossetti, Scott got to
know some of the principal artistic figures of the
middle years of the century. Scott's position as
first master of the Government School of Design
in Newcastle upon Tyne from 1843 to 1864,
while it contributed to his influence in the
north, caused him to remain detached from the
London-based Pre-Raphaelite circle.[1]

Scott was an habitual sketcher of landscape
subjects. He used watercolor to make prepara-
tory studies for the landscape details in his cycle
of paintings of the history of Northumberland,
commissioned by Sir Walter and Lady Trevelyan
for the court of Wallington Hall – a project on
which he worked from 1856 to 1861.[2] *Landscape
with a Gate and Water Meadow* was painted soon af-
ter Scott retired from his post in Newcastle and

moved to London. The seeming casualness of
the composition and the effect of bright midday
sunlight speak of the artist's direct experience of
the landscape. The watercolor is exceptional
among Scott's works, which tend toward a cer-
tain staginess. CN

1. The principal source of biographical information
 on Scott is his own *Autobiographical Notes*, 2 vols.
 (London: James R. Osgood, McIlvaine and Co.,
 1892).
2. For details of Scott's relations with the Trevelyan
 family of Wallington Hall, as well as with Rossetti
 and Ruskin, see Raleigh Trevelyan, *A Pre-Raphaelite
 Circle* (London: Chatto and Windus, 1978).

59

DANIEL ALEXANDER
WILLIAMSON (1823–1903)
A Grey Day, 1865
Watercolor with scraping out
201 × 283 mm (7¹¹⁄₁₆ × 11⅛ in.)
Signed in monogram and dated lower left:
DAW / 1865
The Trustees of the National Museums and
Galleries on Merseyside (Walker Art Gallery,
Liverpool)
Exhibited at Yale and Cleveland only

Williamson came from a Liverpool family of
artists; his father and at least two other family
members were painters in the city. He left
Liverpool in 1847 to live in London; however,
he retained his connections with his native city,
sending works to the annual exhibitions of the
Liverpool Academy. In London Williamson
made minutely detailed oils of landscape and
animal subjects, notably a series of paintings of
cattle on Peckham Common, which show the
strong influence of Pre-Raphaelitism. In 1860 or
1861 he returned to the north, settling first near
Carnforth in Lancashire, where the nearby
Warton Crags provided subject matter for his
paintings, and then in 1864 at Broughton in
Furness, close to the mouth of the River
Duddon on the fringes of the Lake District. For
a while he continued to work in oil, before turn-
ing to watercolor, which provided the staple
medium of his work for the next twenty years.[1]

During the 1860s Williamson gradually elimi-
nated detail from his landscapes. Watercolors
such as *A Grey Day* represent the midpoint of his
transition from Pre-Raphaelite minuteness to a
near abstraction of the forms of nature. The art-
ist experimented with different techniques to
achieve more unified and atmospheric composi-
tions. He informed the textures of his water-
colors with vibrant patterns of color, which he
then allowed to merge on the damp sheets. This
method of puddling colors was derived from
the characteristic technique of Liverpudlian Pre-
Raphaelite oil painting, in which brilliance of ef-
fect was achieved by allowing translucent colors
to mingle over a white ground.[2] CN

1. The chief source of biographical information for
 Williamson is H. C. Marillier, *The Liverpool School of
 Painters* (London: John Murray, 1904), pp. 237–40.
2. See Allen Staley's chapter 11, "The Liverpool
 School," in his *The Pre-Raphaelite Landscape* (Oxford:
 Clarendon Press, 1973), pp. 138–49.

60

JOHN BRETT (1830–1902)
River Scene, near Goring-on-Thames, Oxfordshire,
1865
Watercolor with bodycolor and pen and ink
332 × 462 mm (13⅛ × 18¼ in.)
Dated and signed lower left: 1865 / John / Brett
Whitworth Art Gallery, University of Manchester

In about 1864 Brett had a disagreement with
Ruskin, as the latter described in a letter to
D. G. Rossetti: "I will associate with no man
who does not more or less accept my own esti-
mate of myself. For instance, Brett told me, a
year ago, that a statement of mine respecting a
scientific matter (which I knew *à fond* before he
was born) was 'bosh.' I told him in return he
was a fool; he left the house, and I will not see
him again 'until he is wiser' " (36.493–94). This
falling-out had little impact on Brett's art. Ruskin
had by this time lost interest in the purely aes-
thetic aspects of landscape painting, and Brett
was himself moving away from the minuteness
of Pre-Raphaelite practice and the objective
record making once advocated by Ruskin.
Drawings such as his view of the Thames at
Goring, although literal accounts of the face of
the countryside, are infused with poignant and

mysterious feeling. The sense of remoteness,
which in Brett's *Near Sorrento* (cat. no. 54) frus-
trates the spectator who seeks a closer knowl-
edge of the physical characteristics of the
landscape, is here used to suggest the inviolable
sphere of a dream world. CN

124

61

HENRY MOORE (1831–1895)
Rocky Landscape with Ruined Castle, 1865
Watercolor over pencil
372 × 553 mm (14⅝ × 21¾ in.)
Signed and dated lower right: H. *Moore.* / 1865
Whitworth Art Gallery, University of Manchester

Moore's father is supposed to have said to him when he was a boy: "Whatever else you paint, you must paint the sea."[1] In the course of his career, Henry Moore gained a substantial reputation for the sea paintings and watercolors that were his staple production. However, the critic A. L. Baldry saw him as

a victim of compulsory specialism. A great sea-painter he was beyond all question. . . . But he was equally great in other forms of nature painting. His landscape, as might have been expected from so fine a colourist and such a close student of effects of atmosphere and light, was admirable; and his treatment of pastoral subjects was full of distinction and sound judgment.[2]

Although at certain points in his career Moore worked almost exclusively in oils, in the late 1850s and 1860s he found that the medium of watercolor lent itself to the effects of bright color and detail he was seeking at the time. In 1865, the year of *Rocky Landscape with Ruined Castle*, he contributed to the first General Exhibition of Water-Colours at the Dudley Gallery. The *Spectator* cited him as an artist known for his oils who was casting off his prosaic literalness in that medium and finding a more congenial vehicle in watercolors.[3] The *Art Journal*, on the other hand, commented that "he belongs to a class of painters for some years on the increase, who attempt to get into a picture more than it can comfortably hold."[4] In 1876 Moore became an associate and in 1880 a member of the Society of Painters in Water-Colours. The present watercolor appears to be a Scottish scene, with the remains of a medieval keep in the distance and crofters' huts at the left. CN

1. William Moore, quoted by Elizabeth Ruhlmann, "Henry Moore: His Family and His Art," *The Moore Family Pictures* (London: Julian Hartnoll, 1980), p. 3.
2. A. L. Baldry, "Henry Moore's Animal Studies," Studio 13 (1898): 230.
3. *Spectator*, February 18, 1865, p. 182.
4. *Art Journal*, April 1, 1865, p. 110.

GEORGE SHALDERS (1826–1873)
Fresh Pasture, 1865
Watercolor and bodycolor
292 × 483 mm (11½ × 19 in.)
Signed and dated lower left: *Geo. Shalders / 65*
Randall S. Firestone

Shalders was elected an associate of the Institute
of Painters in Water Colours in 1863. On his first
appearance in the exhibition the following
spring, he was greeted by the press as a major
addition to the Institute. The *Illustrated London
News* confidently predicted that his qualities
would "render him one of the most popular
contributors to this gallery." While the reviewer
objected to his niggling and prettified manner
derived, it was assumed, from Birket Foster, he
concluded: "Mr. Shalders shows over and above
this an unmistakable love of Nature, an appre-
ciation of her beauties that is sometimes really
poetical and [he shows] artistic skill in rendering
them."[1]

Similarities to Birket Foster were apparent. As
a painter of animals in the landscape, Shalders
was also working the same ground as Henry
Brittan Willis, who became a member of the
Old Water-Colour Society in the same year. In
1865, the date of *Fresh Pasture* and the year in
which Shalders attained full membership in the
Institute, the *Art Journal* ended its review of the
Institute's exhibition: "Reserving one word for
animal creation, we need scarcely say that sheep
are folded and driven to field by Mr. Shalders
with a truth and beauty which find no rivals."[2]

In 1867 the *Illustrated London News* saw Shalders
"rapidly winning a place in the very front rank
of living water-colour painters."[3] An early death,
said to have been caused by overwork, cut short
this promising career. An obituary in the *Art
Journal* noted that his landscapes, "in which a
flock of sheep usually formed a prominent fea-
ture, were always pleasing and truthful, but they
wanted vigour." The notice included a plea for
assistance on behalf of the artist's three or-
phaned daughters.[4] SW

1. *Illustrated London News*, April 23, 1864, p. 399.
2. *Art Journal*, June 1, 1865, p. 176.
3. *Illustrated London News*, May 11, 1867, p. 478.
4. *Art Journal*, March 1873, p. 80.

63

ALBERT GOODWIN (1845–1932)
The River at Dusk, 1865
Watercolor with bodycolor, scraping out,
and gum
356 × 493 mm (14 × 19⅜ in.)
Signed in monogram and dated lower left:
AG / 65
Yale Center for British Art, Gift of the Friends of
British Art at Yale

In 1864 Ford Madox Brown wrote to the
Newcastle manufacturer and art collector James
Leathart, recommending the work of "my pupil
Mr. Goodwin." Brown predicted: "I think there
can be no doubt of his becoming before long
one of the greatest landscape painters of the
age."[1]
The River at Dusk dates from the period of
Goodwin's association with Brown. The water-
color's striking contrast of reddish brown and
strong greens and its emphasis on surface pat-
tern at the expense of illusionistic depth reflect
Brown's occasional landscape oils of the 1850s
and 1860s. The twilight atmosphere, with the
moon shining through the trees and a bat glid-
ing above the water, also gives the watercolor
a sense of mystery. Throughout his career
Goodwin would be noted for the poetic quality
of his landscapes.

Prior to entering Brown's studio, Goodwin
had been taught and encouraged by Arthur
Hughes, another artist of the Pre-Raphaelite cir-
cle.[2] Under the tutelage of Hughes and Brown,
Goodwin absorbed the principles of Pre-
Raphaelitism and moved within its orbit of
artists and patrons. It is uncertain how long
Goodwin studied with Brown, but as late as
1870 William Michael Rossetti still referred to
Goodwin as "one of Mr. Brown's pupils,"
though he made it clear that the young artist was
already making a name for himself. Rossetti
characterized Goodwin as "a landscape-painter,
who, within these few years, has taken a very
strong position by the vividness of his percep-
tion of natural appearances, and his uncommon
force of rendering, particularly in colour."[3]
From 1860 Goodwin showed work at the Royal
Academy, and, beginning in 1866, he exhibited
in the General Exhibitions of Water Colour
Drawings at the Dudley Gallery. He became an
associate of the Old Water-Colour Society
in 1871. sw

1. Brown, letter to James Leathart, July 18, 1864,
 quoted in Hammond Smith, *Albert Goodwin, R.W.S.*,
 1845–1932 (Leigh-on-Sea: F. Lewis, Publishers,
 1977), p. 16. The letter is in the Library of the
 University of British Columbia, Vancouver.
2. For Goodwin, see, in addition to Smith's mono-
 graph cited above, Hammond Smith, "Albert
 Goodwin, R.W.S., 1845–1932," *Old Water-Colour
 Society's Club* 54 (1979): 9–23; *Albert Goodwin,
 1845–1932*, exh. cat. (Bolton, Lancs.: Bolton
 Museum and Art Gallery, 1981); and *Albert Goodwin,
 R.W.S., 1845–1932*, exh. cat. (London: Royal Society
 of Painters in Water-Colours, [1986]).
3. W. M. Rossetti, "English Painters of the Present
 Day," *Portfolio* 1 (1870): 117–18.

64

JOHN BRETT (1830–1902)
February in the Isle of Wight, 1866
Watercolor and bodycolor with gum and
scratching out
460 × 354 mm (18⅛ × 14 in.)
Signed and dated lower right: *John Brett 1866*
Birmingham Museum and Art Gallery

The highly romantic watercolor *February in the Isle
of Wight*, in which a ghostly ship in full sail rides
on a distant sea framed by leafless elms, carries
one stage further the dreamlike character Brett
had previously explored in his *River Scene, near
Goring-on-Thames* (cat. no. 60). Children are seen
playing on a verge in the foreground, but the ef-
fect is very different from the pastoral images of
Brett's contemporary Myles Birket Foster. In-
stead of inhabiting some pleasant countryside,
familiar to the spectator from half-remembered
experiences of childhood, these children seem
isolated in a curiously still and melancholy
landscape.

Brett's watercolors of the 1860s represent a
distinct and remarkable subcategory of his
oeuvre. In drawings such as *February in the Isle of
Wight* and *River Scene, near Goring-on-Thames* he ad-
dressed the spectator psychologically in a way
he did not attempt in his paintings of the 1850s
or again in his work after about 1870, when
he more or less gave up watercolor painting.

February in the Isle of Wight was first exhibited
at the Royal Birmingham Society of Arts in
the spring of 1866. It was acquired by the
Birmingham Museum in 1891. It originally
had a pendant entitled *Autumn in the Isle of Wight*
(now untraced). CN

65

GEORGE PRICE BOYCE (1826–1897)
Autumn Landscape with Colliery, 1866–67
Watercolor
286 × 413 mm (11¼ × 16¼ in.)
Signed and dated lower left: *G. P. Boyce 1866–7*
Robert Tuggle

In the autumn of 1864 Boyce visited the north-
east of England, perhaps for the first time. A
new interest in the landscape of the indus-
trialized north may have resulted from contact
with the Bell family. Isaac Lowthian Bell, an
ironmaster who had built up a powerful indus-
trial empire in County Durham, bought draw-
ings from Boyce in the spring of 1864.[1] Bell
sought to encourage artists to look for the pecu-
liar beauties in the northern landscape, which
was being fundamentally changed by industrial-
ization. Boyce was invited to stay on a number

of occasions, and between 1866 and about 1871
he painted various landscape subjects in the vi-
cinity, including views of the Bells' new house,
Rounton Grange at Northallerton, and of the
ancient manor house, Washington Old Hall,
the ancestral seat of the family of George
Washington.[2]

The present watercolor shows a colliery and
pit village in the distance, presumably some-
where on the Durham coalfield. The surround-
ing landscape is largely unaffected by the coal
workings; people pick berries, and all seems
peaceful and undisturbed. Boyce exhibited
various subjects of this type at the Old Water-
Colour Society. In 1867 he showed *Deserted
Colliery, near Washington, County Durham*, a title
which might well describe this watercolor; how-
ever, it appears from the contemporary criticism
that the work exhibited was an evening or
nocturnal scene. A later contribution to the
Society's summer exhibtions was *A Pit Village in
North Durham* of 1870. CN

1. *The Diaries of George Price Boyce*, ed. Virginia Surtees
 (Norwich: Real World, 1980), p. 40.
2. Rounton Grange was built in 1864–67 by Boyce's
 friend, the architect Philip Webb; it is possible that
 either Webb introduced Boyce to the Bells or vice
 versa. Boyce's two views of Washington Old Hall
 are now the property of the National Trust and
 hang in the house.

66

HENRY GEORGE HINE (1811–1895)
Downs near Eastbourne, 1867
Watercolor with bodycolor, gum, and
scratching out
309 × 731 mm (12⅛ × 28¾ in.)
Signed and dated lower left: *H. G. HINE / 1867*
Birmingham Museum and Art Gallery

In the year that Hine painted this characteristic
watercolor of the Sussex Downs, the *Art Journal*
wrote: "The landscapes of H. G. Hine are of sin-
gular beauty. The range of nature's phenomena
they embrace is not, perhaps, very varied. Cer-
tainly they do not deal in contrasts or surprises.
Yet for tone, harmony, and gentleness of senti-
ment, few landscapes can surpass them. In the
management of tender grey greens they ap-
proach to Copley Fielding."[1] Throughout his
career, Hine was noted for the delicacy and
subtlety of his landscapes. According to George
Clausen, who knew Hine in his later years: "He
used to say that it was as difficult and subtle to
model the shapes of the Downs as it was a hu-
man body."[2]

Born in Brighton, Hine remained devoted
throughout his long career to the landscape of
his native Sussex. He was apprenticed to the en-
graver Henry Meyer in London. After two years
in Rouen, he returned to Brighton where he
worked as a wood engraver, contributing illus-
trations to *Punch* and the *Illustrated London News.*
Although Hine seems to have had no formal in-
struction from Copley Fielding, the president of
the Old Society who also had a taste for the
landscape of the Downs, the work of Copley
Fielding was a major influence on the young art-
ist. Hine became an associate of the Institute of
Painters in Water Colours in 1863, a member the
following year, and from 1887 until his death he
served as its vice-president. SW

1. *Art Journal,* June 1, 1867, pp. 147–48.
2. Clausen, quoted in Martin Hardie, *Water-Colour
 Painting in Britain,* 3 vols. (London: B. T. Batsford,
 1966–68), vol. 2, p. 230n.

67

FREDERICK WALKER (1840–1875)
Stream in Inverness-shire, 1867
Watercolor and bodycolor
210 × 305 mm (8¼ × 12 in.)
Signed lower right: *F W*
Private collection

Walker was born and brought up in Marylebone
in London and subsequently lived with his
mother and sisters in Bayswater. Nonetheless, he
made frequent expeditions into the countryside
to paint and was noted as an illustrator of rustic
life. Most years in the late summer he traveled
to the Scottish Highlands to fish. In 1867 he
stayed with the sporting artist Richard Ansdell at
Corrichoillie on the River Spean in Inverness-
shire, arriving on July 31.[1]

The first fortnight of his holiday was spent in
pursuit of salmon. Gradually, however, Walker's
thoughts turned to possible subjects for painting
in the locality. He was unimpressed by the ma-
jestic Highland scenery, admitting to his brother
a preference for the familiar landscape of the
Thames Valley: "I often think of the peaceful
meadows and gigantic shady trees about
Cookham (even though I have been away so
short a time) and compare the scene with this.
No language of mine can draw the difference."

By the middle of August Walker had found a
subject, a characteristic figurative scene within
an enclosed landscape setting. He wrote to his

mother: "You'll be glad to know I've begun
work – a small water colour. . . . It is a pool, and
there will be a young girl on the bank." As for a
model, he wrote: "There is a golden-haired lass
that I noticed last year, who lives at one of the
huts or 'bothies' near this, who will do splen-
didly, if she will only sit." Unfortunately, when
he saw her again, her appearance was not what
he had expected; he confessed to his sister:

*Two Scotch lasses came here yesterday, for me to look at.
One, who was very splendid last year, with bare feet, and
a shock-head of light and beautiful hair, I thought would
do for my water colour . . . but Heaven help us! when they
came, you never saw such swells – such crinolines, such
cotton gloves, such hats and feathers – looking like servant
gals going out on the spree. Of course, I explained through
one of the servants here (for they could only speak Gaelic),
that I would most likely go over to them and draw from
them in their week day dress; but I shall not, for one of
the wenches over here will even do better.*

The watercolor was completed in London in the
autumn of 1867, and was exhibited at the Old
Water-Colour Society the following summer. In
this, as in his paintings generally, Walker com-
bined an instinct for drawing graceful and stat-
uesque figures (a vital formative training had
been his study of classical sculpture at the
British Museum) with a fondness for unspec-
tacular but carefully rendered landscape settings.

CN

1. There are two useful biographies of Walker: Claude
Phillips, *Frederick Walker* (London: Seeley and Co.,
1894), and John George Marks, *Life and Letters of
Frederick Walker, A.R.A.* (London: Macmillan and Co.,
1896). The quotations from Walker's letters describ-
ing his 1867 stay in Scotland come from Marks,
Walker, pp. 114–16.

JOSEPH JOHN JENKINS (1811–1885)
Larpool Beck, near Whitby, exhibited 1867–68
Watercolor with bodycolor over pencil
339 × 504 mm (13⅜ × 19⅞ in.)
Signed lower right: *Jos J Jenkins*
Yale Center for British Art, Gift of the Friends of
British Art at Yale

The establishment by the Society of Painters in
Water-Colours in 1862 of a winter exhibition de-
voted to sketches and studies gave its members
the freedom to venture into areas of technique
and subject matter that lay outside their normal
practice. Jenkins, a genre painter, used the win-
ter exhibitions as a showcase for his attempts at
landscape.

Larpool Beck, near Whitby, exhibited at the sixth
winter exhibition in 1867–68, is one of a num-
ber of Yorkshire views that Jenkins contributed
to the winter exhibitions of the mid-1860s.
While it seems a fairly finished watercolor rather
than a true sketch – a criticism leveled at many
of the works submitted to these exhibitions – it
does have a freshness lacking in the genre pic-
tures that were his mainstay.[1]

Jenkins, after briefly belonging to the New
Society of Painters in Water Colours, joined the
older Society as an associate in 1849 and a full
member in 1850. Between 1854 and 1864 he
served as secretary to the group, taking an active
role in its affairs and earning the trust and grati-
tude of his fellow artists. Throughout his thirty-

five years of membership, he recorded and
researched the history of the Society and of wa-
tercolor painting in Britain. After his death, the
materials he had collected formed the basis
for John Lewis Roget's *History of the "Old Water-
Colour" Society.*[2] SW

1. Jenkins himself commented: "What one may call a
 sketch another considers finished. Still little by lit-
 tle the impression gains that the Winter Exhibitions
 gradually trend towards those of the summer
 months"; quoted in John Lewis Roget, *A History of
 the "Old Water-Colour" Society,* 2 vols. (London:
 Longman, Green and Co., 1891), vol. 2, p. 108.
2. The fullest account of Jenkins's life is provided by
 Roget, *"Old Water-Colour" Society,* vol. 2, pp. 328–35.

ALFRED WILLIAM HUNT
(1830–1896)
Tynemouth Pier – Lighting the Lamps at Sundown,
1868
Watercolor with bodycolor, gum, and rubbing
and scraping out
375 × 536 mm (14¾ × 21⅛ in.)
Signed and dated lower left: *A. W. Hunt 1868*
Yale Center for British Art, Paul Mellon Fund

In 1852 a bill was passed to construct piers at the
mouth of the Tyne to make navigation past the
notoriously dangerous rocks known as the Black
Middens less hazardous. Work began in 1855
and continued over a period of years. Sometime
in the early or mid-1860s Hunt gained permis-
sion from the Tyne commissioners, among
whom he had a number of friends and patrons
including Isaac Lowthian Bell and Robert
Stirling Newall, to go out on the partly con-
structed piers to draw. Various sketches of the
pier survive,[1] as well as two finished water-
colors. The first of these, *Tynemouth Pier – Lighting
the Lamps at Sundown,*[2] was exhibited at the Old
Water-Colour Society in 1866;[3] the second,
*Travelling Cranes, Diving Bell, &c., on the Unfinished Part
of Tynemouth Pier* (private collection), was shown
in 1867.

During the 1860s Hunt was increasingly at-
tracted to landscape subjects in which effects of
atmosphere provided a unifying tonal scheme.
In both finished watercolors of Tynemouth Pier,

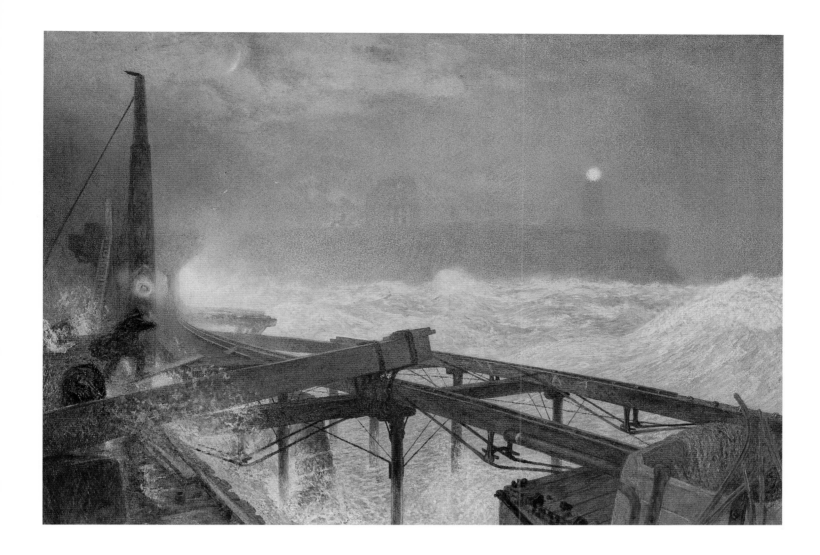

he reveled in the abstract pattern of line and mass, enveloped in vapor and rising spray. His fascination with the subject was, however, more than purely aesthetic; he sought to document an heroic engineering feat. In a letter to Humphrey Roberts, the first owner of the present watercolor, he gave an account of the work, which he admitted "does want a little explanation to all who are not engineers or 'Tyne Commissioners'. To them I hope it would be intelligible enough and effective, and so escape the objection – a serious one to bring against a picture – that it does not tell its tale easily to the eye." Hunt went on:

You must imagine yourself to be standing on the extremity of a wooden staging – on the beams of which are laid tramways – and upon these tramways run travelling cranes with stones and diving bells – the stones to be let down each in its place to form the breakwater, the end of which so far as it has been completed shows, as you look down the gap in the woodwork warf [sic] in the centre of the drawing. The travelling cranes with diving bells and other appliances form the grey archway behind the signal post on the left – and beyond them runs backward for a quarter of a mile at right angles to the rock, the completed pier; and this being a solid mass causes the white cloud of spray where the waves break over it, as well as the forms of the waves throughout the picture, as they are beaten back and break into round masses of foam over the incoming mounds of sea. The gaps in the woodwork allow jets of spray to break upwards through them as on the left of the picture. The great beam tied across with big

chains was, I think, added to strengthen the whole thing after it had been shaken very much by a wreck, which drove against it a day or two before I saw it. The iron rails on the right were bits of the tramway which had been bent and twisted and broken off by this collision. I wonder whether I have made the thing any plainer.[4]

Despite Hunt's insistence on the literalness of his depiction of the construction work, his watercolor also set up symbolic oppositions between current building and the medieval Tynemouth Priory, visible through the mist and darkness on the headland beyond the pier, and between both the modern and medieval structures and the forces of nature. CN

1. A brown wash study of the present subject (Yale Center for British Art) was in the Edwin Wilkins Field album, assembled between 1861 and 1863 as a gesture of gratitude by members of the Old Water-Colour Society to their legal adviser. This has led to the suggestion that Hunt worked on Tynemouth Pier as early as 1862, when he became an associate of the Society. However, it seems more likely that Hunt's sketch was added to the Field album later, sometime after he became a full member of the Society in 1864. The *Art Journal* stated in July 1884 (p. 221) that Hunt's sketches of Tynemouth Pier were done in November 1865, a date that corresponds with his exhibiting a drawing entitled *Tynemouth Pier – North-East Wind* at the Society's winter exhibition of 1865–66.

2. The present watercolor has in this century been known as "Blue Lights," *Tynemouth Pier – Lighting the Lamps at Sundown*, a curious title, as the lamps being lit are green and red port and starboard lights. This was not Hunt's title; only at the sale of Humphrey Roberts's collection, Christie's, May 21, 1908, lot 258, was the watercolor first referred to in print as "Blue Lights."

3. Puzzlingly, the present watercolor is dated 1868. Possible explanations for the discrepancy of dates have been laid out by Jane Bayard in *Works of Splendor and Imagination: The Exhibition Watercolor, 1770–1870*, exh. cat. (New Haven: Yale Center for British Art, 1981), p. 83. It seems unlikely that the present watercolor is a version or variant of the 1866 exhibit; probably Hunt continued to work on the drawing on its return from the Society's exhibition, and the date on the watercolor represents its final completion.

4. The text of this letter, which was once attached to the backing of the watercolor, is known from a copy made by the late Alan Fox-Hutchinson (in the possession of the author).

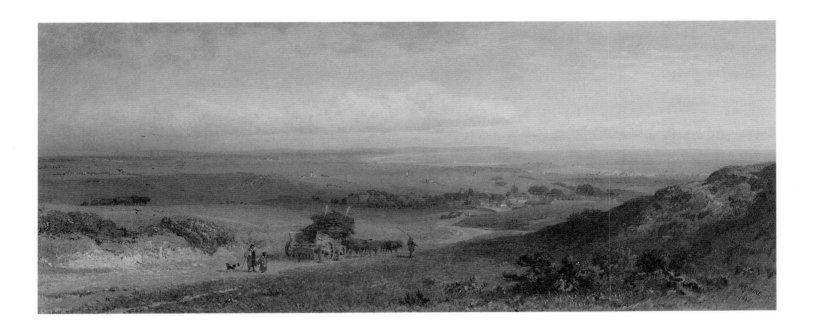

70

HENRY GEORGE HINE (1811–1895)

Pevensey Bay, Sussex, 1868
Watercolor with bodycolor over pencil
291 × 716 mm (11⁷⁄₁₆ × 28³⁄₁₆ in.)
Signed and dated lower right: H. G. HINE / 1868
Yale Center for British Art, Paul Mellon
Collection

This softly atmospheric watercolor presents a view looking toward the old town of Eastbourne clustered around the parish church of Saint Mary's and beyond to Eastbourne New Town on the bay.[1] It was exhibited at the Institute of Painters in Water Colours in 1868. In its review of that exhibition, the *Illustrated London News* found Hine's views of the Sussex Downs "admirable for breadth of effect and quiet sentiment" but noted that they "sometimes incline to slaty monotony from exaggeration of the atmospheric tints."[2] The *Spectator*'s reviewer had no such reservations about the quality of Hine's artistic vision. Ignoring those Downs landscapes that had been a specialty of Copley Fielding, he wrote that Hine was "entirely original, and presents us with views of South-Down slopes as new pictorially as they are beautiful. This pictorial novelty is all the more charming, that it expresses truths and beauties which are the reverse of new to lovers of natural scenery: only the artist was wanted as interpretor."[3] SW

1. I am indebted to C. R. Davey and J. Brent of the East Sussex County Record Office for the precise identification of this view.
2. *Illustrated London News*, May 9, 1868, p. 463.
3. *Spectator*, May 2, 1868, p. 527.

71

CHARLES DAVIDSON (1824–1902)
"In the Leafy Month of June" – Burnham Beeches,
exhibited 1868
Watercolor and bodycolor
447 × 672 mm (17⅝ × 26½ in.)
The Trustees of the National Museums and
Galleries on Merseyside (Walker Art Gallery,
Liverpool)

As with a number of other watercolorists,
Davidson, after making a name for himself in
the New Society of Painters in Water Colours,
left that body for the more prestigious Old
Water-Colour Society. He had been one of the
most promising landscape painters in the New
Society since 1847 and had been made a mem-
ber in 1849. His move to the Old Society in 1855
coincided with the first positive notices of
E. G. Warren's landscapes in the New Society.
Davidson may well have suspected that his own
work would be overshadowed by Warren's.

In the Old Society, of which he became a full
member in 1859, he stood alone as the expo-
nent of detailed rustic scenes until the advent of
Birket Foster, who joined as an associate in 1860.
In that year, the *Spectator* compared the work of
the two artists and concluded: "The landscapes
of Mr. Davidson are more works of feeling, and
they have more of tenderness and modesty of
nature."[1]

In its softness of color and elaborate stippled
technique, Davidson's "In the Leafy Month of June,"
exhibited in the Old Society's summer exhi-
bition in 1868, has much in common with
watercolors of Birket Foster (see, for example,
cat. nos. 47 and 51). In both its subject and its
treatment of dappled sunlight, it also seems to
acknowledge the popular woodland scenes of
Warren (see cat. no. 46). SW

1. *Spectator*, May 5, 1860, p. 432.

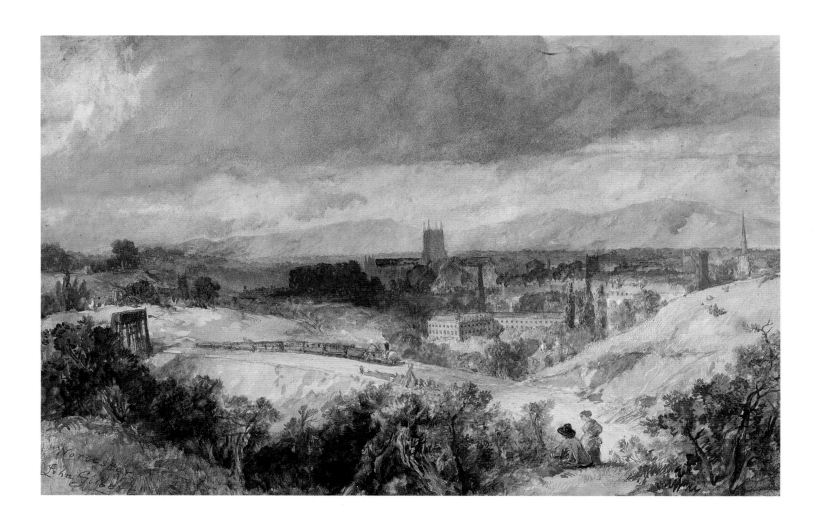

72

JOHN GILBERT (1817–1897)
Worcester, exhibited 1868–69
Watercolor with bodycolor and rubbing out
over pencil
352 × 533 mm (13⅞ × 21 in.)
Inscribed and signed lower left: *Worcester. /
John Gilbert*
Guildhall Art Gallery, Corporation of London

Gilbert was a prolific illustrator, producing over
thirty thousand drawings for the *Illustrated London
News* and providing illustrations for about 150
books. From midcentury he was also a painter
of historical and literary subjects in watercolor.
He became an associate of the Society of
Painters in Water-Colours in 1852, a member in
1854, and its president in 1871. The next year he
was knighted and made an associate of the Royal
Academy, becoming an academician in 1876.

The winter exhibitions of sketches and
studies, which were proposed by Gilbert, pro-
vided him with an outlet for his watercolor
landscapes. The reviewer for the *Illustrated London
News* commented on the winter exhibition of
1868–69: "Among the surprises which these
winter exhibitions generally afford not the least
is that of finding Mr. Gilbert's best powers re-
tained yet controlled by a closer reference to
nature than might be expected in two large
landscape studies, the one presenting a view of
the 'City of Worcester.' "[1] SW

1. *Illustrated London News*, November 28, 1868, p. 527.

73

JOHN WILLIAM NORTH (1842–1924)
The Pergola, ca. 1868–72
Watercolor
292 × 444 mm (11½ × 17½ in.)
Private collection

At the end of 1868 the owner of Halsway Manor took possession of the house, and the arrangement by which North and his friends stayed there on their visits to Somerset came to an end (see cat. no. 55). However, North was determined to maintain his connection with the county to which he had become deeply attached; in 1869 he found a house to rent at Woolston (a village about three miles northwest of Halsway), where he was to remain until 1884.[1] *The Pergola* is a view at Bicknoller, another village on the edge of the Quantock Hills, about half-way between Halsway and Woolston. At the far left can be seen part of the church tower and beyond it the ruined cross, which was also the subject of a drawing by North's friend, George John Pinwell, which he exhibited at the Old Water-Colour Society in the winter of 1869–70.[2]

It is quite likely that North and Pinwell worked together on their views at Bicknoller; in any case, it may be assumed that *The Pergola* was painted in the late 1860s or early 1870s. The minute attention to detail in the watercolor recalls Fred Walker's comment that North's Somerset watercolors of 1868 were "wrought with gem-like care."[3] CN

1. For information about North's various houses and movements in the 1870s, see Herbert Alexander, "John William North, A.R.A., R.W.S.," *Old Water-Colour Society's Club* 5 (1927–28): 40.
2. For an illustration of Pinwell's watercolor and a photograph (perhaps taken by North) of Pinwell sitting on the steps of the cross, see George C. Williamson, *George J. Pinwell* (London: George Bell and Sons, 1900), between pp. 28 and 29.
3. Walker, quoted in John George Marks, *The Life and Letters of Frederick Walker, A.R.A.* (London: Macmillan and Co., 1896), p. 165.

EDWARD LEAR (1812–1888)
A View of the Pine Woods above Cannes, 1869
Watercolor with scraping out and gum
167 × 511 mm (6⁹⁄₁₆ × 20⅛ in.)
Signed in monogram and dated lower right:
EL. 1869; inscribed lower left: *Cannes.*
Yale Center for British Art, Paul Mellon
Collection

While Lear's most characteristic watercolors are elaborated sketches such as *The Dead Sea* (cat. no. 36), he did paint many studio watercolors. Some of these were what he called "tyrants," works that he mass-produced to earn money; others, such as *A View of the Pine Woods above Cannes*, done on commission, as gifts for friends, or for the occasional exhibition, were more thoughtfully conceived and carefully painted.

Lear never belonged to the watercolor societies, although his friend Holman Hunt's election to the Old Society in 1869 encouraged him to put himself forward as a candidate. He wrote to Hunt in 1870: "Now I am going to make 3 Watercolor drawings to try (as you did – tho' I have not the same chance of success,) to get into the Old W. Color. I'm sure 8 or 10 of my various subjects would attract more than everlasting Hampstead Heaths – but perhaps they won't think so."[1]

The Old Society did not appreciate Lear's work, nor did many others apart from a select group of friends and patrons. A few years later he reflected:

One of the most curious points in my Artistic Career, is the steadiness with which my friends have relied on my doing them good work, contrasted with the steadiness with which all besides my friends have utterly ignored my power of doing so. Said a foolish Artist to me – "you can hardly be ranked as a Painter – because all you have done, or nearly all, – is merely the result of personal consideration, & you are comparatively if not wholly unknown to the public." – Says I to he, – "that don't at all alter the qualities of my pictures."[2]

Driven by poor health to escape the harsh, damp English winters in various Mediterranean locales, in the late 1860s Lear intended to establish a winter residence at Cannes. He stayed there from late December 1867 to April 1868 and again in the winter and spring of 1870. He wrote to a friend and patron in January 1868:

Cannes is a place literally with no amusements: people who come must live . . . absolutely to themselves in a country life, or make excursions to the really beautiful places about when the weather permits. I know no place where there are such walks close to the town: and the Esterel Range is what you can look at all day with delight. . . . There is no fog of any sort.[3]

The hard-edged brilliance of *A View of the Pine Woods above Cannes* shows the Esterel Mountains with that clarity of atmosphere which so impressed Lear. In the spring of 1870 he decided against taking up permanent residence in Cannes and built a villa in San Remo on the Italian Riviera, the first of two in San Remo in which he made his home for the rest of his life.

sw

1. Lear, letter to William Holman Hunt, July 7, 1870, quoted in Vivien Noakes, *Edward Lear, 1812–1888*, exh. cat. (London: Royal Academy of Arts, 1985), p. 22.
2. Lear, letter to Lord Aberdare, August 23, 1877, quoted in Noakes, *Lear*, pp. 10–11.
3. Lear, letter to Lady Waldegrave, January 9, 1868, *Later Letters of Edward Lear*, ed. Lady Constance Strachey (London: T. Fisher Unwin, 1911), p. 93.

75
─────────────

THOMAS COLLIER (1840–1891)
Welsh Mountain Landscape, 1869
Watercolor
347 × 535 mm (13⅝ × 21 in.)
Signed and dated lower left: *T. Collier 1869*
Birmingham Museum and Art Gallery

─────────────

From 1864 to 1869, Collier, a native of
Derbyshire and a former student at the
Manchester School of Art, lived at Bettws-
y-Coed in North Wales.[1] While artists of many
stylistic orientations visited and painted at
Bettws-y-Coed in the 1850s and 1860s, the village
was unquestionably associated with its foremost
artistic visitor, David Cox. Although Cox had
been dead for five years when Collier took up
residence there, it is clear that Collier's years at
Bettws-y-Coed were given over to painting char-
acteristic Cox subjects in an evolving style in-
spired by Cox's late manner. *Welsh Mountain
Landscape*, from the end of Collier's Welsh pe-
riod, shows how fully he had absorbed Cox's
method of working and how closely he could
mirror the "deep, grand gloom" of Cox's later
Welsh landscapes.[2]

After Bettws-y-Coed Collier resided briefly in
Birmingham and Manchester and then moved to
London and began the process of establishing .
himself as a professional watercolorist in the
metropolis. After being rejected by the Old
Water-Colour Society, he was elected an associ-
ate of the Institute of Painters in Water Colours

in 1870, becoming a full member in 1872. There
he became the center of a Cox school whose
other members included E. M. Wimperis and
James Orrock. SW

1. The most complete account of Collier remains
 Adrian Bury, *The Life and Art of Thomas Collier, R.I.*,
 (Leigh-on-Sea: F. Lewis, 1944), but see also by the
 same author, "Thomas Collier, Chevalier of the
 Legion of Honour," *Old Water-Colour Society Club* 55
 (1980): 47–50.
2. The phrase comes from a review in the *Spectator*,
 May 5, 1855, p. 462.

140

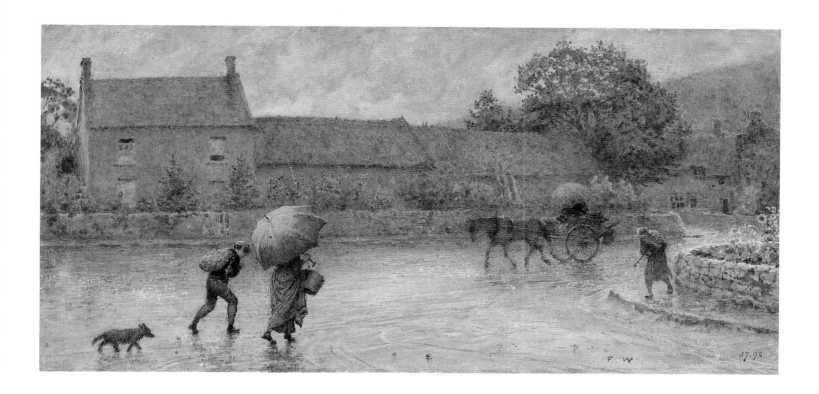

76

CHARLES GREEN (1840–1898)
Upland Cottage
Watercolor and bodycolor
295 × 248 mm (11⅝ × 9¾ in.)
Signed in monogram lower left: CG
Private collection

Green began his career as an apprentice illustrator to Josiah Wood Whymper. He later worked for *Once a Week* and other illustrated periodicals and was subsequently responsible for a notable series of plates for various Dalziel Brothers publications, including their Household Edition of Charles Dickens's *Old Curiosity Shop*. He worked up some of his illustrations into finished watercolors; these and other genre subjects he exhibited at the Institute of Painters in Water Colours, of which he became an associate in 1864 and a member in 1867.

Pure landscapes by Green did not feature among his exhibited works. *Upland Cottage*, however, has certain traits in common with the outdoor watercolors of his fellow illustrators of the late 1860s, Fred Walker, J. W. North, and G. J. Pinwell. These include asymmetrical compositions, a fondness for a rectilinear placing of buildings on the sheet, and the use of bodycolor to give richness to the colors of vegetation and masonry. CN

77

FREDERICK WALKER (1840–1875)
Rainy Day at Bisham, ca. 1871
Watercolor and bodycolor
122 × 253 mm (4⅝ × 10 in.)
Signed lower right: F W
The Board of Trustees of the Victoria and Albert Museum, London

Walker's watercolor shows the main street of Bisham, a small village close to Marlow on the Thames in Berkshire. The artist's mother had first rented a cottage at Cookham a mile or so to the east of Bisham in 1865, and it was there and in the surrounding countryside that he found the subjects of many of his drawings and paintings.[1] In 1871 – the year to which J. G. Marks, Walker's friend and biographer, dated this watercolor – Walker lodged at Spade Oak Ferry, on the river just below Marlow. He was established there on May 14, when he wrote that he had made "one or two preliminaries as to work, and commence in grim earnestness to-morrow. . . . Everything is looking beautiful, and most promising. . . . If the wind would but change, all would be well."[2] References to "this truly infernal weather" occur in subsequent letters. His view of Bisham in the rain was presumably a response to the inclement weather conditions of the early summer of 1871, which prevented his working on the oil paintings with which he was occupied at the time, most notably *The Harbour of Refuge* (Tate Gallery, London).

Rainy Day at Bisham was not exhibited in Walker's lifetime, nor is it mentioned in his letters. In January 1871 he was made an associate of the Royal Academy, an event that marked the general tendency of his work toward large-scale painting in oils. He showed an oil entitled *At the Bar* at the Academy in 1871, while at the summer exhibition of the Old Water-Colour Society, to which he had previously been very loyal, he went unrepresented. CN

1. The life that Walker led at Cookham is described by George D. Leslie, *Our River* (London: Bradbury Agnew and Co., 1888), pp. 15–24.
2. Walker, quoted in John George Marks, *Life and Letters of Frederick Walker, A.R.A.* (London: Macmillan and Co., 1896), pp. 227–29.

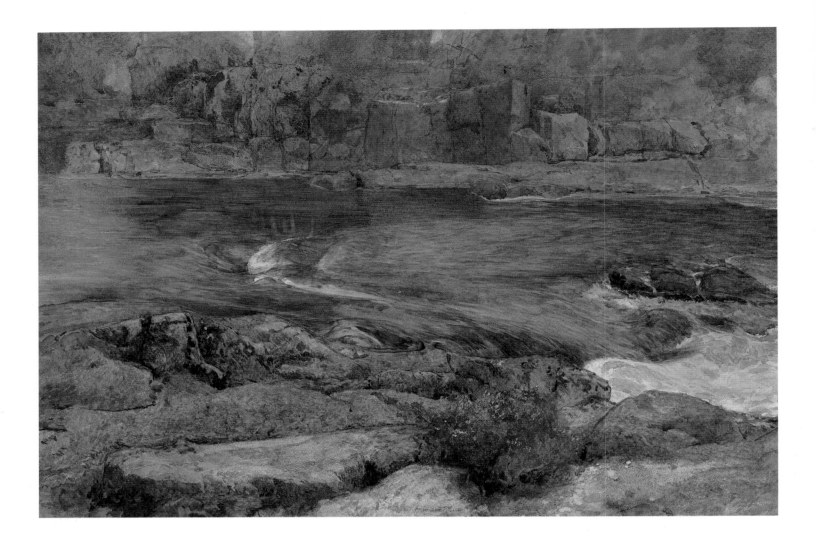

JOHN WILLIAM NORTH (1842–1924)
The Tay, near Stobhall, exhibited 1871–72?
Watercolor and bodycolor with scratching out
362 × 534 mm (14¼ × 21 in.)
Signed lower right: *JWN*
Private collection

No account has survived of North's visits to Scotland in the early 1870s. His good friend, Fred Walker, who was an enthusiastic angler, traveled to the Highlands in the late summer and autumn of most years to fish for salmon. Among others with whom Walker stayed on these occasions was William Graham, a member of Parliament and a collector of contemporary paintings, who rented a house at Stobhall on the River Tay north of Perth. North also knew Graham,[1] and it is probable that this watercolor, which shows the Tay flowing between rocky pavements, was painted while he was a guest at Stobhall, perhaps in company with Walker.

In 1871 North was elected an associate of the Old Water-Colour Society, and from that time until the end of his life he was a regular exhibitor there. He showed three subjects of the River Tay at the Society: *A Waterfall on the Tay* at the summer exhibition of 1871,[2] *The Tay, near Stobhall* at the winter exhibition of 1871–72, and *On the Tay* at the winter exhibition of 1876–77. The present watercolor may well have been the second or perhaps the third of these exhibited

works; its monochromatic quality, the inconsistent level of detail throughout the work, and the unconcern the artist showed toward the conventions of composition would have been entirely appropriate to the Society's annual exhibitions of "Sketches and Studies by Members."

North survived his friends Walker and George John Pinwell by nearly half a century. He became a member of the Old Water-Colour Society in 1883 and also exhibited at the Royal Academy (of which he became an associate in 1893), but he never occupied a commanding position in the art establishment. Hubert Herkomer, Slade Professor of Art and a prominent royal academician, tried to win a wider appreciation for North's painting among the public at large. In a series of lectures and articles, Herkomer claimed North as the true originator of the principles of art which had become associated with Walker. This campaign was an embarrassment to North, and a rift between Herkomer and North occurred in 1897 when it emerged that North had opposed Herkomer's candidacy for the presidency of the Royal Society of Painters in Water-Colours. CN

1. In 1868, on the occasion of Graham's election to Parliament, Walker wrote to his sister Fanny: "North and I are very glad Graham's in; our politics go as far as that!" See John George Marks, *Life and Letters of Frederick Walker, A.R.A.* (London: Macmillan and Co., 1896), p. 161.

2. This is almost certainly the watercolor that was exhibited as *The Falls of the Tay,* no. 524, in the British section of the Rome International Exhibition of 1911, lent from the collection of Harold Hartley. Although of a vertical rather than horizontal format, it is similar in subject and treatment to the present watercolor.

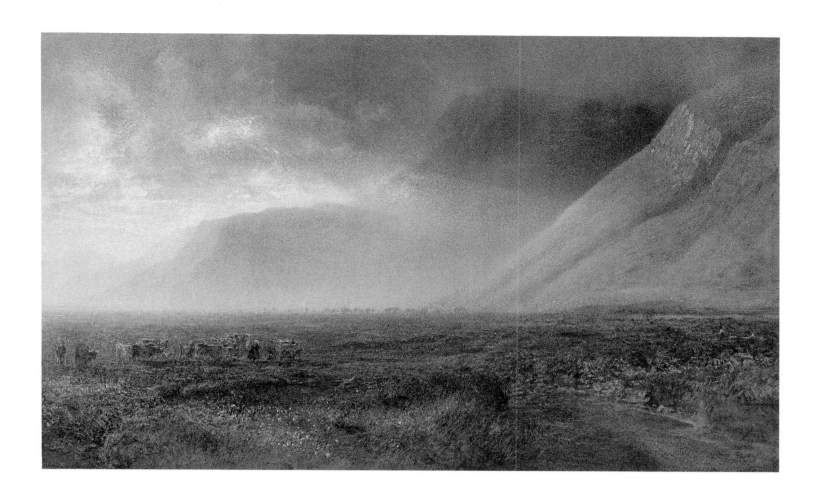

ALFRED WILLIAM HUNT
(1830–1896)
Loch Maree, 1873
Watercolor
318 × 520 mm (12½ × 20½ in.)
Signed and dated lower left: *A W Hunt 1873*
Collection of Chart Analysis Limited, London

In 1865 the Hunt family moved from Durham to London; nonetheless, Hunt regularly made summer expeditions to his favorite painting grounds in Scotland and the north of England. Violet Hunt described her father's working routine: "He did at least two long tramps a day, one to the Morning subject and one to the Evening subject. Morning and evening were again subdivided, inasmuch as he often put away the early morning sketch for a new 'effect' at midday, or a dull early afternoon experiment for a glowing sunset orgy towards evening." Only in the late autumn did Hunt return to London, bringing with him "a host of packing-cases, holding the sheaves garnered from the summer's store. Subjects for oils, or oils nearly finished on the spot, sketches in water-colour in every variety of state, and all to be worked on in the studio."[1]

In the summer of 1873 Hunt stayed at Brantwood, Ruskin's house on the shore of Coniston Water in the Lake District (see chapter 2). That he found the opportunity to travel on northward into Scotland is indicated by the present watercolor, which shows Loch Maree in the northwest Highlands, and another entitled *On the West Coast of Scotland*. Both were exhibited

along with various Coniston subjects at the Old Water-Colour Society the following year.

In his late career Hunt aimed at ethereal and radiant effects of light in his watercolors, which he achieved by painstaking methods. His daughter wrote: "My father's mere manual dexterity was remarkable enough. With those long nervous bird-like fingers he could propel or arrest his brush within the merest fraction of an inch in any given direction and 'place' a dab of colour here or there with the force of a hammer or the lightness of the swish of a bird's wing."[2] Furthermore, he resorted to complicated processes of scraping, scratching, and sponging to unify and enliven the surfaces of his drawings. CN

1. Violet Hunt, "Alfred William Hunt, R.W.S.," *Old Water-Colour Society's Club* 2 (1924–25): 35–37.
2. Ibid., p. 32.

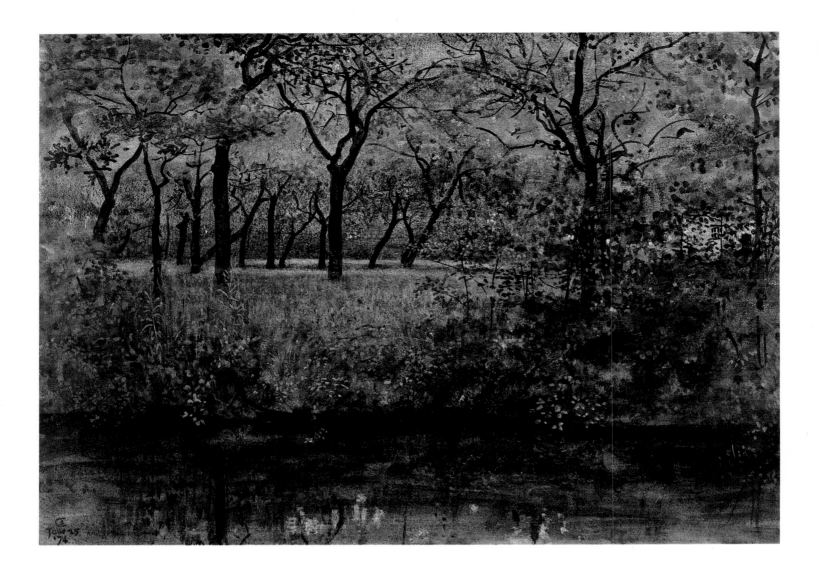

WALTER CRANE (1845–1915)
An Orchard by a Stream, 1874
Watercolor and bodycolor
228 × 318 mm (9 × 12½ in.)
Signed with monogram and dated lower left:
WC / June 25 / '74
The Trustees of the British Museum, London

As a boy Crane was encouraged to draw by his father, who was himself an artist. In 1859 the young Crane was apprenticed to the engraver William James Linton; soon after, he made his first designs for engraved plates, which marked the beginning of his long and prolific career as a book illustrator. He also wanted to establish himself as a painter. In 1862 his oil *The Lady of Shalott* (Yale Center for British Art) was accepted at the Royal Academy. Despite this early success, Crane was never accepted as one of the principal painters of the age, and his relations with the different associations were generally unhappy.

Crane took up landscape painting during a prolonged Italian sojourn in 1871–73. Frederic Leighton introduced Crane to Giovanni Costa,

who was, according to Crane, "full of artistic sympathy and helpful criticism of one's work."[1] Crane learned from Costa how to concentrate on the main elements of the landscape, and he came to understand how excessive detail or picturesque qualities could distract from the mood of a composition. In Italy Crane painted the wide panoramas and bleached color of the Roman Campagna. After his return to England his watercolor landscapes assumed a more verdant character but retained the granular textures and unified color schemes with which he had experimented in the south.

In his autobiography Crane described the movements that he and his family made in the summer of 1874, first staying with friends at Hythe overlooking Southampton Water, then on to Swanage in Dorset.[2] Crane's view of an overgrown riverbank and orchard may well have been made in the course of this expedition along the English south coast. Pure landscape drawings such as this represented the most personal aspect of the artist's production – done for his own satisfaction rather than to further his reputation. Crane occasionally sent landscape

watercolors to the Dudley Gallery in the mid-1870s, and from 1877 also to the Grosvenor summer exhibitions, but he was better known in London for his more elaborate allegorical subjects, which were usually painted in oil.

CN

1. Walter Crane, *An Artist's Reminiscences* (London: Methuen and Co., 1907), p. 128. For Crane's life and art, see also Greg Smith and Sarah Hyde, ed., *Walter Crane, 1845–1915: Artist, Designer and Socialist*, exh. cat. (Manchester: Whitworth Art Gallery, 1989).
2. Crane, *An Artist's Reminiscences*, p. 157.

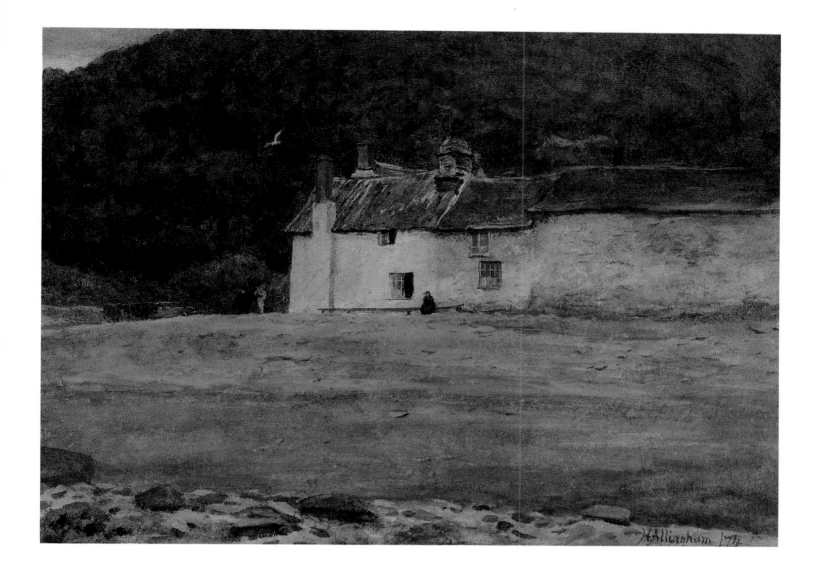

81

HELEN ALLINGHAM (1848–1926)

Last House at Lynmouth, Devonshire, 1874
Watercolor and bodycolor
188 × 263 mm (7⅜ × 10⅜ in.)
Signed and dated lower right: *H Allingham / 74*
Yale Center for British Art, Paul Mellon Fund

Helen Paterson studied at the Birmingham
School of Design, the Royal Female School of
Art in London, and the Royal Academy Schools.
While at the Royal Academy Schools, she began
to support herself by drawing illustrations for
Once a Week and other periodicals. This led in
1870 to a permanent position as an artist on the
staff of the *Graphic*.[1]

On August 22, 1874, she married the poet
William Allingham. *Last House at Lynmouth*
derives from a visit to Devonshire shortly after the wed-
ding.[2] It must be one of her earliest watercolors
to bear the signature "H Allingham," and it sig-
nals a change of direction in her art.

With her marriage she gave up her post on
the *Graphic*. Although she continued to produce
occasional illustrations for the *Cornhill* and other
magazines and books, she was now more fully
engaged in establishing a career as a watercol-
ist. She had been exhibiting drawings at the
Dudley Gallery since 1870. In 1875 she was
elected an associate of the Society of Painters in
Water-Colours. At the time she could hope to
progress no further in the Society, but, when
women were admitted to full membership in
1890, she was immediately elected. SW

1. For biographical information on the artist, see
 Marcus B. Huish, *Happy England, as Painted by Helen
 Allingham, R.W.S.* (London: Adam and Charles Black,
 1903), and Ina Taylor, *Helen Allingham's England:
 An Idyllic View of Rural Life* (Exeter: Webb and
 Bower, 1990).
2. An album of Allingham drawings in the
 Huntington Library, San Marino, Calif., contains a
 page of sketches marked "Devonshire 1874." One
 sketch is inscribed: "our cottage – Lynmouth";
 another is dated "Aug 30/74."

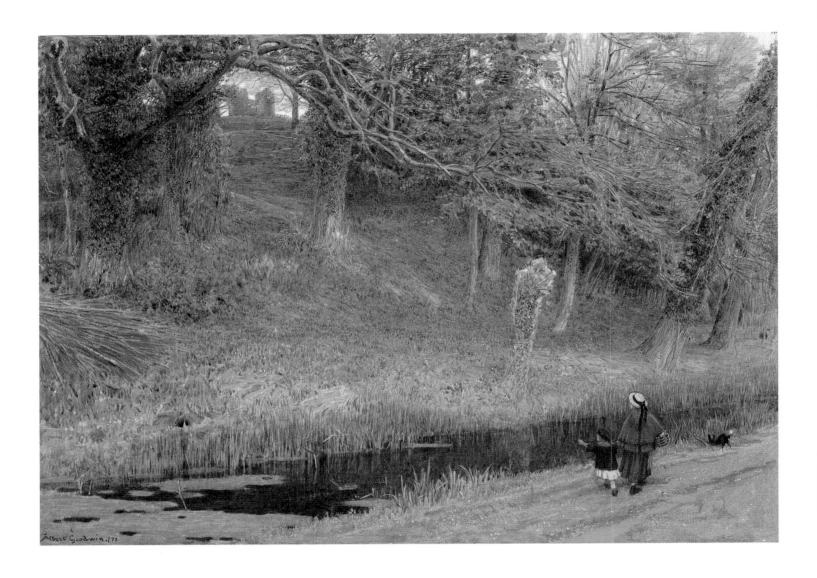

ALBERT GOODWIN (1845–1932)
A Pleasant Land, 1875
Watercolor with bodycolor and scraping out over pencil
251 × 362 mm (9⅞ × 14¼ in.)
Signed and dated lower left: *Albert Goodwin. / 75*
The Board of Trustees of the Victoria and Albert Museum, London

Although Goodwin was an associate of the Society of Painters in Water-Colours from 1871 (becoming a full member in 1881), he continued to contribute works to the Dudley Gallery exhibitions. It was there in 1874 that he exhibited a watercolor with a quotation in place of a title: "And they saw on the other side a pleasant land full of Flowers and winding Paths and did hear the song of the singing birds."[1] The same quotation was inscribed on an old artist's label affixed to the present watercolor, which is almost certainly the exhibited work, even though it is dated a year later.[2] The *Spectator*'s review of the Dudley exhibition commented that the watercolor "tells its simple tale, and leaves a strong impression on the mind."[3] The *Illustrated London News* noted "the cramping, imitative influence" of Fred Walker, but found the drawing "otherwise charming."[4]

A Pleasant Land follows the period in the early 1870s when Goodwin was in close contact with Ruskin. In the spring of 1871 the young artist stayed with Ruskin at Abingdon, and later in the year he was with Ruskin again at Matlock Bath, producing drawings for him on both occasions. The following summer Goodwin accompanied Ruskin on a three-month tour of Italy. Years later Goodwin recalled Ruskin's influence with gratitude: "I owe much thanks to Ruskin, who bally-ragged me into a love of form when I was getting too content with colour alone; and colour alone is luxury."[5] sw

1. The source of the quotation has not been identified; however, it echoes the description of the Land of Beulah in John Bunyan's *The Pilgrim's Progress*, to which Goodwin made reference in his landscape *The Delectable Mountains*, exhibited at the Royal Society of Painters in Water-Colours ten years later.
2. Goodwin may have worked further on the watercolor the following year, but it is also known that he went back to his works in later years supplying signatures and sometimes dates that were not completely accurate.
3. *Spectator*, February 14, 1874, p. 209.
4. *Illustrated London News*, February 14, 1874, p. 150.
5. Goodwin, *The Diary of Albert Goodwin, R.W.S., 1883–1927* (privately printed, 1934), entry for July 18, 1900, p. 37.

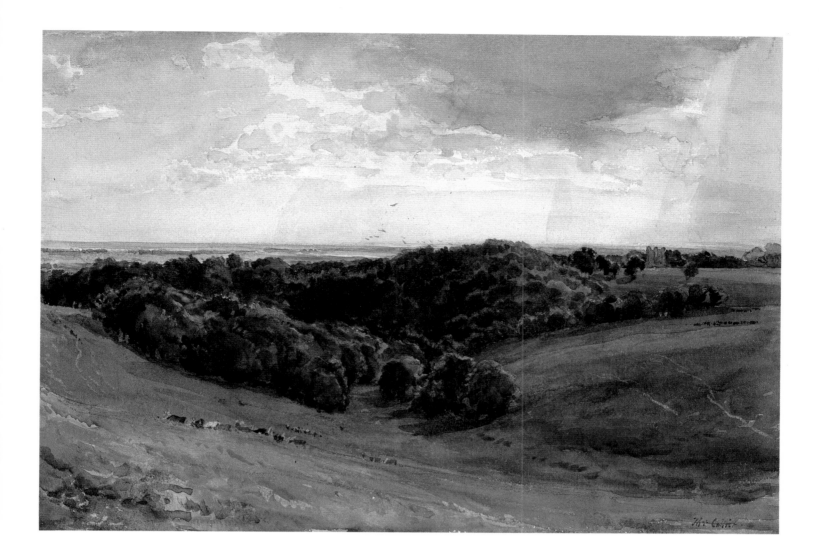

83

THOMAS COLLIER (1840–1891)
Arundel Park, ca. 1875–80
Watercolor over pencil
243 × 356 mm (9⁹⁄₁₆ × 14 in.)
Signed lower right: *Thos. Collier*; inscribed on the
back of the mount: *No. 372 Arundel park by*
T. Collier, RI
The Syndics of the Fitzwilliam Museum,
Cambridge

In 1878 Collier exhibited at the Paris Universal
Exposition a large watercolor of Arundel Castle
in Sussex that he had painted three years ear-
lier.[1] For it he was awarded the French Legion of
Honor. The present watercolor is one of a num-
ber of versions of the composition, which was
obviously a favorite of the artist.[2] Writing of one
of these, exhibited at the Institute of Painters
in Water Colours in 1880, the *Art Journal* com-
mented: "The peacefulness of De Wint and the
force of the elder Cox find fitting union in this
drawing."[3]

The Fitzwilliam watercolor is a splendid ex-
ample of the sort of breezy open landscape for
which Collier was noted. In the year of his elec-
tion to full membership in the Institute, the
Illustrated London News wrote of him: "Mr. Collier
possesses a fine sense of aerial effect and clear
expanse of space on common land or down.

His execution is highly descriptive, and there is
great beauty as well as truth in the brilliant, sil-
very tone which pervades most of his works."[4]

SW

1. The watercolor (present whereabouts unknown) is
 reproduced in Adrian Bury, *The Life and Art of Thomas*
 Collier, R.I. (Leigh-on-Sea: F. Lewis, 1944), pl. 8.
2. Two versions were in the collection of Frederick
 Nettlefold, one dated 1874 and the other 1880; see
 C. Reginald Grundy, *A Catalogue of the Pictures and*
 Drawings in the Collection of Frederick John Nettlefold
 (London: privately printed, 1933), pp. 70–71 and
 74–75. Two other versions, one dated 1878, are in
 the Victoria and Albert Museum, London.
3. *Art Journal*, June 1880, p. 190.
4. *Illustrated London News*, May 4, 1872, p. 434.

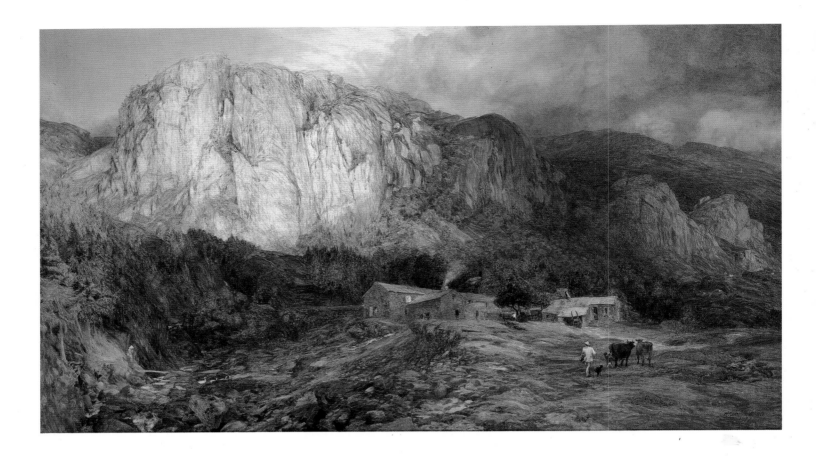

84

HENRY CLARENCE WHAITE
(1828–1912)
Castle Rock, Cumberland, 1877
Watercolor
762 × 1333 mm (30 × 52½ in.)
Signed and dated lower right: *H. Clarence Whaite /
1877*
The Trustees of the National Museums and
Galleries on Merseyside (Walker Art Gallery,
Liverpool)

Whaite was born and brought up in Manchester.
He enrolled for a while at the Manchester
School of Design but later, in 1852, moved to the
Royal Academy Schools in London. His early
ambition was to be a figure painter, but a jour-
ney to Switzerland soon after he had completed
his studies persuaded him that he should devote
himself to the representation of mountainous
landscapes. Ruskin referred to several of
Whaite's early exhibited works in *Academy Notes.*
Clearly Ruskin was drawn to the type of subject
that Whaite painted as well as to his meticulous
technical approach, yet he found grounds for
criticism in the artist's obsessive observation of
minute detail (see chap. 2, p. 35). Whaite was
not discouraged by Ruskin's seemingly contra-
dictory verdicts, continuing right through his
long career to paint in an essentially Pre-
Raphaelite style. Oil and watercolor landscapes
from all stages in his career have rich and highly
worked surfaces, the movement and luminosity
of which depend on the conjunctions of fine
touches of different colors.

Whaite found the great majority of his land-
scape subjects in North Wales, where he spent
most of each summer. He also occasionally
painted in the Lake District and in other parts of
Cumberland and Westmorland. He gained a
foothold in metropolitan art circles when in
1872 he became an associate of the Old Water-
Colour Society. This massive watercolor was ex-
hibited there in the summer of 1877, its full title
given as *The Castle Rock of the "Bridal of Triermain,"
Vale of St John's, Cumberland.* "The Bridal of
Triermain" was a romantic poem by Sir Walter
Scott. The huge rock formation, looming over
the vale in Whaite's picture, had been trans-
formed in Scott's poem into an enchanted cas-
tle, visited by King Arthur. Although Whaite
exhibited regularly with the Old Society, the as-
sociation with which he was most closely in-
volved was the Royal Cambrian Academy, of
which he became the president. CN

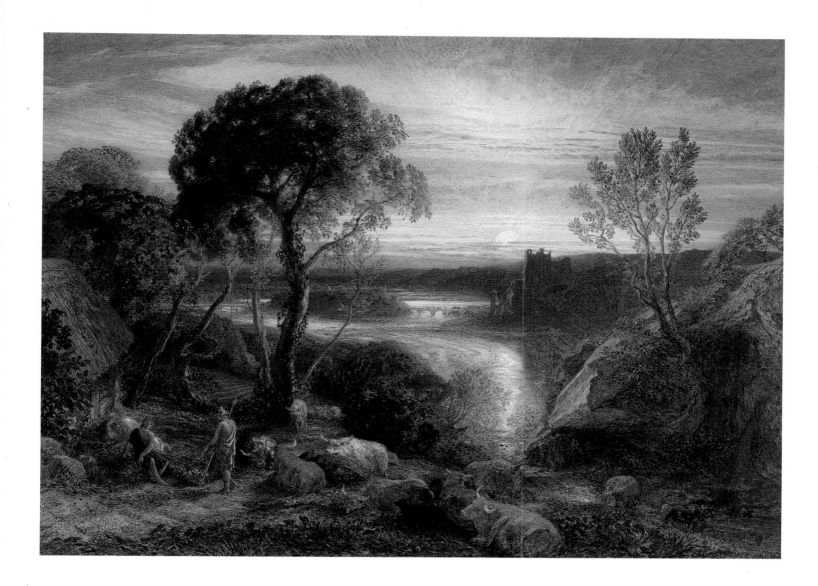

85

SAMUEL PALMER (1805–1881)
Tityrus Restored to His Patrimony, exhibited 1877
Watercolor and bodycolor with gum
502 × 699 mm (19¾ × 27½ in.)
Signed lower right: SAMUEL PALMER
Birmingham Museum and Art Gallery

William Blake's illustrations to Dr. R. J. Thornton's *Pastorals of Virgil* had been one of Palmer's earliest inspirations. From 1856 he worked intermittently on his own "paraphrase in verse" of Virgil's *Eclogues*, and in the last years of his life he began a set of etchings to illustrate his translation. *Tityrus Restored to His Patrimony*, exhibited at the Old Water-Colour Society's summer exhibition of 1877, is an illustration of the first eclogue, a dialogue between the exiled Meliboeus and Tityrus, a shepherd whose lands have been restored to him. It is the only exhibited watercolor that Palmer produced in connection with his Virgil project.[1]

In the Old Water-Colour Society's catalogue, Palmer included the following lines from his own translation:

O fortunate old man!
Then these ancestral fields are yours again;

And wide enough for you. Though naked stone,
And marsh with slimy rush, abut upon
The lowlands, yet your pregnant ewes shall try
No unproved forage; neighb'ring flocks, too nigh
Strike no contagion, nor infect the young;
O fortunate, who now at last among
Known streams and sacred fountain-heads, have found
A shelter and a shade on your own ground.

The critic in the *Spectator* singled out *Tityrus Restored to His Patrimony* as having a "distinctively higher aim" than the other landscapes in the exhibition. Palmer was the only successor to Turner in attempting "the higher poetical landscape" rather than "literal transcripts from nature." Palmer was also likened to Turner in having "seen the sun, and firmly grasped the fact that to reproduce that, is the greatest triumph of the painter's art." The critic then turned to the watercolor itself, writing:

Mr. Palmer, with the instinct of a true poet, has painted the landscape as Tityrus might have been supposed to see it, radiant no less with bright memories, than with the glowing sunlight. The whole tone of the picture is a wonderful example of the harmony gained by combinations of pure colour when used with experience and perfect knowledge, but the sky, with the sun bursting forth the last time through the long lines of crimson cloud, is the masterpiece

of the picture, and is certainly one of the finest pieces of painting in water-colour which we have ever seen.[2] SW

1. No etching of this composition was begun. When, shortly after Palmer's death, A. H. Palmer completed the etchings and edited his father's text for publication, he included a reproduction of the watercolor as an illustration to the first eclogue; Samuel Palmer, *An English Version of the Eclogues of Virgil* (London: Seeley and Company, 1883).
2. *Spectator*, April 28, 1877, p. 537.

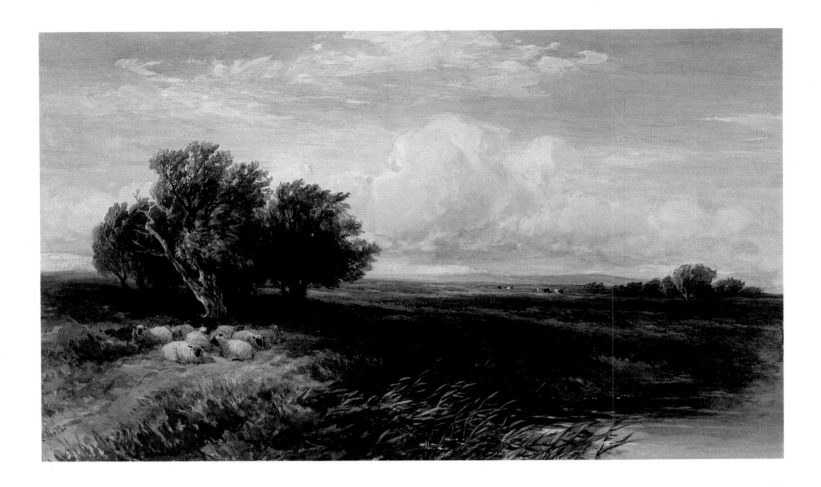

86

EDMUND MORISON WIMPERIS
(1835–1900)
Across the Common, 1878
Watercolor with scratching out over pencil
457 × 690 mm (18 × 27⅛ in.)
Signed and dated lower left: *EMW*.78.
Birmingham Museum and Art Gallery

Wimperis trained in the studio of the wood en-
graver Mason Jackson, and at the outset of his
career provided drawings for the *Illustrated London
News*. His work for the periodical may have
brought him into contact with Myles Birket
Foster; certainly, when Wimperis began painting
in watercolor in the mid-1860s, his small, highly
detailed drawings in a stipple technique showed
a clear resemblance to those of Birket Foster.

About the time of his election as an associate
of the Institute of Painters in Water Colours in
1873, when he presumably came to know
Thomas Collier, Wimperis's style began to grow
in breadth. *Across the Common*, from five years
later, shows the influence of Cox mediated
through Collier. Wimperis was elected a full
member of the Institute in 1876 and, at the death
of H. G. Hine in 1895, succeeded him as vice-
president.

In the late 1870s Wimperis and Collier be-
came close friends and frequent sketching com-
panions. Both were devoted to working in the
open air, and both were connoisseurs of dra-
matic cloud-filled skies. As Wimperis's son re-
called: "Neither could endure for long, without
some mild form of malediction, the uninter-
rupted reign of unveiled sunshine."[1] SW

1. Edmund Wimperis, "Edmund Morison Wimperis,
 R.I.," *Walker's Quarterly* 1, no. 4 (July 1921): 16.
 Wimperis described in considerable detail the
 equipment and materials used by his father in out-
 door sketching.

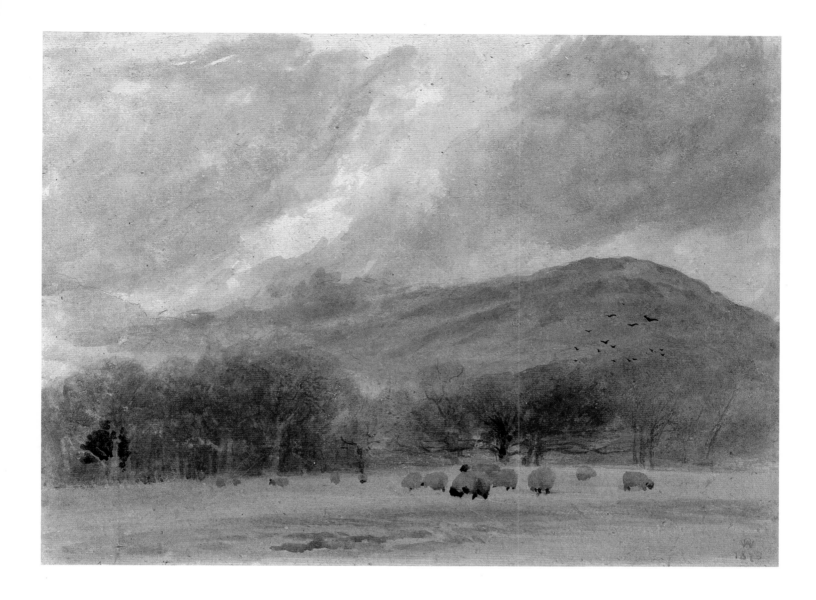

87

DANIEL ALEXANDER
WILLIAMSON (1823–1903)
White Pike, 1879
Watercolor
362 × 533 mm (14¼ × 21 in.)
Signed in monogram and dated lower right:
DAW / 1879
The Trustees of the National Museums and
Galleries on Merseyside (Walker Art Gallery,
Liverpool)
Exhibited at Yale and Cleveland only

According to H. C. Marillier, Williamson, during
a long period of illness, "spent his days looking
out of windows upon all the changing lights and
seasons of the year, accumulating an intimate
knowledge of these phases of nature which he
afterwards turned to good account." The water-
colors he painted in the late 1870s, such as *White
Pike*, represent an instinctive and highly individ-
ual assimilation of the principles of impression-
ism. Marillier noted Williamson's "masterly
studies of woodland or open country, with cat-
tle and other natural features handled in the
broad manner that he said was warranted by his
previous minute observation."[1] In his insistence
that breadth and freedom of handling were only

justifiable as the outcome of a detailed study
of nature, Williamson shared the outlook of
J. W. North and J. W. Inchbold.

Apart from occasional contributions to the
Dudley Gallery exhibitions in the late 1860s,
Williamson's watercolors were probably little
known to the public at large. It seems that he
depended on a small circle of loyal patrons,
foremost among whom were James Smith of
Blundellsands and Miss Miller, the daughter of
John Miller, the Liverpool supporter of the Pre-
Raphaelites. Each of these collectors formed
large groups of Williamson's work, which they
in turn left to the art galleries of Liverpool and
Birkenhead. That Williamson enjoyed some rep-
utation among fellow artists is indicated by the
inclusion of a series of his watercolors at the
first exhibition of the International Society of
Sculptors, Painters, and Gravers, organized by
James Whistler in 1898. CN

1. H. C. Marillier, *The Liverpool School of Painters*
 (London: John Murray, 1904), p. 239.

88

MYLES BIRKET FOSTER (1825–1899)
A Dell in Devonshire
Watercolor with bodycolor over pencil
242 × 508 mm (9½ × 20 in.)
Signed in monogram lower left: BF
The Board of Trustees of the Victoria and Albert
Museum, London

The degree of Birket Foster's success as an illustrator in the 1850s and the state of his burgeoning career as a watercolorist can be gauged by his building in the early 1860s a lavish Tudor-style house, known as The Hill, in Witley, Surrey. He employed the firm of Morris, Marshall, Faulkner and Company to design the interior and filled the house with watercolors, oil paintings, books, and objets d'art. It became the center for lively social activity involving the family and artist friends such as Fred Walker, William Orchardson, and Charles Keene.[1] There were various anecdotes of London dealers racing down to Witley whenever it was rumored that Birket Foster had completed new watercolors, a further testimony to the popularity of his work.[2]

Birket Foster had first moved to Surrey in 1860 because he found in its countryside an abundant source of subjects for his art. Although the motifs of his exhibited works ranged throughout Britain and the Continent, he remained particularly fond of Surrey. Devonshire, on the other hand, rarely figured in his work. An intended visit to North Devon in the late summer of 1878 may well have furnished the subject for this watercolor.[3] SW

1. Jan Reynolds, *Birket Foster* (London: B. T. Batsford, 1984), gives a detailed account of The Hill and life there.
2. See Reynolds, *Birket Foster*, pp. 105 and 112.
3. In a letter of August 6, 1878, quoted in Reynolds, *Birket Foster*, p. 145, Birket Foster mentioned that North Devon would be part of his travel plans if time permitted. A rare Devon subject exhibited by him at the Royal Water-Colour Society in 1880 suggests that he may indeed have been in Devon in that period.

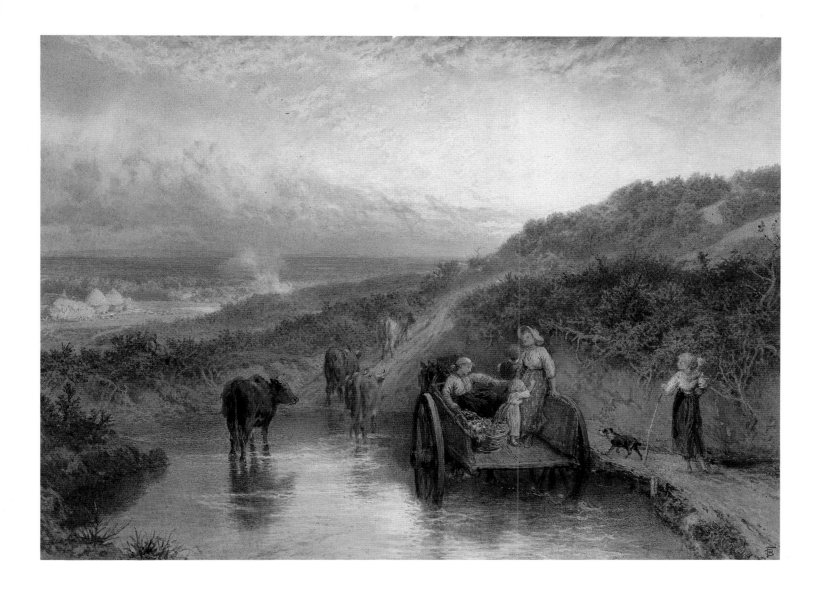

89

MYLES BIRKET FOSTER (1825–1899)
Bringing Home the Cattle
Watercolor with bodycolor
337 × 460 mm (13¼ × 18⅛ in.)
Signed in monogram lower right: BF
Birmingham Museum and Art Gallery

If Birket Foster's watercolors were popular and highly sought after by the public, the response of the critics to these works was much more divided. His watercolors were frequently dismissed as trivial or merely pretty. Their very popularity seemed suspect, the artist being accused of employing technical "tricks, at once puerile and meretricious, which have made him so generally popular."[1] It was the mechanical nature of his execution that drew the most criticism, and this style of "*pointillé* mannerism,"[2] as one critic put it, was inevitably attributed to his background designing illustrations for wood engraving. According to another critic: "His stippled skies have as many lines or threads as a piece of lace or a cambric handkerchief."[3] Yet it was also acknowledged that he could achieve effects of great luminosity, as he certainly did in the evening glow of *Bringing Home the Cattle*.

By the 1880s Birket Foster's watercolors, though they still sold well, appeared decidedly old-fashioned. In 1882 a loan exhibition of works by Birket Foster was presented by the London dealers L. and W. Vokins. Reviewing that exhibition, the *Spectator*'s critic wrote that his popularity was a holdover from the past. Birket Foster, "one of the first to combine a greater amount of natural detail, with the form of composition in which he had been educated," had given new life to the old, picturesque conception of landscape. The critic concluded: "Really fine colour and really subtle drawing are not to be found in these works, and could hardly have been expected; but the colour is as delightful as mere prettiness and variety of tint can be, and the drawing is minute and careful."[4] SW

1. *Spectator*, December 7, 1867, p. 1383.
2. *Illustrated London News*, November 28, 1868, p. 527.
3. *Art Journal*, June 1, 1867, p. 147.
4. *Spectator*, March 4, 1882, pp. 294–95.

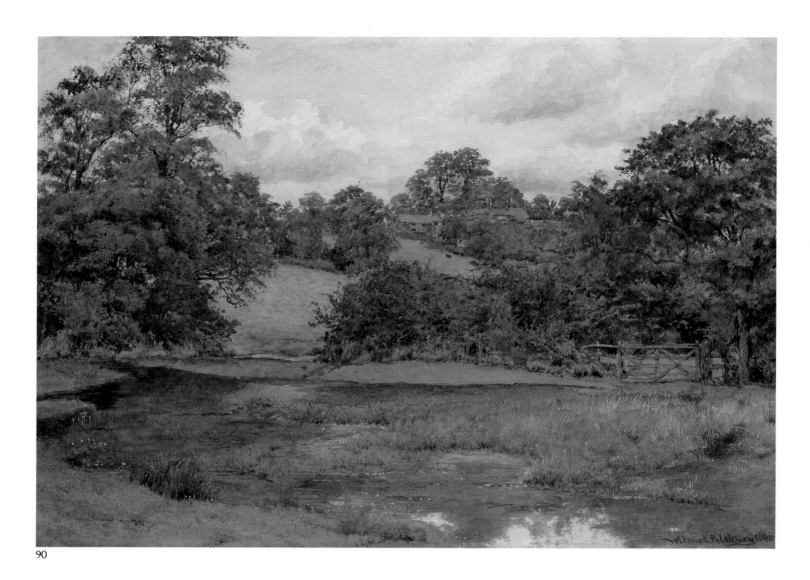

90

90

WILMOT PILSBURY (1840–1908)
Landscape in Leicestershire, 1880
Watercolor with bodycolor
251 × 353 mm (9⅞ × 13⅞ in.)
Signed and dated lower right: *Wilmot Pilsbury 1880*
Collection of Mr. and Mrs. Michael Bryan

Pilsbury was born and brought up in Cannock Chase in Staffordshire. He studied at the Birmingham School of Art and subsequently qualified as an art teacher at the South Kensington Schools. His first appointment was to the West London School of Art, and in 1870 he became headmaster of the newly formed Leicester School of Art. From 1872 onward he occasionally exhibited watercolors at the Royal Academy, but in 1881 he was elected an associate of the Old Water-Colour Society, which became his principal outlet. Displays of his watercolors were also held at the Fine Art Society in 1903 and 1908, the latter being a memorial exhibition.

Pilsbury's scenes of the closely confined meadows and farmyards of the eastern Midlands around Leicester speak of his intimate knowledge and direct experience of the landscape. On the occasion of the second of his two Fine Art Society exhibitions, the *Studio's* critic dubbed Pilsbury's "a conventional art, with a precedent

in the work of Mrs. Allingham, and a great deal of its charm – a charm arising out of pleasant subjects, and a love of the English country-side so strong that it impels towards sympathetic expression."[1] Like J. W. North and Helen Allingham, Pilsbury rigorously observed the details that identify specific areas of the country-side. The construction of the gate on the right-hand side of the present watercolor locates the view in Leicestershire. CN

1. *Studio* 44 (1908): 142–45.

91

JOHN WILLIAM INCHBOLD
(1830–1888)
View above Montreux, 1880
Watercolor with bodycolor
308 × 505 mm (12⅛ × 19⅞ in.)
Signed, inscribed, and dated lower left:
I. W. INCHBOLD / MONTREUX 1880
The Board of Trustees of the Victoria and Albert Museum, London

Inchbold received some instruction in drawing in his native Leeds before going to London to study color lithography with Louis Haghe, and in about 1847 he entered the Royal Academy Schools. He commenced his professional career by exhibiting a group of watercolors at the Society of British Artists in the winter of 1849–50. His early style of watercolor painting was loose and atmospheric; the views that he made of London and the Thames bear an unconscious similarity to Turner's 1819 views of Venice.[1] In 1852 a work of Inchbold's at the Royal Academy was seized upon by William Michael Rossetti as a praiseworthy example of the rising Pre-Raphaelite landscape school. Later in the 1850s Inchbold came under the sway of John Ruskin, who encouraged him to paint Alpine subjects and who commented on his exhibited works in *Academy Notes*.

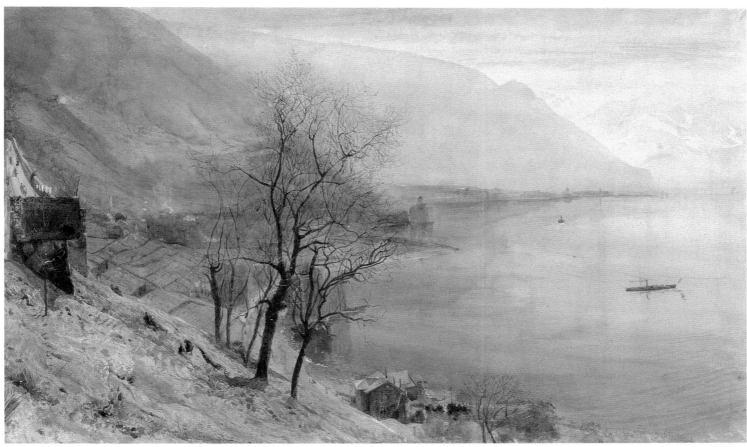

91

In the mid-1850s Inchbold seldom painted in watercolor; however, in the winter of 1857–58 he used the medium in the course of an Italian journey, and in doing so reverted to the breadth and freedom of his early London views. It seems that he considered watercolor appropriate to this more personal and expressive style even at a time when his exhibited oil paintings remained minutely detailed. In the 1860s, notably during several visits to Venice, he sought more generalized effects in both oils and watercolors; his views of cities at night anticipated the nocturnes of James Whistler.

From 1869 onward Inchbold was dogged by financial problems; he led an increasingly insecure and peripatetic existence until about 1877, when he left London to live at Montreux on the Lake of Geneva. Almost all his later work, including the three watercolors in this exhibition, were Swiss views (see also cat. nos. 92 and 94).

The present watercolor shows the view from the hillside above Montreux, looking toward the Castle of Chillon, the eastern end of the Lake of Geneva, and the distant mountains of the Col des Mosses and Les Diablerets. Writing about this watercolor, Allen Staley points out the origin of its composition in Inchbold's oil painting *Lake of Lucerne* (Victoria and Albert Museum, London) of 1857. Each is concerned with the effects of aerial perspective and the brilliance of direct and reflected sunlight in the Alpine landscape. Both depend on a high vantage point and an abbreviated foreground to allow the spectator to gauge the angle of vision. Staley recognizes a continuity of accurate observation, even

when coupled with a more modern aesthetic purpose:

The delicate pattern of bare branches also recalls the minutely drawn branches in such earlier works as In Early Spring [Ashmolean Museum, Oxford]. But here the branches of the foreground trees are used as a foil to the hazy indistinctness of the rest of the landscape. The vaporous effect is subtle and lovely, but is remote from the crystalline Pre-Raphaelite clarity of Inchbold's earlier works.[2]

CN

1. See Allen Staley, *The Pre-Raphaelite Landscape* (Oxford: Clarendon Press, 1973), p. 111. Staley's chapter on Inchbold (pp. 111–23) provides the best account of the artist's life.
2. Staley, *Pre-Raphaelite Landscape*, p. 122.

92

JOHN WILLIAM INCHBOLD
(1830–1888)
Wooded Slope with Four Figures, ca. 1880–88
Watercolor and bodycolor over pencil
356 × 253 mm (14 × 10 in.)
Signed, inscribed, and dated lower right:
I. W. INCHBOLD / VEVEY / 8.4.188[?]
The Visitors of the Ashmolean Museum, Oxford

Inchbold's watercolor is a view of the wooded hillside on the north shore of the Lake of Geneva at Vevey, a mile or two west of Montreux, where the artist lived for the last ten years of his life. A distant crest of snow-clad mountains can be seen between the trunks and branches of the trees, while in the foreground a mass of new vegetation indicates the coming of spring.

The watercolor represents Inchbold's return to the vernal theme and compositional format of two much earlier oil paintings: *A Study in March* (Ashmolean Museum, Oxford) and *Mid-Spring* (private collection),[1] which he had exhibited at the Royal Academy in 1855 and 1856 respectively. Inchbold frequently sought to describe or evoke a precise time of year in his works; both *A Study in March* and the present watercolor convey the sights and sensations of a new season. *Wooded Slope* also adopts the vertical arrangement of the two paintings of the 1850s, with a low vantage point and the sloping terrain giving prominence to the foreground, above which trees and branches allow only a glimpse of sky and distant horizon. Ruskin's verdict on

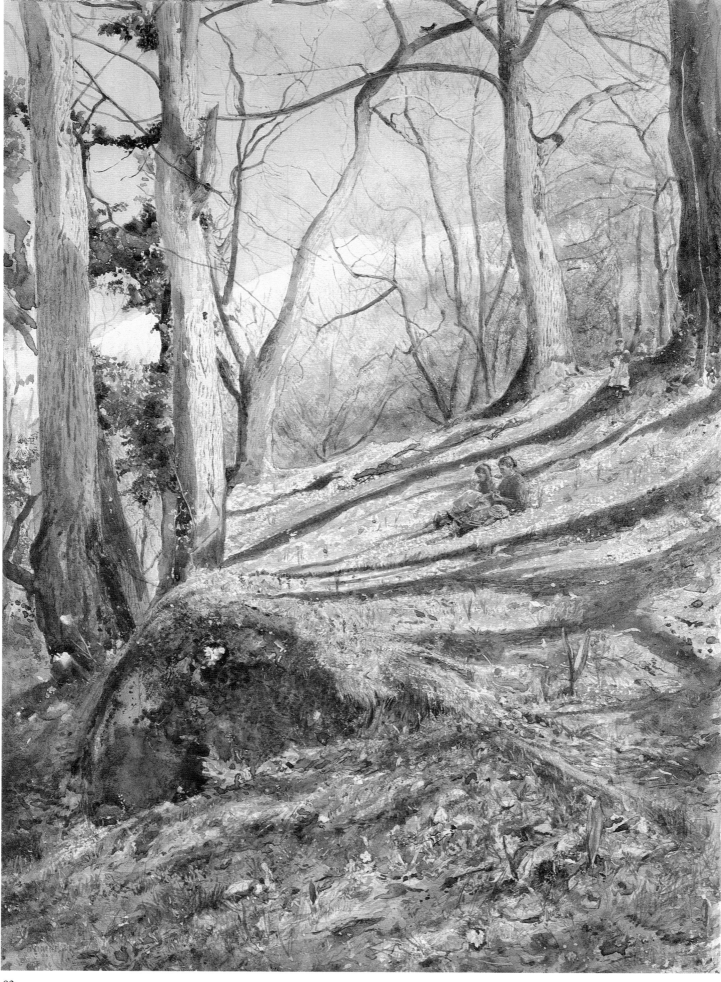

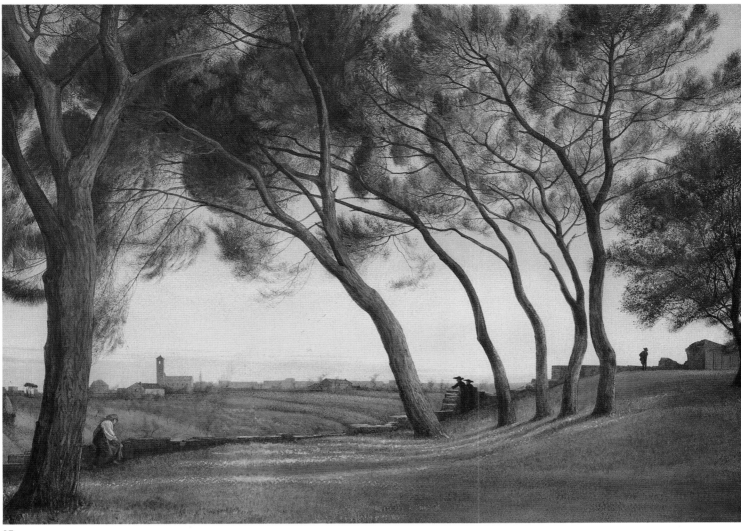

93

Mid-Spring in 1856 had been that the artist "must choose subjects with more mass of shade in them" (14.59–60). In a sense Inchbold's late watercolor is a response to that advice; he has introduced a breadth of handling and a unifying sense of atmosphere to a type of subject he had previously treated with minute attention to detail. CN

1. Mid-Spring was sold at Sotheby's in London, November 26, 1986, lot 14.

93

GEORGE HOWARD, NINTH EARL OF CARLISLE (1843–1911)
View from the Front of St. John Lateran, Rome, ca. 1880–90
Watercolor
533 × 737 mm (21 × 29 in.)
The Trustees of the Tate Gallery, London

Howard's mother had been a pupil of Peter DeWint. Although she died soon after his birth, the young Howard was surrounded by examples of her work. While a schoolboy at Eton, he filled sketchbooks with pencil drawings of his fellows and of landscape and topographical studies. In 1860, as an undergraduate at Cambridge, he read *Modern Painters,* and the watercolors that he did as a young man are distinctly Ruskinian.[1]

The Howard family was aristocratic, influential, and enormously rich. Although George Howard was forty-six before he succeeded to the earldom and estates in Cumberland, Yorkshire, and Northumberland, he had, nonetheless, always enjoyed a privileged way of life. Under no pressure to earn his living, he could afford to travel abroad to study works of art and to indulge an interest in painting. In the winter of 1865–66 Howard traveled in Italy with his wife, looking at pictures and wherever possible meeting artists. In Rome they made friends with Giovanni Costa, who became the principal influence on Howard's painting, and who in turn received professional support from Howard. In 1883–84 Howard was a founder member of the Etruscan School – that loose association of English, Italian, and American painters, all of whom were friends and acolytes of Costa.

Howard's *View from the Front of St. John Lateran, Rome,* was probably painted during one of the artist's frequent visits to Italy in the 1880s. The view was taken from the terraced garden above the Porta San Giovanni and looks east along the line of the ancient walls of Rome toward what was in the nineteenth century open countryside.

In the distance may be seen the Romanesque bell tower of the church of Santa Croce in Gerusalemme.

Howard shared with Hercules Brabazon Brabazon the rare distinction of being an amateur whose works were honored by contemporary professional artists. Costa may have disapproved of the use of watercolor, but others encouraged Howard's work in the medium – not least his friend Edward Burne-Jones. Howard's paintings and watercolors were not for sale; nevertheless, he participated enthusiastically in the exhibitions of the day. His work was first presented to the general public in 1867, when he sent watercolors to the Dudley Gallery. Subsequently he was a mainstay of the Grosvenor and New galleries. He also occasionally exhibited at the Royal Academy and eventually became an honorary member of the Royal Society of Painters in Water-Colours. CN

1. For biographical information on Howard, see Virginia Surtees, *The Artist and the Autocrat* (Salisbury: Michael Russell, 1988); also Sandra Berresford and Paul Nicholls, *Nino Costa ed i suoi cmici inglesi,* exh. cat. (Milan: Circolo della Stampa, 1982), and Christopher Newall, *The Etruscans: Painters of the Italian Landscape, 1850–1900,* exh. cat. (Stoke-on-Trent Museum and Art Gallery, 1989).

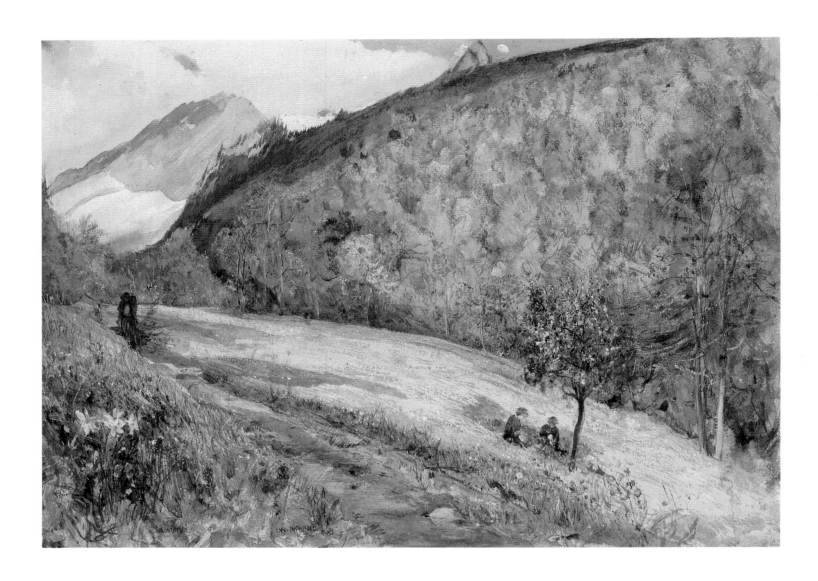

94

JOHN WILLIAM INCHBOLD
(1830–1888)
Montreux, 1881
Watercolor with bodycolor over pencil
248 × 356 mm (9¾ × 14 in.)
Inscribed, signed, and dated lower left:
MONTREUX / I. W. INCHBOLD 1881
Private collection

Inchbold's love of Alpine scenery remained
with him to the end of his life, and the water-
colors he painted in the 1880s of the mountains
of the canton of Vaud are among his most in-
tensely felt and personal productions. The pres-
ent watercolor, a view of an upland meadow
and wooded hillside near Montreux, is painted
with an urgency and freedom that speak of the
artist's delight in his subject. Broad washes of
transparent color are laid on the sheet to estab-
lish the underlying structure of the composition.
Superimposed on these washes, a pattern of
frenzied calligraphy conveys the textures of veg-
etation, occasionally interspersed with more
carefully drawn details such as the clump of nar-
cissi in the left-hand foreground. What at first
seems haphazard and a rejection of the princi-
ple of loving observation resolves itself before
the eye into a truthful evocation of the forms
of nature. CN

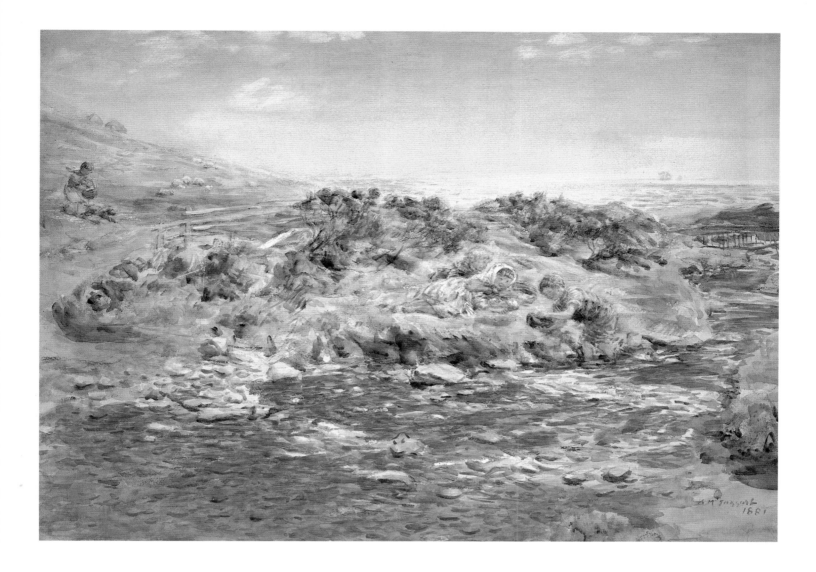

WILLIAM McTAGGART (1835–1910)
Whins in Bloom, 1881
Watercolor over charcoal
540 × 743 mm (21¼ × 29¼ in.)
Signed and dated lower right: *W McTaggart / 1881*
National Galleries of Scotland, Edinburgh

In 1878 the Royal Scottish Society of Painters in Water Colours was founded in Glasgow. McTaggart, already a respected and popular member of the Royal Scottish Academy, was one of the new society's council members and the following year became its vice-president.

McTaggart was not primarily a watercolorist, but in the 1870s and 1880s he worked seriously in the medium, painting not just small sketches but larger works for the exhibitions of the new Scottish watercolor society. Like his oils, McTaggart's watercolors were frequently painted outdoors, although the children, which are such a constant feature of his characteristic coastal scenes, were generally added later in the studio. This seems to have been the case with *Whins in Bloom*, which achieves by its flickering brushwork and sun-drenched color the sense of spontaneity and atmospheric evanescence that McTaggart sought in both his watercolors and oils. James Caw, the artist's son-in-law, claimed that the liberation of his oil-painting technique

from Pre-Raphaelite finish to impressionist freedom was prefigured by his work in watercolor.[1]

In 1894 Caw wrote of McTaggart in the *Art Journal* as "a Scottish impressionist," developing his own brand of impressionism in provincial isolation.[2] It can be shown that McTaggart was well aware of developments both in London and on the Continent. Yet this awareness left little imprint on his art; or rather, the lessons he learned from his contemporaries and from the masters of the past were so completely assimilated that they disappear in a style that is wholly McTaggart's own. SW

1. James L. Caw, *William McTaggart: A Biography and an Appreciation* (Glasgow: J. Maclehose and Sons, 1917), p. 71. Caw's volume has been the standard work on the artist; to it should be added Lindsay Errington, *William McTaggart, 1835–1910*, exh. cat. (Edinburgh: National Gallery of Scotland, 1989).
2. James L. Caw, "A Scottish Impressionist," *Art Journal*, August 1894, pp. 243–46.

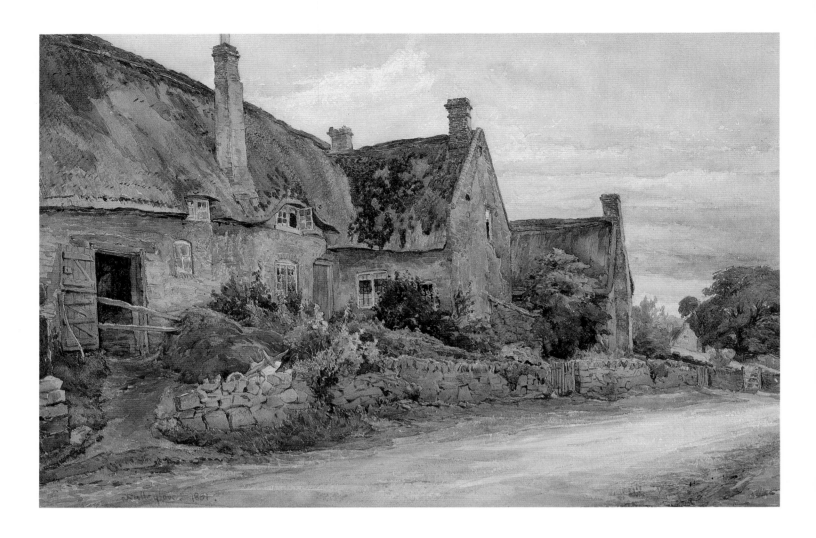

96

JOHN FULLEYLOVE (1845–1908)
Thatched Cottage with Barn, 1881
Watercolor over pencil
336 × 508 mm (13¼ × 20 in.)
Signed and dated lower left: *JFulleylove. 1881.*
Yale Center for British Art, Paul Mellon
Collection

Thatched Cottage with Barn belongs to that popular category of late Victorian landscape, the rustic cottage;[1] however, Fulleylove's approach is more straightforward than that of Helen Allingham, the principal exponent of this imagery. His watercolor technique is looser and bolder than Allingham's, and his presentation of these rustic buildings is more dispassionate, with no neatly attired children and young mothers to reinforce the image of rural felicity. Fulleylove's watercolor is actually closer, in both its treatment of the subject and its silvery tonality, to the farmyard scenes of Wilmot Pilsbury, who taught art in Leicester, where Fulleylove was born and lived until 1883.

Fulleylove worked as a clerk for a firm of architects before turning to watercolor painting, and a taste for architectural subjects runs throughout his work. He began exhibiting in London in 1871, was elected an associate of the Institute of Painters in Water Colours in 1878, and made a member the following year. His earlier works were mostly of English rural subjects like *Thatched Cottage with Barn*, but beginning in 1886 a series of exhibitions of his work at the Fine Art Society established his reputation as a travel artist. His watercolors of France, the Holy Land, and Greece, for which he was most noted in his lifetime and with which he is still most frequently associated, were executed in a technique more fluid than seen here and with heightened color. SW

1. A companion to this watercolor, *Thatched Cottages and Cottage Gardens*, also signed and dated 1881, is also in the Yale Center for British Art.

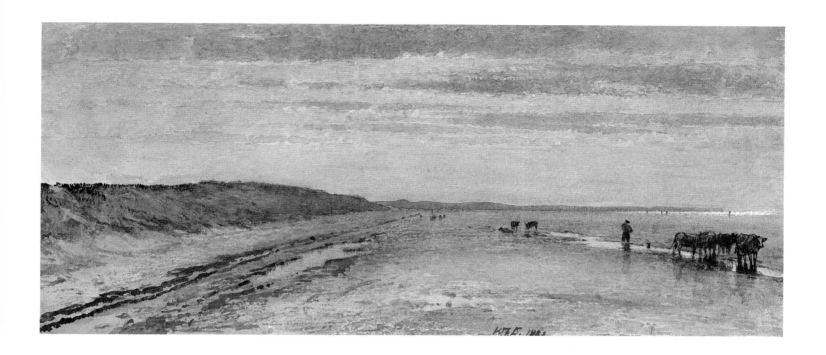

97

WILLIAM FETTES DOUGLAS
(1822–1891)
Ebb Tide, 1882
Watercolor with scratching out
165 × 358 mm (6½ × 14⅛ in.)
Signed and dated lower right: *W.F.D. 1882.*
National Galleries of Scotland, Edinburgh

In the late 1870s and 1880s the paintings and
drawings of the Hague School were embraced
by certain British artists and critics, as a reaction
against the garish color and excessive detail that
they felt to be endemic in their native art. While
the Hague School had a limited impact on the
development of British watercolor, its influ-
ence can be detected in works such as *Ebb Tide*
by Fettes Douglas, who visited Holland and
Belgium in 1878. In its restricted palette of grays
and browns, its simple composition, and its air
of melancholy, the watercolor pays homage to
contemporary Dutch artists such as Willem
Roelofs and Anton Mauve.

Like Sir George Harvey, who preceded him as
president of the Royal Scottish Academy, Fettes
Douglas was not primarily a watercolorist. He
was known for his oil paintings of scenes of
Scottish history. A bank clerk who taught him-
self to paint, Fettes Douglas was elected to the
Royal Scottish Academy in 1854 and became its
president in 1882, after five years as the curator
of the National Gallery of Scotland. It was also in
1882, the year in which he painted this somber
scene, that he received a knighthood. He had
taken up watercolor in the late 1870s when ill-
ness forced him for a time to put aside work on
large-scale oils. SW

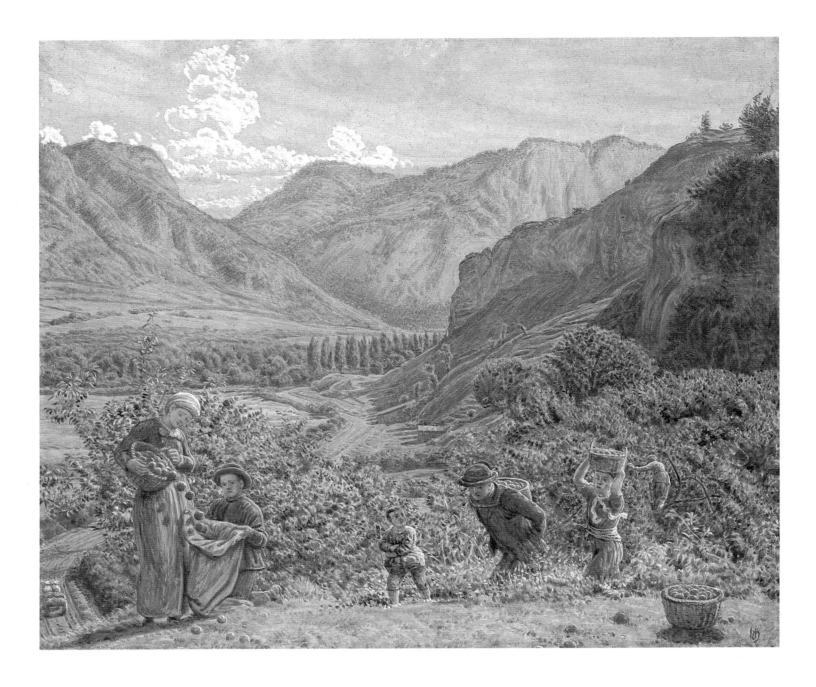

98

WILLIAM HOLMAN HUNT
(1827–1910)
The Apple Harvest – Valley of the Rhine, Ragaz,
1883
Watercolor and bodycolor
390 × 442 mm (15⅜ × 17⅜ in.)
Signed in monogram lower right: *Whh*
Birmingham Museum and Art Gallery

Throughout the 1860s and well into his later ca-
reer, Holman Hunt intermittently painted land-
scape watercolors, usually when he was abroad
and perhaps as a means of relaxation. Two late
subjects, *Study of Moonlight Effect from Berne
Overlooking the River Nydeck to the Oberland Alps*
(Rijksmuseum, Amsterdam) and the present
watercolor, derived from Hunt's travels in
Switzerland. The latter was painted in the au-
tumn of 1883, when Hunt had retired to the
mountains to rest after a period of intensive

work on *The Triumph of the Innocents* (Walker Art
Gallery, Liverpool). He continued to be inter-
ested in the quality of light to be observed in
landscape subjects. The critic of the *Athenaeum*
found the watercolor "illuminated in a splendid
manner, and painted in that high pitch of colour
which is peculiar to Mr. Hunt. It is impossible
to deny the truth of the artist's impressions,
although others may not share them, but the
world at large is not able to see colour in light
at the pitch represented here. . . . Time has not
diminished Mr. Hunt's passion for strong
colours."[1]

For some years Hunt had ceased to send
works to the Royal Academy. In his later career
he preferred the more discreet forum of the
Grosvenor and New galleries, and of dealers'
premises such as the Fine Art Society. In 1869 he
was elected to the Old Water-Colour Society, be-
ing particularly honored by not having first to
serve as an associate. From then on he became a

regular participant in the summer exhibitions
held in Pall Mall East, and it was there, in 1885,
that the present watercolor was first shown.

CN

1. *Athenaeum*, May 2, 1885, p. 574.

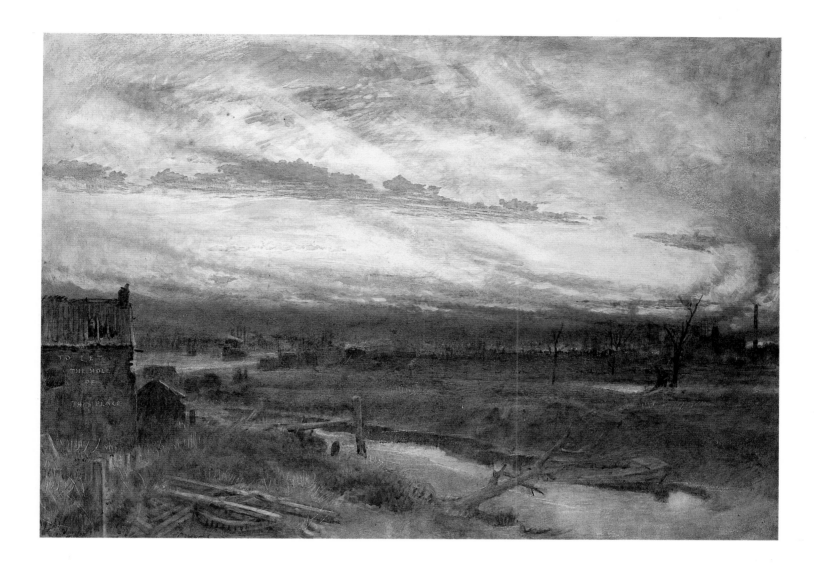

99

ALBERT GOODWIN (1845–1932)
A Sunset in the Manufacturing Districts, 1883
Watercolor with bodycolor and scratching out
533 × 775 mm (21 × 30½ in.)
Signed and dated lower left: *Albert Goodwin. / 83*
Courtesy of Chris Beetles Limited, London

In 1883 Goodwin began to keep a diary. Its early entries are almost exclusively devoted to the spiritual crisis through which he was then passing.[1] His anguished concern with man's relationship to God informs *A Sunset in the Manufacturing Districts*, which he exhibited at the Royal Society of Painters in Water-Colours summer exhibition of 1884 with a quotation from the Bible: "The Heaven even the Heavens are the Lord's but the earth hath he given to the children of men" (Ps. 115:16).

Goodwin had been patronized in the 1860s by the Newcastle lead manufacturer James Leathart, producing for him – among other watercolors of Newcastle and its environs – a view of Leathart's Saint Anthony Works. By the 1880s Goodwin's response to the industrial landscape had darkened and grown more critical. Whether he intended the dramatic sunset as an instance of heavenly beauty in contrast to earthly desolation or as an indication of divine wrath at human despoliation of his world, Goodwin underlined his attitude toward the industrial wasteland by the punning notice scrawled on the ruined building on the left: "TO LET THE HOLE OF THIS PLACE."

When *A Sunset in the Manufacturing Districts* was exhibited at the Royal Society, the *Spectator's* critic took the occasion to contrast Goodwin's watercolors in the exhibition with the "perfectly pure naturalistic paintings" of George Arthur Fripp that hung near them: "Mr. Goodwin has nearly everything which Mr. Fripp lacks, – daring, originality, imagination, poetry, and keenest sense of beauty of colour. His work is as crammed with meaning and hints of thought as the other is free of them; he is for ever feeling something, or wanting us to feel something, about sea, and sky, and moorland, and river."[2]

SW

1. Albert Goodwin, *The Diary of Albert Goodwin, R.W.S., 1883–1927*, was privately published by the artist's family two years after his death.
2. *Spectator*, May 10, 1884, p. 615.

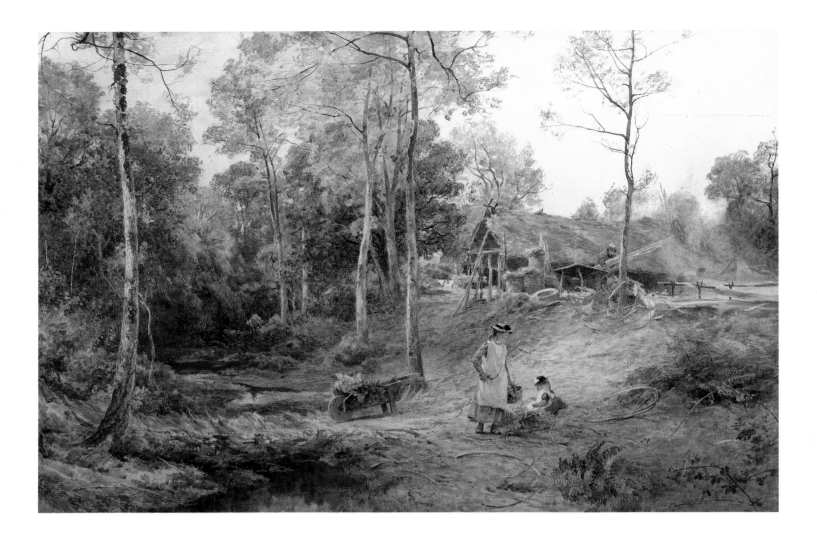

100

JAMES AUMONIER (1832–1911)
In a Gloucestershire Wood, 1883
Watercolor with scratching out over pencil
510 × 760 mm (20 × 30 in.), approx.
Signed and dated lower right: *J. Aumonier 1883*
Maidstone Museums and Art Gallery, Bentlif
Trust Collection

Aumonier began his career as a designer of cal-ico prints. In the 1860s he turned to painting and began exhibiting with the Institute of Painters in Water Colours in 1876. By the follow-ing year the *Athenaeum* remarked that he had al-ready "done a good deal to bring into vogue a recognised French style of colouring, toning, and treating light."[1] He became a full member in 1879. In the next decade, the *Spectator* noted:

Perhaps no landscape-painter of the present day has mas-tered more thoroughly than Mr. Aumonier the delicate gra-dations of atmosphere. His painting is, too, a curious combination in its intellectual aspect of the older and the modern schools of water-colour painters. There is a trace therein of the scientific spirit, but it is so gently and subtly introduced as to be scarcely perceptible.[2]

In a Gloucestershire Wood was exhibited in the Institute's summer exhibition of 1883. While the children in the foreground gather ferns, besom (broom) making is carried on behind them.

sw

1. *Athenaeum*, April 28, 1877, p. 553.
2. *Spectator*, June 25, 1887, p. 865.

101

JOSEPH KNIGHT (1837–1909)
Conway, 1883
Watercolor and bodycolor
532 × 450 mm (21 × 17¾ in.)
Signed and dated lower left: *J. Knight. 1883.*
The Trustees of the National Museums and Galleries on Merseyside (Walker Art Gallery, Liverpool)

Knight was one of the many Victorian landscape painters who were drawn to the dramatic scen-ery of North Wales. Although he was born in Manchester and lived there until 1871, he spent the decade from 1875 at Llanwrst and Bettws-y-Coed. After a few years in London, he re-turned to Wales, settling in Conway, the subject of this watercolor from his earlier Welsh period.

He had lost his right arm in an accident at the age of four. As a young man, he worked as a photographer's assistant in Manchester, teaching himself to paint. He became a regular exhibitor at the Dudley Gallery and a member of the Dudley committee. In 1875 he wrote that, while he had begun as a portrait and figure painter only, "the last few years I have given most of my time to the study of landscape." He also stated that, although most of his work had been in wa-tercolors, he was "just beginning to understand the (to me) more difficult medium of oil paint-ing."[1] Although he exhibited oils with the Royal Academy and various provincial institutions, he remained primarily a watercolorist, joining the Institute of Painters in Water Colours in 1882.

sw

1. "Autobiographical Sketch," appended to an obitu-ary of the artist in an unidentified newspaper, from the files in the Walker Art Gallery, Liverpool.

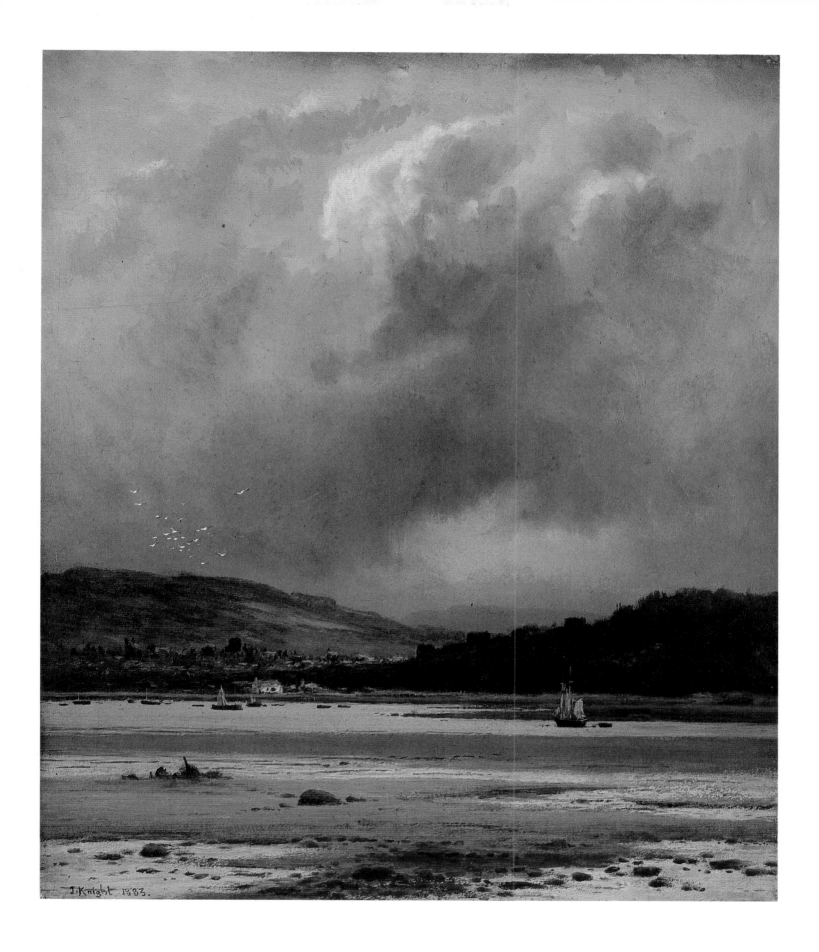

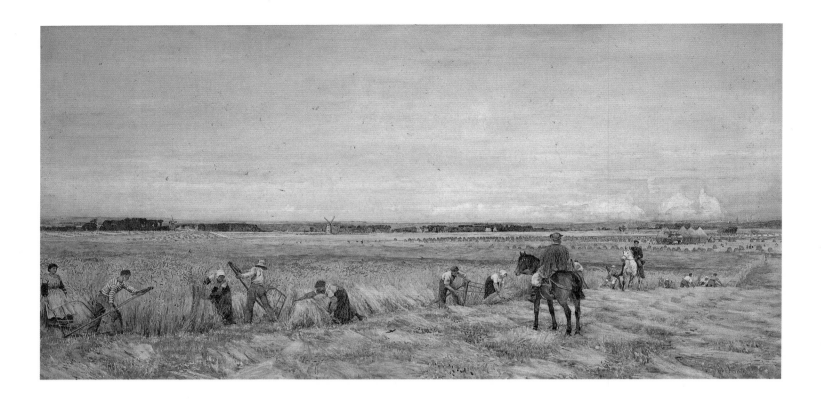

102

LIONEL PERCY SMYTHE
(1839–1918)
*Field of the Cloth of Gold: 'Twixt Calais and
Guines*, exhibited 1883
Watercolor
610 × 1245 mm (24 × 49 in.)
Indistinctly inscribed lower right: *Field of the Cloth
of Gold*
Private collection

Smythe was a near contemporary of Fred
Walker and J. W. North and, like them, was born
in London; however, while he was still a boy he
spent periods of time in France and was partly
educated there. Childhood holidays were spent
at Le Château des Fleurs at Wimereaux in
Normandy. In adult life Smythe and his wife,
Alice, made frequent visits to France, and from
1879 onward the family lived almost entirely
in Normandy. Until 1882 they occupied a
Napoleonic fortress on the coastal dunes near
Boulogne, but eventually the building was en-
gulfed by the encroaching sea. They then moved
to the Château d'Honvault, on a hill between
Wimereaux and Boulogne, which was to pro-
vide his principal home and the frequent sub-
ject of his paintings for the rest of his life.[1]

The idea for the *Field of the Cloth of Gold* came to
Smythe in 1869 when he visited Guines while on
his honeymoon. His half-brother, the marine
painter W. L. Wyllie, described the subject with
reference to the oil version that Smythe made
of it:

*Many elaborate studies were made, all exactly like the
country itself. In Smythe's picture, the great chalk ridge
which terminates in Cape Blanc Nez is seen foreshortened
from the land side. The towers and spires of Calais jut up
beyond the flat, all rich with enormous cornfields dotted
with quaint windmills and the lanky elms one sees in
Artois and Picardie. Busy harvesters reap in the old fashion
of the country, the man swinging his great scythe, the*

*woman following gathering the swathes and turning them
over in regular succession. . . . Field after field stretch away
into the distance, crowded with busy peasants reaping,
gleaning, or stacking the golden corn. A very characteristic
French shanderydan cart drawn by a white cob along a
neat road sends up a cloud of dust in the middle distance.*[2]

The historical allusion of the title is to the
meeting between Henry VIII of England and
François I of France, which was the occasion of
great festivity in splendid surroundings and
which took place at Guines in 1520. Wyllie iden-
tified the two principal figures with their histori-
cal counterparts: "Right in the foreground is a
stout farmer on a brown horse, typical of Bluff
King Hal, whilst another mounted on a dappled
grey comes trotting over the swathes of corn. He
may stand for François Premier."[3]

The composition was an important one for
Smythe, and over the years he treated it in differ-
ent media. In addition to the present watercolor,
which was exhibited at the Royal Institute of
Painters in Water Colours in 1883, he made
an oil painting that was shown at the Royal
Academy the following year; he also made an
etching of the subject. That the watercolor was
considered one of the artist's most ambitious
and successful works is indicated by its selection
as an exhibit in the British section of the World's
Columbian Exposition held in Chicago in 1893.

CN

1. For biographical information about the artist, see
 Rosa M. Whitlaw and W. L. Wyllie, *Lionel P. Smythe,
 R.A., R.W.S.* (London: Selwyn and Blount, 1923), and
 Rosa M. Whitlaw, "Lionel Percy Smythe, R.A.,
 R.W.S.," *Old Water-Colour Society's Club* 1 (1923–24):
 61–68.
2. Whitlaw and Wyllie, *Smythe*, pp. 60–61.
3. Ibid., p. 61.

103

LIONEL PERCY SMYTHE
(1839–1918)
Mowers with Elm Trees
Watercolor
350 × 248 mm (13¾ × 9¾ in.), sight
Private collection

Mowers with Elm Trees is typical of the kind of land-
scape watercolor that Smythe painted in the
French countryside and exhibited in London. It
is not possible categorically to identify the pres-
ent watercolor with any specific exhibit; how-
ever, Smythe showed a drawing entitled *Haymaking*
among the first group of watercolors that he
sent to the Institute of Painters in Water Colours
in 1881, which may perhaps be this work.

Smythe became a member of the Institute the
following year and continued to send works to
the open exhibitions of that group until 1889.
In 1892 he became an associate of the Royal
Society of Painters in Water-Colours and in 1894
a full member. To the end of his life he was a
regular exhibitor at the Pall Mall East gallery
of the Royal Society. Some members of the
Institute resented this transfer, feeling that
Smythe, like so many watercolorists before him,
had deserted their organization for its more
prestigious rival. According to his biographer,
however, "he resigned because he was not paint-
ing many water colours at the time, and he did
not like to be tied down to anything."[1]

Smythe's watercolors of French country peo-
ple owe something to the tradition of the idyll-
ists, although the freedom of their technique
went beyond anything done by Walker. Ad-
mirers of Smythe's works were struck by the au-
thenticity of their expressions of the patterns
and colors of the countryside. CN

1. Rosa M. Whitlaw and W. L. Wyllie, *Lionel P. Smythe,
 R.A., R.W.S.* (London: Selwyn and Blount, 1923),
 p. 107.

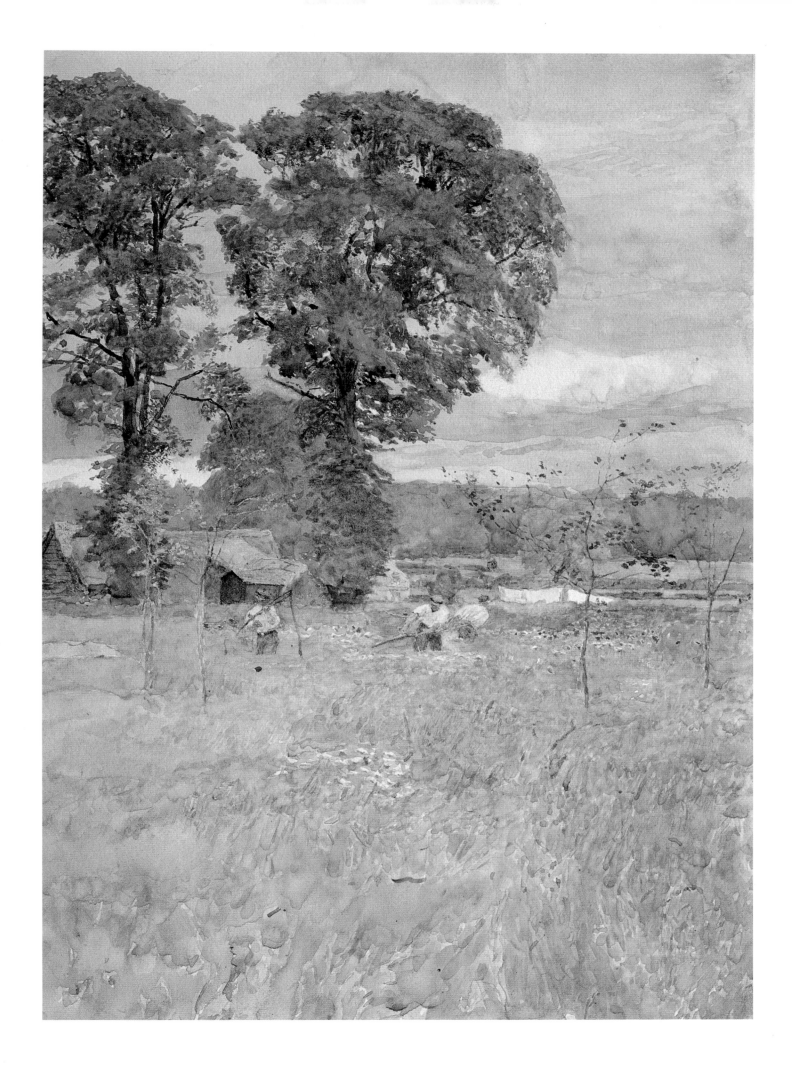

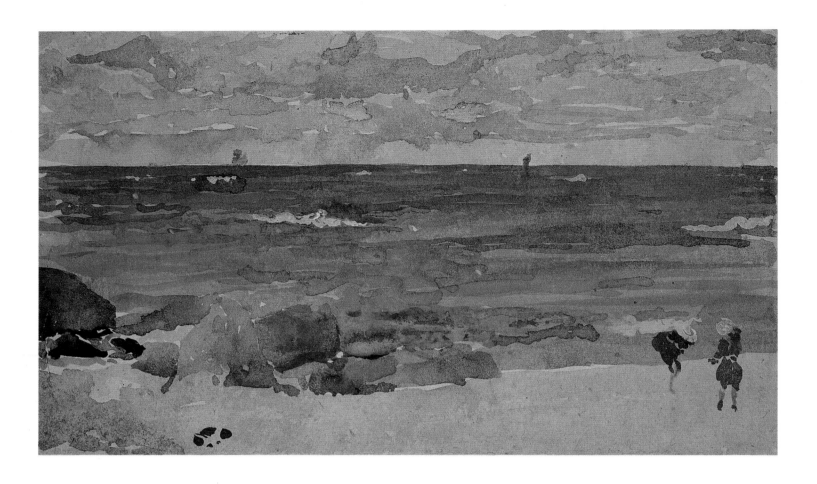

JAMES McNEILL WHISTLER
(1834–1903)
Beach Scene with Two Figures, ca. 1883–90
Watercolor with bodycolor
125 × 214 mm (4⅞ × 8⅜ in.)
Inscribed lower left with the artist's butterfly
emblem
Birmingham Museum and Art Gallery

According to his biographers, Joseph and
Elizabeth Pennell, Whistler used watercolor oc-
casionally throughout his career; however, they
regarded the 1880s as the decade when he came
to recognize the full potential of the medium.
Although they confessed that it was difficult to
ascertain when he reached that mastery of wa-
tercolor painting which enabled him to touch
"perfection in many a little angry sea at Dieppe,
or note in Holland, or impression in Paris,"[1] they
believed that he gained complete control of the
medium when he was in Venice in 1879–80.
Venice Harbour (Freer Gallery of Art, Washington,
D.C.) is an early example of Whistler's using a
wet-paper technique to achieve atmospheric ef-
fects. His drawing of London Bridge in the same
collection, probably done shortly after his re-
turn from Italy, shows him deliberately exploit-
ing methods and subject matter previously
explored by Turner.[2]

Beach Scene with Two Figures is representative of
Whistler's watercolor painting of the 1880s. He
found that coastal landscapes and sea subjects

offered the type of simplified composition that
most interested him – usually an arrangement of
horizontal bands across the width of the sheet,
analogous to the schemes of wall decoration
that he was designing at the time, or strong
diagonals and semiabstract triangular patterns.
Figures, generally touched in with swift calli-
graphic markings, provided carefully calculated
counterbalances to the larger masses of the
composition. Whistler made various painting
trips to coastal regions: to the Channel Islands,
to Southend, and in 1883, in preparation for the
exhibition "*Notes*" – "*Harmonies*" – "*Nocturnes*" of
the following year, to Saint Ives in Cornwall.

Whistler's landscape watercolors were un-
known to the general public before the 1884 ex-
hibition, held at Dowdeswell's Gallery in New
Bond Street. On the whole the exhibition was
well received; according to the *Art Journal*, "the
landscapes exhibit a knowledge and close obser-
vation of cloud and wave form which will be a
surprise to many." However, the reviewer
showed a preference for the artist's "street
scenes taken for the most part in the purlieus of
Chelsea."[3] In 1892 the success of Whistler's exhi-
bition "*Nocturnes, Marines and Chevalet Pieces*," held
at the Goupil Gallery, derived mainly from the
last category – which consisted of figurative sub-
jects in oil. Whistler was an influential and cele-
brated figure in both English and Scottish artistic
circles, but the watercolor landscapes he painted
late in his career – depending as they did on
extreme dexterity of handling, with their im-

mensely subtle and refined power of expression
– were beyond the aesthetic pale for the major-
ity of Victorian gallery goers. CN

1. E. R. and J. Pennell, *The Life of James McNeill Whistler*,
 2 vols. (London: William Heinemann, 1908), vol. 2,
 p. 80.
2. For illustrations of and commentary on these two
 watercolors, see David Park Curry, *James McNeill
 Whistler*, exh. cat. (Washington, D.C.: Freer Gallery
 of Art, 1984), nos. 91 and 97.
3. *Art Journal*, June 1884, p. 191.

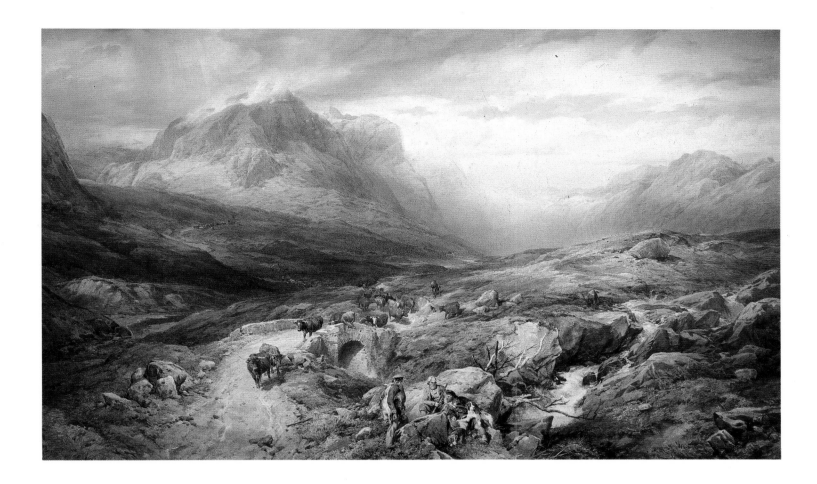

105

THOMAS MILES RICHARDSON, JR.
(1813–1890)
The Pass of Glencoe from Rannoch Moor, 1884
Watercolor with bodycolor, rubbing out, and
scraping out
762 × 1270 mm (30 × 50 in.)
Signed and dated lower right: *T. M. Richardson /
1884*
Guildhall Art Gallery, Corporation of London

The critics generally concurred that the summer
exhibition of the Royal Society of Painters in
Water-Colours in 1884 was one of the best show-
ings that the Old Society had made in years.
According to the *Art Journal,* it was marred only
by an infatuation with oversized works.[1]
Richardson's *The Pass of Glencoe from Rannoch Moor,*
exhibited there, must have contributed to that
impression. By the 1880s Richardson's large,
picturesque views of Scottish and Continental
scenery, although they remained popular and
fetched high prices, were mostly ignored by the
critics or dismissed as formulaic. Neither his
style nor his subject matter had changed appre-
ciably since the time of his election as a member
of the Old Society in 1851.

Richardson was the son and pupil of Thomas
Miles Richardson, Sr., a noted northern land-
scape painter. From the age of fourteen the
younger Thomas exhibited regularly in his na-
tive Newcastle. He began sending works to
London exhibitions in 1832, finally moving to
London after becoming an associate of the
Old Water-Colour Society in 1843. He was a reg-
ular and prolific exhibitor with the Society.

J. L. Roget noted the "clever drawing and work-
manlike skill in manipulation of material" but
added: "As might be expected from so prolific a
painter, there is much similarity of treatment in
his many landscapes. In his finished drawings
the pictorial arrangement conforms to a settled
system of construction."[2] SW

1. *Art Journal,* June 1884, p. 190.
2. John Lewis Roget, *A History of the "Old Water-Colour"
 Society,* 2 vols. (London: Longman, Green and Co.,
 1891), vol. 2, p. 285. Roget's is still the most com-
 plete account of Richardson's career, but see also
 Marshall Hall, *The Artists of Northumbria,* rev. ed.
 (Newcastle upon Tyne: Marshall Hall Associates,
 1982), pp. 149–50, and Paul Usherwood, *Art for
 Newcastle: Thomas Miles Richardson and the Newcastle
 Exhibitions, 1822–1843,* exh. cat. (Newcastle upon
 Tyne: Tyne and Wear County Council Museums,
 1984), pp. 79–80.

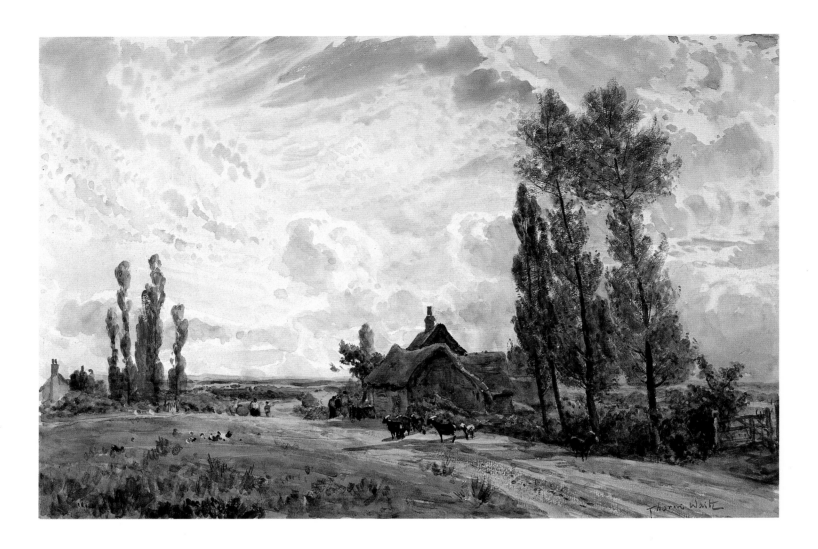

106

ROBERT THORNE WAITE
(1842–1935)
Landscape with Goats, ca. 1884
Watercolor
359 × 534 mm (14¼ × 21 in.)
Signed lower right: *Thorne Waite*
Royal Society of Painters in Water-Colours,
Diploma Collection, London

When he became a member of the Royal
Society of Painters in Water-Colours in 1884,
Thorne Waite presented *Landscape with Goats* as
his diploma piece. With it he declared his alle-
giance to DeWint and to the brand of landscape
painting in watercolors practiced by his friend
Thomas Collier and others in the Royal Institute
of Painters in Water Colours. Between 1861 and
1865, Thorne Waite studied architectural drafts-
manship at the South Kensington School. An
inclination toward landscape watercolors was
already in evidence, encouraged, no doubt, by
a season spent with Collier at Bettws-y-Coed.[1]

Thorne Waite was not, however, fully of the
Collier camp of Cox- and DeWint-inspired land-
scape. At the time of his election as an associate
of the Old Water-Colour Society in 1876, Thorne
Waite was modeling his watercolors so closely
on those of Birket Foster that the older artist
complained that the new associate was copying
him. Even after his technique broadened and
drew closer to Collier's, Thorne Waite still re-

tained a sweetness – what one critic dismissed
as "an incurable trick of prettiness"[2] – in his rus-
tic imagery which recalled Birket Foster. SW

1. Ian C. Cooke, "The Golden Days of Robert Thorne
 Waite, 1842–1935," *Old Water-Colour Society's Club* 58
 (1983): 15–24.
2. *Spectator,* December 9, 1882, p. 1578.

107

ARTHUR MELVILLE (1855–1904)
Kirkwall, Orkney, 1885
Watercolor with bodycolor
368 × 508 mm (14½ × 20 in.)
Inscribed lower left: *Kirkwall*; signed, inscribed,
and dated lower right: *Arthur Melville / Orkney /
1885*
The Robertson Collection, Orkney

In the early summer of 1885, Melville and James
Guthrie visited the island of Orkney. Guthrie
was a central figure in that group of young Scots
painters who came to be known as the Glasgow
School, or, as the painters themselves preferred,
the Glasgow Boys. He traveled around the
Scottish countryside looking for realist subjects,
establishing himself in 1883 in the small
Berwickshire village of Cockburnspath, where
his friend Melville was a frequent visitor.[1] The
Edinburgh-based Melville had a more cosmo-
politan background. He studied in Paris in 1878
in the Académie Julian and worked in the artists'
colonies at Barbizon and Grez-sur-Loing. From
1880 to 1882 he traveled in Egypt and the
Middle East – the first of a number of visits to
North Africa, which supplied the exotic subjects
for much of his art.

While the brilliant North African light had its
effect on Melville's palette, his watercolors from
Orkney have the dark-toned quality of much
late-century British and Continental realist paint-
ing. His visit to Kirkwall, the county seat of
Orkney, produced a clutch of somber water-
color masterpieces, including *The West Front of
St. Magnus Cathedral* (Dundee Museums and Art
Galleries) and the present watercolor, in which
the silhouette of Saint Magnus Cathedral domi-
nates the dusky landscape. sw

1. For the Glasgow Boys, see Roger Bilcliffe, *The
Glasgow Boys: The Glasgow School of Painting, 1875–1895*
(London: John Murray, 1985); for Melville, see
Romilly Fedden, "Arthur Melville, R.W.S.," *Old
Water-Colour Society's Club* 1 (1923–24): 39–59; Agnes
Ethel Mackay, *Arthur Melville, Scottish Impressionist*
(Leigh-on-Sea: F. Lewis, 1951); and *Arthur Melville,
1855–1904*, exh. cat. (Dundee Museums and Art
Galleries, 1977).

108

WILLIAM FRASER GARDEN
(1856–1921)
A Hayfield, Bedfordshire, exhibited 1886
Watercolor
273 × 381 mm (10¾ × 15 in.)
Private collection

Garden was a member of the Fraser family of painters, Scottish by origin and loyal supporters of the Jacobite cause, who lived in Bedford from the 1850s. It seems that he changed his name from Garden William Fraser to William Fraser Garden to distinguish himself from his six brothers, several of whom painted watercolor landscapes similar to his own.[1] He seems to have received some instruction in painting while still a schoolboy, but what his other formative artistic experiences may have been is uncertain.[2] Never a member of any professional association, he displayed his works in London at the Dudley and later at the Royal Institute of Painters in Water Colours, as well as at the Royal Academy, each of which was open to nonmembers. He and his brothers also sent their watercolors to annual exhibitions in the Bedford Assembly Rooms. In due course Garden gave up exhibiting in London; his last contribution to the Royal Academy exhibitions appeared in 1890. In later life his reputation as a painter was

restricted to the neighborhood in which he lived, and he relied on a small number of local clients for sales.

In 1882 Garden moved with his father and brothers to Hemingford Grey on the River Great Ouse east of Huntingdon. He subsequently had a family of his own and established himself in the neighboring Fenland village of Hemingford Abbots. He was always short of money, and in old age he led an eccentric existence, living at the Ferryboat Inn at Holywell and paying his bills with drawings instead of bank notes.

Garden's watercolors are a manifestation of the late-century revival of interest in the representation of landscape subjects in minute and painstaking detail. He chose picturesque but unremarkable subjects in his immediate locality – decrepit mill buildings and riverside inns along the banks of the Great Ouse, as well as pure landscapes such as the present watercolor. His works of the late 1880s and early 1890s are extraordinary in their pellucid quality of light and their exact delineation of architectural and landscape detail.

A Hayfield, Bedfordshire was shown at the Royal Academy in the summer exhibition of 1886, where it was displayed in the newly completed Water Colour Room. There is no recorded response to this painting, but it formed part of a group of traditional and more advanced water-

colors – works by Hubert Coutts and Arthur Melville were also included – which was on the whole well received. CN

1. W. F. Garden's brothers were Francis Arthur Anderson Fraser, Michie Forbes Anderson Fraser, George Gordon Fraser, Arthur Anderson Fraser, and Gilbert Baird Fraser. They were born between 1846 and 1865, W. F. Garden being the fourth child. All were painters except Michie Forbes Anderson Fraser, who joined the consular service and helped to support all the others financially.
2. For biographical information about Garden and his brothers, we depend on a short article by Charles Lane, "Art as a Family Affair," *Country Life,* June 28, 1979, pp. 2105–6. See also William Andrew Baird Grove, *The Frasers: A Local Family of Artists,* published to coincide with an exhibition of paintings by the Fraser family at St. Ives, Cambridgeshire, 1980.

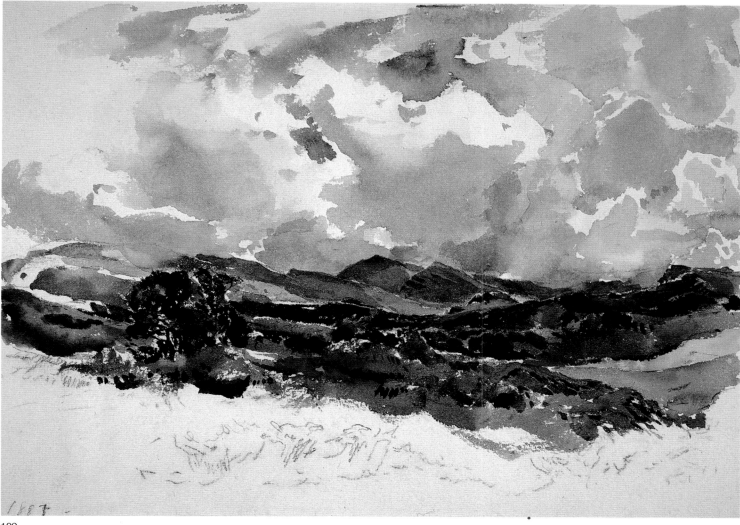

109

109

THOMAS COLLIER (1840–1891)
Hilly Country with Clouds, 1887
Watercolor over pencil
241 × 347 mm (9½ × 13⅝ in.), sight
Dated lower left: 1887
The Trustees of the British Museum, London

This is one of a group of watercolors, mostly sketchy and from late in Collier's career, that his widow gave to the British Museum in 1904. Although it seems unlikely that *Hilly Country with Clouds* would have been exhibited, similar watercolors must have been in the mind of the *Spectator*'s critic in 1885 when he characterized Collier as being "great in expanses of moorland, shadowed by rolling clouds and swept by strong, fresh winds." The critic continued: "His secret is, in a lesser manner, as was the secret of Cox; it is Nature itself that we see here, – Nature occasionally sombre, rough, and even dirty, but always fresh and strong."[1] James Orrock wrote of his friend:

It is perhaps not too much to say that "Tom" Collier was the finest of sky painters, especially of rain and cumulus clouds, while possessing more mastery of direct modelling and pearl-grey shadows in his skies and landscapes than any member of our brotherhood. His painting of cloud-life was little short of magical. He was slow and deliberate,

and when he had finished the intention was complete. In moorland, with brilliant skies full of "accident," he has never had a rival.[2]

SW

1. *Spectator*, June 6, 1885, p. 751.
2. Orrock, quoted in Byron Webber, *James Orrock, R.I., Painter, Connoisseur, Collector,* 2 vols. (London: Chatto and Windus, 1903), vol. 2, p. 62.

110

JAMES PATERSON (1854–1932)
Moniaive, Dumfriesshire, 1889
Watercolor over pencil
319 × 223 mm (12½ × 8¾ in.)
Signed, inscribed, and dated lower left: *James Paterson. / Moniaive. 1889*
Hunterian Art Gallery, University of Glasgow

Paterson was born and brought up in Glasgow, the son of a warehouse owner. His parents sought to discourage him from taking up painting as a career, but even at the time when he was supposed to be earning his living in business, his leisure was devoted to art and he took painting lessons from a local art teacher,

A. D. Robertson. In 1874 works by him – one of which was a watercolor – were exhibited at the Royal Scottish Academy, and the following year he was represented in the annual exhibition of the Glasgow Institute. Eventually, his father relented, and in 1877 Paterson went to Paris, studying under the painter Jean-Paul Laurens. In 1882 Paterson returned to live and work in Glasgow, where he and a group of his contemporaries who came to be known as the Glasgow Boys began to explore what has been described as "a broad and powerful manner of painting, which would represent the weight and mass of things and secure the unity and fullness of tone which had been neglected by most Scottish artists in favour of a more elaborate and less closely related rendering of nature."[1]

After his marriage in 1884, Paterson settled in the village of Moniaive in Dumfriesshire, the landscape of which region provided the main subject of his watercolor painting in the years that followed. Later Paterson wrote down his reasons for wanting to live in the remote countryside:

When a painter loses touch with reality he is in a perilous state. No definite course of life and study can be specified, but . . . to paint landscape, and find out for oneself its possibilities . . . [and] to marry metaphysically some well-chosen place, seeking not the obvious picturesque, but

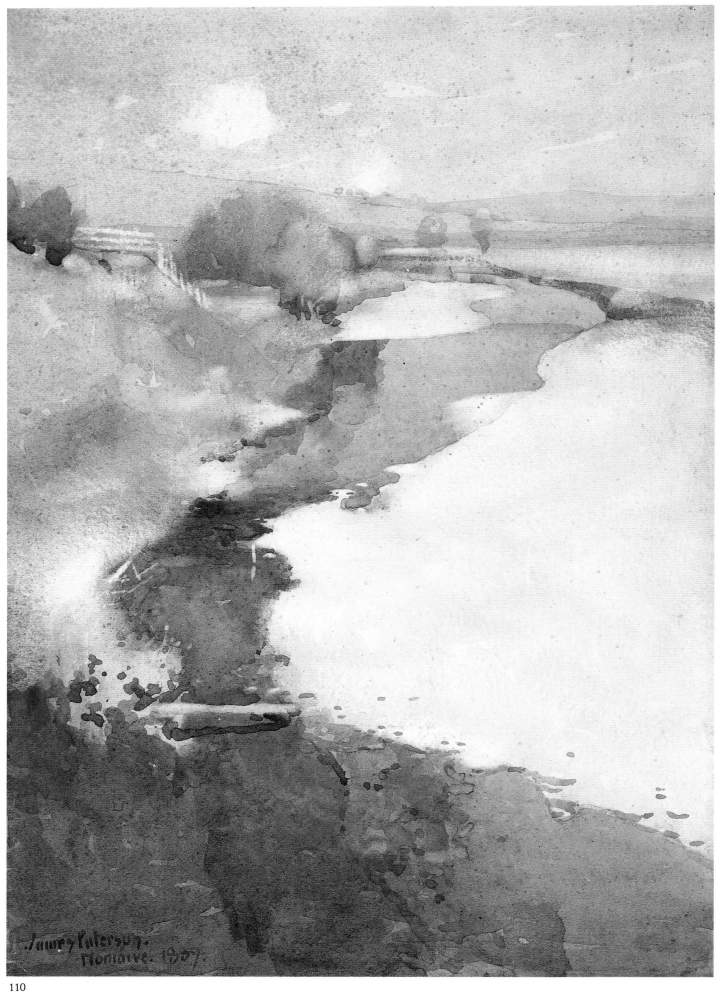

James Paterson.
Moniaive. 1907.

110

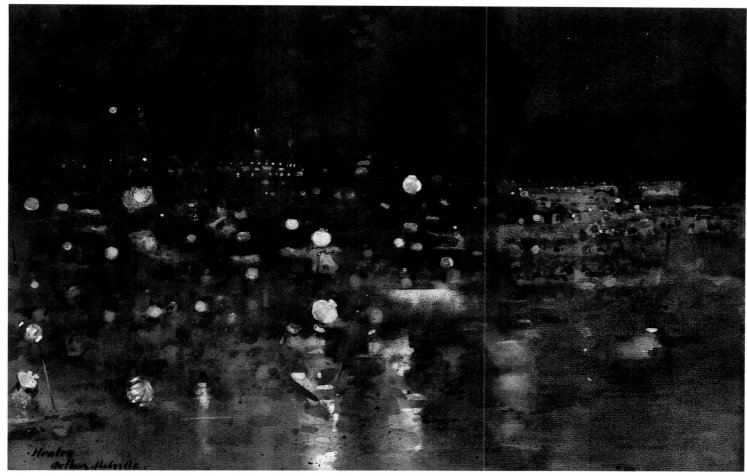

111

allowing nature's features gradually to find their way to the heart, and thence issue in sentient artistic expression.[2]

The present watercolor, which shows the bed of a burn winding through the Lowland country-side, is presumably a view of the Cairn Water which joins the River Nith at Dumfries.

Paterson and his family remained in Dumfriesshire until 1897, from which time they lived in Edinburgh, at least for the winter months of each year. Paterson kept in touch with other Glasgow Boys and was a regular participant in the exhibitions where they showed their works. In 1884 he became an associate of the Scottish Water Colour Society, which from then on provided a principal outlet for his watercolor landscapes, and of which association he became president in 1922. He also sent works to the New English Art Club and, in the last year of its existence, the Grosvenor Gallery; furthermore, he contributed to the European reputation of the Glasgow School by sending works to exhibitions in Munich and Paris. He became an associate of the Royal Society of Painters in Water-Colours in 1898, and a full member ten years later. CN

1. James L. Caw, "James Paterson," Old Water-Colour Society's Club 10 (1932–33): 45.
2. Paterson, quoted in Ailsa Tanner, James Paterson, Moniaive, exh. cat. (Milngavie: Lillie Art Gallery, 1983).

111

ARTHUR MELVILLE (1855–1904)
Henley Regatta by Night, 1889
Watercolor with bodycolor
377 × 552 mm (14⅞ × 21¾ in.)
Inscribed, signed, and dated lower left: *Henley / Arthur Melville. / 89.*
Janine Rensch, Switzerland

At the beginning of 1889, Melville moved from Edinburgh to London; he had been elected an associate of the Royal Society of Painters in Water-Colours the previous year (he would become a full member in 1899). At his first exhibition with the Society, he was pegged by a critic as being in the "so-called realistic division," but it was acknowledged that he was "the most brilliant, forcible and stylish in his statement of facts."[1] Melville was already an associate of the Royal Scottish Academy, and he had exhibited at the Royal Academy in London as well as sending works to the Dudley Gallery and the Royal Institute of Painters in Water Colours.

Melville painted this watercolor of the famous and fashionable Henley Royal Regatta on the Thames (founded in 1839) in the summer of his first year in London. The watercolor was exhibited three times in 1891: in an exhibition at Dowdeswell's Gallery; in the summer exhibition of the Royal Water-Colour Society; and again in the autumn exhibition at the Walker Art Gallery in Liverpool, where Melville had been invited, along with James McNeill Whistler, to hang the show.

Henley Regatta by Night is, in fact, very much indebted to the nocturnes of Whistler. As with many of Melville's watercolors of the late 1880s and 1890s, it has a degree of elegant abstraction unusual in the works of his fellow Scots in the Glasgow School. When it was exhibited at the Royal Water-Colour Society, a critic noted its "brilliancy" but added: "We doubt if the public taste is sufficiently educated to appreciate the method by which his effects are obtained."[2] Melville's technique was later described by his friend Theodore Roussel:

Melville's method was pure watercolour, but watercolour applied on a specially prepared paper. This paper was soaked in diluted Chinese white, till it was literally saturated and impregnated with white. He worked often into a wet surface, sponging out superfluous detail, running in those warm browns and rich blues and reds which he knew so well how to blend and simplify. His colour was often dropped on the paper in rich, full spots or blobs rather than applied with any definite brush-marks. The colour floats into little pools, with the white of the ground softening each touch. He was the most exact of craftsmen; his work is not haphazard and accidental, as might be rashly thought. Those blobs in his drawings, which seem meaningless, disordered and chaotic, are actually organized with the utmost care to lead the way to the foreseen result.[3]

SW

1. *Art Journal*, June 1888, p. 189.
2. *Illustrated London News*, April 25, 1891, p. 539.
3. Roussel, quoted in Julian Halsby, *Scottish Watercolours, 1740–1940* (London: B. T. Batsford, 1986), p. 133.

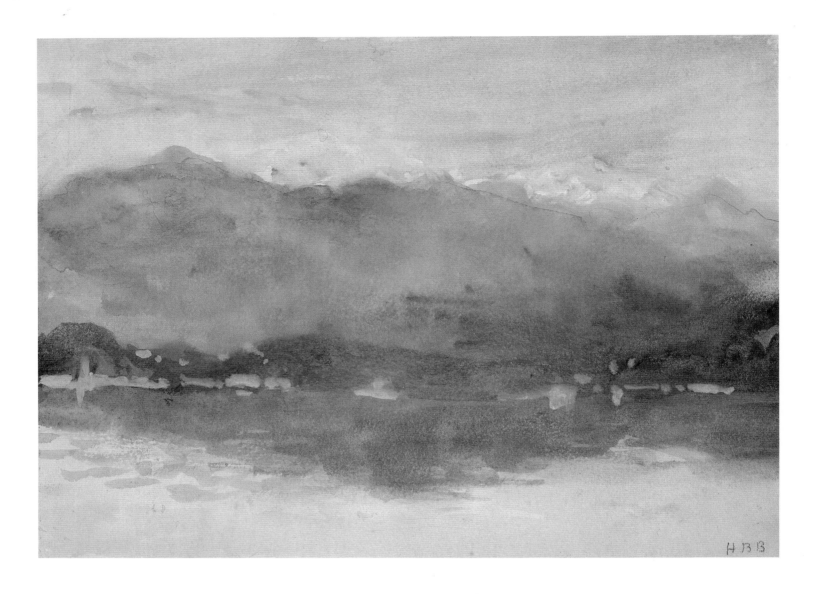

HERCULES BRABAZON
BRABAZON (1821–1906)
Lago Maggiore
Watercolor and bodycolor
242 × 330 mm (9½ × 13 in.)
Signed lower right: H B B
Collection of Chart Analysis Limited, London

Brabazon started life as Hercules Brabazon Sharpe. He was born and brought up in Paris, where his father had business interests. As a boy he showed an inclination toward the arts, and his parents arranged for him to be given drawing lessons. Later the Sharpes returned to England and set up in a house in Sussex built for them by Decimus Burton. Hercules was educated at Harrow, where he devoted himself to playing the piano and painting watercolor landscapes. He went on to Trinity College, Cambridge, where he read mathematics. He subsequently ignored his father's wish that he should read for the bar but instead departed for Rome to paint and study music. In 1847 his older brother died, and as a result the Brabazon estates in Ireland, which had been inherited from an unmarried uncle, passed to him. By special license he adopted the ancient name

of his maternal family, becoming Hercules Brabazon Brabazon. From that point on, almost for the rest of his life, Brabazon led an extremely comfortable but relatively obscure existence, devoted for the most part to travel and painting.[1]

Brabazon was an indefatigable visitor to museums and galleries, making incisive and subtle studies, or "souvenirs" as he called them, of the paintings he admired. He was particularly drawn to the Venetian and Spanish schools, but also to the earlier British watercolorists – evocations of the works of DeWint, Cox, Constable, Cotman, and Turner occur among his exhibited drawings. The bulk of his work, however, consisted of studies of landscape and buildings observed in the course of his peregrinations in Europe and farther afield.

Ruskin and Brabazon were friends, traveling and painting together in northern France on one occasion in 1880. In the last decades of the century, Brabazon's work became known and admired among a younger circle of artists. In 1891 he was proposed for membership in the New English Art Club by Philip Wilson Steer; two landscapes painted by Brabazon, one entitled *Lago Maggiore* and perhaps identical with the present watercolor, were selected for display in

the club's winter exhibition of 1891–92. On this occasion, as also in December 1892 when an exhibition devoted to Brabazon's drawings opened at the Goupil Gallery, critical opinion was unanimous in its approval. George Moore considered Brabazon's watercolors a revelation of nature:

In a time of slushy David Coxes, Mr. Brabazon's eyes were strangely his own. Even then he saw Nature hardly explained at all – films of flowing colour transparent as rose leaves, the lake's blue, and the white clouds curling above the line of hills – a sense of colour and a sense of distance, that was all, and he had the genius to remain within the limitations of his nature.[2]

CN

1. The principal source of biographical information on Brabazon is C. Lewis Hind, *Hercules Brabazon Brabazon* (London: George Allen and Company, 1912); see also Hilarie Faberman, *Hercules Brabazon Brabazon, 1821–1906*, exh. cat. (Queens College: Godwin-Ternbach Museum, 1985). T. Martin Wood, "The Water-Colour Art of H. B. Brabazon," *Studio* 35 (1905): 95–98, gives an account of the artist's technique.
2. Hind, *Brabazon*, p. 98.

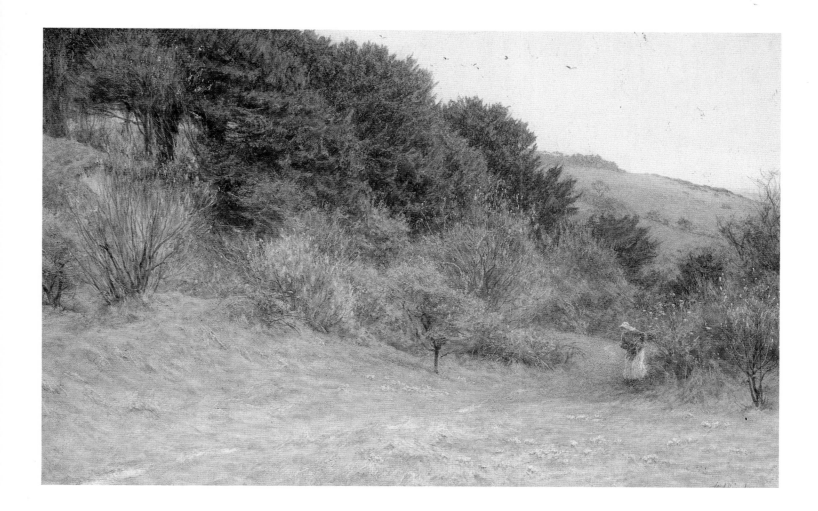

113

HELEN ALLINGHAM (1848–1926)
North Downs Landscape
Watercolor
240 × 380 mm (9½ × 15 in.), sight
Signed lower right: H *Allingham*
Private collection

From 1881 to 1888 Allingham lived in the village of Sandhills in Surrey, near Witley where Birket Foster had his home. She made the cottages and the countryside of Surrey and to a lesser degree neighboring Sussex the subjects of her art. In 1886 the Fine Art Society gave her a solo show with the title *Surrey Cottages*. The exhibition was so successful that it was followed by another, *In the Country*, the next year. It was during her stay in Surrey that Allingham established the basic subject types on which her popularity would securely rest until at least World War I.

The skies in her watercolors are generally milky and the light has the even, neutral quality of an overcast day – as in *North Downs Landscape* – suggesting a reliance on formula rather than direct observation of changing conditions of light and atmosphere; however, Allingham was indefatigable in working out of doors in all weathers to the very end of her life. During her residence in Surrey and later, after she had returned to London, when she made regular expeditions into the countryside of Surrey and Middlesex, her frequent sketching companion was Kate Greenaway.[1] SW

1. Ruskin paired the two artists in his lecture on "Fairy Land" in 1883 (33.327–49).

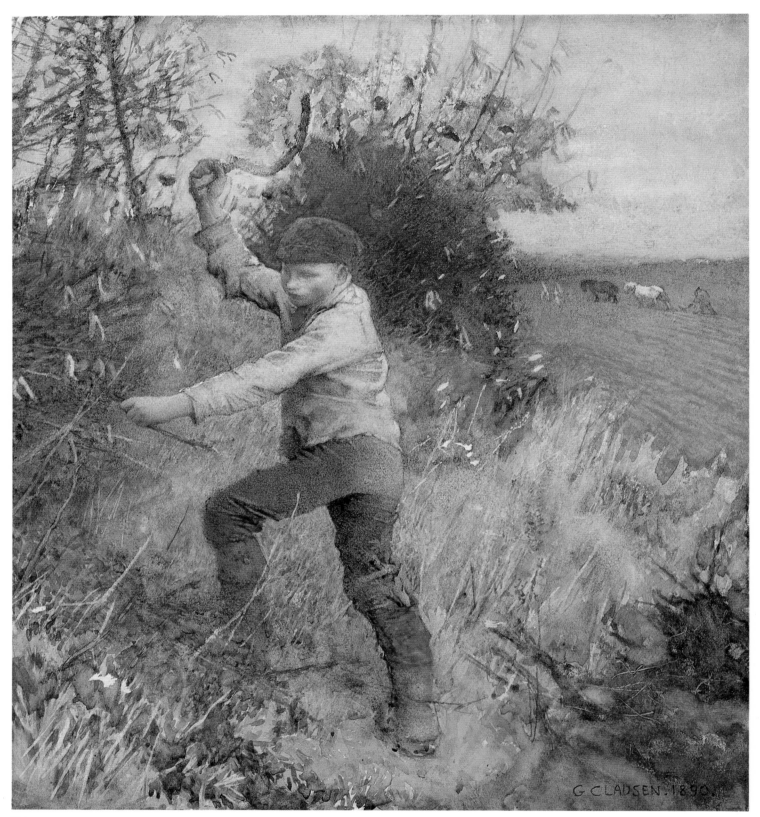

114

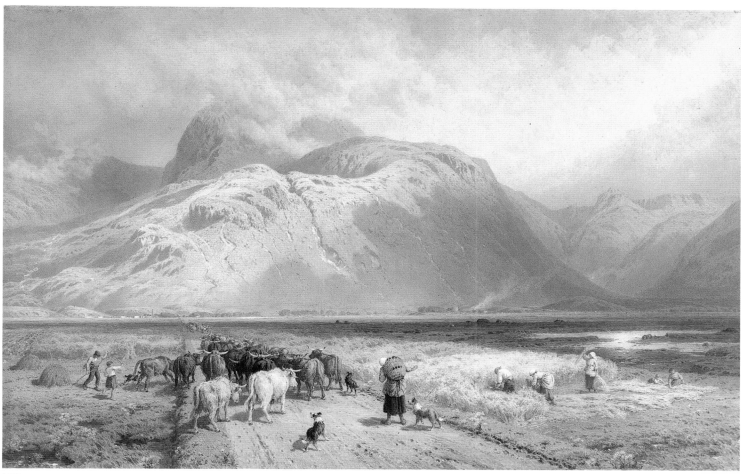

115

114

GEORGE CLAUSEN (1852–1944)
Boy Trimming a Hedge, 1890
Watercolor and bodycolor with scratching out
over pencil
390 × 354 mm (15⅜ × 14 in.)
Signed and dated lower right: G CLAUSEN. 1890
Birmingham Museum and Art Gallery

The London-born Clausen was the son of a
painter of Danish extraction. From 1867 he
served an apprenticeship to a firm of decora-
tors, while in the evenings he attended art
classes at the South Kensington School. His early
watercolors suggest that he had read and assimi-
lated Ruskin's *Modern Painters*. In about 1875 he
visited Holland and Belgium, and in the course
of a brief sojourn in Antwerp, he came to appre-
ciate the freedom and expressiveness of modern
European art.[1] Other influences on Clausen's
early career, as revealed by the watercolors and
oils he exhibited at the Dudley Gallery and the
Society of British Artists in the early 1870s, were
the works of Fred Walker and the idyllists, and
the aesthetic "arrangements" of Whistler. The
rural naturalism of the Scots painter John
Robertson Reid impressed Clausen in the late
1870s but was soon superseded by the influence
of the French painter Jules Bastien-Lepage,
works by whom were shown at the Grosvenor
Gallery in 1880.

Resolving to paint rustic subjects in an honest
and objective way, Clausen went to live in the
country – first at Childwick Green, then near
Cookham in Berkshire, and finally (from 1891) at
Widdington near Saffren Walden in Essex – so as
to gain further familiarity with his chosen sub-
ject matter. It was a move which he subse-
quently described as "a liberation." He wrote:
"One saw people doing simple things under
good conditions of lighting: and there was al-
ways landscape. And nothing was made easy for
you: you had to dig out what you wanted."[2]

In the late 1880s and early 1890s Clausen was
increasingly drawn to figures in motion – men
wielding scythes or winnowing grain, for exam-
ple – as opposed to the more static images of
men and women standing in the fields or gate-
ways or trudging along country lanes which he
had previously addressed. The present water-
color, exhibited at the Royal Society of Painters
in Water-Colours in 1890, seems to have been
an experiment in this type of dynamic
composition.

While Clausen tended to use oils for his more
ambitious rustic subjects, he made watercolor
landscape studies and painted reduced water-
color versions or variants of his larger oil paint-
ings and also used the medium for more experi-
mental purposes. That he was happy to see his
drawings exhibited and sold is indicated by his
having been a member of both watercolor soci-
eties – the Institute from 1879 to 1888 and the
Royal Society as an associate from 1889 and a
full member from 1898. Clausen was elected an
associate of the Royal Academy in 1895. He be-
came a royal academician in 1905 and served as
professor of painting and the director of the
Academy Schools. He was knighted in 1927.

CN

1. For biographical information on Clausen, see
 Kenneth McConkey, *Sir George Clausen, R.A.*, exh. cat.
 (Newcastle upon Tyne: Tyne and Wear Museums,
 1980).
2. George Clausen, "Autobiographical Notes," *Artwork*,
 no. 25 (1931): 19.

115

MYLES BIRKET FOSTER (1825–1899)
Ben Nevis, exhibited 1891
Watercolor and bodycolor over pencil
785 × 1179 mm (30⅞ × 46-⅜ in.)
Signed in monogram lower right: BF
Laing Art Gallery, Newcastle upon Tyne
(Tyne and Wear Museums)

Although Birket Foster exhibited Scottish sub-
jects throughout his association with the Society
of Painters in Water-Colours, he seems to have
been particularly drawn to the landscape of the
Highlands in the last two decades of his life.
Among the many Highland scenes which he
sent to the Society exhibitions are a *Ben Nevis* in
the winter exhibition of 1883 and another, pre-
sumably this large and impressive watercolor, in

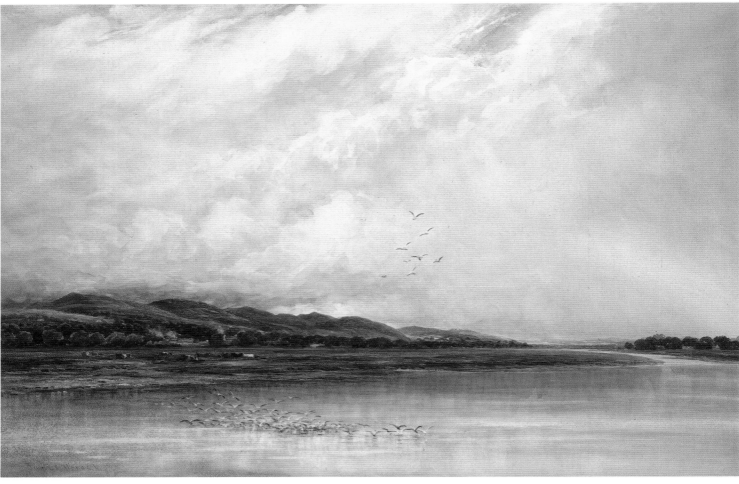

116

the summer exhibition of 1891. Asked by the Berlin Academy for a list of what he considered his most important works, Birket Foster included this *Ben Nevis* as one of the principal drawings of his later years.[1] SW

1. Jan Reynolds, *Birket Foster* (London: B. T. Batsford, 1984), pp. 160–62. Birket Foster had been an honorary member of the Berlin Academy since 1874.

116

JAMES ORROCK (1829–1913)
On the Nith, Dumfriesshire, exhibited 1891
Watercolor over pencil with scraping out
495 × 750 mm (19½ × 29½ in.)
Signed lower left: *James Orrock*
The Board of Trustees of the Victoria and Albert Museum, London

Orrock, the son of a dental surgeon in Edinburgh, followed his father into dentistry, establishing his own practice in Nottingham. Interested in art from an early age, he studied in his spare time at the Nottingham School of Design and began collecting watercolors of the older English school: Cox, DeWint, Copley Fielding, Bonington, and William Henry Hunt.[1] In 1866 Orrock gave up dentistry and moved to London to devote himself to art. He took lessons in watercolor painting from his fellow

Scotsman William Leighton Leitch. Orrock's own watercolors, however, were closer stylistically to those works of Cox and DeWint that he avidly collected, and when he joined the Institute of Painters in Water Colours – as associate in 1871 and member in 1875 – he formed the nucleus, along with Thomas Collier and E. M. Wimperis, of a Cox school within that body.

Orrock continued to amass a considerable collection of both watercolors and oils, including works by Reynolds, Gainsborough, Turner, and Constable.[2] He produced numerous articles and essays for the art periodicals and was a frequent lecturer on art. In his collecting, writing, and lecturing, as well as in his own watercolors, he was a fervent admirer and champion of English art of the early nineteenth century. He was also a vigorous defender of the medium of watercolor. He took part in the debate over the permanency of watercolors that arose in the late 1880s and lent heavily from his collection to the loan exhibition of historical watercolors held at the Royal Institute to refute the charges that overexposure had irreparably damaged older watercolors.[3]

On the Nith, Dumfriesshire was exhibited at the International Exhibition of Fine Arts in Berlin in 1891. While the watercolor shows some affinity with the somber tonal landscapes of the Hague School, it is also testimony to Orrock's unswerving allegiance to the landscape watercolors of Cox and DeWint. SW

1. For Orrock's life and extensive quotations from his writings on art, see Byron Webber, *James Orrock, R.I., Painter, Connoisseur, Collector*, 2 vols. (London: Chatto and Windus, 1903).

2. Orrock was also a dealer, and it has been suggested that many so-called Constables sold by Orrock either were known by him to be fakes, were forgeries commissioned by him, or were painted by Orrock himself. See Charles Rhyne, "Constable Drawings and Watercolors in the Collections of Mr. and Mrs. Paul Mellon and the Yale Center for British Art: Part II: Reattributed Works," *Master Drawings* 19 (Winter 1981): 403–7.

3. The controversy began with a letter to the *Times* by J. C. Robinson, claiming that the collection of English watercolors at the South Kensington Museum had been ruined by continuous exposure to daylight. A number of artists, led by James Linton, president of the Royal Institute, tried to dispute Robinson's charges, which were seen as a threat to the livelihood of watercolorists and a challenge to the practices of curators and collectors. The correspondence on the issue was published as *Light and Water-Colours: A Series of Letters Addressed to the Editor of "The Times"* (London: G. Parnell, 1887).

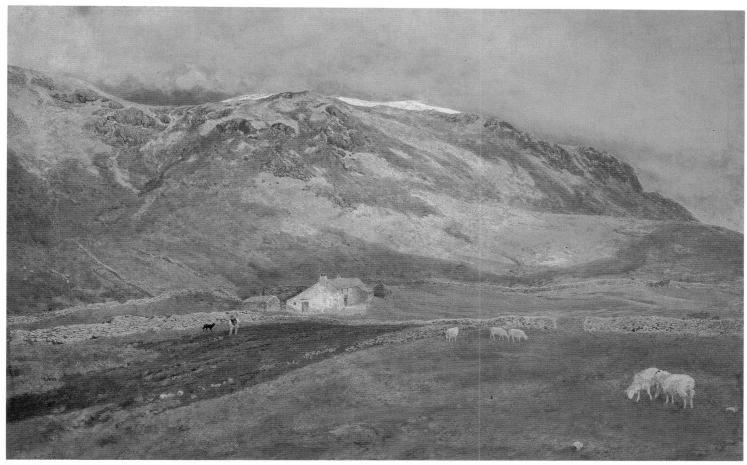

117

1. Coutts changed his name from Hubert Coutts Tucker. As an exhibitor he was variously listed with the Christian names Hubert and Herbert.

117

HUBERT COUTTS (d. 1921)
A Sheep Farm in the Duddon, exhibited 1891
Watercolor
508 × 800 mm (20 × 31½ in.)
Signed lower left: *Hubert Coutts*
Mr. and Mrs. Richard Dorment

Coutts[1] lived at Ambleside in Westmorland and painted landscape subjects in the English Lake District. This watercolor represents an upland farm in early spring in the valley of the River Duddon, which flows in a southerly direction from the central mass of the Furness Fells in the Lakes. Coutts shared with J. W. North an interest in evoking specific times of the year and showed farming activities appropriate to the season. Here Coutts depicts the golden browns of dead bracken only recently crushed by the weight of snow. In the left-hand distance a farmer digs up a root crop – probably either turnips or swedes – as a supplementary foodstuff for his flock.

Coutts was a regular exhibitor at the Dudley Gallery from 1874 and became a member of the Royal Institute of Painters in Water Colours in 1912; however, like Henry Clarence Whaite, he was probably better known to northern collectors than to the London gallery-going public. *A Sheep Farm in the Duddon* was first exhibited at the Royal Academy in 1891 and was subsequently shown in the British section of the World's Columbian Exposition held in Chicago in 1893.

CN

118

WILLIAM FULTON BROWN
(1873–1905)
Woodland Scene, 1894
Watercolor
495 × 390 mm (19½ × 15⅜ in.)
Signed and dated lower right: *W. F. Brown R.S.W.* / *–1894*
Glasgow Art Gallery and Museum
Exhibited at Yale and Cleveland only

Brown trained as an artist in his native Glasgow under his uncle, the painter David Fulton, and later at the Glasgow School of Art. He went on to paint watercolors of historical genre subjects and interiors, some of which he exhibited at the Royal Scottish Water Colour Society. During his brief career, Brown failed to establish a lasting reputation for himself and seems to have been hardly known at all for landscape subjects, even to his contemporaries. Nonetheless, the wet-paper technique of *Woodland Scene* – similar to that of Paterson, Melville, and other members of the Glasgow School – shows Brown very much in step with more advanced Scots painting of the 1890s.

CN

119

HELEN ALLINGHAM (1848–1926)
Harvest Field, near Westerham, Kent,
ca. 1895–1900
Watercolor with scratching out
254 × 177 mm (10 × 7 in.)
Signed lower right: *H Allingham*
Whitworth Art Gallery, University of Manchester

In 1889 the *Spectator* commented on Allingham's drawings: "They show how refined and delicate Art may deal with Nature, and find it full of suggestions of beauty without forfeiture of truth; and are feminine in the best sense of the word, without any of the artistic weakness that pleads for consideration in the name of the sex."[1] The following year, the bar to her advancement in the Royal Society of Painters in Water-Colours on the basis of her sex was removed, and she became a full member.

In the 1890s she enjoyed great popularity, based largely on her watercolors of Surrey cottages. By the end of the decade she was making efforts to expand the range of her subject matter. An exhibition of Venetian pictures at the Fine Art Society in 1904 was not a success. A few years earlier she had made a more modest attempt at enlarging her repertoire with a group of harvest scenes in the Kentish countryside near Westerham. The present watercolor probably derives from one of her visits to Westerham in the late 1890s.

SW

1. *Spectator*, May 4, 1889, p. 609.

W.F.Brown. RSW.
-1894.

118

119

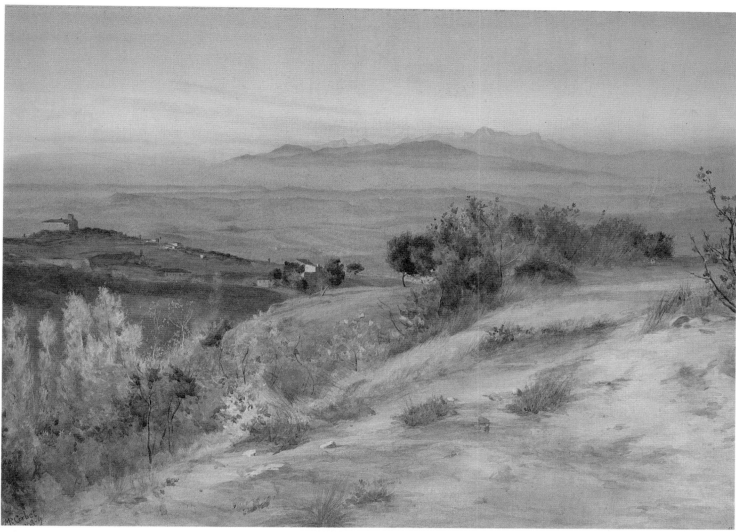

121

120

EDWARD JOHN POYNTER
(1836–1919)
Isola San Giulio, Lago d'Orta, 1898
Watercolor with bodycolor and scraping out
537 × 365 mm (21⅛ × 14⅜ in.)
Signed in monogram and dated lower right:
18 EJP 98
Yale Center for British Art, Paul Mellon Fund

In contrast to the watercolor painting of most of his contemporaries, which tended to become increasingly atmospheric and generalized in its forms, Poynter's became more minute and painstaking as his career proceeded. An example of the type of highly detailed landscape he painted in his later years is the present view of one of the north Italian lakes in Piedmont. Isabel McAlister in the *Studio* described this watercolor as "a fairylike island surrounded by blue water, with picturesque houses nestling on the shore, and the mountains in the distance seen through a mist of pearly grey, giving a touch of mystery to the scene," and commented, "Sir Edward is particularly happy in catching the true atmospheric tones, and a certain serenity of outlook and restrained colour ensure the sense of repose which is characteristic of his landscapes."[1] However, such enthusiasm for Poynter's watercolor landscapes was by

no means universal. In 1904 a critic for the same periodical, reviewing an exhibition of Poynter's watercolors at the Fine Art Society, had found them "on the whole, disappointing, for too many of them were spoiled by his habitual trick of over-elaboration, and were lacking in spontaneity and brilliancy of method."[2]

Poynter regarded his landscape watercolors as an important part of his output as a professional artist. He sent works to the General Exhibition of Water-Colours at the Dudley Gallery in 1865 and in due course showed landscape watercolors at the Grosvenor and New galleries. In 1883 he became an associate and in the following year a member of the Royal Society of Painters in Water-Colours. CN

1. Isabel G. McAlister, "Some Water-Colour Paintings by Sir Edward Poynter, P.R.A.," *Studio* 72 (1917): 94. The present watercolor is reproduced on p. 97.
2. *Studio* 30 (1904): 252.

121

MATTHEW RIDLEY CORBET
(1850–1902)
From Volterra, Looking towards the Pisan Hills,
1898–99
Watercolor
502 × 692 mm (19¾ × 27¼ in.)
Signed and dated lower left: MR Corbet / 1898–9
Private collection

Corbet was born in South Willingham in Lincolnshire. He was one of the first students to be admitted to the Slade School of Art in London and later attended the Royal Academy Schools. Throughout his career, he made frequent painting expeditions to Italy, particularly to Umbria and Tuscany, and he was often a guest at the Italian painter Giovanni Costa's house at Bocca d'Arno close to Pisa.[1] It was perhaps in the course of one of these visits to Costa that Corbet painted the present watercolor, which shows the vespertine Tuscan landscape looking westward from the environs of Volterra toward the coastal range above the port of Leghorn.

From Volterra, Looking towards the Pisan Hills is typical of Corbet's evocative yet closely observed representations of the Italian landscape. Costa encouraged artists to simplify the forms of the landscape in order to convey a sense of solidity and structure. Both Costa and Corbet favored a

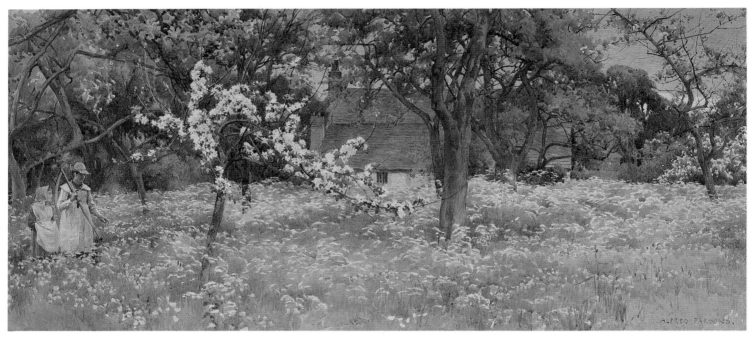

122

panoramic approach, giving particular emphasis to the outline of the horizon. Local color tended to be suppressed in favor of tonal unity. Costa and his English followers almost invariably chose to represent the landscape at dawn or dusk, when the effect of light was softest and most poignant.

The majority of Corbet's exhibited works – whether at the Grosvenor or New galleries or at the Royal Academy – were oil paintings, a bias which may have reflected Costa's own admonitions against watercolor, a medium that he considered facile and inexpressive.[2] Nonetheless, *From Volterra, Looking towards the Pisan Hills* was shown at the Royal Academy in 1899, demonstrating that Corbet himself believed in the fundamental legitimacy of watercolor.　　CN

1. Sources of biographical information are "M. Ridley Corbet: The New Associate of the Royal Academy," *Magazine of Art* 26 (1902): 236–37, and another notice of his election as A.R.A. in the *Art Journal*, March 1902, pp. 92–93. See also Christopher Newall, *The Etruscans: Painters of the Italian Landscape, 1850–1900*, exh. cat. (Stoke-on-Trent Museum and Art Gallery, 1989), pp. 37–38 and 70.
2. See, for example, the account of Costa's instructions to George Howard, in Olivia Rossetti Agresti, *Giovanni Costa: His Life, Work, and Times* (London: Grant Richards, 1904), p. 127.

122

ALFRED WILLIAM PARSONS
(1847–1920)
Mrs. Bodenham's Orchard, Herefordshire
Watercolor and bodycolor
241 × 533 mm (9½ × 21 in.)
Signed lower right: ALFRED PARSONS.
Courtesy of Chris Beetles Limited, London

Parsons began his working life as a post office clerk in London. After a year or two in this uncongenial occupation, he enrolled as a student in the evening classes held at the South Kensington School. In due course he left London and began a career as a professional artist, working in both oil and watercolor and as an illustrator.

Born and brought up in the countryside, Parsons was first and foremost a painter of rural subjects. As A. L. Baldry wrote:

The open air attracted him as a vast storehouse of artistic material. . . . He began immediately to paint out of doors, studying always directly from nature, and aiming assiduously at the acquisition of a thorough and exact knowledge of landscape characteristics. . . . He gained a peculiar freshness of interpretation, expressive of a frank reliance upon his judgment of the relative value of the facts that nature presented to him. The subjects he began to treat showed a pleasant quaintness of taste that was never eccentric, and an agreeable preference for character over mere popular prettiness.[1]

Parsons was a prolific exhibitor in the galleries of late Victorian London. He first exhibited at the Dudley Gallery in 1876. He also showed at the Grosvenor Gallery from 1880 to 1887. He became a member of the Institute of Painters in Water Colours, exhibiting there in the 1880s; subsequently, however, he transferred to the Royal Society of Painters in Water-Colours, eventually becoming its president. In 1897 he became an associate of the Royal Academy and in 1911 an academician.　　CN

1. A. L. Baldry, "Some Sketches by Alfred Parsons, A.R.A.," *Studio* (1899): 153–54.

123

JAMES THOMAS WATTS (1853–1930)
Woodland Landscape in Winter
Watercolor
317 × 260 mm (12½ × 10¼ in.)
Signed lower right: JAMES T. WATTS
Collection of Chart Analysis Limited, London

Watts was born and brought up in Birmingham, where he studied at the School of Art. As a young man he read the works of Ruskin and dedicated himself to a revival of Pre-Raphaelite realism; later he was attracted and influenced by the pleinairism of contemporary French schools of landscape. Thus Watts's landscape painting – which almost always shows woodland subjects in autumn or winter – combines meticulous detail with a sense of atmosphere and quality of light.

At some point in his early career Watts moved to Liverpool, where he became a respected member of the artistic community. He was a regular contributor to the Liverpool Autumn Exhibition and also sent works to exhibitions in London – to the Royal Academy, the Royal Society of British Artists, and the Institute of Painters in Water Colours. He was a member of various art societies, including the Liverpool Academy of Art, the Royal Cambrian Academy, and the Royal Birmingham Society of Artists.

CN

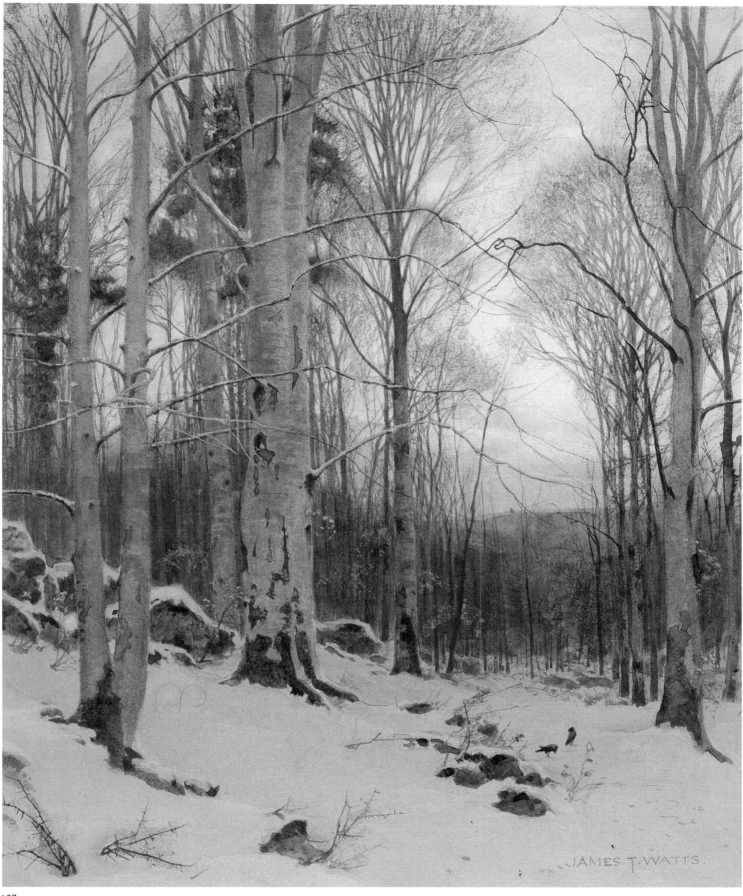

123

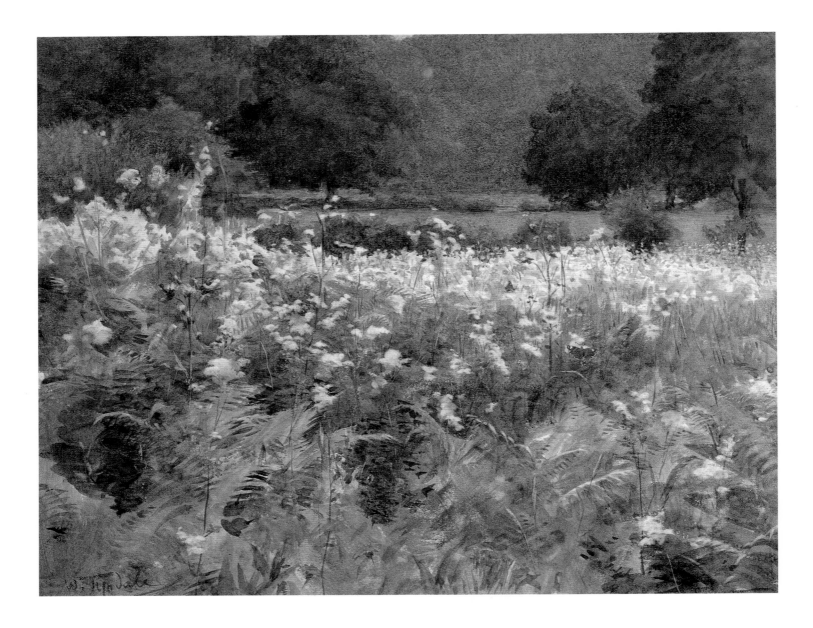

124

WALTER TYNDALE (1855–1943)
Meadow Sweet, near Royden
Watercolor
178 × 228 mm (7 × 9 in.)
Signed lower left: *W. Tyndale*; inscribed on verso:
Meadow Sweet, near Royden
Courtesy of Chris Beetle: Limited, London

Walter Frederick Roofe Tyndale was born and
brought up in Bruges, Belgium, and his early
training took place in the Bruges Academy of
Art. He and his family moved back to England
when he was sixteen, and for several years they
lived in Bath. In about 1874 Tyndale returned to
the Continent to study painting, first in Antwerp
and then in Paris, where he enrolled in the
Académie Bonnat and subsequently in the stu-
dio of the Belgian artist Jan van Beers. Only in
the late 1870s did the artist settle in England.[1]

For a while Tyndale painted portraits and
genre subjects and worked principally in oils.
From about 1890 he lived at Haslemere in Surrey;
perhaps the influence of the countryside as well
as the example of other painters such as his
neighbors Helen Allingham and Claude Hayes
encouraged him to take up landscape subjects
and the medium of watercolor. Tyndale traveled
widely in Europe, North Africa, the Middle East,
and Japan. He recorded these places in a series of
books written by him and illustrated with color
plates after his watercolors. Along with John
Fulleylove, he was one of the last of the succes-
sion of British topographical watercolorists who
supplied the taste for information about remote
places and different cultures.

Meadow Sweet, near Royden shows a quintessen-
tially English landscape – moist and fertile and
free from any disturbances. Tyndale's view
seems likely to have been taken somewhere in
East Anglia; the placename "Royden" does not
appear in geographical gazetteers, but "Roydon"
is the name of at least three villages, one in
Essex and two in Norfolk.

Tyndale was a member of the Royal Institute
of Painters in Water Colours and a frequent par-
ticipant in its summer exhibitions. His work was
also presented in a series of exhibitions, orga-
nized by the picture dealers Dowdeswell and
Dowdeswell, which took their themes from the
various countries he visited and painted in.

CN

1. The principal source of biographical information
 on Tyndale is Clive Holland, "Walter Tyndale: The
 Man and His Art," *Studio* 38 (1906): 289–97.

125

WILLIAM CALLOW (1812–1908)
Père Lachaise Cemetery, 1905
Watercolor over pencil
200 × 302 mm (7⅞ × 11⅞ in.)
Signed and dated lower left: *W. Callow 1905*
Birmingham Museum and Art Gallery

By the time he put his signature and the date on this drawing, the ninety-three-year-old Callow had outlived several generations of watercolorists and witnessed several cycles of change in the art of landscape watercolors. Through long years of exhibiting with the Old Water-Colour Society, he was seen as one of the stalwarts, his contributions too familiar to require much comment but always recognized as being well crafted and appealing.

Père Lachaise Cemetery recalls the watercolor sketches of Bonington and Müller, watercolor as it was practiced in the days when Callow was starting his career, yet it did not seem out of place with contemporary watercolors by John Singer Sargent or Philip Wilson Steer. While the watercolor has the look of a sketch done on the spot, it must have been based on a study done either thirteen or twenty-one years before. After marrying for the second time in 1884, Callow honeymooned in Paris and Switzerland. His next and last trip to the Continent was an 1892

visit to Italy. Traveling back to England, he stopped in Paris but found the weather "intensely hot, so that we stayed there only long enough to visit an unattractive Exhibition at the Salon."[1] SW

1. William Callow, *Autobiography*, ed. H. M. Cundall (London: Adam and Charles Black, 1908), p. 146.

126

HENRY HOLIDAY (1839–1927)
Hawes Water, ca. 1918
Watercolor
228 × 292 mm (9 × 11½ in.)
Signed lower right: h.h.
The Board of Trustees of the Victoria and Albert
Museum, London

Holiday's artistic training took place at Leigh's
School in London, where his fellow student was
Fred Walker, and from the winter of 1854–55 at
the Royal Academy Schools. He painted land-
scape subjects as a student and, like many of his
contemporaries, came under the influence of
Pre-Raphaelitism. In 1857 he competed for the
Turner gold medal for landscape painting, the
subject of which in the first year the prize was
offered was simply "An English Landscape."
Holiday submitted a view on the coast at
Durlestone Bay in Dorset, made on the basis of
careful work out of doors. It turned out that the
council of the Academy awarded the prize to
another student whose work, according to
Holiday, was the only entry that had not been
studied directly from nature, and which was as

a result "weak and conventional and without
character." Holiday recalled: "The council was
determined to crush the pernicious heresy of
studying from nature."[1] In the course of a long
and diverse career, Holiday frequently painted
landscape studies in both oil and watercolor,
usually small in scale and always precisely de-
scriptive of a particular place.

From his first visit to the Lake District in 1855,
Holiday was entranced by the beauty of the
landscape of that region, and over the years he
frequently returned, eventually buying a small
farm and building a house there. A. L. Baldry
reminisced of Holiday:

*He was especially fond of wandering up hill and down
dale in the Lake District. . . . Always on these tramps he
carried a sketch book and he made numberless notes of the
wild scenery which fascinated him by its rugged bareness
and its architectural dignity of line. He used sometimes to
say that he had drawn every mountain in the Lakes from
the top of every other mountain, a permissible boast which
gives a good idea of the variety and character of his
excursions.*[2]

Haweswater is the most easterly of all the
Lakes and among the most remote. Holiday's

view is of the upper lake, above the point where
the expanse of water was nearly divided by a
spit of land. (The lake is now a reservoir, and
this feature has been submerged.) The road
seen running between the stone walls in the
foreground is the one which still follows the
southeastern shore of the lake and which ends
at the foot of Harter Fell. According to the lists
of Holiday's works compiled by his daughter,
Winifred, the present watercolor was painted in
1918.[3] Despite its late date, the watercolor retains
an essentially Victorian style and approach to
landscape, harking back to the heyday of Pre-
Raphaelitism. CN

1. Henry Holiday, *Reminiscences of My Life* (London:
 William Heineman, 1914), p. 45.
2. A. L. Baldry, *Henry Holiday* (London: Walker's
 Galleries, 1930), p. 37.
3. Ibid., p. 77.

Selected Bibliography

The following list has been limited to general works dealing with landscape and watercolor in the Victorian period. Books and articles on individual artists and specific topics may be found in the notes to the chapters and catalogue entries.

Bayard, Jane. *Works of Splendor and Imagination: The Exhibition Watercolor, 1770–1870.* Exhibition catalogue. New Haven: Yale Center for British Art, 1981.

Cohn, Marjorie B. *Wash and Gouache: A Study of the Development of the Materials of Watercolor.* Exhibition catalogue. Cambridge, Mass.: Fogg Art Museum, Harvard University, 1977.

Halsby, Julian. *Scottish Watercolours, 1740–1940.* London: B. T. Batsford, 1986.

Hardie, Martin. *Water-Colour Painting in Britain.* Edited by Dudley Snelgrove with Jonathan Mayne and Basil Taylor. Vol. 3, *The Victorian Period.* London: Batsford, 1968.

Holme, Charles, ed. *The Royal Institute of Painters in Water Colours.* London: Studio, 1906.

Landscape in Britain, 1850–1950. Exhibition catalogue. London: Arts Council of Great Britain, 1983.

Mallalieu, H. L. *The Dictionary of British Watercolour Artists up to 1920.* Woodbridge, Suffolk: Antique Collectors' Club, 1976.

Mingay, G. E., ed. *The Victorian Countryside.* 2 vols. London, Boston, and Henley: Routledge and Kegan Paul, 1981.

Newall, Christopher. *Victorian Watercolours.* Oxford: Phaidon, 1987.

Roget, John Lewis. *History of the "Old Water-Colour" Society.* 2 vols. London: Longmans, Green and Co., 1891. Reprint (2 vols. in 1). Woodbridge, Suffolk: Antique Collectors' Club, 1972.

Stainton, Lindsay. *Nature into Art: English Landscape Watercolours.* Exhibition catalogue. London: British Museum Press, 1991.

Staley, Allen. *The Pre-Raphaelite Landscape.* Oxford: Clarendon Press, 1973.

Wood, Christopher. *The Dictionary of Victorian Painters.* 2d edition. Woodbridge, Suffolk: Antique Collectors' Club, 1978.

Index

Photograph Credits

Photographs have been provided by the owners, except as noted:

Chris Beetles Limited: 99, 122, 124; The Bridgeman Art Library, London: 58, 72, 100, 105; Richard Caspole: 65, 94; Richard Caspole, Yale Center for British Art: figs. 1 and 2, and 2, 5, 6, 9–11, 13, 16, 17, 25–28, 36, 38–40, 43, 45, 48, 51, 53, 56, 63, 68–70, 74, 81, 96, 120; Prudence Cuming Associates Limited, London: 31, 49, 50, 78, 79, 90, 112, 121, 123; Hove McNeill: 103; Lou Meluso: 62; John Mills Photography Ltd., Liverpool (for the Walker Art Gallery): 59, 71, 87, 101; Peter Nahum Ltd., London: 29, 32, 37; John Neitzel, Skylite Photo Productions, New York: 47, 108; Antonia Reeve Photography, Edinburgh (for the National Galleries of Scotland): 35, 57, 95, 97; Sotheby's London: fig. 4; Charles Tait: 107; Rodney Todd-White and Son, London: 55; John Webb, London (for the Tate Gallery): 7, 93.